•	

WATERCOLOUR ARTIST

WATERCOMPLETE WATERCOLOUR ARTIST

JENNY RODWELL

PELHAM

First published in Great Britain by Pelham Books Ltd 27 Wrights Lane Kensington London W85TZ

First impression 1987 Text © 1987 by Jenny Rodwell

Copyright © 1987 The Paul Press Limited

All rights reserved. No part of this publication may be reproduced, stored in a retrieval system, or transmitted in any form or by any means, electronic, mechanical, photocopying, recording or otherwise, without the permission of the copyright holder.

British Library Cataloguing in Publication Data

Rodwell, Jenny

The Complete Watercolour Artist

1. Watercolour painting

1. Title

751.42'2

ND2420

ISBN 0-7207-1727-2

Typeset by Peter MacDonald, Twickenham Origination by Union Grafica, Verona, Italy Printed and bound in Italy by Poligrafici Calderara

Art Editor Project Editor Tony Paine Sally MacEachern

Photography

Ian Howes

Artists

Don Wood (Materials Section) Ian Sidaway

Richard Wise (cover illustration)

Designers

Grub Street Design, London

Carol Suffling

Art Assistant

Sue Brinkhurst Picture Researcher Liz Eddisan

Art Director

Stephen McCurdy

Editorial Director

Jeremy Harwood Publishing Director Nigel Perryman

6

INTRODUCTION

8

THE WATERCOLOUR TRADITION

76

MATERIALS AND EQUIPMENT

104

PRACTICAL WATERCOLOUR TECHNIQUES AND PROJECTS

STRETCHING PAPER CREATING WHITE 12 Still Life MIXING PAINT 13 Seated Nude WET ON DRY CREATING TEXTURE A Seascape 14 Crab Chapel with Cypress Trees 15 WET ON WET 16 Snow Scene 2 Basket of Fruit DRYBRUSH PEN AND WASH 17 Windows and Shutters Potted Cactus The Village Church WARM AND COOL PERSPECTIVE **COLOURS** The Tuileries, Paris Apples on a Plate 19 The Artist's Father Receding Hills LIGHT TO DARK DARK TO LIGHT Anemones in a Window Jar with Dried Flowers 8 Alexa Sunlit Field 21 Blue Irises WATERCOLOUR PENCILS MASKING Woman by a Window On the Verandah 10 MONOCHROME MIXED MEDIA A Misty Scene 23 Corn on the Cob

227

SIMPLE TECHNIQUES

PAINTING TREES
Winter Trees
Summer Trees
PAINTING SKIES

28 Gouache Skies29 Using a SpongePAINTING WATER

PAINTING SKIES Cloud Study Sunsets

30 Choppy Waves31 Waterfall32 Swimming Pool

250

GLOSSARY AND INDEX

Introduction

Watercolours have been popular for centuries. Their luminous transparency helps to produce a freshness that cannot be equalled by any other medium. However, there are pitfalls as well. The attraction of watercolour has encouraged many people to work in it—and quite a few of these have been disappointed by the results. This is because they have plunged into the business of painting without the necessary initial understanding of the principles and techniques of the medium with which they are working. They may not have realized, for instance, that it is vital to be patient and allow the colours to dry, and so have ended up with paper awash with uncontrolled colour. Or they may have become alarmed by the difficulty of obtaining flat washes.

The aim of this book is to provide the necessary grounding to help all artists working in watercolour to overcome such difficulties and so enable them to exploit the potential of the medium to the full. It is therefore not just a beginner's tool; it will help those who have already begun, and also those who have some experience, but who wish to broaden their methods and use of materials. With knowledge of the appropriate techniques and with practice, painting in watercolour can be one of the most exciting of all art forms. It can also satisfy two quite different methods of working — the methodical and the spontaneous.

The best approaches

With some knowledge of the basic materials and techniques, and with experimentation, all the characteristics of water-colours can be turned to advantage. For instance, you can adopt a strictly methodical approach to your painting, if you wish. You can make a fairly precise drawing, plan where your colours are to go, mix and dilute them to get the right shades, and then carefully block in the shapes and build up the tones, allowing the paint to dry between stages. You can also use "drybrush" technique, squeezing water off the brush for intricate, textured work.

On the other hand, the very fact that watercolours tend to flood and "bleed" into each other when wet means that a spontaneous approach can be adopted, too. This means that you can set out deliberately to let "chance" play an exciting part in the creation of your pictures. Both approaches, too, can sometimes be combined; a small amount of flow, or colour-bleeding, can work well within the confines of a carefully structured picture.

Watercolour characteristics

What makes the medium seem daunting to the beginner is the fact that watercolours are transparent; this means that you cannot paint a light colour over a dark one, because the darker colour will show through. Once you have made a dark mark on the paper, you are committed, and you can alter the effect only by painting an even darker colour on top of it. This is the chief difference between watercolours and oil paints. You cannot simply paint over a picture in layers, as you can with oils, literally covering up mistakes.

Other differences affect the way you can actually paint. With oils, for instance, the addition of the "highlights" – the lighter, sometimes pure white, tones that usually depict the reflections of light onto the objects in the picture - can sometimes be left until the final stages. With watercolours, however, the colours are conventionally applied from "light to dark". Therefore the highlights are often simply areas of the picture that have been left unpainted; the white is the paper itself. When colours are applied, the lighter tones go on first, and the darker ones are built up on top of this. This means that you need to know which areas of the picture are going to be the lighter ones, for they will be left with less paint or none at all.

Moreover, oils can be manipulated while they are being applied; the paint can be actually moved around on the surface of the canvas, and the colours will not adhere properly to the surface until they are dry. Watercolours, however, cannot be used in this way, since, as their name implies, they are mixed with water. It is usually water that governs the tone - the more diluted the colour, the lighter the tone will be.

Mixed media

There have always been different types of watercolour, but nowadays the range is greater than ever before. And, of course, watercolour can be mixed with other media.

As you will see from the historical survey of the watercolour tradition that forms the opening section of this book, there have been times when watercolours were used to make preliminary sketches for oils – and also periods when it was considered "impure" to add any other materials to what was considered strictly a "watercolour painting". Today, however, many artists prefer to vary the use of their materials without inhibition. For instance, you can use coloured pencils with watercolour washes, while pen and ink and gouache (an opaque version of watercolour) all have their possibilities. Opaque watercolour is older than might be supposed – many of the Old Masters used gouache, or "body colour" as it was known, for the final highlights.

Remember, though, that, though the medium has its disciplines and rules, you should never allow them to become a straitjacket and dominate you. What matters above all else is that you establish which methods, techniques and materials best suit you and your approach to your painting; if you bear this in mind as well as the necessary basic precepts, you will not go far wrong.

THE WATERCOLOUR TRADITION

Watercolours are one of the oldest artistic mediums known. Physical evidence of their use by Stone Age people still survives – hidden in the darkness of caves that, for reasons unknown, were decorated by the world's first artists. From this time onwards, watercolours added their own particular flavour to artistic history.

It was not until the 18th century, however, that watercolour paintings became recognized as works of art in their own right. Since then, they have enjoyed enduring popularity among amateur, as well as professional, artists. Two of their chief qualities are their freshness and versatility, which, as this section of the book demonstrates, have been constant factors in the development of the watercolour tradition from earliest times to the present day.

THE FORERUNNERS

PREHISTORIC ART

ALTHOUGH LITTLE IS KNOWN about our prehistoric ancestors of some 20,000 years ago, they certainly included some sophisticated artists. These figurative painters of the Old Stone Age, or Upper Palaeolithic period, crawled into the inner recesses of huge limestone caverns, taking with them primitive paints made from earth, mineral and animal pigments - red and yellow ochre, manganese, graphite, and iron oxides of a deep blood red colour – as well as tools for scratching outlines, implements for rubbing the paint onto the surface, and in some instances, tubes of bone for blowing or spraying very fine powdered pigments. Black marks found on cave walls and roofs indicate that they must have illuminated the awesome darkness with the faint light given by simple, animal fat lamps.

The artists would have found it no easy task to reach the roofs and walls of these deep galleries. It is thought that they adopted uncomfortable positions on the shoulders or backs of others, or lay flat on their backs on narrow ledges. The paints they used were made from pigment that had been pounded to powder, thinned with water and mixed with some kind of binding medium that clung to the rock surface. The moisturized make-up of these paints helped to preserve the paintings in the damp atmosphere of the limestone caves.

STANDING BISON

Altamira, Spain

Here is vivid evidence of the ability of the cave painters – the heavy, rather menacing strength of the bison has been captured in masterful representational fashion. It is typical of the distinct detail with which many of the animals were painted, and shows levels of observation that seem surprisingly modern – quite unlike some of the symbolic and stylized methods found in much primitive and ancient art. In the cave paintings, the animal takes precedence. The human form is rarely seen, and then almost as a stick figure in cartoon form, sometimes pointing arrows at the animals.

Working in this way, the painters created vivid and lifelike pictures, mostly of the animals – typically the bison – which Palaeolithic people hunted. In some cases, the artists repeatedly painted new images over the top of their previous work. Many of these final paintings survived, undisturbed for thousands of years until comparatively modern times.

The first discovery of these spectacular paintings was made in the late 19th century at Altamira, northern Spain. They immediately challenged current notions of the culture and abilities of prehistoric peoples. Many historians of the time were incredulous, unable to believe that "those creatures" were so technically skilled. Some condemned the cave paintings as fakes.

Another major discovery was made in 1940 when four boys playing near Montignac, in the Dordogne, France, came across the Lascaux Cave paintings. Since then other paintings have been found, and 20th century scholars, aided by scientific testing, have accepted the cave paintings as genuine. However, it was difficult for people to accept that the true forerunners of the revered Masters were these primitive Stone Age painters who decorated remote, dark caverns so many thousands of years ago.

Ever since the discovery of these cave paintings, there has been speculation about their purpose, and particularly about why they were painted in the dark. The suggestion that Stone Age people might have had keener eyesight seems unlikely, since it is almost certain that they had to light the caves. The most common theory is that the paintings were a form of magic, and that the darkness might have been intended to inspire religious awe as the shapes and colours flickered in the lamplight. The over-painting of one picture on top of another suggests that the artists were not painting to decorate the caves, but in the belief that the act of depicting an animal would help in the hunting of it.

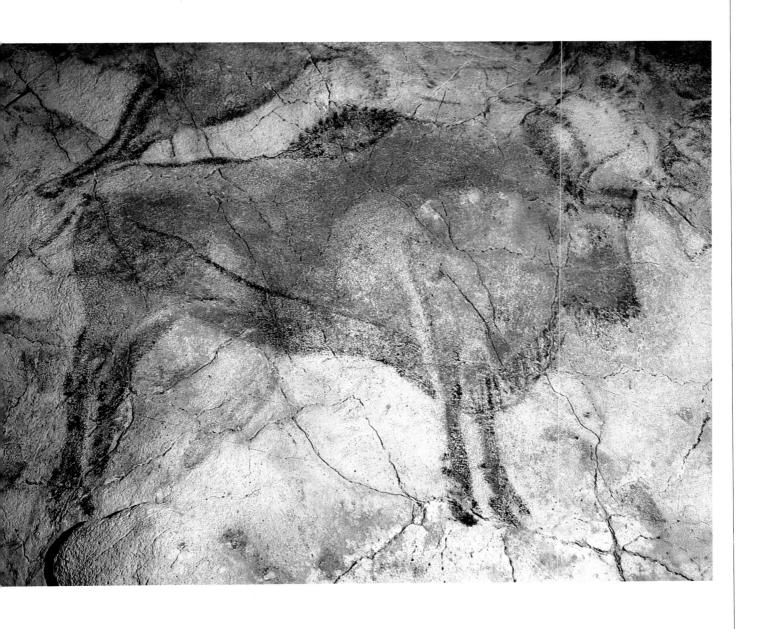

THE FORERUNNERS

EARLY MATERIALS

(Papyrus and Parchment)

The painters who decorated buildings, tombs and papyrus texts throughout 3000 relatively stable years of ancient Egyptian history were not encouraged to be adventurous, neither were they recognized as artists in their own right. The work of writing and painting was done by the same craftsmen, the scribes, who were likely to have been trained in a broad range of skills. Yet there appears to have been a hierarchy among them, for some were major administrative figures in Egyptian government. It seems likely that a team of scribes was sent to carry out a specific task, some drawing outlines, some writing and some adding colour and detail, perhaps with a "master" intervening at crucial points.

The painters worked with pigments which came mainly from minerals. Iron oxides, for instance, were used for red, while blue was made from silica. copper and calcium. Carbon produced black, and chalk, or gypsum, formed the basis of white. Other pigments included yellow ochre, and a green derived from powdered malachite. The pigments were diluted with water, and a binding agent, probably of vegetable or animal gum, was added to them. With these paints, and sometimes beginning with a thin overall colour wash, the scribes produced some brilliant colours, many of which are still surprisingly intense. It is the mineral composition of the paints which has helped them to retain this vividness over the centuries. The equipment found in tombs is unexpectedly simple, forming a

striking contrast with the sophisticated results achieved by the scribe-painters. Both writing and painting were done with brushes, ranging from fine rush brushes with chewed ends to pieces of palmrib and fibrous wood beaten out into a stiff brush-shape at one end.

With this equipment, and after rigid training, a scribe painter was expected to create pictures according to a set style, known as "aspective". Figures were a formalized mixture of profile and frontal view – stylized eyes, drawn from the front, are combined with a head which is in profile; the legs are in profile, but the shoulders face squarely to the front; and so on. The rules were rarely broken. But there was scope for creativity as can be seen from the lively poses; the tricks of design where limbs or clothes cross boundary lines; the vivid animals, birds and plants represented; and, not least, from the mixing of colours on the palette which produced subtle secondary hues.

Papyrus formed the accepted surface for writing and painting during ancient times. The papyrus surface was made by splitting the stems of the papyrus reed, which grew in abundance in marshy areas. Later parchment, made from animal skins, gained ground in Greek and Roman times (although papyrus long remained the most favoured), and gradually came into widespread use, providing the surfaces for Biblical texts and for the spectacularly illustrated religious scripts of the early centuries AD.

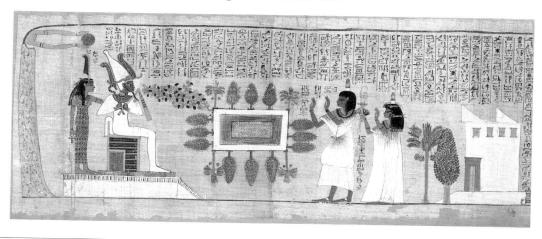

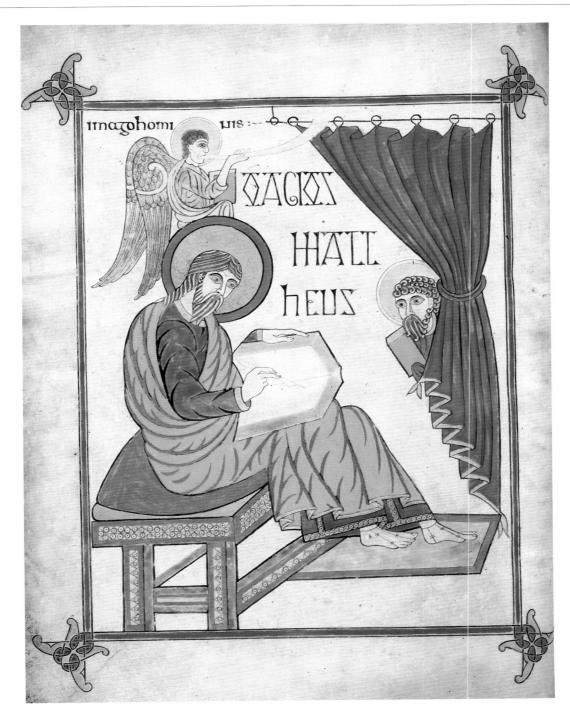

NAKHTE AND HIS WIFE Book of the Dead (c. 1320-1290 BC)

Like the cave-painters thousands of years before them, many of the artists of ancient Egypt painted for "galleries" that would, they thought, remain in perpetual darkness. They created vivid colours and animated scenes on papyrus rolls, which were then sealed inside the tombs of great personages.

These texts were intended to assist their owners when they came before Osiris, the judge of the dead, and also to guide them through the intricate preparations for an afterlife. The papyrus rolls found by archaeologists have been gathered together

and, although the versions differ, the collection is known as the Book of the Dead.

The version shown here is a papyrus manuscript prepared for Nakhte, a high-ranking scribe and military leader. He and his wife are shown emerging from their house to greet the rising sun and the god Osiris, who is sitting on a dais. Like many such scripts, the text itself is visually subordinate, done in plain black without elaboration, very much like a modern illustrated book. The illustration is linear, and yet complex: the figures are drawn in formal profile, but with typical Egyptian aspective, the trees around the pool appear to be growing at right angles. (LEFT)

PORTRAIT AND SYMBOL OF ST MATTHEW Lindisfarne Gospels (c. AD 690-700)

The Lindisfarne Gospels, illustrated manuscripts from the remote monastery of Lindisfarne, on Holy Island, off the northeast English coast, represent an artistic triumph of the Anglo-Saxon era. This particular illustration is linear, without much feeling of depth, but it is enriched with the bright colours typical of the great age of manuscript illumination. (TOP)

THE FORERUNNERS

FRESCOES

WITH THE ART OF fresco painting, humankind can be said to have reached one of its peaks. Real fresco is the most beautiful form of decorating the interiors and exteriors of buildings yet produced by artists. Sadly, however, it is no longer in widespread use, as the techniques involved are not suited to modern construction methods. Fresco painting rose to its high point during the Renaissance, and it seems unlikely that any technique devised in the future will ever be so brilliantly attractive and, at the same time, so effective as a means of decorating walls and roofs. When carrying out classical or true fresco, known by its Italian name of Fresco buono, the artist applies pigments mixed with water directly onto wet plaster - the process involves plastering and painting in one meticulously coordinated operation. If the plaster has been made from absolutely pure materials – such as white lime which is free from gypsum, and pure sand – then the acids in the air cause a chemical reaction which crystallizes the pigments into the plaster. The result is an image which is actually part of the building itself, rather than a decoration added later.

The term *Fresco secco* is used for painting onto dry plaster. Before the artist begins painting, the wall is wetted thoroughly with lime water. Ancient Rome produced some beautiful wall paintings, most of which were probably painted onto plaster that had already dried.

It was *Fresco buono*, however, which came triumphantly into its own, from approximately the 13th century to the 16th – the work done then has been unmatched since. The most meticulous standards were reached: only the purest lime – two years at least in a lime pit – could be used; then the freshly-laid surface was painted with powdered earth pigments ground in purest water. The chapel frescoes done by Giotto (1266/7-1337) in Padua are recognized as masterpieces, as are his frescoes in the chapels of Santa Croce, Florence.

In the 16th century many painters reverted to *Fresco secco*. In the 19th century, there were attempts in northern Europe to revive pure fresco, but they were defeated by the dampness of the climate, which retained acids produced by smoke.

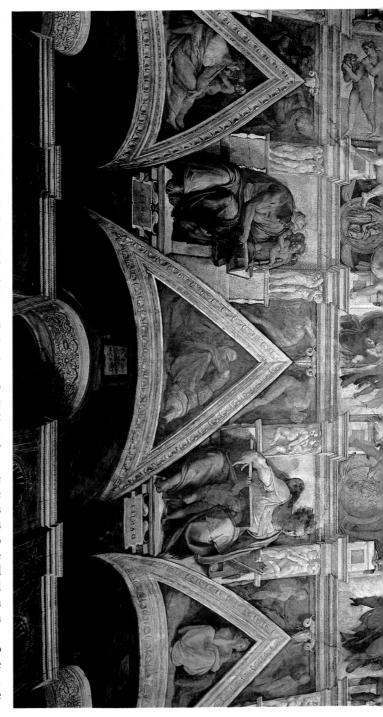

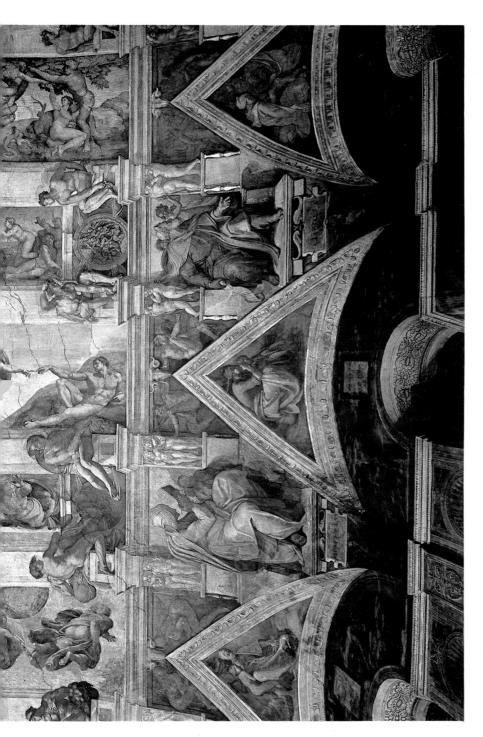

SISTINE CHAPEL CEILING

Michelangelo Buonarroti (begun in 1508)

In one of the world's most famous masterpieces, Michelangelo (1475-1564) brought the whole ceiling of the Sistine Chapel into brilliant life with figures that seem to float and glide off the surface. This is fresco at its grandest.

The series of paintings, based on Genesis, took two and a half years to complete, gradually creeping forward across the great ceiling, section by section, in time with the final laying of plaster.

In executing frescoes, especially major ones of this sort, it was essential, first, to create a complete guide, or cartoon, and this had to clearly indicate each day's area of painting. Most artists planned their colour schemes exactly, before the actual work started. Sheets of tracing could then be placed over the surface and the design imprinted by indenting, or by powdering through holes.

Meanwhile, the plaster brought to the site was the product of years of careful tending. The lime would be stored in a lime pit and watered and stirred for at least two years before being pure enough for use. Any mistakes in the making of the plaster could mean that the fresco would soon be distorted by reactions of discolouring caused by chemical impurities.

The plaster was applied in three layers. The first layer, which was known as the trusilar, was rough-cast, and this was followed by a second layer, the arricciato, which was richer in lime. Next, the area which could be covered by the painter in one day was estimated, and the third layer was applied to that surface only. Known as the intonaco, this was richer still in lime.

In the Sistine Chapel, plastering and painting would have been executed from high scaffolds. The painting itself was initially built up in thin transparent washes, which ran into the wet plaster and were absorbed by it—a flooding technique similar to a watercolour wash. At this stage, more detail was added, including highlights in the form of pure white lime. The Italian painters were fond of using thatching and shading for conveying shape and form.

THE EAST

CHINESE ART

Water-based paints have been employed in China for at least 3000 years, with long and tenacious traditions of philosophy and religion often governing their use.

The art of both China and Japan is noted for its liveliness: the figures are obviously moving; the bamboos sway; leaves and flowers rock in the wind. The techniques which have produced these effects are based partly upon the fact that writing was done with a brush on silk or paper. The absorbent surfaces of these materials encouraged Chinese painters to use thin, non-viscous media, such as ink and water-soluble paints.

A silk-making industry, based on silkworm farming, had been established in China by 2000 BC. The silk obtained from the cocoon of the silkworm readily absorbs water and is ideal for painting in delicate washes. Painted silk was hung on walls as decoration, or kept in a scroll as a primitive form of book.

The Chinese also produced paper at an early date. It is said to have been invented in AD 105 by Tsai-Lun, who beat plants into fibres which he then wove into webbing. Not long afterwards, materials such as rags and old nets were also being used in paper-making.

For centuries, the art of painting in China was regarded as inseparable from that of writing. Far from being the preserve of specialist artists, it was considered an essential skill – particularly for scholars, poets, philosophers, and even emperors – and was taught from childhood. As a result, many pictures strongly reflect philosophical themes.

IRIS WITH BUTTERFLIES AND INSECTS

(16th century) by an anonymous artist

This handscroll in ink and colours on silk comes from a period that marks a resurgence of new freedom and colour in Chinese art, during the Ming Dynasty (1368-1644).

Under the influence of such philosophical themes as Taoism and Buddhism, some Chinese painting had been going through a kind of purification, towards a very simple and austere ideal of tranquillity. Mu-ch'i (c. 1200-1270), a

Zen monk painter, produced a mystical picture entitled "The Evening Bell of a Temple in Fog", where distant, tiny points of landscape can just be glimpsed through the haze. The landscapes of other painters, too, became increasingly composed of empty space; some of them brilliantly capturing a mood of mystery and distance with a few strokes of ink.

After Mongol conquerors had ruled China between 1280 and 1368, the country became reunited under a native dynasty – the Ming. For the arts, there was a period of relaxation and revived colour, accompanied by brighter pictures of

Some are aimed at imparting wisdom to the viewer in a fairly direct and conscious way, supported occasionally by beautifully-designed pieces of text. Other pictures, however, especially the great landscapes, are visual forms of meditation.

Their landscapes attempt to achieve a tranquil relationship with nature. Those figures which appear are often dwarfed by looming mountains and overhanging trees. Whirls of mist curl around the dramatically emphasized mountains. The humans appear small and fragile, reflecting their humble and transient place in the natural and irresistible order of the world. The ideas that formed the intellectual basis for these pictures came from doctrines such as Taoism and Buddhism which stressed the need to accept one's place in the grand scheme of nature.

Although, in China, landscape has always been considered the proper subject for paintings, people are portrayed from time to time as major and interesting characters. The human body, however, does not appear as the main focus of visual interest, as is so frequently the case in western art. Instead, the figures are seen as part of the process of daily life and ritual. One of the best known of these silk handscrolls, painted by the Emperor Hui Tsang (who reigned from 1101-25), depicted women preparing a scroll of newly-woven silk. Another well known artist, Chou Fang (c. 740-800), painted high-ranking ladies in graceful postures taken from daily life at court. They are posed beside sprigs of foliage, small animals, or birds which complement their fashionable elegance.

animals and court scenes. Officiallyappointed artists reappeared, but they
were not subjected to quite such severe
restrictions as before. Bird and flower
painters, for example, once again worked
for the court, but no longer under the
discipline which had required close study
of a subject. In some cases, this resulted in
work which was merely decorative, or
repetitious of earlier masters – but some
painters, like the anonymous one featured
here, benefited from the new freedoms.
Imaginative touches resulted in beautiful
pictures and raised the term "decorative"
onto a higher plane.

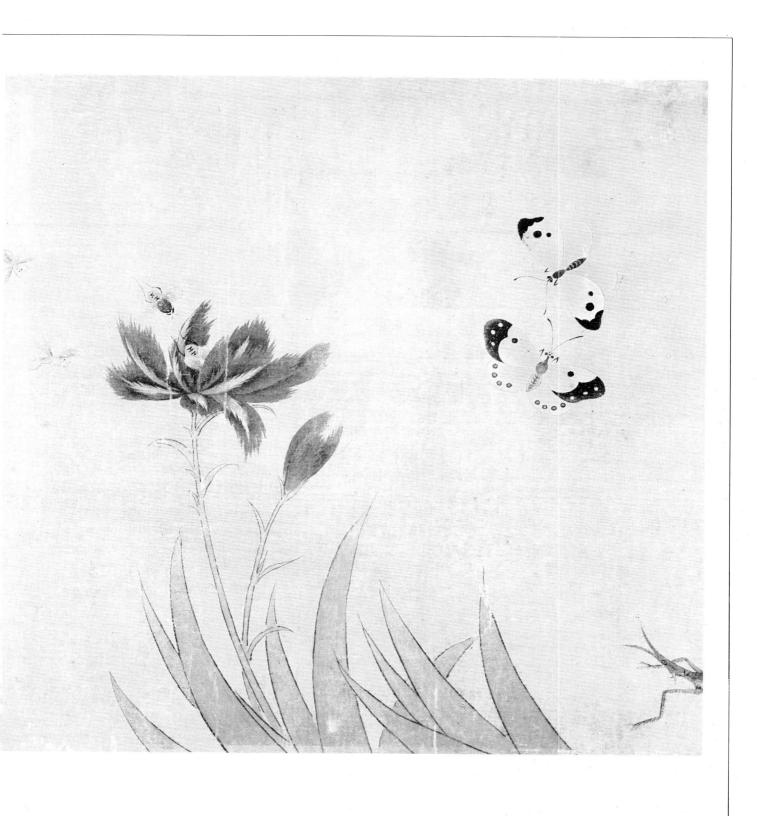

THE ADMONITIONS OF THE INSTRUCTRESS TO THE COURT LADIES (detail)

(4th century) by Ku K'ai-chih

One of the greatest masters of early Chinese painting was at work during the period of the "six dynasties" when, from AD 222-589, the previous Han Empire was broken up into three kingdoms. Ku K'ai-chih (344-c.405) lived under the Eastern Chin dynasty. Already, strict guidelines had been laid down for paintings, including approved ways of using brushes, faithfulness to objects, and the copying of earlier works to maintain continuity of tradition. There are extant copies of Ku K'ai-chih's work, and this

handscroll, in ink and colours on silk, is probably one of his original paintings.

The figures, outlined in fine brushstrokes, are clearly individual characters, rather than stylized human forms. The scroll has a serious moral theme, based on the often fragile relationships between men and women, but there is also a slightly irreverent, humorous touch.

Ku K'ai-chih's paintings, like much of Chinese art, were inspired by literary and philosophical ideas. This scroll illustrates some writings by Chang Hua. The moral tone is demonstrated by a piece of text which says, "Men all know how to adorn their faces but none know how to ornament their minds".

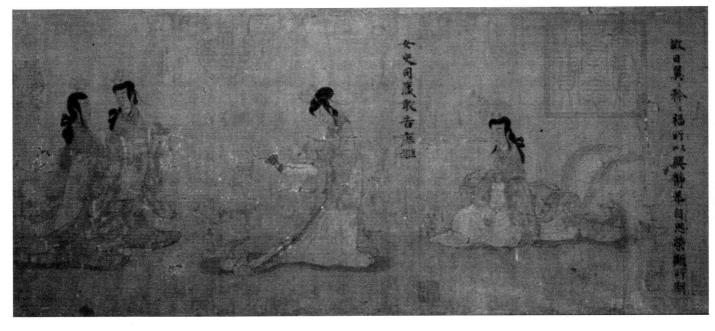

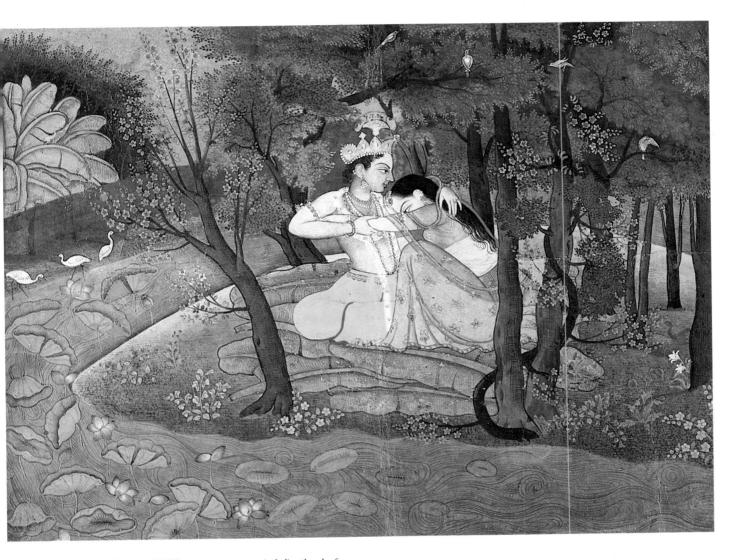

RADHA AND KRISHNA IN A GROVE from the Rajasthani school (18th

from the Rajasthani school (18th century)

A god, who has descended to human form, and a milkmaid, wander through an idyllic grove in this love scene from one of the most colourful periods of Indian art – the Rajput-Hindu tradition of miniature painting. This tradition flourished between the 16th and 19th centuries, in two main schools – the Rajasthani in Rajputana, and the Pahari in the Punjab. It had its roots in court life and entertainment, and drew much of its inspiration from Indian epics and legends.

The cult of Vishnu was extremely popular throughout northern India, inspiring plays, stories, songs and pictures. The Hindu god Vishnu took human form in various ways, including the role of Krishna, who represents joy and love – the antidotes to suffering. There is a lightly mischievous side to him and his amorous adventures with the cowmaidens, among whom Radha was his favourite, had a great fascination for Indian storytellers and artists, who often concentrated on this happier aspect of an old cult, which in earlier, sterner versions had told of Krishna leaving his maidens and fighting against tyranny.

Flowers and jewellery are painted with precision, and the faces are in profile, stylized in a way which was common in this tradition. The overall concern for design and colour and the stylized hills and buildings, give a magical quality to the picture. It escapes from mundane reality and takes the viewer to a happier world.

THE FIRST WATERCOLOUR ARTIST

ALBRECHT DÜRER

(1471-1528)

Albrecht dürer was the first European painter to use watercolour as a serious alternative to oils. His love of natural history and his careful observation of plants, birds and animals led him into a full exploration of the medium. For watercolour, with its delicate, transparent tones, made it possible for him to achieve scientific precision in his depiction of nature. Dürer trained both as an engraver and as an oil painter; a combination which enabled him to use line and colour to produce watercolours which are striking in their detail.

Yet, after Dürer's death, despite the virtuosity of his pictures, watercolour fell back into obscurity – regarded as a secondary medium suitable for miniatures, decorating manuscripts, and as a working-step towards oils. Nearly 300 years were to pass before it gained recognition as a medium in its own right.

The turn of the 15th century is generally considered to mark the end of the Early, and the beginning of the High Renaissance. Dürer, therefore, lived through some of the most important decades in the history of art. He was a contemporary of artistic giants – including Michelangelo, Raphael, Titian, Botticelli, Hieronymus Bosch and Leonardo Da Vinci.

THE GREAT PIECE OF TURF

(1503) by Albrecht Dürer

This picture is a classic example of the cliché, "before its time". Dürer's watercolour of a section of grass and wild flowers stood apart from the mainstream art of its time and remained isolated for centuries. Its style of stark realism uncannily anticipates much modern painting and illustration.

In order to show every plant in its entirety, Dürer took almost a ground-level, cross-section view, rather than setting up a conventional visual composition. At the same time, he exploited the transparency of watercolour – using it to

The young Dürer learned engraving from his father, who was a goldsmith, and he later became especially skilled in copperplate engravings. From an early age, he had thus developed a highly sensitive awareness of line with its varying thickness and its depiction of detail. This approach is reflected in all his watercolours, particularly his botanical works which are a combination of transparent colour and beautifully observed outlines.

His mastery of colour was further developed when he became a pupil in a painter's studio. Later, in the 1490s, he travelled through Germany and visited Italy. Biographers note that he saw the work of other artists, and was impressed by it; he also began to paint landscapes in watercolours. Back in his native city of Nuremberg, Dürer opened his own studio in 1495. Later, he sought and won patronage from some of the most powerful figures of his time, including Charles V, and Maximilian I. Meanwhile, Nuremberg was becoming one of the first strongholds of Protestantism. Dürer favoured the doctrines of the Reformation and became a friend of Luther's. A true Renaissance man, his wide range of interests also led him to write treatises on geometry, perspective and fortifications.

depict shape and form, and to capture the feeling of sunlight on the foliage.

Dürer was blissfully untroubled by a convention which would have a dominating effect on watercolourists in later centuries, particularly in the 18th century – in order to be "pure", a watercolour painting had to be truly transparent; therefore, the use of opaque white, body colour was considered to be "cheating". In this picture, he used body colour to sculpt the forms of the foliage; while some of the outlines of the grass and leaves were drawn in pen and ink. The colour was blocked in initially, with fairly loose brushstrokes. Then, he worked into areas of the picture until each blade of grass showed up crisply and separately.

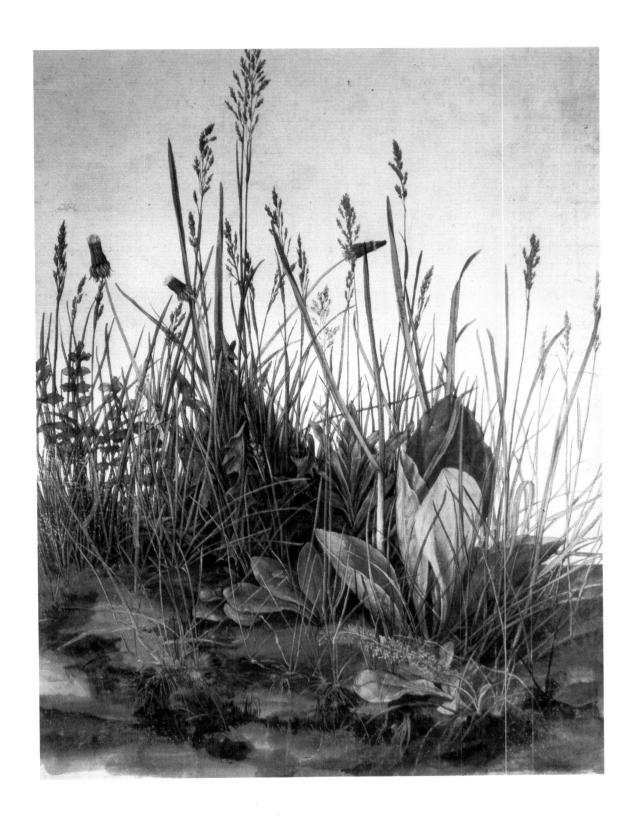

A GUIDE FOR OTHER MEDIA

RUBENS

TO A 20TH CENTURY observer, Rubens' great studio in Antwerp would have resembled a bustling, well-organized factory. The Flemish master created nearly 1,000 pictures during his lifetime, many of them enormous panels which would span the entire wall of a modern house. Watercolour was a key process in the production of these massive oil paintings.

Peter Paul Rubens (1577-1640) was able to produce such an astonishing output as a result of the methods he devised for executing paintings. First he decided upon the basic outlines of each picture. Next, he made a drawing, and from this he created a detailed watercolour sketch. The use of watercolour enabled Rubens to quickly work out the arrangement of colour and tone before committing the painting to oils. The sketch acted as a design for the workshop. Rubens' assistants enlarged it to its full scale and filled in the main areas. Rubens then added the finishing touches.

Throughout most of the 16th and 17th centuries, the use of watercolour in Europe was restricted to the secondary role of acting as a tone and colour guide for oil paintings. It was, in fact, a natural extension of the cartoon.

A cartoon, in this sense, is a fullscale drawing for an oil painting, or a fresco. It was pinned to a wall, canvas or panel and then transferred to the surface, either by tracing over the outlines, or by pricking small holes along them, so that fine charcoal dust could be sifted through.

Initially, cartoons were drawings done in monochrome, but artists increasingly used white body

NEREID AND TRITON

by Peter Paul Rubens

Nereid, a mythical nymph of the Aegean Sea, and Triton, the legendary son of the god Poseidon, are depicted here in a dramatic picture which establishes a harmony between the shapes of the figures and the movement of the waves. Nereid is a typically Rubenesque colour for the highlights. This application of bright white enabled them to work out the full tonal range of the picture at cartoon stage. When Raphael (1483-1520) was commissioned to produce designs for tapestries which were to hang in the Sistine Chapel, he produced fullscale coloured cartoons, using a type of watercolour.

Anthony van Dyck (1599-1641) also used watercolour as a working stage for oil paintings, but in a very different way from Rubens. Van Dyck built up a store of possible backgrounds for his portraits by painting watercolour sketches, often of landscapes, from life. The sketches acted as colour guides, and formed the basis for the realistic backdrops in his pictures.

After Rubens' death, many of his assistants perpetuated the tradition of using watercolour as a preparatory stage in oil painting. Jacob Jordaens (1593-1678), for instance, finished some of the master's uncompleted works, and then for the rest of his career he continued to follow Rubens' techniques closely.

Apart from Dürer, who had had died in the first half of the 16th century, there were no major painters using watercolour as an end in itself. There was, however, one slight exception. The preliminary watercolour sketches of a few artists in the Netherlands started to gain recognition as paintings in their own right. The most important of these artists were the van Ostade brothers – Adriaen (1610-84) and Isaack (1621-49) – and Allart van Everdingen (1621-75), whose work influenced many Dutch contemporaries.

voluptuous woman; while Triton is shown with the shell horn traditionally borne by this character who was supposedly half human and half dolphin.

On top of these rich forms and colours, Rubens has used pure opaque white; and in this case the white body colour is employed not only to describe highlights but also to emphasize the shiny wetness of the subject.

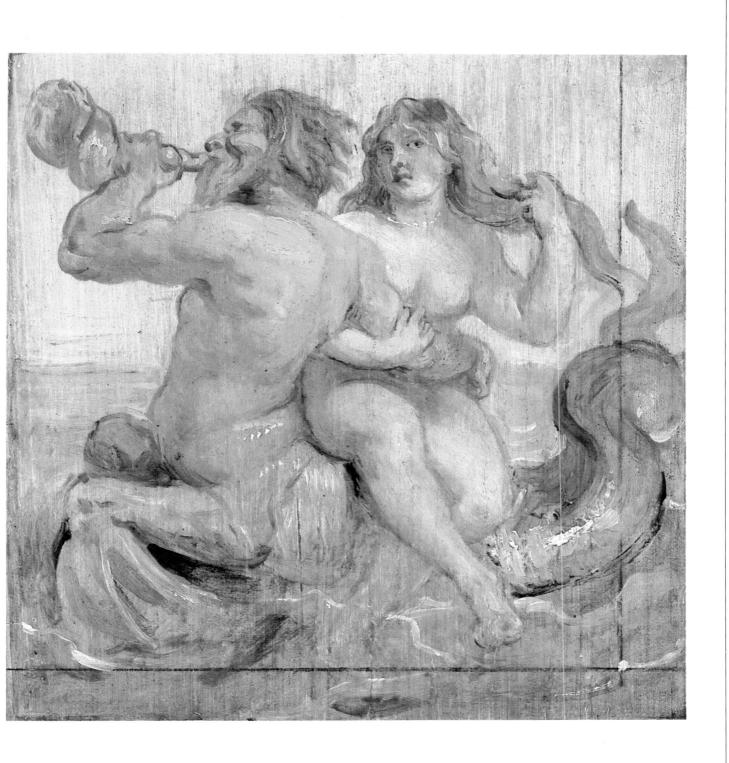

A GUIDE FOR OTHER MEDIA

RAPHAEL

(The Sistine Chapel Tapestries)

In the second decade of the 16th century, a series of giant watercolours was transported across Europe from Italy to Brussels. Raphael (1483-1520) had been commissioned to design a set of 10 vast tapestries to adorn the Sistine Chapel, which was being refurbished. Although the Italians were acknowledged masters of painting, the Flemish were considered to be better at manufacturing tapestries. Raphael, therefore, painted 10 watercolour cartoons, some of them standing more than nine feet (three metres) high, to act as a guide for the weavers.

Although some of their colours have faded, eight of these cartoons have survived – a fact which surprises historians since the cartoons were painted on sheets of paper which had been joined together. In addition, no great care was taken to preserve them after the tapestries had been completed. It was only in later years that they came to be regarded as precious artworks.

Raphael's experience as an engraver was to prove invaluable when he had to tackle one of the major problems involved in designing the tapestries: the weavers would not be standing in front of their work, but would weave from behind the tapestry frame. This meant that Raphael had to paint the watercolours as mirror images. Christ, for example, is shown lifting his left hand, instead of his right. This "reverse style" is a standard technique of engraving, where the image on the metal plate produces a reverse imprint on paper.

Raphael knew that his cartoons would be used

TAPESTRY OF THE MIRACULOUS DRAUGHT OF FISHES

(1515-16) by Raphael

The weavers have done their job to perfection, but they were restricted by the nature of tapestry itself. The colours, the gestures and the facial expressions have all been translated faithfully into the tapestry silk. The stark contrast between colours has helped enormously, as can be seen, for instance, from the way the figures and birds stand out vividly against the background.

by weavers hundreds of miles away, with no possibility of consultation, and that therefore it was important to make the designs clear and simple. This desire for simplicity governed every aspect of the cartoons. Each colour used in the figures was chosen, so that it is dramatically lighter, or darker than the colour behind it. The colours selected for the clothing are pure and vivid; the folds and creases of the material depicted in stark contrast. The facial expressions are bold, even exaggerated, thus making their interpretation even more straightforward. Raphael's designs were also intended to smooth the transition from paint into silks: the silks of the tapestry would be less manageable, and colour subtleties difficult to translate.

The watercolours were full-sized cartoons enabling the weavers to work from them directly. At that time, it would have been difficult to manufacture a suitable surface large enough for this purpose; therefore, Raphael painted onto sheets of paper which had been glued together. The pigments were bound in animal glue, which made the colours opaque; some of them have faded with time. Raphael's assistants would have ground and mixed these colours.

The studio would have found it easy to divide the labour for these watercolour cartoons. The assistants would have blocked in wide areas of colour, which would dry quickly, allowing for further stages. The master himself would have filled in the more intricate details, such as facial expressions.

The texture of tapestry means that it inevitably flattens the images in a picture. It is difficult, if not impossible, to create the illusion of reality, as the viewer is all too aware of looking at a flat design—the weave itself is a constant reminder of this. For instance, the atmospheric perspective, which in the painting pushes the hills back into the distance, has not been successfully interpreted in the tapestry, although the colours are accurately depicted. The clear edges of the hills mean that the haziness of far distance has been lost.

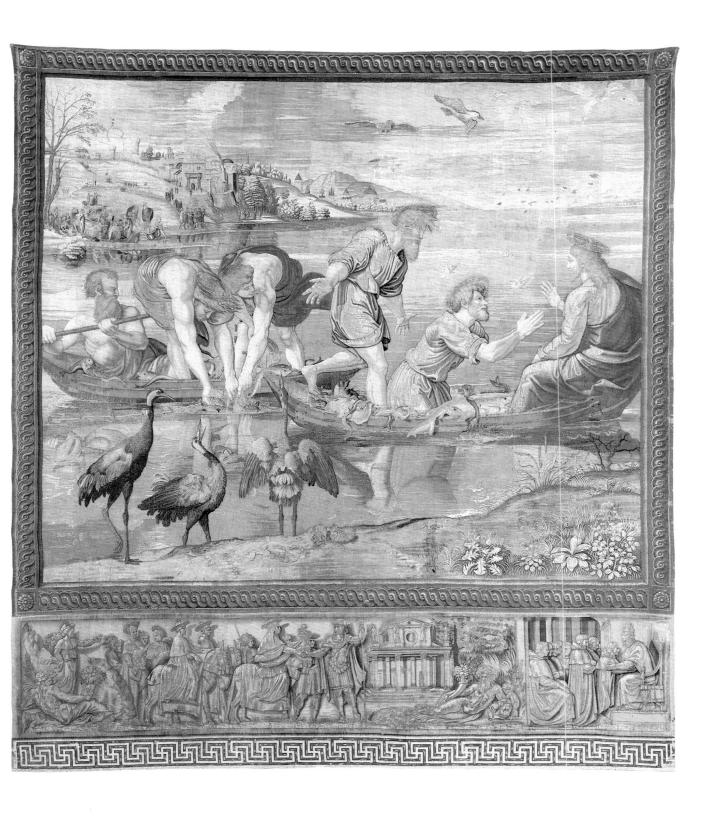

THE MONOCHROME TRADITION TONAL WASHES

A BROWN WASH, used extensively in the 17th century as a preliminary tonal sketch, gradually became increasingly accepted as a finished art form in its own right. It was this neutral medium, rather than any range of brighter colours, which anticipated the great watercolour tradition of the 18th century. A few artists introduced a limited number of colours into their range of washes, but these were earthy and subdued, and were never used to interpret actual colours in a realistic way. Instead, they were seen as an extension of tone and not as colours in themselves. Earth reds, siennas and umbers were usually employed to establish the tones of a subsequent oil painting, when the realistic colours would be painted in, with the help of this tonal guide.

A rapid wash is a versatile technique, which enables artists to work out their ideas quickly in a way that is not possible with massive, traditional oil paintings. It is, therefore, easy to understand why some of these washes began to develop into finished work, and to gain respect as a independent part of an artist's repertoire. Many washes intended purely as preliminary guides for oils have a strikingly complete quality about them, so rich are their variations in tone. In fact, looking back at the work of Rembrandt and also at that of Nicolas Poussin (1594-1665), it is often impossible to differentiate between a wash sketch that was

THE GOOD SAMARITAN ARRIVING AT THE INN

(1641-43) by Rembrandt

This loose sketch of a famous Biblical scene was done in pen and brush, and brown ink, corrected in places with opaque white. The group of figures with the horse have been drawn with a pen, but peripheral shapes have been drawn directly with a brush as the artist laid down the washes. In fact, many of Rembrandt's most beautiful drawings were done with the brush alone.

One of the most distinctive characteristics of Rembrandt's oil paintings is his personal way of interpreting light. It is not always technically accurate; for instance, his light intended as a guide, and one which was a finished work. Some scenes were interpreted in loose strokes and blobs of colour, and are surprisingly modern in appearance. This is particularly true of some of the washes done by Rembrandt (1606-69), and the French painter Claude Lorraine (1600-82), whose wash drawings were loose and free compared with his oils.

Brown wash was a true forerunner of water-colour, in that painters could use it to build up a picture with layer upon layer of thin tone. Extremely dark tones could be achieved by using this method. Often the light paper colour was used to depict the light tones and highlights – a technique that would be exploited during the classic age of watercolour painting.

However, artists often used monochrome washes outdoors to make quick sketches of landscapes, and this required a different technique. The artist would choose a grey, or medium-toned paper – often white or off-white, tinted with a light colour wash – to establish a middle tone. The artist could then work towards darker, or lighter tones by applying brown wash – usually sepia or bistre – for the shadows, and opaque body colour for the highlights. The darker initial surface meant that the outdoor artist could establish a middle tone quickly, instead of gradually breaking down an expanse of flat white.

may come from different sources, or he may have added some "extra" light-source in order to emphasize a particular feature. His success with this unconventional approach is a tribute to his exceptional ability. In the hands of a lesser painter the results would undoubtedly appear artificial, or staged. Rembrandt used light and shade for effect, and to create a sense of drama, rather than in any realistic way.

In this picture, by working with brush in areas outside the central group, the artist has been able to suggest distance and the amorphous shapes of night. The shadows, where the central light has diffused outwards, have been painted in diluted sepia, thus creating an eerie night-time light.

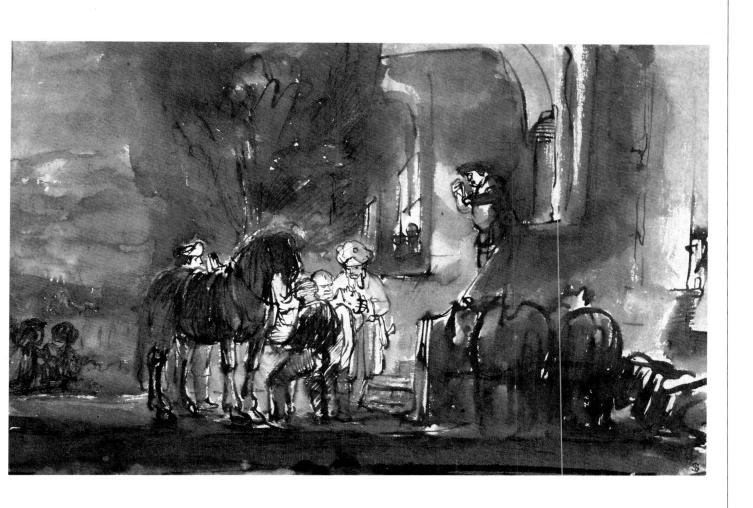

FATHER OF ENGLISH WATERCOLOUR

PAUL SANDBY

(1725 - 1809)

IT IS FITTING that Paul Sandby should be regarded as the "father of English watercolour", for he was a lively, experimental painter who was able to break free of his own training and traditions. The work of this former military draughtsman marks the beginning of the great period of English watercolour painting, when it changed from being a dry topographical recording medium to a fresh means of interpreting nature.

In the years immediately following the 1745 rebellion of Bonnie Prince Charlie, Sandby was sent to Scotland to work on a military survey. As he followed in the footsteps of the redcoats, he visited some of the wildest parts of the Highlands, and although his task was to record the lie of the land in strictly practical charts, he developed a love of scenery that was to emerge later in his painting.

Sandby was totally fascinated by nature, both in its calm and mature state, as in Windsor Great Park, and in its bleak and rugged regions. Sandby lived in London from about 1752, and he often painted in Windsor Park, where his brother was Deputy Ranger. Thomas Sandby (1721-98) had produced tinted sketches of guns and equipment for the army, as well as some architectural drawings, and he went on to paint pictures which were very similar to Paul's.

A MILKMAID IN WINDSOR GREAT PARK

(1765-70) by Paul Sandby

In creating this composition, dominated by the tall, twisting trunks of the central trees, Sandby has produced what came to be regarded as the classic watercolour. The transparency of the medium has been brilliantly exploited to produce a sense of delicate light, and cool shade. He has used very pale washes in the middle and far distance to give the impression of hazy sunlight, while the long shadows on the woodland floor introduce the concept of time passing.

Sandby was more interested in creating a

Despite his technical background, Paul Sandby introduced a style which reflects an emotional response to the landscape, and is one of the main characteristics of his work. Sandby was highly sensitive to atmosphere and to light. He applied brushstrokes loosely in order to suggest the falling of sunlight on foliage, climatic variations, the wildness of remote areas, and the feeling evoked by glimpses of crumbling medieval walls in ancient parkland.

Sandby was also very innovative and imaginative in his use of materials. He was said, for example, to have once mixed a "warm" black colour by combining the burnt edges of his breakfast croissant with gum water. Sandby felt under no obligation to adhere to a strictly transparent way of working, and therefore he freely applied both watercolour and body colour, either in combination, or separately.

In 1760, Sandby exhibited a series of pictures in London. This was the first public display of water-colours as pictures in their own right, rather than "tinted drawings". From then on, Sandby had a profound influence on the watercolour artists of his day. This influence was increased by the fact that he was very much a public figure, who took an active role in artistic events, and was a founder member of the Royal Academy, London.

general impression of foliage, than in a detailed rendering of each individual leaf or twig. He has achieved this effect with loose brushstrokes; producing bursts of reflected sunlight around the tops of the trees, and allowing a pale golden wash to show through the leaf canopy.

The shadowy areas of the overhanging branches have been built up with freely applied patches of warm and cool neutral tones. The forms of the trunks and foliage have been brushed in loosely and sketchily, and the shadows on the trunks suggest the gnarled and ancient texture of the bark. This loose brushwork was a fresh and totally innovative approach to painting an historic subject, such as Windsor Castle.

DISCOVERING EUROPE

THE GRAND TOUR

As england developed its trade and communications and increasingly looked outwards, the idea grew among wealthy families that their sons needed a little polish. A kind of travelling "finishing school" emerged – young aristocrats, accompanied by their tutors, following roughly the same route through continental Europe. The tutors, some of whom must have had difficult charges, were nicknamed "bear leaders", and the travels became known collectively as "The Grand Tour". The custom reached its peak in the 1760s.

The young men learned commerce and trade in Amsterdam before travelling through Germany and Austria to Italy. Finally, they returned north to Paris where they refined their horsemanship.

In Italy, they studied art. Eighteenth century Europe was fully aware of the genius of the Italian Renaissance, and all artistic pilgrims wanted to see the work of the great masters. Watercolour was the ideal medium for recording these travels; thus some of the young tourists received painting lessons, while some took painters along with them.

Other travellers soon followed their example. Newly rich businessmen, for instance, took their families on trips to the fashionable resorts.

It all meant that many artists saw, for the first

time, classical ruins and dramatic Alpine landscapes – scenes which dominated 18th century painting, and which were the beginnings of Neoclassical art and the Romantic Movement.

Souvenir prints, the 18th century equivalent of the picture postcard, became popular. These monochrome engravings – views of famous scenes, paintings and architectural ruins – were widely distributed by enthusiastic travellers. The artists involved in their production included Michael "Angelo" Rooker and John Robert Cozens. Cozens, whose entire work (apart from one known oil painting) is in watercolour, visited Switzerland, as well as touring Italy. He was greatly influenced by his travels, and is noted for his muted colours, often featuring blue-green or blue-grey.

Soon it became fashionable to buy tinted prints, individually coloured with watercolour washes, rather than the traditional black and white pictures. Colour became increasingly important, making etched line and tone redundant. Topographical watercolour paintings, often precise and tightly rendered, became recognized and sought in their own right – a trend which marked the beginnings of what was to become known as the "English National Art".

LAKE NEMI

by John Robert Cozens

When Constable described the landscapes of John Robert Cozens (1752-97) as "all poetry", this lakeside view must surely have been one of the paintings he had in mind. The picture brings together in one single image all those elements which prompted future generations to regard Cozens as the

first artist of the Romantic Movement – his love of nature, his response to wild scenery, craggy mountains and changing skies.

A certain melancholy almosphere pervades all the paintings of Cozens. The painter, in fact, went mad towards the end of his life, suffering from what was diagnosed as "melancholia". He was treated by Dr. Thomas Monro (see pp 34-5), but died without recovering.

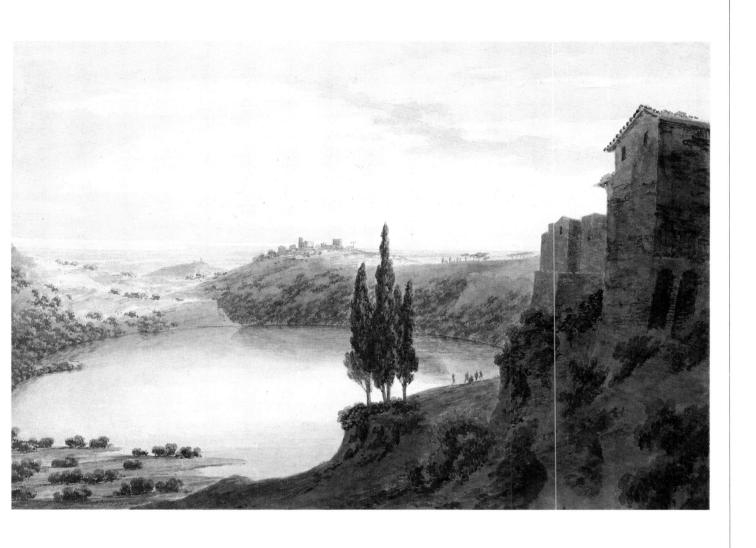

THE ENGLISH WATERCOLOUR PAINTERS

J.M.W.TURNER

TURNER IS UNIVERSALLY acknowledged as one of the true masters of watercolour, even though he spent much of his life trying to escape from this medium into what he saw as the grander world of oils. He held his first watercolour exhibition at the astonishingly early age of 15, and went on to push the possibilities of the medium to the limits of innovation.

In his watercolours, Turner strove to capture the very essence of light – so much so that some of his pictures seem almost to dissolve as you look at them. Even more remarkably, he succeeded in achieving the same effect in the heavier and less spontaneous medium of oil paint, though not everyone approved. Critics in the 19th century said that Turner's landscapes were "pictures of nothing".

Criticism was something that Turner met throughout his artistic career; eventually it was to turn him into a sour and withdrawn man, openly contemptuous of public taste. His artistic life started when he became an apprentice. After colouring prints for a beer merchant, he started work at 13 for the topographer Thomas Malton, making detailed maps, plans and drawings. This apprenticeship taught Turner a great deal about the importance of precision and perspective and much of his early work was clearly influenced by this kind of detail.

TINTERN ABBEY

(1794) by J.M.W. Turner

This picture shows the heavy influence of Turner's topographic apprenticeship, with its intricate attention to line and structure. But there are already signs of change. Although the basic drawing and underlying structure remain crucial, tone is

The young Turner was also helped by a typical 18th century "enthusiast". This was Dr Monro, who founded an informal art school to encourage young artists of the day, including Turner and a contemporary who greatly influenced him, Thomas Girtin (see pp 34-5).

Up to the age of 21, Turner was essentially a watercolourist and, throughout his life, he continued to paint in the medium, as he found he could make money from this type of work, which he partly based on his many sketching tours. His travels took him to Italy several times, which was where he became fascinated by colour, especially when related to light. This obsession came to dominate his work; it also excited furious controversy. When you look at his pictures, including the large oil paintings which he increasingly undertook, you can see this obsession literally bursting into the images, and distorting convention as a result.

Turner's oil paintings were bitterly attacked, though by the 1840s they were also being strongly defended. Some critics said that his oils were "enlarged watercolours"; though this is incorrect, the two naturally influenced each other. He left 20,000 watercolours behind him on his death; few of them had ever been exhibited to the public, but they are now highly praised for the light and colour effects.

described in areas of warm and cool wash, which Turner uses not just to describe form, but also to create atmosphere.

As Turner progressed, the subdued greys, blues and sepias of his early palette gave way to a more colourful approach. The lines faded, becoming less intense as the artist became increasingly involved with light, space and colour.

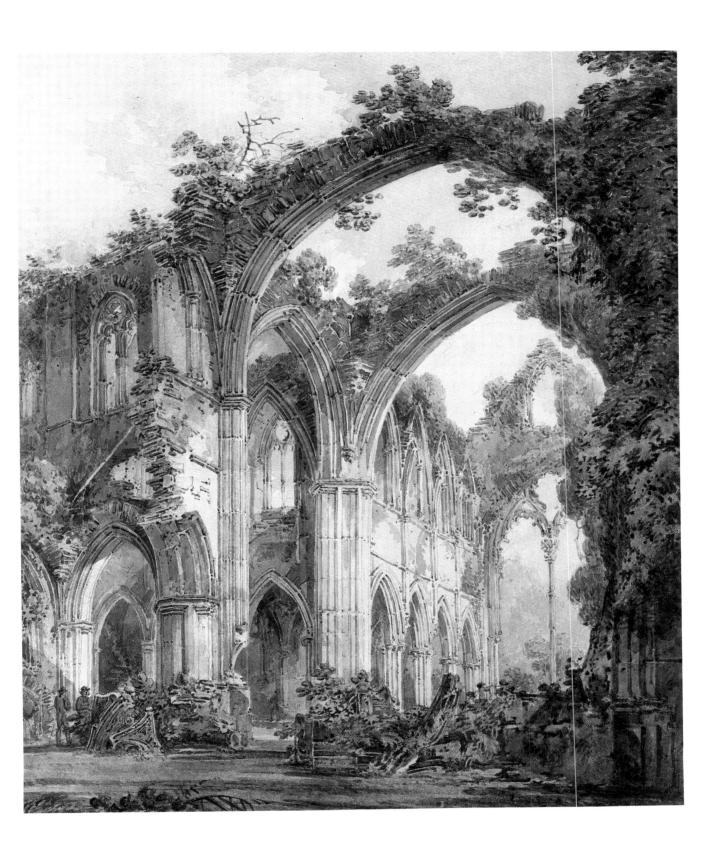

THE ENGLISH WATERCOLOUR PAINTERS

MONRO'S ACADEMY

DR. THOMAS MONRO (1759-1833) was a man ahead of his times. A medical doctor, he specialized in mental illness — a field which, at that time, was often the target for contempt and mockery. Monro was also an amateur artist and a collector of art. In 1794, this interest in art and artists inspired him to open his own "school" for young watercolour painters, at his home in Adelphi Terrace, London.

After buying easels, drawing boards and materials, Monro made it known that he would provide supper and half a crown to anyone who attended for a few hours. The young artists who gathered at Monro's home to copy the works of other painters were brought into contact with some of the eminent artists of the day. At that time artists were apprenticed, rather than sent to art school, and the idea of forums and central workplaces was a new one; the Royal Academy had been started only in 1768, and the Society of Artists in 1760.

Watercolour painting probably owes more to this doctor of medicine than to any of the artistic personalities of the time; for Monro's school brought together the two greatest watercolour painters of the late 18th and early 19th century – J.M.W. Turner and Thomas Girtin.

Both Turner and Girtin worked as topographical draughtsmen until, aged 19, they met at the Academy. As part of their early apprenticeship at Dr. Monro's school, they performed rigorous artistic exercises, including the meticulous copying of some of Canaletto's drawings which were part of Monro's collection. These exercises, a common form of tuition for apprentices at that time, helped to refine their topographical skills. The two young painters cooperated and influenced each other, to the extent that it is difficult to tell some of their earlier works apart.

After a visit to Paris, Girtin developed his craft to such a level that, despite the shortness of his life, he personifies an important stage in the evolution of watercolour painting. His work bridges the gap between the stained drawings of the 18th century and the fully-fledged medium of the 19th century. When Girtin died, aged 27, Turner expressed his admiration with the words, "If poor Tom had lived, I should have starved".

THE GARDEN TERRACE

by Thomas Girtin

This harmonious and tranquil picture demonstrates what an inventive watercolourist the artist was. Thomas Girtin (1775-1802) introduced among other things a fresh way of painting trees: he turned away from the linear representation of foliage, and instead executed leaf masses and clusters of trees with a series of broad washes, the dense areas of foliage being indicated by layers of darker tone.

In 1794 Girtin went on the first of his sketching tours. His colour scheme broadened from a blue, green, grey theme which reflected Cozens' work, into more varied, rich, warm tones. Girtin loved the rolling hills and valleys of Yorkshire, but he also excelled at classical subjects and complicated townscapes. This picture reflects Girtin's mastery of structure and linear perspective, a technique which was lavishly demonstrated later in an enormous panoramic view of London exhibited in 1802, the year of his death.

A PORTRAIT OF DR. THOMAS MONRO by Henry Monro

Young painters were encouraged to gather at the Doctor's home to draw and paint. These gatherings gradually became known as the "Monro School", or "Monro Academy".

THE FIGURE

(Away from Landscape)

DURING THE 18TH century, watercolour painting was dominated by landscape – grand sweeps of Alpine scenery, romantic views of crumbling ruins, and the architecture of towns and villages. Artists had escaped from the tight topographical style of tinted drawings, and watercolour became a recognized medium in its own right.

The human figure often appeared, alone or in groups, in these landscape paintings, but rarely in a central role. Mostly, figures were represented sentimentally, in romantic settings designed to appeal to popular taste.

The work of painters such as James Ward (1769-1859) and Joshua Cristall (1767-1847) heralded a different approach. In their pictures, the figure was often central, while landscape became a background for the person. These painters were interested in figures, not as romantic characters, but as real people. Ward, in particular, avoided the romantic, and the "Frenchified" stylishness of 18th century taste. There is a sturdiness and honesty about his peasants and country people, who are

painted in their working clothes, with every idiosyncrasy of dress and facial expression included.

Meanwhile, the caricature, which provides such brilliant insights into the 18th century's corruption, social pretensions and bawdiness, had evolved into an art form in its own right. The term "caricature" was first used in English in 1748, although the idea of exaggerating human characteristics was not new. These pictures – some done in bitter satire and some with affection – often involved the use of watercolour, if only to colour drawings and engravings. One of the best-known 18th century caricaturists, Hogarth (1697-1764), used watercolour occasionally to add a colour wash to drawings.

Other prominent caricaturists employed watercolour much more frequently, combining the mass-produced commercial picture with the skill of the watercolourist to produce a work of art. Thomas Rowlandson (1756-1827) and James Gillray (1757-1815) are regarded as two of the foremost exponents of this technique.

THE FRENCH HUNT

by Thomas Rowlandson

Rowlandson began work as a serious painter—often of portraits—but, having spent a fortune left to him by an aunt, he then paid off his debts with a prolific output of drawings. He was popular during his own lifetime, but after his death he was not to become popular again until the end of the 19th century.

Although the subject of this picture is robust, sometimes gross, the handling is not. The colours and tones are subtle, and the line never loses its sensitivity. Rowlandson was not an analyzer of society, nor an intellectual. Incidents and scenes, rather than social comment, appealed to him. He worked quickly; a few lines may depict an

entire figure, while a face is sometimes drawn with the simplicity of caricature. In a group composition, such as this, the faces are drawn to a formula, rather than individually conceived. Rowlandson spent two years in Paris studying art, and it has been said that his use of line was more French than English. He certainly liked sinuous, winding shapes and billowing forms; sometimes, as in this case, they take on a more scrawny and scraggy appearance—usually they were painted in thin washes of local colour.

Rowlandson's early work was strongly influenced by John Hamilton Mortimer (1740-79), a painter and draughtsman. The hatchings and cross-hatchings, for instance, used to emphasize tone in Rowlandson's paintings are borrowed from Mortimer.

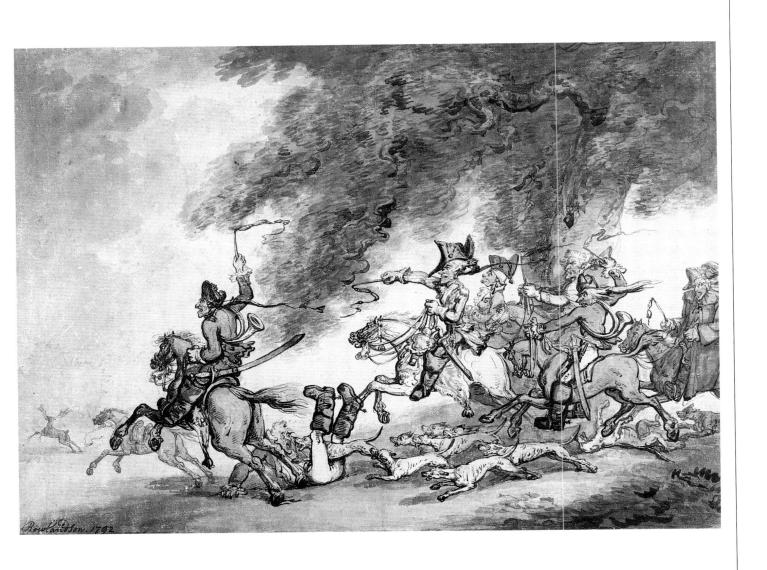

A NEW TRADITION

(Figures and Fantasy)

A NEW TRADITION began to develop towards the end of the 18th century, led by a few highly imaginative painters. Their approach was in stark contrast to the strictly observed, realistic and representational pictures of people and landscapes that had so far typified the 18th century water-colourists. The new subjects were drawn from the imagination; from ideas that soared above what some might regard as mundane. It was a visionary approach, removed from the idea that artists should paint the world as they saw it.

William Blake (1757-1827), was a poet as well as an artist, composing the famous "Songs of Innocence" and "Songs of Experience", among others. His most famous work is a series of 21 watercolours illustrating the Book of Job. Blake moved completely away from the representational style of painting. He created his own world – a

SATAN AROUSING THE REBEL ANGELS (PARADISE LOST)

by William Blake

Blake's early works were traditional, fitting into the Neoclassical style, but his later pictures, such as the one illustrated, show the full effect of his individual romantic direction, influenced by medieval imagery, and the Mannerist forms of the later Renaissance.

Like Fuseli, Blake was inspired by literature. He admired particularly the works of Dante and Milton. Blake also came under the influence of Michelangelo and the figures in this painting demonstrate the same dramatic boses and expressions.

At the beginning of his career, Blake was an engraver, and this can be seen in his absolute sureness of line. Engravers describe space and shading by varying the thickness world of vivid colours, which he used subjectively, not literally – composed of strange, dramatically-posed figures set in a dreamlike environment. He used space, not naturally, but in a deliberately contrived, stylized manner. The themes of his pictures were metaphysical and religious.

Blake's followers included Samuel Palmer (1805-81), who was the best known of a group of painters called the Shoreham Ancients – artists who lived in and around Shoreham in Kent and who (for at least part of their careers) drew on the same medieval, mystical imagery.

The Swiss-born Henry Fuseli (1741-1825) was another romantic individualist whose pictures also went against convention. Some of his work bears a striking resemblance to Blake's, whom he described as "damned good to steal from". He was also strongly influenced by Michelangelo.

of the line, because they are largely dependent on linear representation. This picture demonstrates how Blake has been able, with professional ease, to exploit this facility. Many of Blake's watercolours are coloured drawings, with a strong, fluid pen and ink outline. His colour and his interpretation are subjective and imaginative, yet very subtle; occasionally being little more than tinted tone. Blake refused to copy nature, which he said would result in nothing but, "blots and blurs"; instead, he relied upon visions and the power of his imagination.

Strangely, Blake was little appreciated in his own lifetime; his work was controversial, and often criticized. But, despite his lack of popular appeal, Blake influenced artists within his own circle; he has also had a tremendous impact on 20th century painting and illustration, and today his followers are numerous.

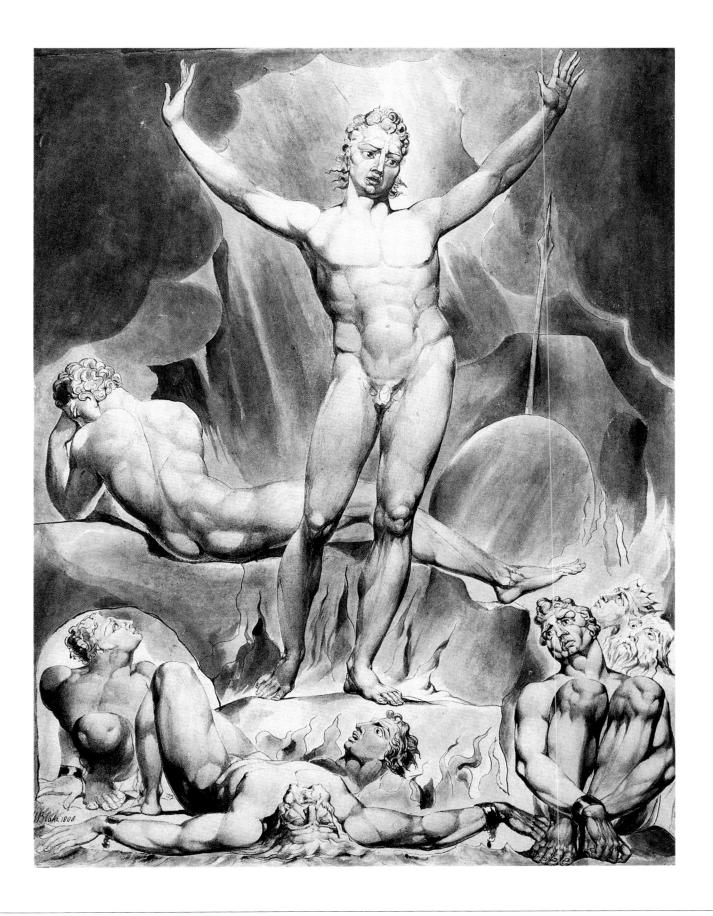

EARLY SOCIETIES

Despite the Growing use of watercolour by major artists during the 18th century, the art institutions still had to be convinced that watercolour was not an inferior medium to oils. The Royal Academy in London, for example, in the early years of the 19th century, still gave the best positions to oils and miniatures. In addition, those who painted only in watercolour were not admitted to membership.

Watercolourists reacted by forming societies where they could hold their own exhibitions. The first group, formed in 1804, was known as the Old Watercolour Society. Its shows were so successful that competition among members for recognition and exhibition spaces, combined with the Society's tendency towards exclusiveness led to the establishment of a rival institution: the New Society of Painters in Miniature and Watercolours.

The careers of several painters form a bridge across this transition period. John Varley is typical of them. His prolific output influenced not only the Society's exhibitions, but also the work of other artists, such as John Sell Cotman, David Cox, and Peter de Wint.

English watercolours were exhibited at the Paris

World's Fair in 1855 and this helped the medium to achieve wider popularity throughout Europe. Critics expressed a lively interest in the 114 English watercolours on display in Paris. They noted that artists of the first rank in England were devoting much time to producing watercolours as finished works; and that some of these pictures possessed the vigour of oil paintings, thus demonstrating the versatility of the medium. The French journalist Edmond About drew his readers' attention to the fact that there were two societies in London devoted to encouraging and selling watercolours. Although the use of watercolour was by no means new to continental European artists, watercolour paintings came to be regarded for a while as an "English" contribution to the contemporary art scene.

Gradually, the English art establishment began to accept watercolour as an art form in its own right; yet this was still a long process. Attitudes could not be changed quickly: for instance, the Old Society eventually received permission from Queen Victoria to add the word "Royal" to its name, but this was not until 1881, after the deaths of some of its major contributors.

RHYL SANDS

by David Cox

David Cox (1783-1859) had been an enthusiastic pupil of Varley's. But this blustery, atmospheric scene contains a new freedom. Cox was one of a group of new members who joined the Old Society early in the second decade of the 19th century. Their adventurous use of colour breathed fresh life into British watercolour, but it also exposed them to criticism. Cox, for instance, was accused of being hasty and careless. He liked to work on a rough, slightly offwhite paper, which absorbed colour wash, and has since become known as "Cox paper". He applied a preliminary wash over pencil, or charcoal, and then built up more washes, using a very wet, rich colour. The brushstrokes in the foreground are shorter, designed to add careful detail. Specks of the rough paper beneath tend to show through the pictures. The overall effect is one of spontaneity.

WALTHAM ABBEY

by John Varley

This is a craftsmanlike picture done by a man who, though sometimes criticized, was undoubtedly a powerful figure in the development of watercolour painting. John Varley (1778-1842) was acknowledged as a great teacher, who published a series of books on the techniques of painting, such as Principles of Landscape Painting, and a Practical Treatise on the Art of Drawing in Perspective. His work inspired thousands of amateurs to wander the countryside with sketchbooks, and to try their hand at watercolours which, owing to their portability and to the speed with which they could be applied, were ideally suited to hobbyists, as well as professional artists.

Varley became an artist, as did his younger brother Cornelius, despite stubborn opposition from a middle-class father. One of the original members of the Old Watercolour Society, Varley perfected such techniques as the laying down of interrelated colour washes, to form an overall harmony of effect. His careful juxtaposition of light and shade can be seen in this picture.

One of Varley's most quoted remarks, "Nature wants cooking", stressed the importance he attached to the refinement of nature, and to the attention which artists should pay to detail when painting a picture. He also recommended that every picture should contain a "look-there" a focal point to attract the eye. In this picture, for example, the viewer is invited to look straight down the road, past the figure entering the shadow of the tree.

Varley was one of the most prolific watercolour painters, and his work tends to become repetitive—the same subjects and themes appear again and again. In addition, some pictures seem less inspired and energetic than others. Nevertheless, Varley was undoubtedly a major contributor to the art of watercolour painting, influencing the work of many other artists.

THE ENGLISH WATERCOLOUR PAINTERS RECOGNITION

There was generally more encouragement for watercolour painters to explore their own avenues as the 19th century advanced, than there had been when the medium was becoming established. With watercolour now widely used and recognized, painters began to think of themselves as mainstream artists, rather than as members of a new minority medium. One of the consequences of this attitude was that artists began to develop a markedly individual approach, even if they were associated with a group. For instance, Samuel Palmer, although linked with the Shoreham Ancients (see pp 38-9), is recognized as an artist with a distinct personal style.

This new confidence meant that many artists began to break away from the rigid confines of accepted working methods – by combining various mediums, and by mixing watercolour with body colour. Palmer, for instance, liked to use thick gouache and, on occasion, to mix oil, ink and watercolour in the same painting. Constable,

BRIDGE OVER A TRIBUTARY OF THE WITHAM RIVER IN LINCOLNSHIRE

by Peter de Wint

The dominant feeling in the watercolours of Peter de Wint (1784-1849) is one of tranquillity. The Lincolnshire landscape was his favourite subject; his wife's family came from the county town of Lincoln, and the artist's best work was painted in the vicinity.

De Wint trained as an apprentice with the mezzotint-engraver, J.R. Smith. Later he met Varley and through Dr. Monro, he was influenced by Girtin. De Wint was one of the second generation of artists who joined the Old Watercolour Society and then played a major role in establishing high standards for English watercolour. De Wint's style, once established, remained constant for most of his life. although primarily an oil painter, used water-colours and gouache – mainly for his weather and sky pictures.

There was also a tendency for painters to concentrate on British landscape rather than looking to the continent of Europe. The main reason for this was simple. The French Revolution and the Napoleonic Wars meant that European travel became increasingly hazardous.

From a 20th century vantage point, it is possible to identify groups of "local" artists. The Norwich School, for example, centred around East Anglia and included artists such as Cotman and John Crome (1768-1821). Cotman, however, is also associated with Yorkshire, where he spent his most fertile and fruitful period. Constable found endless inspiration in the hedgerows and soft countryside of his native Suffolk. Palmer and his followers in Kent became associated with Shoreham and the surrounding countryside, while de Wint fell in love with his wife's home county of Lincolnshire.

This painting of the bridge and the woman has been done with great affection, which gives the scene a feeling of intimacy. It illustrates de Wint's brilliant technique in depicting the surface of the water, and is also a fine example of his robust mastery of colour. The artist has produced a scene which is aglow with warm tones; contrast is provided by a cool, pale sky. The viewer's attention is concentrated on a luminous semicircular zone under the arch of the bridge, which is reflected in the water.

De Wint applied rich colours in washes with a loaded brush. He then used a sharp instrument, possibly the end of the brush, to scratch highlights into the colour, causing the white paper to show through. These touches of sparkling white make the ripples on the river and the foliage in the foreground stand out, and help to bring the picture to life.

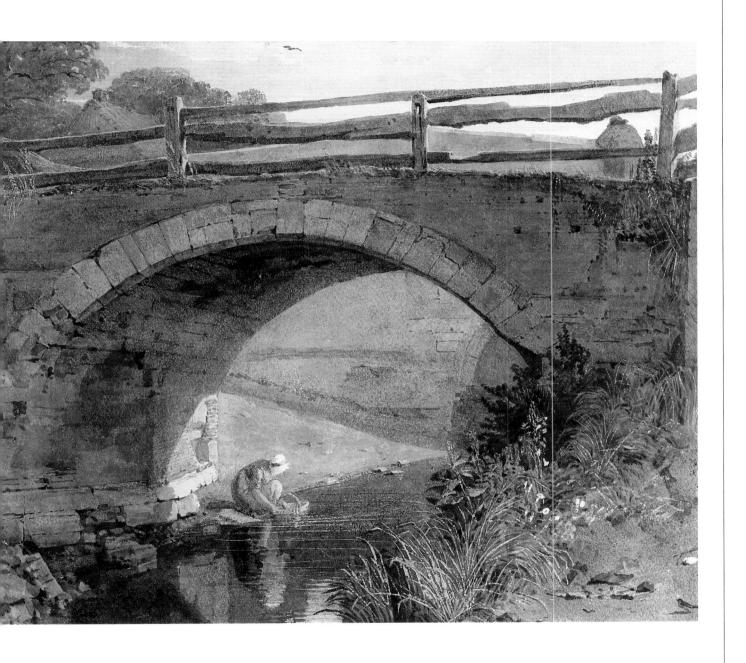

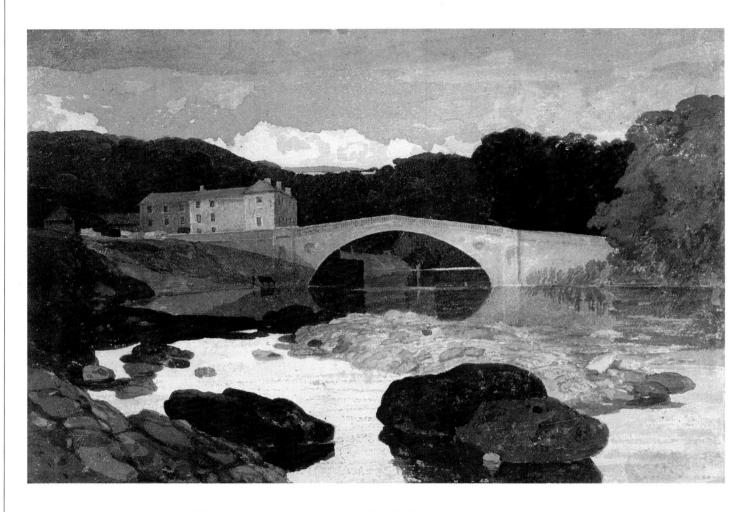

GRETA BRIDGE, YORKSHIRE

(1807) by John Sell Cotman

Cotman (1782-1842) was one of Dr. Monro's pupils. Between the ages of 21 and 23 he made three visits to Yorkshire, where he did much of his best work.

Greta Bridge shows an understanding of form and abstract composition which makes detail unnecessary. Cotman uses washes of clear colour - a technique probably learned from Varley at Dr. Monro's. The picture reveals the artist as an instinctive colourist, laying down areas of flat wash which suggest their own detail. The rocks, for example, are formed from simple washes of warm and cool colours, as are the trees. The effect is staggering - so real that the viewer tends $not\ to\ notice\ the\ simple,\ abstract$ composition, the arrangement of positive and negative tones, and the contrasts between light and dark shapes.

IN A SHOREHAM GARDEN

by Samuel Palmer

A garden is taken into a dreamlike dimension, full of glowing colour, in this watercolour and gouache picture by Samuel Palmer (1805-81) - one of an extraordinary series of paintings using an approach that was later largely abandoned by the artist. The touches of gold and the white circular strokes of gouache are characteristic of work he produced between 1826 and 1835, known as his "Shoreham

Even without the Shoreham period, Palmer would have been a prominent painter, for he produced many conventional landscapes of high standard; some with flashes of brilliance. The son of a bookseller, he is not known to have received any formal training, yet he was exhibiting at the Royal Academy by the age of 14.

In 1824 he met Blake, who was then in

his late 60s. Palmer regarded Blake as a prophet. He became one of a small group of Blake followers known as the Shoreham Ancients, and he endowed the Kent village with something of the same religiouslycharged mysticism that the 20th century painter Stanley Spencer gave to the village of Cookham by the River Thames.

The Shoreham band of artists included John Linnell (later to become Palmer's father-in-law), George Richmond, Francis Oliver Finch and Edward Calvert. They saw themselves as helping to create a Golden Age; an age of romance and poetry, unhampered by materialistic considerations.

Palmer's personal visionary approach was ahead of his time, and he has had a great impact on the 20th century. The technique used here is essentially modern, but the feeling evoked by the figure and the composition seems to take the viewer back to medieval times - an atmosphere which pervades many of his Shoreham paintings.

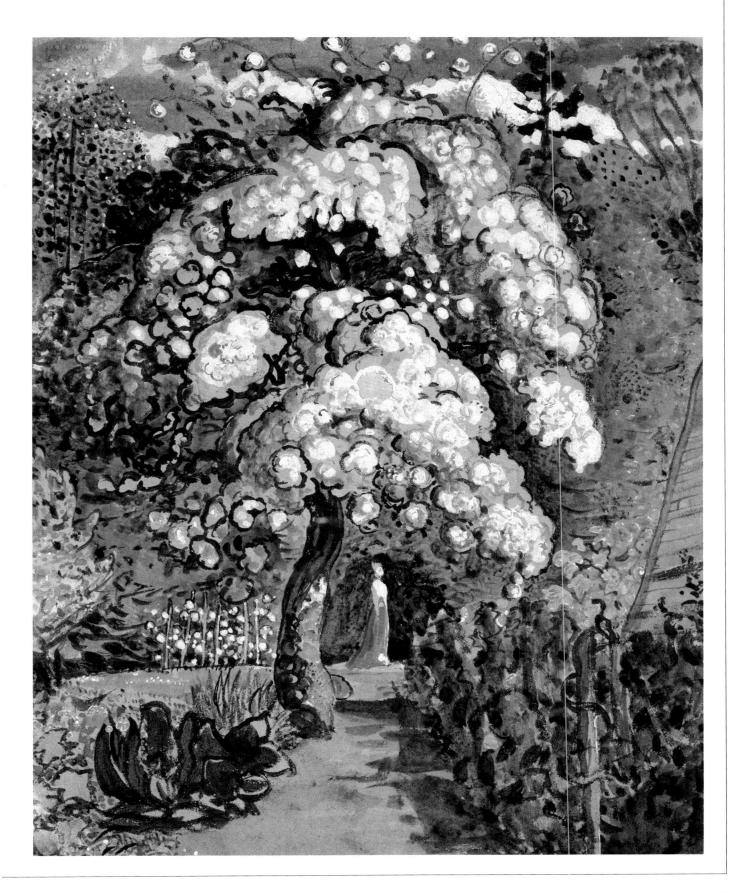

WILLIAM MORRIS

(The Pre-Raphaelite Movement)

The "PRE-RAPHAELITE BROTHERHOOD", a movement which looked back romantically to what they believed was an inspired golden age before Raphael, emerged in the late 19th century in open revolt against the current art establishment. Rich colours, ornamentation, and extravagant detail were introduced into their work, and some leading Pre-Raphaelites were grand experimenters in watercolour. The artists of this movement made their entrance with a flourish upon a rather conservative scene, and were initially often laughed at, although they later became extremely popular.

Leading figures among the Pre-Raphaelites were William Holman Hunt, Dante Gabriel Rossetti, Edward Burne-Jones and John Everett Millais. Many of their pictures have a distinctly medieval flavour – the viewer almost expects to see distant castle towers among the hills and trees of their miniature landscape backgrounds – combined with a sense of magical legend. One of their aims was to fuse poetry and romance with full, colourful illustration. In order to achieve this, they allowed their imaginations to roam freely, but at the same time they adhered strictly to traditional skills. Their drawing, for instance, was of the highest standard, while they became experts at using and adapting a wide range of materials.

The Pre-Raphaelite movement worked mainly in oils, but when they used watercolour it was not in the traditional manner of transparent washes and working from light to dark. Instead artists used colour densely, with as little water as possible, building up detail until the paint was uncoventionally thick. They also worked in gouache, exploiting its opaque properties to create the same

dense, detailed image. It is, in fact, quite difficult to differentiate between their gouaches and water-colours and their oils.

Looking back, it is possible to see a fluctuating development, from Blake through Samuel Palmer to the Pre-Raphaelites, of a magical theme, an attempt to transport viewers from the mundane, material world into a spiritual and idealistic universe, populated by figures from religious, mythical and romantic legends. Embodied in the Pre-Raphaelite pictures, however, decorating the tableaux of imagined and legendary events and forming the background, is a loyalty to nature which called for painstaking reproduction in precise detail of foliage, fruit, flowers and animals.

William Morris (1834-96) became closely linked with the Pre-Raphaelites, and under his influence they took a new direction; still in rebellion, but this time against the drab uniformity of industrial production.

Morris studied architecture, then painting, and later became committed to design. He believed that mass-production methods denied people the opportunity of developing their full potential. In an attempt to change this, he formed a company, Morris and Co., to produce beautifully designed decorations that would transform the interiors of 19th century homes. He produced carpets, tapestries, wallpaper, other textiles and glass, with the help of artists such as Burne-Jones. Morris also founded the Kelmscott Press in 1890 with the aim of producing well-designed books. Although Morris introduced a new and influential movement in design, he remained traditional in his use of heavy colours and full decoration.

AVON CHINTZ

by William Morris

The intertwined flowers and foliage, reminiscent of the illuminated manuscripts of early Celtic and Christian art, form part of Morris's attempt to change the face of a society that he felt had become grey and inhuman. He frequently employed watercolour for his working designs.

THE SCIENTIFIC TRADITION BOTANICAL ART

Watercolour has been widely employed in the service of science. This is because the medium allows colours and tones to be built up gradually to precise requirements, making it exactly right for the execution of the tiny details of plants and animals.

The first botanical painters compiled herbals, books of remedies based on herbs, which were popular in most European countries. The purpose of their paintings was not to decorate the herbals, but to make it easier to identify the plants. A notable example is the Italian *Dioscorides* herbal (c. 512) which contains many plates painted with an opaque colour akin to gouache, while the Carrara herbal (c. 1400) is even better known.

When the Western world's interest in science was reawakened at the time of the Renaissance, a host of botanical painters began recording the minute characteristics of thousands of species. However, these painters did not regard themselves as artists, but as illustrators and illuminators. Although Dürer is regarded as the first real water-colour artist, in fact these early botanical painters had used watercolour and body colour long before he was born.

From the 16th century, Europe was engaged in discovering and exploring the rest of the world. Botanists and scientists – such as Jacques Le Moyne de Morgues, who went to Florida in 1564, and his colleague John White – travelled far and wide, producing paintings of exotic flora and fauna, which were often the only means of bringing their

HOG PLUM (SPONDIAS MOMBIN)

(c. 1700) by Maria Sibylla Merian

Mrs Merian used watercolour and body colour on vellum. She was essentially a student of insects, but even when the plant is a secondary subject, her paintings are worthy of recognition as botanical records. Although Mrs Merian was a talented draughtsman, with untiring powers of observing detail, she painted with imaginative flair. As a result she almost creates another, vivid, world in which the characteristics of the plants are strictly accurate, yet somehow larger than life, with

discoveries home. Another of these adventurers was Mrs Sibylla Merian (1647-1717) whose paintings of Surinam provide a unique record of its flowers, vegetables, insects and birds.

The Dutch trade in Asia opened up new possibilities for this type of watercolour painting. The flowers and plants of Ceylon, Bengal, Java and Japan, for example, were drawn and painted by a German, Engelbert Kaempfer, who travelled as a surgeon with the Dutch East India Company. Similarly, trade paved the way for botanical painters to record the flora and fauna of Africa and the West Indies.

The 18th century – the Age of Enlightenment – with its revived interest in plants, horticulture, art and travel, was also the age of sponsors and benefactors. Sir Joseph Banks, President of the Royal Society from 1743 to 1820, was especially interested in botany. Under his auspices, artists were encouraged to go abroad – Alexander Buchan and Sydney Parkinson, for instance, accompanied James Cook on the *Endeavour* – and under his patronage the Bauer brothers, Francis and Ferdinand, were able to leave Germany and work in England.

Today, coloured botanical illustrations are almost always done in watercolour, or gouache. The teaching methods of art colleges specializing in scientific illustration have changed little since the early masters; the emphasis is still on strict observation and the ability to produce a technically correct, yet visually pleasing, image.

insects forming an integral part of these imaginative tableaux.

The daughter of a Swiss engraver,
Matthaus Merian, Mrs Merian too
engraved some of her paintings. While
staying at a convent in Holland, Mrs
Merian saw a collection of South American
insects, and decided that one day she would
go and paint the living ones. In 1698, aged
51, she set off with her daughter for
Surinam, where she was to spend two years
drawing and painting the wild life. Her
collection of paintings was published under
the title Metamorphosis Insectorum
Surinamensium.

ELLEBORE OILLET from: Les Choix de plus Belles Fleures

(1827-33) by Pierre-Joseph Redouté

The Frenchman, Pierre-Joseph Redouté (1759-1840) produced some of the world's most beautiful plant portraits. Redouté's supreme opportunity came when the Empress Josephine employed him to record the vast range of flowers in the gardens of her chateau of Malmaison. From this commission and later work came the series of books which were to establish Redouté's reputation. The latest contemporary techniques in colour printing were used in producing the books; some of these techniques, involving advanced methods of stipple engraving, were developed by Redouté himself.

CABBAGE ROSE (ROSA CENTIFOLIA) by Jan van Huysum

This watercolour, done in layers of transparent wash, is very different from the coloured drawings of many horticultural illustrators. Jan van Huysum (1682-1749) was essentially a flower painter rather than an illustrator. His work includes drawings, watercolours and oils.

Van Huysum's watercolours are loosely painted. The brushstrokes alone describe the forms of the petals and leaves, while the background is washed in behind the flowers, immediately giving the picture

a sense of space. Imperfections and irregularities on the leaves are faithfully portrayed, in contrast to some of the early Dutch oil paintings of flowers, where each flower head was arranged so that it faced the painter and did not obscure any of the others.

Horticulture became well established in Europe during the 17th century; wild flowers were propagated for use in gardens, while new plants were introduced from other countries. This growing interest stimulated a demand for portraits of the new flowers, and Holland became an important centre of this genre.

COLOUR SKETCHING

SPONTANEITY

THE DIFFERENCE BETWEEN a watercolour sketch and a watercolour painting is often a fine one. In general, it is impossible to decide by looking at a work, since a painting which appears to be merely a sketchy image could well be a finished picture. The definition really lies in the intention behind the work; usually a sketch is done for reference, as a quick recording of a scene or event which the artist intends to use in a more finished product later.

Before watercolour gained status as a medium in its own right, it was often used as a means of making preliminary sketches for an anticipated oil painting. In fact, watercolour has never quite relinquished this role; it is still a convenient, compact way of making colour sketches. Frequently such sketches become as well known as the finished painting; while, on other occasions, the finished picture is lost or destroyed, and only the sketches survive.

During the era of the Grand Tour, which reached its peak in the 18th century (see pp 30-1), the tourist's equivalent of the modern camera was

VIEW OVER A WIDE LANDSCAPE WITH TREES IN THE FOREGROUND

by John Constable

Constable (1776-1837), more than any other 19th century painter, understood the English skies with their ever-changing weather patterns. He once declared: "The sky is the keynote, the standard of scale, and the chief organ of sentiment—it governs everything." Constable's interest in cloud formations and in weather patterns went further than his paintings. He studied the subject, becoming familiar with the

needed. A watercolour sketch could be done quickly, either by the young aristocrat on tour – refining his artistic talents – or by a painter, engaged for that purpose.

A host of famous painters have used water-colours to make preliminary sketches – among the best known collections are those done by Eugène Delacroix on his African journey in 1832. The pages of his sketchbooks reveal a magical insight into Arab life: tiny thumbnail sketches record details of market places, Moorish interiors and domestic items. Delacroix used these sketchbooks as the basis for later oil paintings; none of them however retained the charm of these early miniature colour sketches.

Gouache is particularly useful in the sketching role, it has a directness and immediacy, which allows the artist to lay down very strong opaque colours quickly and accurately. One artist who made extensive use of gouache was Gwen John, whose simple colour sketches are becoming increasingly respected.

meanings of certain formations and indications. It is known, for instance, that he was influenced by Luke Howard's The Climate of London.

Constable's reputation as an oil painter has overshadowed his skills in watercolour, although it was in watercolour that he was best able to record the transient effects of wind, rain and sun. His watercolours were seldom exhibited until recently, however.

This watercolour sketch is one of hundreds of studies made by the artist, to capture the atmospheric seasonal and temperate effects of the English weather.

A STOUT LADY, AND OTHERS, IN CHURCH

(1913-25) by Gwen John

This quick pencil and wash picture, based on a drawing sketched hurriedly in church, has been done with the economy of detail, line and colour that watercolour allows; yet it contains a wealth of information. Rarely can so much atmosphere have been captured so quickly with a pencil and brush.

Gwen John (1876-1939) wrote, "People are like shadows to me and I am like a shadow". In this picture not only the people, but the shapes between them are washed in with a shadowy quality. Gwen John made hundreds of watercolour and gouache sketches similar to this one. She had become religious, and was fascinated by the congregation at the church in Meudon outside Paris where she worshipped at this period in her life.

Most of the gouaches of this series cannot be precisely dated, but they all reveal the influence of Japanese prints. However, the abstracted compositions, patterns and simplified shapes are never allowed to detract from the subject; instead they enhance it.

GIRL CARRYING A PALM FROND (1927-32) by Gwen John

This charcoal and gouache sketch of a young girl clutching a palm frond—probably at a Palm Sunday ceremony—has been executed in subdued colours. Once again, it reveals the influence on Gwen John of Japanese art. She has used simple, flat, graceful shapes, with very little actual form indicated in paint. This technique is reminiscent of Eastern prints, where simple, cut-out figures are placed in such a way that the shape of the background becomes an important part of the composition.

With a minimum number of brushstrokes, the artist has captured the churchlike atmosphere, the silent solemnity of the occasion and the solitude of the young girl. Gwen John has built up the background in short, vertical strokes of colour, in exactly the same way that she does in her oil paintings. She has achieved this by taking advantage of the opacity of the gouache paint, using very little water, and applying the colour in broken areas, thus allowing the coloured ground to show through.

Gwen John lived an obscure life, and her talent was largely unrecognized until very recent times. For instance, a series of her later gouaches, watercolours and sketches—of which this is one—were thrown into a cupboard by an acquaintance, where they remained for years.

PICTURE AND WORD

ILLUSTRATION

THE ILLUSTRATION OF text by means of pictures is one of the oldest forms of art, and watercolour has been associated with it from the very beginning. However, these pictures, whether on scrolls, walls or in books, were necessarily confined to a very limited number of viewers.

Even after the invention of the printing press, it was still not possible to mass-produce colour illustrations. Sometimes, finished engravings were hand-tinted with watercolours, but these were understandably always restricted in number. Books containing watercolour paintings, such as botanical illustrations, were printed, but they were relatively expensive, and therefore reached only a small audience; for the cheaper mass market, printers used black and white line drawings. The history of mass illustration in the 18th and 19th centuries therefore developed independently of watercolour which, until modern times, remained a medium for paintings directed only at a comparative few. Nowadays, however, this situation has changed dramatically: technological advances mean that, for the first time, colour pictures can be mass-produced.

Watercolour reproduces well; modern printing techniques can capture exactly the pale translucent character of the paint, making it difficult at times to distinguish a good quality print from the original. In addition, because oil paint takes a long time to dry, the modern illustrator almost automatically turns to watercolour or gouache, with acrylics being used occasionally.

Gouache, the "body colour" favoured by painters who illustrated individual books before the age of printing, has remained a major medium for illustrators because of its strength of colour and opacity. Indeed, far from replacing the two traditional mediums – gouache and watercolour – modern technology has made them accessible to a vastly extended audience. The scribe who took such pains to paint the vivid watercolours accompanying his sacred texts would surely be astonished to discover that his works could now be reproduced by the million.

LES (DEUX) CONFRERES

by Honoré Daumier

An outspoken cartoonist who was imprisoned at one time for ridiculing the French king Louis Philippe, Honoré Daumier (1808-79) took an unsentimental and highly critical look at contemporary life in his illustrations for satirical journals. His illustrations had a wide influence; for instance, the work of H.K. Browne (Phiz), who illustrated for Charles Dickens, is regarded as having become sharper and better drawn after he studied Daumier's technique.

Lawyers were one of Daumier's favourite subjects, depicted with his usual ruthless

and acutely-observed characterization. In this pen and ink and watercolour picture of two lawyers conferring, Daumier's skill at capturing gesture, posture and expression is self-evident. The two men lean back in happy self-satisfaction, feet stolidly implanted, in a composition which features stark contrasts between light and dark. The figures are drawn in a fluid, painterly way, with the forms being described by the brush as it applied the paint; the curving shadows and highlights emphasize the swing of the long cloaks. The cartoonist's skill in fluid drawing has brought a touch of caricature into the two bony faces, which are highlighted so that they shine with a rather sinister gleam.

THE FLOWER WINDOW

(c. 1894-7) by Carl Larsson

This watercolour is one of the highlights of a career devoted largely and fruitfully to domestic culture. It belongs to a series of illustrations entitled Ett Hem (The Home) – a title which reveals much about the artist's aims and ideals.

In this 19th century domestic scene, one of the Larssons' daughters tends the plants in the well-lit home which was the inspiration of so many of the works by the Swedish illustrator Carl Larsson (1853-1919). The house, Little Hyttnäs, was the home of Larsson and his wife Karin for most of their married life, and it meant far more to them than just a place in which to live. The home itself naturally looms large in all family life, but to the Larssons it was also the vehicle for their creativity in design and decoration. Together they turned the place into a work of art, painting murals on the walls, and decorating and collecting with an extraordinarily individual flair.

"A home is not a lifeless object but a living entity...it must keep changing from moment to moment," wrote Larsson. "If I should die, which oddly enough is perfectly possible, I think to myself that our home will go on all the same." The house has indeed gone on, not as a home, but certainly as a place to enjoy; it has been made into a national museum.

Larsson's style of illustration was later favoured by the famous 20th century German design centre, the Bauhaus, whose members liked the way he incorporated everyday objects into his art, so that art merged with life and function rather than being isolated from it.

Most of Larsson's illustrations combine washes of colour with pen and ink outline. A superb draughtsman, Larsson uses line in a way which does not flatten the image. Secondary lines, details, and objects in the distance are almost imperceptibly defined with a fine drawn outline; bolder use of pen and ink describes foreground objects and main forms. Larsson is also selective, choosing when not to use an outline, as can be seen in the pattern of the runner rug on the floor, and the striped fabric on the wooden chair.

BLIND GIRL WEARING FOX FUR (1981) by Catherine Brighton

The girl's unseeing eyes stare blankly from this watercolour by Catherine Brighton (born 1943) – part of a set of illustrations for a children's book. Because the girl in the picture is blind, touch is of paramount importance, so the artist has attempted to convey the texture of all the elements in this girl's world.

The painter worked from an actual fox fur, kept in her studio for several days, to make sure she thoroughly captured its "furriness". She avoided the temptation of trying to depict every single hair, and instead painted directional brushstrokes to give an overall impression. Some areas of the watercolour paper were left to show through, in order to create highlights and to accentuate the gleam in the fox's glass eyes.

The artist always begins a picture with a line drawing in pencil on paper, which is

then traced onto watercolour paper over a light-box. In pictures featuring figures, she starts with the face – the focal point which attracts the viewer's attention. She believes that the face conveys the emotion and that there is no point continuing with the rest of the painting until this is exactly right; washes of local colour can then be worked into small areas, such as the brown shadows on the coat draped around the little girl.

For this picture, the artist started painting the girl's hair by building up a grey tone, leaving streaks of the white paper showing through; the main dark area of the hair was then filled in with lamp black. When this had dried, Catherine painted a thin wash of Prussian blue over the whole hair area, including the white highlights, to give that bluish sheen often seen on black hair. Unlike many watercolourists, she did not blend the washes, but waited for each area to dry before applying a new tone. The result is a precise image with crisp edges, in

contrast to another common watercolour style which aims at a blurred effect – colours are allowed to "flood" or "bleed" into each other by applying them wet on wet.

Catherine Brighton makes a living writing and illustrating picture books for young children. She says, "For me, a book begins not with a literary idea, but with an image. I see a picture in my mind, and weave the story around that".

She dislikes using photographs, and refers to them only for checking small points of technical accuracy, such as the appearance of a particular type of wheel; never as a base from which to paint a picture. She says, "People are so used to looking at photographic images that they think they are really true, but photographs form only one way of conveying what we see. A photograph gives a frozen image. With a painting, you have more control. You can set out to deliberately convey feelings, atmosphere and mood".

WATERCOLOUR PAINTING IN AMERICA

THE NEW WORLD

American art was growing rapidly in sophistication by the last decades of the 18th century; and it was not long before American artists began to influence the Old World – a trend that has continued to the present day when America leads the way in many areas of Western painting. The process began when American artists went to Europe to study and work. One of the earliest of these "eastward-bound pioneers" was the Pennsylvanian-born oil painter Benjamin West (1738-1820) who first travelled through Italy and then settled in London, where he became president of the Royal Academy.

At the same time as explorers pushed into the vast interior of the American continent, artists began to paint the new landscape in all its varied aspects. For instance, the ornithologist John Audubon (1780-1851), after an education in Paris, went on numerous expeditions into the forests; the paintings of the birds he observed were to become famous not only in America, but also in Europe. Later, in the 19th century, artists recorded "the wild west" in watercolour and oils, producing pictures which, as well as conveying an idealistic image, often showed its way of life and its landscapes with unsentimental realism.

Ironically, as the United States became increasingly confident and powerful in the second half of the 19th century, its citizens began looking

NEGRO BOY DANCING

by Thomas Eakins

For this watercolour of a boy dancing, watched by the man whose foot taps the rhythm, and accompanied by a youth whose body moves to the music, Eakins reversed an age-old process. Instead of drafting a quick watercolour sketch which might later be used as the basis for an oil painting, he made a preliminary study in oils as the basis for the finished watercolour picture.

Thomas Eakins (1844-1916) had an eye

towards the Old World for cultural inspiration. Works of art were imported and there was a frank and open interest in learning from the old traditions of Europe.

At the same time, watercolour in America was experiencing a surge of vigorous growth; the American Water Color Society was founded in 1866, with Samuel Colman as its first president. One of its founder members was Winslow Homer, a painter whose fresh and realistic approach marked a new stage in American art.

Homer, like many other American artists, went to the Old World for education and to gain experience before returning to America, as did Thomas Eakins and Maurice Prendergast. Other Americans remained in Europe, either permanently or for long periods, and exerted considerable influence there. Whistler, for example, settled in London in 1859; while Mary Cassatt (1844-1926) became a prominent follower of the Impressionists. John Singer Sargent (1856-1925) kept a studio in Paris and then lived mainly in England, painting portraits of celebrities such as Ellen Terry, before becoming a landscape watercolourist.

Watercolour painting in America, therefore, was not only influenced by Europe, but its envoys and emigrants played a powerful role in European art. This flow of influence in both directions across the Atlantic has continued to this day.

for detail; he enjoyed capturing the minute facts of everyday life in his paintings. Some of his pictures are reminiscent of the 18th century cartoon; not so much gross caricature or exaggeration, but that 18th century fascination with features and expressions, and with touches of sharp realism, that can freeze a moment in time, leaving behind a vivid glimpse of the past. Despite their accuracy and detail – sometimes produced by working from mathematically precise plans — Eakins' pictures are full of life and movement.

GREY AND GREEN: A SHOP IN BRITTANY

(1893) by James Abbott McNeill Whistler

This picture of a Brittany street scene bathed in sunlight has been gently interpreted by the artist in a series of subtle warm and cool tones. Unlike many of the artists of this time, Whistler (1834-1903) was concerned less with the literal content, than with the visual harmony of the paint on the paper. Here, he uses an uncontrolled technique, largely painting wet into wet washes, yet applied in a highly controlled way. The sepias, umbers and greys work together as part of a careful balance; understated, in a low tonal key.

The wet into wet technique is usually associated with spontaneity, because it is impossible to completely control the "bleeding" of the colours into each other as they dry. Whistler employs this loose approach, but the range of colours he uses is very disciplined, so that the image is never really out of control, even though the picture has an impressionistic look.

The roots of this approach come from

Whistler's experience of oil painting, for he learned under Charles Gleyre, a French painter, who insisted upon a methodical approach involving careful preparation of the palette. The mixtures of paint, even of the various tones of one colour, had to be kept strictly separate and neatly ordered, so that a particular tone could be related to a precise point in the painting. This is not possible with watercolours; yet Whistler applied the same strict approach to produce pictures of subtle tonal ranges, with an impressionistic freshness added by the "bleeding" effects of the watercolour.

Whistler's paintings are very atmospheric. He was sensitive to mood and weather, and although he painted a great deal in oils and pastels, his watercolours allowed him to portray subtle nuances of light and atmosphere. He was also very receptive to new ideas and was always studying other artists: Rembrandt, Corbet, the Impressionists and Japanese prints all had an enormous influence on his ideas and his work. He, in turn, affected many other painters, including Gwen John, Wilson Steer and Walter Sickert.

LOW TIDE, BEACHMONT by Maurice Prendergast

Maurice Prendergast (1859-1924) had the American artist's liking for the factual detail of everyday life, and he was able to combine this effectively with some of the ways of interpreting and seeing which he learned in Paris. He was fascinated by typically American scenes, particularly busy streets and crowded beaches.

This picture also reveals his liking for decoration: it is a whimsical arrangement of prettily dressed girls standing among rounded rocks. The figures and the stones are treated almost as flat shapes.

Prendergast's concern is with a colourful

arrangement, and the overall effect of the figures seen against the background; the composition becomes almost a piece of decorative illustration.

Prendergast studied at the Académie Julian, arriving in Paris at the age of 21, when Impressionism was in full swing. He became deeply influenced by Impressionist painting, and also by Cézanne. His choice of colour and his calligraphic brushstrokes are often reminiscent of Post-Impressionist painting, of which Cézanne is a representative. In 1914, Prendergast returned to New York where he exhibited with a radical group, Los Pocho, which, in many ways, marked the beginning of a fresh era in American painting.

END OF WINTER (1946) by Andrew Wyeth

A spiky, dead tree stands out starkly against a bleak winter landscape in a picture, which is typical of Wyeth's works at this time. Wyeth (born 1917) moved first from the comparatively broad washes of his earlier work towards a very linear style of painting, based on detailed drawings. Towards the late 1940s his choice of subjects began to settle into the rather stern landscapes for which he is best known.

Andrew Wyeth never went to art school, but was trained entirely by his father, N.C. Wyeth, an illustrator of children's classics and tales of the old wild west, and a painter of western and rural scenes. In 1945 Andrew's father was killed in a motor accident on a rail crossing. Wyeth has acknowledged the effect this trauma had upon him, and perhaps under this influence, his later paintings can be seen as articulating a disenchanted inner vision of the world. Many of Wyeth's paintings

show a lonely rural world, devoid of modern technology and in need of repair. His palette of greens, browns, ochres and monochromes conveys a feeling of pessimism. There is a nostalgia, perhaps, for a vanishing rural America, but there is little sentimentality in the pictures of its delapidated buildings and bare scenery.

One of Wyeth's greatest skills is his ability with drybrush technique. When using this technique the artist squeezes the excess water from the brush, dips the almost dry brush into paint diluted with a very small amount of water, and then rubs the colour onto the surface; thus obtaining a much tighter control over the painting. Although the traditional watercolourist works from light to dark, allowing the surface of the paper to show through as highlights, the procedure can be varied. Some of Wyeth's watercolours employed variations on the light to dark approach, allowing him to exploit one of the most useful assets of drybrush technique - the application of very precise highlights.

PALM TREE, NASSAU by Winslow Homer

Winslow Homer (1836-1910) left Paris too soon to be much influenced by Impressionism, yet when seen with modern hindsight his work seems to be an anticipation of that movement. His watercolours have a sense of luminous light, particularly the skies and water where, like the Impressionists, he has used broken colour. The grass in the foreground of this picture is imposed red and green—an optical mixing of colour in the painting rather than on the palette. This is a technique used later by some of the Impressionists, and particularly by the Neo-Impressionists.

Homer, however, is difficult to place in any movement; his pictures combine ethereal light and motion with crisp, graphic shapes which point to his training as an illustrator. Born in Boston, Massachusetts, Homer worked as an illustrator for Harper's Bazaar. He was a correspondent during the Civil War, reporting from the front, as well as recording it in his sketchbook. Later, he travelled extensively in America, seeking its most isolated corners, and, after the age of 40 he devoted his life entirely to painting, setting out to capture scenes typical of the Americas. Sometimes he worked in oils, but it was in watercolour that he was first able to depict the wild landscapes and seascapes which mark the best of his work.

In this picture, Homer combines bold, direct washes, used for the sky and water, with the disciplined yet expressive brushstrokes that capture the windswept branches of the palm trees.

MODERN EUROPEAN WATERCOLOURS

WIDER CHOICES

The modern artist reaches out for whatever medium is required at the time, and is far less likely to specialize – mostly because new technology has made possible an increasing freedom of choice. Versatility with materials is important for artists; their imagination can often be constrained by the technical means at their disposal, whereas greater variety of choice may stretch an artist's creative powers.

The story of watercolour in the late 19th and 20th centuries therefore becomes one of blending with other media. However, watercolour by no means disappears. The majority of modern European painters have used watercolour and gouache during the course of their careers – sometimes, as in the past, for preparatory sketches, but often in multi-medium pictures. However, there are many artists, such as Paul Klee, who worked predominantly in watercolour.

Watercolour can have a liberating influence, offering new possibilities to artists who have been working in other mediums. This was certainly true for Paul Cézanne who used the medium extensively in the latter period of his working life. It revealed new avenues, and fresh ways of attacking

STILL LIFE WITH CHAIR, BOTTLE AND APPLES

(c.1905) by Paul Cézanne

Cézanne believed that shape was given real form by applying paint in such a way that it represented the reflection of light upon the various planes of the shape's complex surfaces. When he said, "It is the reflection which envelops", he was describing the way that light wraps itself around an object, giving it reality and depth. He thought drawing was important, but he was never entirely happy with the idea of drawing lines first and then applying paint afterwards.

Watercolour came to Cézanne's assistance. He was able to describe an object with thin transparent washes, laying tone and colour inside the tentative, often broken lines of his rough outline, and using the direction of the brushmarks to describe undulating, jagged, or smooth surfaces. The result was almost a blending of

problems, which affected his work not only in the watercolour medium but also in oils.

Gouache, too, encourages an adventurous approach. Its strong colours have enabled movements such as the Expressionists and the Vorticists to achieve vivid effects quickly and spontaneously.

Watercolours and gouaches have been used widely by abstract painters. For instance, Kandinsky, the pioneer of abstract painting, used watercolour because it enabled him to transmit his intuitive ideas quickly onto paper.

In the 20th century the medium has become less important than the concept of the picture. This process began in the last part of the 19th century, when the content of pictures began to take precedence over the mediums in which they were executed. A painter such as Seurat, for instance, saw himself essentially in terms of his technique – pointillism – and he used various mediums, including watercolour, to explore his preoccupation with optical mixing and broken colour; while to a modern painter who wanted to achieve a transparent colour, it would probably matter little whether this effect was obtained with watercolour, coloured inks, or thinly applied oils.

outline, tone and colour which gave him flexibility and the correct "feel" from the very outset.

Many students have tried to understand Cézanne's apparent obsession with outline. Close observation of this picture shows that he has analyzed the form and then used the shape and direction of the brushstrokes to "sculpt" the individual objects. By using watercolour, he has quickly established the rounded, three-dimensional aspect of the fruit, without having to draw a flat shape in outline; in effect the real drawing is done with a brush

Paul Cézanne (1839-1906) was one of the dominant figures in the Post-Impressionist era. The Impressionists had employed colour to establish atmosphere, but Cézanne's meticulous use of it to express form signalled a change of approach. He worked mainly in oils, but his later watercolours are acknowledged to be some of the finest examples of his fresh use of colour.

TWO SUBMARINES BY A JETTY (1941) by John Nash

The water in this picture is represented very simply: the underlying lighter surface shows through thin washy strokes, while freely applied darker strokes depict the reflection of the jetty. The contrasting matt shapes of the submarines loom out of the reflective watery surface, their hard metallic forms accentuated by the careful application of tone.

The British painters John and Paul Nash are often associated with war pictures. Both painted striking illustrations of the First World War, which was a predictably grim experience for them. John wrote of the attack which inspired his oil painting Over the Top: "It was in fact pure murder and I was lucky to escape untouched". In the Second World War, the

two brothers became Official War Artists: Paul (1889-1946) to the Air Ministry and the Ministry of Information, and John to the Admiralty.

John Nash was less immediately involved in the Second World War, and this watercolour has an objective feel about it; the emphasis is on form and mood, rather than on the actual event. Together with an earlier watercolour entitled Nocturne: Bristol Docks, it reveals Nash's interest in the stark forms of shipping.

The work of John Nash (1893-1977), much of it in fact consisting of peaceful landscape, is that of an individual artist who did not belong to any particular movement. He was fascinated by the effects of colour on landscape, and by its forms and tones; yet he was not strictly a realistic painter. In fact, sometimes his interpretations verge on the abstract.

STUDY FOR IMPROVISATION 25 (GARDEN OF LOVE)

(1912) by Wassily Kandinsky

This watercolour comes from a period of Kandinsky paintings that can be regarded as revolutionary, for it is one of the first pictures which later became known as "abstracts". Wassily Kandinsky (1866-1944) is regarded by many as the father of modern abstract painting - the founder of an approach which moved away from the world-as-seen, going far beyond the imaginative leaps and dreams of such painters as Blake and Palmer. Kandinsky was painting abstract pictures by 1910, and has since become a source of inspiration for many of those modern artists who use form to suggest meaning and feelings rather than to represent physical objects.

Kandinsky, born in Moscow, received an extensive education and trained as a lawyer.

Throughout his life he remained an intellectual, deeply interested in spiritual ideas and in theosophy – speculation about divine existence on a high, almost obscure level beyond normal science and religion – a movement that was partly a reaction against the materialism of the 19th century. These ideas inspired most of his paintings.

Among his works were a series of finished abstract pieces known as Compositions; and a series of Improvisations, which were less finished works. The picture illustrated is a watercolour study in preparation for one of the Improvisations.

Kandinsky felt that art could lead the way towards a new spiritual epoch that would replace the old materialistic world. He chose watercolour as the medium for much of his work, as it enabled him to develop a picture in his characteristically spontaneous and intuitive way.

YOUNG ACROBAT AND CHILD (1905) by Pablo Ruiz Picasso

Picasso (1881-1973) was a multi-medium artist: during his career he moved freely between oil, gouache and watercolour, charcoal and collage, lithography, etching and aquatints, just as he moved between various styles of drawing and painting.

The Spanish-born painter, who spent the bulk of his working life in France, often used watercolour and gouache as preliminary sketches for larger paintings. This picture is one of many studies that he made for the painting, Trapeze Artists (Family of Saltimbanques). The

delicate shades represent a stage in Picasso's development between his "blue" period and his "rose" period.

In the years 1905-6, Picasso was preoccupied with such subjects as acrobats and circus performers. The "circus" period follows a stage when Picasso had been painting rather austere figures, with blue as the predominant colour. The circus pictures mark a move towards more subtle colour variety.

The figures in this picture are defined with a single black line, used mainly to depict the facial features. The linear drawing treatment separates the figures from the background, which is blocked in with wedges of colour. The lines give an extra clarity, helping to throw the figures forward in the composition.

Elsewhere, the image is built up with layers of opaque gouache over more transparent watercolour washes. The short deliberate brush marks are used confidently to create form; precisely drawn strokes of pale and dark grey denote light and shade respectively. An extensive use of white gives the painting a pastel, chalky appearance which integrates the figures into the landscape. This effect is enhanced by the way colours used for the clothing of the figures have been repeated in the sky and in other elements of the backdrop.

AT THE SEASIDE

by Wyndham Lewis

Wyndham Lewis (1882-1957) is one of those 20th century artists who tried to convey feelings and associations through his pictures.

Industrial imagery, and a fascination with sharp angles, contrast, and graphic impact became typical of a certain school in English painting, when a group formed by Wyndham Lewis in 1914 began to combine some of the ideas of Cubism and Futurism into a new British movement, which tried to reconcile art with the age of machinery.

The Vorticist group's magazine, Blast, features graphic and dramatic images of giant machinery in motion. The work of these painters, like this picture, often shares with Cubism the aim of depicting a subject in distinct planes, producing the look of a relief sculpture. Many of the Cubist paintings of Braque and Picasso have a similar sculpted appearance, dividing the surface into tilted planes at different angles in order to create depth.

Although the subject is figurative, the impact and strength of this picture depends largely on the tension created by the abstract arrangement between the main shapes.

CONTEMPORARY WATERCOLOURS

VERSATILITY

Many contemporary artists use watercolour, but few can be called watercolour artists. Some mix watercolour with other materials in mixed media pictures, while others switch frequently from one medium to another. Painters often combine watercolour with other materials when they want to convey a variety of textures, or create a contrast between opaque and transparent areas.

Advances in technology have resulted in new watercolour products. It is possible, for instance, to obtain a highly concentrated form of watercolour which produces extremely bright colours, which are ideal for illustrators and graphic artists, as the concentrates enhance the intensity and brightness of the reproduced print. Watercolour pencils and sticks enable artists to combine line and areas of colour, using the same materials. Watercolour paints themselves are now available in a variety of forms, such as cakes, pans and tubes. This range of choice, combined with gouache and cheaper poster paints, has helped to make watercolour a more accessible medium.

In addition, the transparent, washy effects of watercolour can be reproduced with new types of paint such as acrylic, which is cheap and easily obtainable in large quantities. This means that watercolour effects can be created on a large scale with none of the traditional technical limitations, such as the difficulty in preserving the painted surface. As a result, the traditional style of watercolour painting has become much more widespread and commonly used.

PORTRAIT OF A YOUNG GIRL

(1986) by Ian Sidaway

how little change there has been over the centuries in the basic principles and techniques of watercolour. The final oil painting was a large portrait of this girl and her sister in a detailed setting. The artist did watercolour sketches of the various aspects of the final picture; here, he is experimenting, using the speed and convenience of watercolour to achieve a likeness, and also a freshness, which is sometimes lost when painting directly in oils, because of the need to rework detail. Usually, portrait painters find it necessary to make considerable changes as they work, checking whether the sitter likes the way the picture is taking shape. Preliminary watercolours, therefore, are an excellent means of coping with change. The face and hair of the young girl are portrayed in loose, simplified washes. The artist is using this stage to work out the main areas of tone; simplifying the hair into four main tones, and the face into a range of warm and cool flesh tints. White paper represents the pale areas and highlights, and gives a lively, immediate

feel to the portrait.

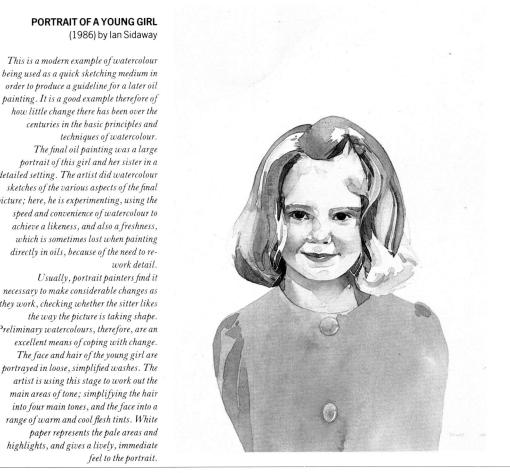

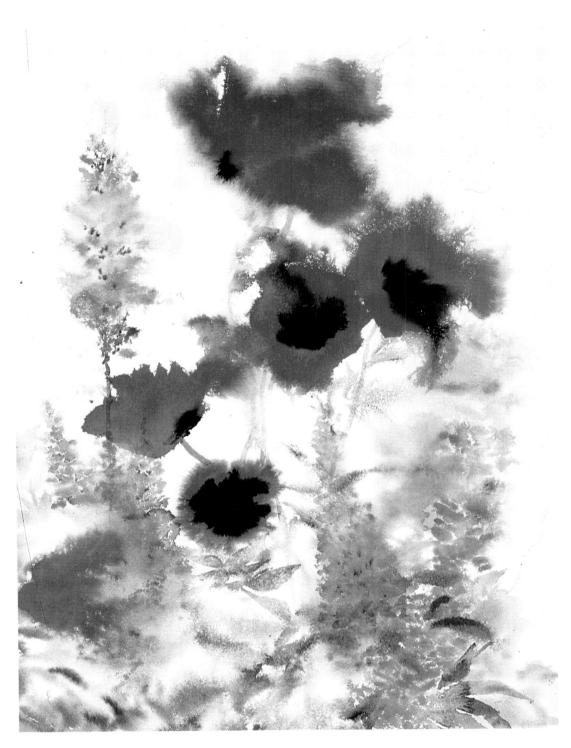

ORIENTAL POPPIES AND LUPINS (1986) by Caroline Bailey

The botanical illustrators sought to record detailed scientific images of flowers; whereas Caroline Bailey wants to capture an image of flowers as they may appear to the human eye at a given moment, evoking a particular mood in the viewer, or reflecting the viewer's feelings at the time.

Caroline Bailey has worked in oil and

pastel, but she mainly uses watercolour and gouache; sometimes combined in the same painting. She works very loosely, wet into wet, onto large sheets of stretched watercolour paper, occasionally using liquid colour to benefit from the impact of a stronger and more concentrated pigment. While she works, she often sprays water onto the paper to keep the surface damp enough for the colours to bleed. She always mixes her own green, because she wants to

avoid what she calls a flat, synthetic look.

Caroline (born 1953) was trained in textile design and she has an eye for splashes of colour which verge on abstract design. However, it would be misleading to call her an abstract painter, for all her work is concerned with figurative subjects: mainly landscapes, trees, plants and flowers. Even when the pictures veer towards the abstract, they are still firmly based on direct observation.

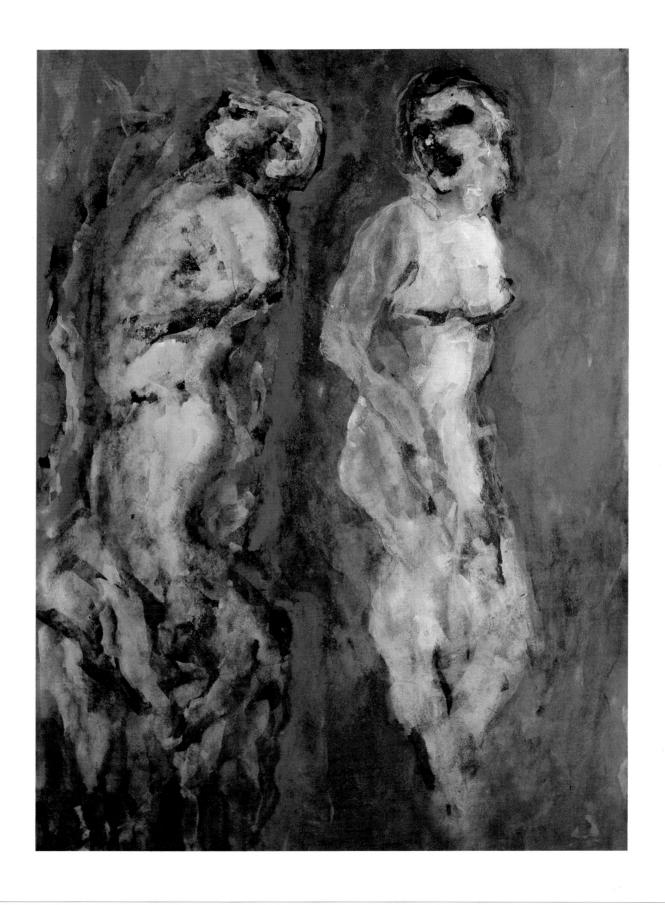

CLOUD MOCKS IXION

(1985) by Arturo Di Stefano

The mythical character Ixion, a shunned murderer on earth, had, nevertheless, been carried to heaven by Zeus, but responded by trying to seduce the supreme god's wife, Hera. Ixion was tricked into sexual union with a cloud that had been fashioned to resemble Hera, and the resultant offspring were the legendary half-horse, half-human monsters, the Centaurs. Ixion was punished by being bound to a fiery wheel and condemned to roll through the sky for all eternity.

In this 1067 × 762mm (42 × 30in) painting (unusually large for the medium) Arturo Di Stefano (born 1955) uses the versatility of gouache to represent the ancient myth in his own way. Like many artists in recent years, Di Stefano uses paint, not to convey an impression of something before him, but to say something of his own; his choice of materials and techniques, therefore, is determined by what he wants to say.

In this picture, Ixion is haunted by the appearance of the object of his desire. Gouache allowed Di Stefano to apply thin washes which soaked in and stained the paper, and also to paint thicker opaque brush marks. The paint's qualities are important: much of the cloud is a thin stain, lacking the substance of the flames of desire in which Ixion is condemned to burn; the fire and the body of Ixion are painted in a dramatic exchange of reds, yellows, oranges and blacks. One colour violates another, enacting Ixion's pain and passion.

English born of Italian descent, Di Stefano painted a series of pictures based on the myth of Ixion, in both oil and gouache on paper. He is one of those artists who wants to reunite painting with poetry and literature. He wants to make painting part of imaginative culture, rather than just concerned with its own history. In this respect, he reminds one of Blake and Fuseli.

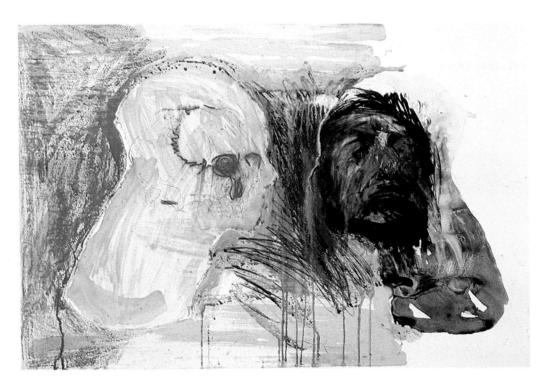

DRAWING FROM THE EMBLEMS AND ICONS SERIES

(1986) by Adam Lowe

An important part of this mixed media picture by Adam Lowe (born 1959) is its physical surface, a feature which predominates when the work is seen in its original form. The picture is one of a series featuring coloured photocopies collaged onto watercolours, and mixed with pencil, chalk and wax. The surface contrasts of texture, especially between the fluid but flat watercolour, and the transparent semi-gloss surface of the wax, are as important as the figurative imagery.

The artist says the picture can be seen in terms of a rhetorical conflict between reason and sensation – reason being the skull and sensation the profile of a head. Neither the photocopied head nor the fluid wash profile

are drawn as if fully crystallized into a final state; they have a deliberately amorphous, undefined quality. The washed area behind the profile is scarcely defined; treated in loose brushstrokes, although it is contained within a fairly definite outline. The way the paint is used within the outline is very sketchy and uncommitted, whereas the artist has treated the photocopied head in spontaneous but definite strokes of a very dark and emphatic tone. Yet he has worked on this, too, in a way that does not bring it to an absolute conclusion. Therefore, the two images relate to each other, not because they are connected pictorially within the composition, but because they are both in a state of change. Obviously, the artist has had to freeze the shapes in time, but by using these techniques he has nevertheless tried to convey the idea that the images are still in a perpetual state of flux.

MATERIALS AND EQUIPMENT

FOR ALL WATERCOLOUR artists, the tools of the trade are immensely important. Given the range of options available, it is perilously easy to make the wrong choice – or to buy items of equipment that are luxuries, rather than essentials. This section starts by showing you what you need to set up a home studio and what equipment to choose when working outdoors.

From this, the section goes on to explain just why developing an awareness of the potential of colour is so important, explaining basic facts and theories, showing you what happens when paints are mixed and, equally importantly, how to mix them. This lays the foundations on which you can develop your own palette and create colours to suit your individual approach. Finally, it sets out the basic rules of composition, showing you how to select subjects and how to plan your pictures to best effect.

THE WORKPLACE

WATERCOLOUR ARTISTS have an advantage over those who work in other media: their materials are relatively compact, and easy to carry and set out. The paints are small, the easels are usually lightweight and collapsible, and the supports, instead of involving unwieldy, wooden stretchers and boards, are simply sheets of paper, or card. All this means that your workplace can be a highly organized studio, a corner of a room in your house, or even a mobile arrangement which can be put away if necessary.

For exploratory outdoor work, you will need no more than a sketchbook and a small box of paints. Armed with these, you can make quick sketches as the basis for more finished work.

The working surface

Watercolour artists need to apply their thin washes on a flat surface, and then to tilt the surface so that they can add detail. A beginner working at home can start by using a flat piece of board, fixing the paper to it, and tilting the board by propping it up with a few books — varying the heights for different stages of the painting. However, you will probably find that a makeshift arrangement like this becomes cumbersome, and that it is worth buying a special drafting table, or a worktable with storage drawers, and a top that can be adjusted so that it slopes. An easel is also essential (see pp 86-7 for full details).

Comfort, light and storage

Soldiers have an old saying: "Any fool can be uncomfortable". Certainly, comfort is a key factor when planning your working environment; and it is surprising how often it is ignored. Before deciding on a working area make sure it is free from draughts. Then, try to arrange the room so you can walk about easily – for a break or a re-think. For detailed, careful work, you need a comfortable chair, preferably one that swivels, so that you can reach easily for different tools. A chair with adjustable height is especially valuable if you are working with tilting surfaces and tabletop easels, while a high stool is useful if you intend to work at a tall easel.

Light is of crucial importance. Ideally, your workplace should have maximum daylight; white walls will help to provide light. Many artists work under artificial light; some even prefer it as this means that their light source is constant. Daylight bulbs produce near-natural light, but some artists use lamps with ordinary bulbs.

When planning a working environment, make allowances for storage. The most immediate problem – where to place your water, paints and brushes – can be solved by using a side table, or buying a mobile stand. However, you will find that stocks of paper, collections of sketches, and piles of finished paintings tend to build up rapidly, and that you will require a desk, or table with a large number of drawers. If you work on a large scale, it may be worth buying a plan chest with shallow, very broad drawers.

A final word of advice: keep your workplace tidy and organized from the start. You should know exactly where to find a particular colour, tool, or reference book – delay in finding equipment may be disastrous if, for example, you have a wet painting in urgent need of alteration. Also, if you work with brushes, palettes and water jars which are dirty the paints will lose their vividness.

Ideally your workplace should have good natural light. White walls increase the amount of light. A desk lamp, either with an ordinary bulb, or a daylight bulb, is a useful alternative form of light. Light tabletop easel. Board with support attached. Work table. A comfortable chair, preferably on wheels, or one that swivels is essential for detailed work Mobile stand for water, paints. brushes and supports

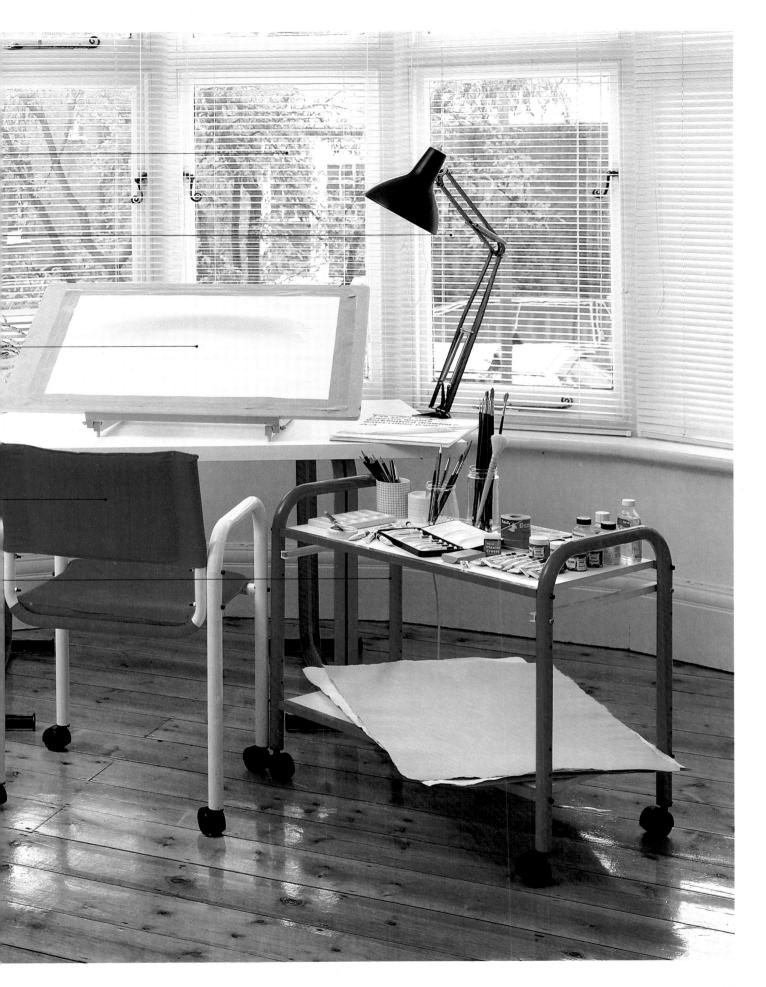

PAINTS

EARLY WATERCOLOURS were manufactured as hard sticks, and were rubbed onto the palette with water to extract the colour. Today, the colours come in three main forms: pans, tubes and cakes. You can also buy liquid watercolour in bottles; opaque colour – such as gouache and poster colour – in jars; and watercolour pencils.

Watercolours are basically pigments which have been mixed with water and gum arabic (to bind them together), glycerine (to stop the paint from cracking), and a preservative. It is sometimes said that watercolours tend to fade, but this is an unfair simplification, as in fact some pigments are more stable and permanent than others. Among the very durable colours are the umbers, the siennas, viridian, coeruleum blue, cobalt blue, terre verte and yellow ochre. On the other hand, chrome yellow, carmine and Vandyke brown are notoriously fugitive, and do not age well.

Watercolour

True watercolour contains no opaque substances and is, therefore, transparent. The best is made from real pigments and is often referred to as "artist's" quality. It is more expensive than

lower grade, or "student", paint, but the colours are more vivid, which means that almost all professional and experienced painters use the superior product. "Student" quality watercolours are frequently made with cheaper, substitute pigments; such colours are often called "fugitive" and cannot be relied on not to fade.

When buying paints for the first time it is a good idea to choose at least a few basic colours from the "artist's" range. There really is a difference, and it would be a pity to judge the medium without experiencing some of the better quality pigments. "Student" paints are useful if you feel you want to try a new colour, yet are not quite sure whether you will like it. Experiment with the cheaper paints; if you get on well with certain colours, buy the "artist's" version next time round.

Compressed powder cakes are the cheapest form of watercolour paint. They are slow to use, in the sense that it takes a long time to moisten the paint sufficiently with the brush to produce a dense colour.

Look after your paints: watercolours last for a long time if you treat them well. Always replace the lids of tube colour. If you do not, the paint will go hard very quickly. Should you accidently allow this to happen, do not abandon the paint; in an emergency, you can cut open the tube and use it as an improvised pan. Pans, too, can become very dry and hard; when this happens, a few drops of water will revive the paint.

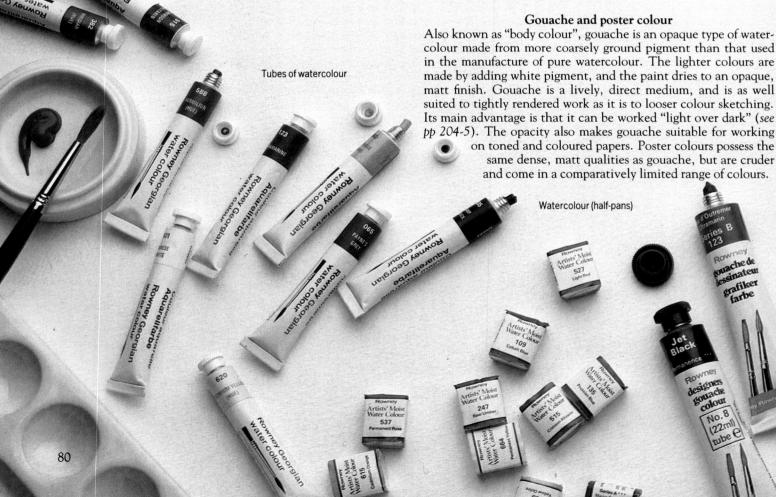

Liquid watercolour

Some watercolours are manufactured in liquid form; they are often highly concentrated and come in bottles, usually with their own "eye-dropper" for adding controlled amounts of colour to water. Concentrated colour can be fugitive - some pigments fade quickly. It is, however, popular with designers and illustrators because of its exceptionally bright and glowing colours. Moreover, if the work is intended for reproduction only, the life-span of the original is usually less important.

Sets and boxes

As well as being sold as individual tubes, pans, cakes and jars, all the different watercolour types can be bought in sets and boxes. Paintboxes are invaluable for outdoor work, enabling you to slip your entire watercolour equipment into an inside pocket and carry it around with you. Sets of paints - tubes packaged in wooden or cardboard boxes - are also very convenient and make ideal presents.

Watercolour pencils

Rowney

designers gouache

colour

No.8

(22ml) tube e

To combine line with areas of wash, choose watercolour pencils. This comparatively new medium, a cross between coloured pencils and watercolour paint, is available in a wide range of colours.

Gouache

gouached

dessinateu

grafiker farbe

itanium White mence *** Rowney designen

WATERCOLOUR SETS AND BOXES Watercolour, gouache, watercolour pencils, and concentrates are all available in sets. These provide a convenient basic palette, which can be expanded gradually as you gain more experience.

All watercolour paints are laboratory-tested to ensure that their colour, consistency, and transparency remain constant. Most manufacturers indicate each colour's degree of permanency as follows: permanent; normally permanent; moderately permanent; or fugitive.

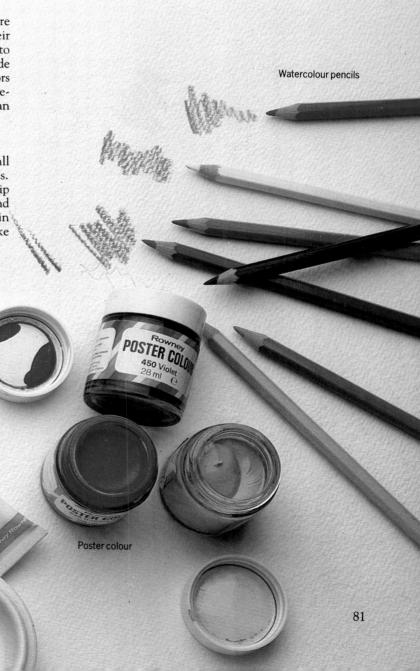

BRUSHES

ALL WATERCOLOUR brushes are softer than the brushes used for oil painting. There are two main categories available: natural and man-made. What follows is your guide to choosing the best.

Without question, the best watercolour brush you can buy is the so-called sable brush. The hairs for this come from the tail of the kolinsky, or Siberian weasel, which explains why such brushes are expensive. If properly maintained, however, sable brushes can last for a very long time, thus making their cost worthwhile.

What makes sable brushes so distinctive? To start with, they have a springiness and pliancy all of their own - qualities that lend themselves to lively, yet controlled brushstrokes. It is this facility that cheaper brushes find difficult to

imitate. Sable brushes also absorb and hold paint well, while keeping their perfectly

mixed with sable are cheaper still; of the two the ox hair variety is generally considered to be superior. Hair from goats, camels and mongoose is also sometimes used.

Synthetic watercolour brushes fall roughly into two types: soft ones with a texture and flexibility intended to mimic the qualities of natural hair; and all-purpose nylon brushes, which are suitable for watercolour, oil, or acrylic painting.

Brush shapes

All brushes consist of a head bound to a wooden handle by means of a metal ferrule. You can judge the quality of a brush by examining the condition of its bristles - these should be firmly pointed with no odd hairs straying out of place.

Brushes with a round ferrule are known as "round brushes"; if the ferrule is slightly flattened they are termed "flat" brushes. "Filberts" are brushes with bristles which have been cut off at the

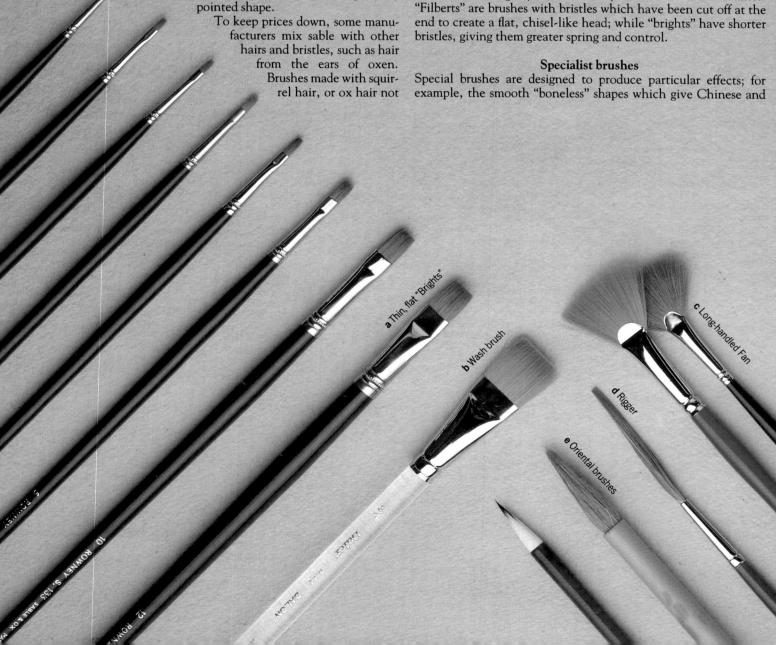

Japanese watercolours their distinctive quality are produced by specific brushes. These bamboo or cane-handled brushes can be useful for applying washes and flecks of colour, but they are not always suitable for work outside the Oriental styles.

Watercolour artists often use fan-shaped brushes for blending colours. They come in various sizes. There are several larger brushes designed specifically for flat washes and, though expensive, they are indispensible when it comes to covering large flat areas of colour. The dabber, with its full rounded head of bristles, is a popular example.

Bristle brushes, normally used with oils or acrylics, are stiffer than the typical watercolour brush, making them useful for scrubbing out lighter areas and for the correction of mistakes.

For linear techniques and drawing with watercolour, artists often use long, tapering brushes. These brushes, sometimes known as "riggers", are designed for lettering and poster writing. Miniatures and finer detail can be done with specialist sable brushes, known as "retouching" brushes. They have particularly short bristles. Small decorators' brushes are useful for painting large areas and for some special effects, such as splattering. Stencil brushes, made from hard-wearing bristles, are ideal for stippling as well as stencilling.

BRUSHES

a "Brights", for lively, controlled brushwork; b Wash brush, for flat expenses; c Fan, for blending; d Rigger, for line and calligraphic brushstrokes; e Oriental brushes, for flowing, undulating line; f Rounds, for general purpose watercolour work; g Synthetic brushes make inexpensive alternatives; h Mop brush, for textural washes, such as sky and water.

Brush sizes

Standard brush sizes normally range from 00 to 12 or 14, the 00 representing the smallest size. Some manufacturers have a larger size, while some produce an 000 for particularly fine work.

The size of some flat brushes is expressed as bristle width. One series, for instance, runs from 5mm (1/4in) to 25mm (1in).

Brush care

Every time you use a brush, you should rinse it out with water; after finishing a painting session, clean your brushes thoroughly with mild soap and warm water. Shake the brushes into their natural shape – do not squeeze them – and allow them to dry naturally. It is very difficult to get a brush back into its proper shape if you do not take these steps.

Many brushes are sold with small plastic protectors that fit over the bristles. Do not make the mistake of throwing these protectors away; instead you should always use them to keep your brushes well protected, until you actually need them.

SUPPORTS

THE "SUPPORT" IS the artist's working surface – the material on which the picture is painted. Fortunately for the watercolourist, this means paper, which is economic in price, conveniently and commonly available, and easy to carry around.

The support is extremely important to a watercolour painter, as it plays an active and direct role in the making of a picture. Watercolour paper comes in a wide variety of weights, textures, colours and quality. In many cases, the texture itself is an integral part of the picture, its roughness showing through in the form of speckles, and adding a touch of spontaneity and liveliness. In this way, for example, tiny specks of highlight can be added to a sky, light shining through leaves can be made more luminous, and sunlight can be given a more realistic shimmering effect.

Coloured papers are often combined with gouache, their colour being incorporated into the picture. Pure watercolour is sometimes used on very pale tinted paper, but this means that you

lose the effect of the bright white highlights.

Most watercolour paper has a right side and a wrong side. The correct side, on which the texture is carefully prepared, is usually coated with size (see glossary). If you hold up the paper and inspect it, you will notice that the grain on the correct side has a more natural, less symmetrical, appearance, while on the wrong side the grain is more regular.

The best paper is hand-made from pulped linen rag, which has been skilfully processed to eliminate impurities, and then coated with size from an animal glue solution. Hand-made papers can be recognized by the maker's watermark; also they often have

irregular edges, as opposed to the smooth clean-cut edges of papers which have been machine-made from wood pulp.

If you are starting out as a watercolourist, it is probably advisable to avoid some of the more extremely textured, or coarse-grained paper. This type, which has an extra rough surface, is popular with many artists, but can sometimes present the beginner with problems, because it is much more difficult to control the paint as it washes onto the irregular support. However, when you become more experienced, this type of paper can produce a beautiful, luminous sparkle through the washes, because the paint sinks into the pitted surface and leaves speckles untouched.

Cold-pressed and hot-pressed

The most common watercolour paper, and the type usually recommended for beginners, is a semi-rough, medium-quality paper. Usually known as "cold-pressed", it is also sometimes described by the odd-sounding term "not" paper, because it has not undergone the alternative process of hot-pressing. Also popular among many very experienced artists, cold-pressed paper is intended as a compromise to suit different methods of working; its slightly textured surface gives some spontaneity to washes, but will also receive line well, and is suitable for fine, detailed brushwork.

Hot-pressed paper is designed to provide a suitable support for drawings. This fine-grained paper is pressed while hot to straighten it, and its hard smooth surface is ideal for drawings in pencil, pen and ink, or line and wash. Some watercolour artists like its

uncompromisingly slippery surface, which can make washes slide and spread rapidly, as well as increasing the luminosity of colours. Many artists, however, find that it is not absorbent enough for conventional watercolour painting.

Stretching the support

Unless watercolour paper is either thick, or ready-mounted (see below), it can be warped by the application of paints and water. You may, therefore, wish to stretch any thinner, or unmounted paper before use.

First, place the sheet of paper in a tray of water, or hold it under a running tap, until it is thoroughly wet. Then carefully shake off excess water and place the paper on your drawing board. The board should be larger in area than the paper, and thick enough not to warp as wet paper dries upon it. When placing the paper on the board, make sure that the correct side faces upwards. Now stretch the paper slightly, holding it with both hands. Immediately after wetting and stretching, stick the edges of the paper to the board with strips of gum-backed tape. For extra strength, pin the corners of the paper and tape to the board with drawing pins, then leave the paper to dry naturally.

The main reason for stretching paper is to prevent it from wrinkling when it is wetted. However, papers vary in weight and the heaviest ones can sometimes be used without stretching them first. Paper has traditionally been measured in pounds per ream (480 or 500 sheets) and this is still in common use. However, the official metric measure is grams per square metre (gsm or gm). As

a guide, thin paper may be referred to as weighing 70 pounds (150gsm), while a heavier grade would be perhaps 140 pounds (285gsm). Some of the toughest papers can be stretched on special frames, rather like those for stretching canvas, but these are unsuitable for thinner papers.

Some artists stretch their paper on thinner boards, or card, for easy transportation. However, the card can warp as the wet, stretched paper dries, although this can be offset by stretching the paper on both sides of the card.

Ready-prepared watercolour boards – thin paper mounted by being glued onto sturdy pieces of card – are available if you want to avoid stretching your own paper. These will keep their shape while you are painting, and they are available in pads, usually of about 25 sheets each.

SURFACES
Watercolour papers are specially
made to meet the exacting
requirements of particular techniques
and to produce specific effects. The
artist's choice depends largely on the
subject, the techniques used, and the
effect required. There are three basic
types of paper in general use: Rough,
Not, and Hot Pressed (H.P.)

Photograph Tif Hunter

85

EASELS

THE WATERCOLOUR ARTIST needs an easel which is easy to carry, easy to pack, and which has a strong enough grip to hold a board on which the watercolour paper is fixed. One of the most popular choices for general use – the studio easel – has a heavy wooden frame, clamps, and wheels. It can be used for watercolours if necessary, but easels designed like this tend to have frames fixed in a vertical position, which is not really best suited to watercolour. The watercolour artist usually finds it easier to have a work surface which can be tilted, so that wet washes can be applied when the board is horizontal, and details painted in when the board is adjusted to a convenient angle.

Tabletop easels

A vast variety of easels is now available for artists, many of which are suitable for watercolourists. One of the most popular is almost a miniature version of the studio easel, except that it is specifically designed for use on a tabletop, and therefore has no wheels. It also has sloping back-struts which enable the main frame to be tilted to the desired angle. However, this type of easel will not generally allow the support to be lowered completely to the horizontal.

Another tabletop easel is much simpler: it consists basically of a frame to hold the board, which is propped up on deckchair-type slats at the rear, giving a wide but limited range of tilted angles. Like the previous one, this type usually comes in wood. It often has pads on the bottom, to prevent it from slipping. It is ideal for

the home or studio, because it can be so easily moved about, and the board can be rested on it without being clamped, making it simple to remove and place on a flat surface.

Standing easels

The watercolour artist can also make use of an easel designed in the simple, "blackboard holder" style, with two legs in front, and an adjustable one at the back, and often with broad "shelves" or "height trays" on which to rest the watercolour board. However, all the types mentioned are essentially indoor easels; if you take them outdoors you will need to find an almost perfectly flat piece of ground on which to place them.

Outdoor easels

Some of the best of these are made of light metal, with individually adjustable legs. They can be set up to a standing height, they have a moveable bar with clamps for fixing the board and tilting it at any angle from flat to vertical, and they can be folded to almost umbrella-like proportions for carrying. Wooden easels with adjustable legs are heavier to carry, but may have stable wooden trays on which paints and water can be rested.

Probably the most popular of all is the wooden box easel. This combines a traditional collapsible easel with a wooden box for carrying painting equipment. The box transforms into a deep combined tray/tabletop which can be used for paints, palettes, water, and other materials.

EASELS

a Salisbury "box easel" — folding and versatile for many types of work; b Canterbury — lightweight, folding easel; c St Pauls — similar to Canterbury, but with supports for a box; d Westminster — metal, folding easel.

TABLE EASEL

A compact easel, ideal where space is limited. This model is adjustable and can be set at any angle

ROWNEY
superior quality
Bockingford draw
water colour paper

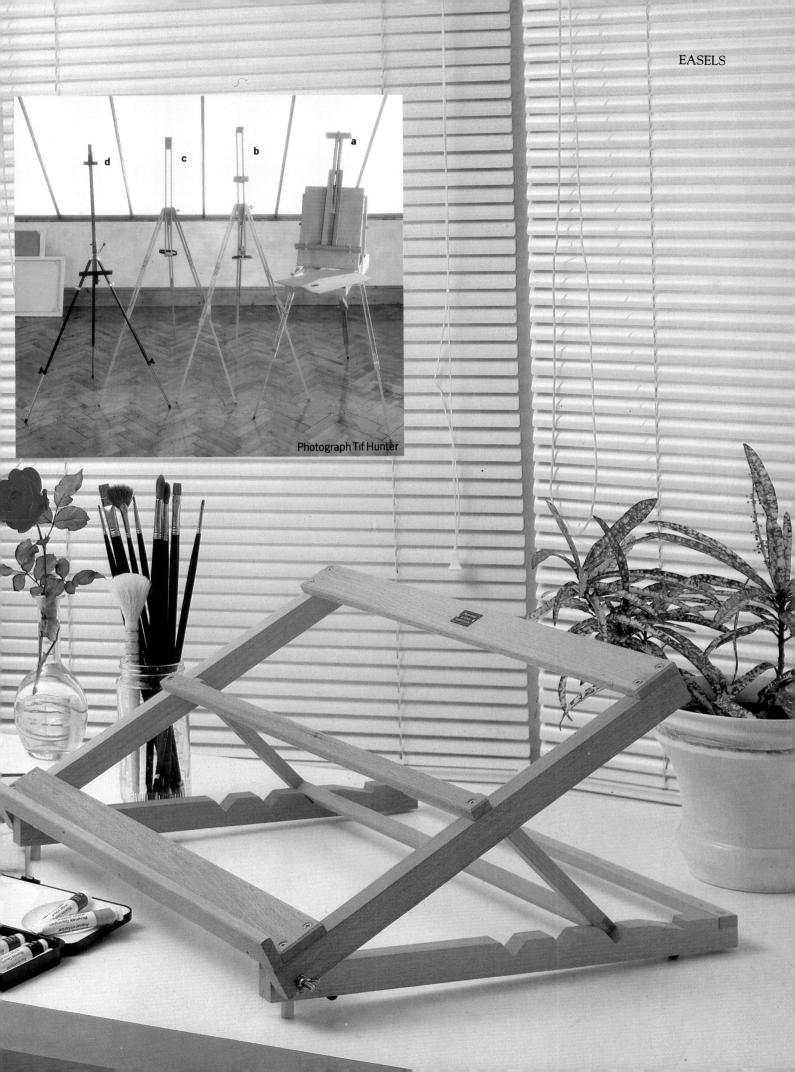

OTHER EQUIPMENT

APART FROM THE materials and equipment already mentioned in previous sections, you will also need a number of miscellaneous items, most of which are illustrated on this page.

Graphite drawing pencils range from very hard to very soft: the softer the pencil, the darker and more feathery the strokes; while a hard pencil produces a pale, thin line. You will probably use a B or 2B most of the time.

A good quality drawing board will last a lifetime and is a worthwhile investment. However, you can make your own, provided that the wood is sturdy and will not warp or bend.

Mediums and additives

The only additive you actually need for painting in watercolour is some clean water, but there are various substances which can be mixed with the paint, or water to produce specific effects, or make the application of colour easier.

Gum water, is a thinner alternative which improves the flow of the paint and also brightens the colours. A little glycerine prolongs the drying time of paint, which is particularly useful when working one colour into another while the paint is still wet; it also counteracts the drying effect of sunlight and central heating. If you want to speed up the drying time of paint, add a 96% solution of alcohol to the water. A small amount of refined oxgall poured into the water will improve the flow and adhesiveness of paint. To create specific areas of white, apply masking fluid with a brush and allow it to dry. Colour can now be safely applied. When this is dry, rub off the masking fluid with your finger, or an eraser to reveal the crisp white shapes beneath. Special purpose varnish will protect the picture surface without adversely affecting the painting, and help to bring out the resonance and brilliance of the colours. However, purists argue that varnish changes the traditionally dull, matt watercolour finish.

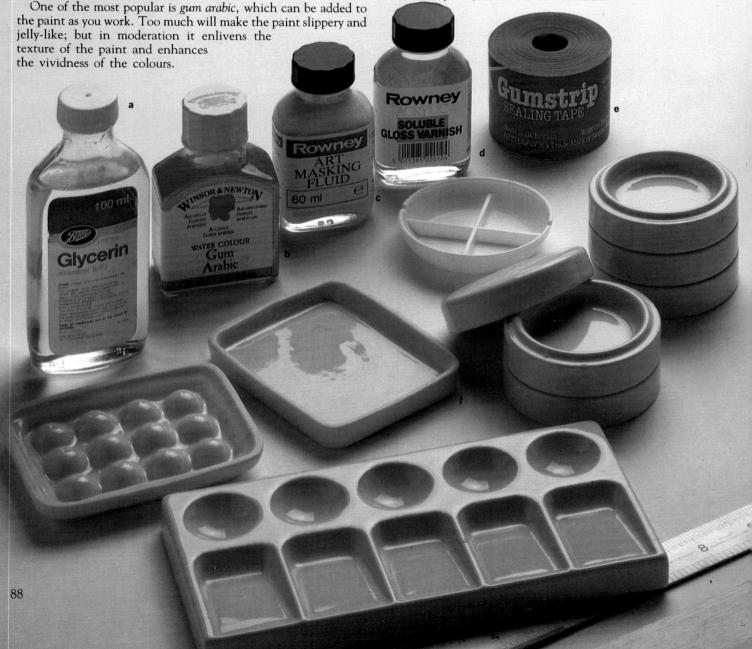

The "lightbeam" primaries, also known as the "additive" primaries, are *green*, *red* and *blue*. They are the main components of white light as divided up by the prism, and are of interest to the pure science of light, and to printing and photography. Imagine you are viewing beams of light. If you remove green, by using a special light filter, the result is the mixture of the other two – magenta. If you filter out the red, the result is the combination of blue and green, which is cyan. Filter out the blue, and you will have a combination of green and red, which shows up as yellow.

But light is not paint. And, as every painter knows, green and red pigments do not make yellow. For the artist, therefore, the primary colours are *red*, *yellow* and *blue*; and, in ideal conditions, it should be possible to mix every other hue from them. The combinations of these primaries are known as subtractive mixing.

The artist, however, immediately runs into a problem: conditions are never ideal. The paint used by the artist is an absorbent surface, just like any other object, and the absorption of some of the light causes the resulting colour – known as the "secondary" colour – to lose brightness.

If you mix red, yellow and blue together in equal amounts, the colours darken, and absorb more light; less light is reflected, and the result is dark grey. It is important to remember this tendency of the primaries to become greyer when mixed together, as it helps to explain the problem of loss of brightness.

In the 19th and 20th centuries, artists have given much thought to this problem: To prevent colour becoming neutralized and muddy, many of the Impressionists sought to mix colours "optically", instead of on the palette, by painting different colours directly and separately onto the support. This technique allows the viewer's eye to blend the colours together. The Impressionists were also aware of the importance of painting "light", as well as colour, in order to capture its shimmering effects. As a result, they did not automatically paint shadows as grey, but as a complementary colour to the light; in sunny yellow light, for example, shadows would appear as purple.

The technique of optical mixing was used in more extreme ways by the Pointillists, such as Seurat and Signac, who produced paintings consisting almost entirely of coloured dots. Their colours were more rigidly separated than those of the Impressionists: orange, for example, was depicted as areas of red and yellow dots. Colour printing is done on very similar lines.

OPTICAL MIXING
Instead of mixing colours on the palette, you can apply them separately, in such a way that the viewer's eye blends the colours together optically. These samples show how you can mix blobs of pure colour to create the illusion of another colour: for example, red dots and yellow dots create an optical mix of orange.

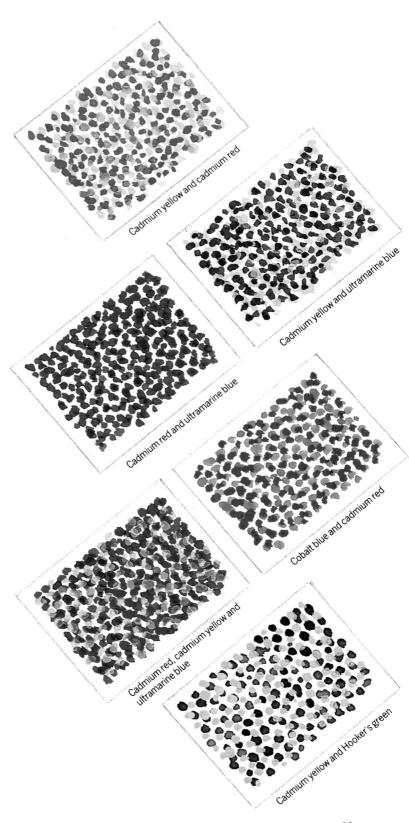

FINDING OUT ABOUT COLOUR

THE FIRST SKILLS in the mixing of colours are taught in the nursery or infant school. Children find out that a yellow crayon scribbled over a red one makes orange, or that blue and yellow crayon makes green. Unfortunately, this basic knowledge is often forgotten, and any return to colour mixing in later years tends to become bogged down in more complex colour theory. You should, therefore, go back to that early stage of experimentation, and see what happens when you mix various colours. Usually, you will find that what you discovered in those early years was more valuable than any theory you have learned since then.

Secondary and tertiary colours

A secondary colour is obtained by mixing two primary colours. Thus green, orange and violet are the secondaries. Tertiary colours are those obtained by mixing a primary and a secondary colour together. The tertiaries are red-violet, violet-blue, bluegreen, yellow-green, yellow-orange and orange-red.

Complementary colours

Every colour has a complementary, or opposite, colour. On a simple colour wheel, this is the colour which falls opposite; for example, green is the complementary of red and orange of blue.

The use of complementary colours is crucial, as they can be the making of a picture. Shadows, for instance, can be represented in

a darker tone of the complementary colour of the subject, or of the light shining on the subject. Complementary colours can be used to balance a picture and create harmony; or, in contrast, a picture painted predominantly in greens can be brought to life by adding a small area of red.

The practical colour wheel

The neatly labelled colour wheel, with its primaries of yellow, red and blue, is not actually the best guide for mixing colours. In watercolours, the equivalents of the primaries are cadmium yellow, cadmium red, and a blue which is somewhere between cobalt and ultramarine. If, therefore, you want to mix any of the secondary colours, there are better ways of doing it than automatically choosing two of the so-called primaries.

The practical colour wheel illustrated, uses lemon yellow and cadmium yellow; cadmium red and alizarin; and cobalt blue and ultramarine. You will find it useful to devise your own practical colour wheel, by experimenting with different varieties of colour: for instance, madder and carmine make different and specific violets when mixed with ultramarine; and lemon yellow, yellow ochre and raw umber produce a variety of greens when combined with a whole range of blues. No chart will give you the same valuable information and experience that you will gain from putting together a colour wheel yourself.

THE PRACTICAL COLOUR WHEEL The standard colour wheel with the primary colours - red, yellow and blue is of limited use to the artist when it comes to mixing actual paint. This is because, in practice, the primaries do not produce the brightest secondaries: for example, in painterly terms, primary red and primary blue, when mixed, make a dull brown rather than the expected violet. On the other hand, a colder red such as alizarin mixes with ultramarine to produce a good violet. Similarily, a cold blue and cold vellow - cobalt and lemon produce a more vivid green than primary blue and primary yellow. Artists, therefore, find it far more effective to develop their own practical colour wheel. In order to mix the best secondary colours, the wheel illustrated includes a cold and a warm version of each primary colour. Use this as a general guide for developing your own colour wheel, and experiment with different colours until you achieve the desired results.

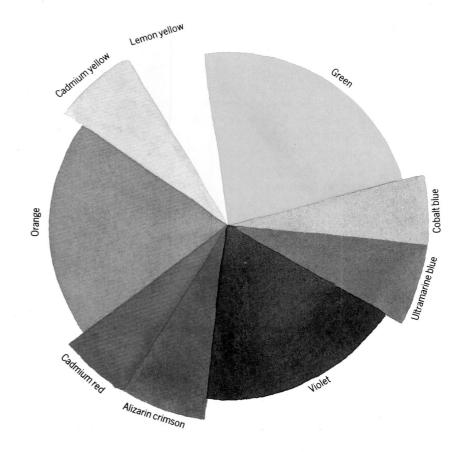

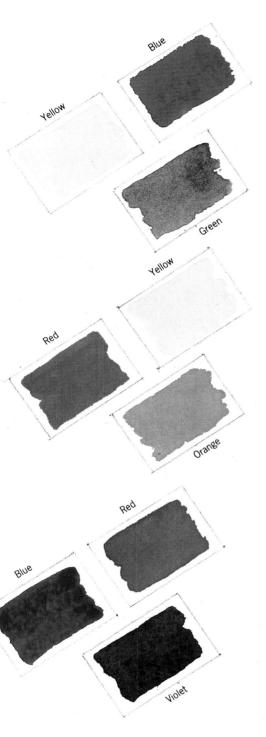

SECONDARY COLOURS
Secondary colours are those
produced when two primaries
are mixed together (left): hence
yellow and blue make green;
red and yellow make orange;
and blue and red make violet.

TERTIARY COLOURS
A tertiary colour is one mixed from a primary and a secondary colour (right): therefore yellow and orange make yellowy-orange; yellow and green make yellowy-green; blue and green make bluish-green; blue and violet make bluish-violet; red and orange make reddish-orange.

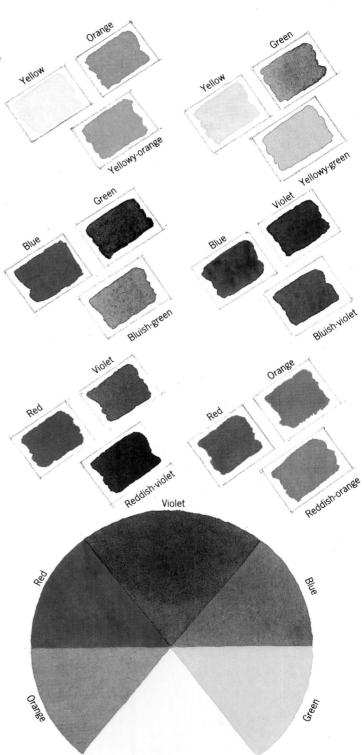

COMPLEMENTARY COLOURS
These are colours which lie opposite each other on the colour wheel. Thus violet and yellow are complementaries, as are blue and orange, and red and green.

TONES AND NEUTRALS

TONES – THE LIGHTS AND DARKS – contribute as much to a successful painting as the colours themselves. Every colour has a tonal value, a shade of grey ranging from almost white to almost black. A pale colour, such as yellow, is tonally light; deeper colours, such as red, are tonally dark. If you can imagine how a colour would look in a black and white photograph, you are close to understanding its tonal value.

When planning and painting a picture, the tones should be given careful consideration. If you find it difficult to see and assess the tones of your subject, try looking at it through half-closed eyes. This eliminates some of the local colour, making it easier for you to pick out its light and dark areas. An awareness of tone, of the contrast between lights and darks, can help you bring a subject to life. If the tones are ignored, your painting will lack a feeling of space; three-dimensional forms, without the proper balance of light and shade to describe them, can look flat or otherwise distorted; and your composition can seem altogether uninspired and visually dull. The arrangement of the lights and darks can be responsible for the success or failure of a painting.

As soon as you begin to tone down a pure primary colour, or a pure mix of two primaries, you will start to approach what are known as the neutral colours. These are the hues which are much lower in "saturation", i.e. they have less colour-brilliance. As green, for instance, becomes less green, it becomes more neutral, or it begins gradually to approach grey.

The word "pure" is applied to a primary colour, or a mix of two primaries. There are various ways of lowering the saturation of these pure hues: you can simply add white, which immediately begins to remove some of the pure colour brilliance; thus red becomes less red and more pinkish. (In watercolour painting, of course, you could simply add more water, diluting the colour so that more of the white paper shows through.) Another way is to add black, which darkens the colours; although this is rarely advised because it tends to deaden colours. (An alternative would be to add a dark hue, such as raw umber or Payne's grey.)

A third method of lowering the saturation of a "pure mix" of two primaries is to add another colour, thus producing a neutral. First, take a single primary colour, and mix an equal amount of another primary with it. You have now produced another pure colour: red and blue, for instance, make violet. If you add a third colour, you will create a duller, less pure hue, which is the neutral. You can adjust the colour-bias, i.e. the extent to which one colour is more recognizable than the others, by varying the proportions in the mixture.

In practical terms, neutrals are extremely important. If you paint always in pure colours, their impact will be lost and you will produce a rather flat picture, lacking form and interest. Without neutrals, the contrast, which allows the viewer to compare the brightness of a primary or secondary is lost. You also need neutrals to create harmony in a picture: if the neutrals are mixed from the basic colours used in the composition, the final picture will have a synthesis, a sense of wholeness. Another way of achieving this sense of harmony would be to choose a theme colour, one which reflects the character of the subject, and to mix a little of this with most of the colours used in the painting.

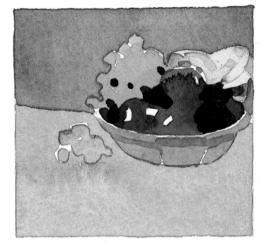

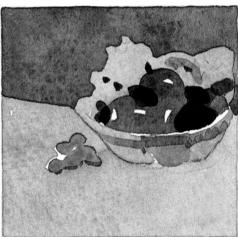

THE TONAL SCALE
For each colour there is a tonal
equivalent, somewhere on a scale
between very dark grey and very light
grey (above left). With watercolour this
means that you need mix only one
tone – the darkest. Water can then be
added to make progressively diluted,
and therefore lighter, tones. The still
life (above) shows the same subject,
first in colours and then in tones.

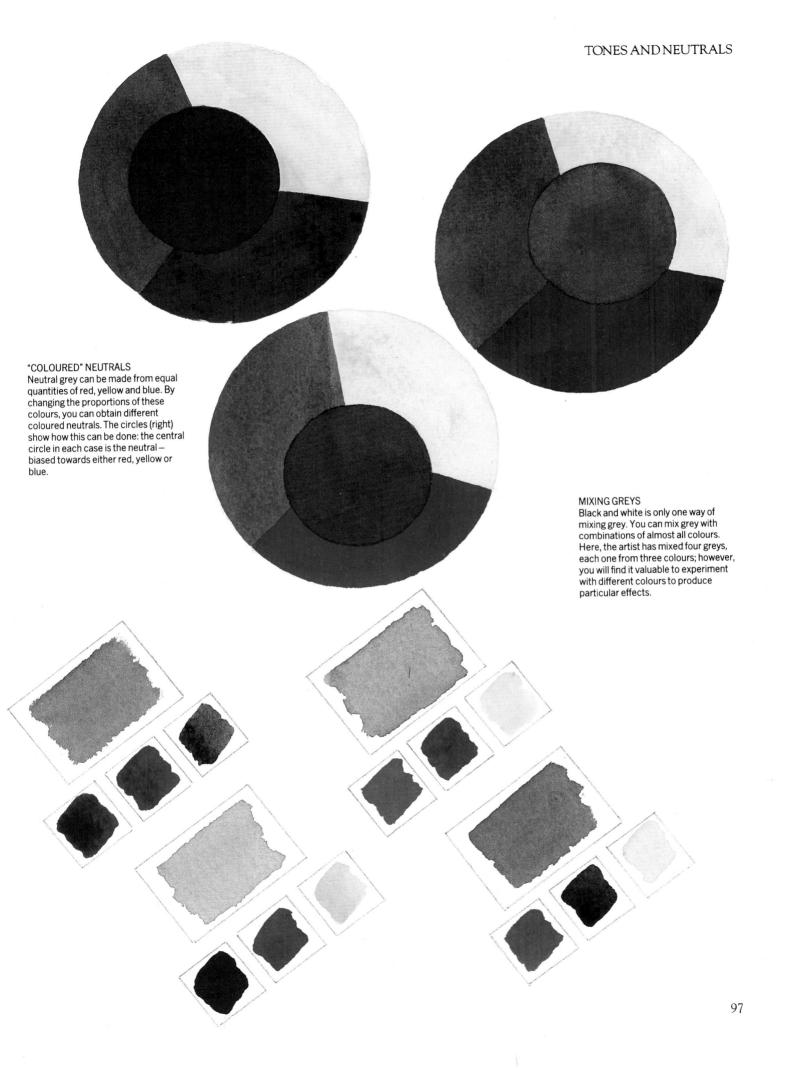

START WITH A SIMPLE SUBJECT

THE FRESH, TRANSLUCENT brightness of watercolours is suited to any subject and mood. A splash of colour can recall a patch of flowers once glimpsed on a wild hillside before the light faded. A few simple brushstrokes can indicate a flurry of human movement in the distance, or give a convincing impression of a figure in the foreground. Yet the same paints can create the sharp, objective focus of the laboratory, allowing the artist to follow with faithful precision the microscopic shapes and forms of a single plant.

Nevertheless, all this scope can prove most unfortunate for the beginner. The very fact that watercolour is so versatile may be daunting at first, especially if you are over-ambitious. If you are using watercolour for the first time, or if your experience of the medium is comparatively limited, you should start with some-

thing fairly simple.

The projects in the practical section of this book are specially designed to cover the various techniques and principles of water-colour painting in a gradual and systematic way. Basic, uncomplicated subjects are chosen for the initial demonstrations; more complex, ambitious ones for later projects. Successful water-colour painting is largely a question of experience, of expertise acquired through an accumulative process of mastering techniques and learning how to control paint. So be patient. Stick to straightforward subjects at first. When you feel competent and confident, move onto the next stage. There is nothing more frustrating and disappointing than to spoil a painting by trying to do too much too quickly. Some people put away their paints forever after an ambitious, but disastrous first attempt.

Initially, choose a subject with a limited number of elements, where the composition is not too busy. If you set out to capture the form of a vase, for instance, it will be much more difficult if the vase itself has a complicated surface pattern; so choose a plain one. If you wish to begin with a still life, then try a few simple

shapes, such as pieces of fruit.

If you are setting out to paint landscape as a beginner, start with a scene possessing fairly stark contrasts of colour and tone, possibly with something clear and sharp in the foreground. It is usually easier if the scene can be divided into a definite distance, middle distance and foreground; for example, a gatepost in the foreground, a tree in the middle distance and a hazy hill in the background. Be active in your search for suitable landscape. After arriving at a spot where you wish to paint, explore the area, assessing its possibilities until you find the simpler views.

Painting outdoors

For rapid, on-the-spot painting, watercolour is unbeatable: the paints are small and portable; the easel is light, and usually collapsible; and the colours are quick drying. Even if you don't complete the painting outdoors, colour notes and preliminary sketches can be made with watercolour, enabling you to work on the finished picture at home, or in the studio from first hand reference, and with a fresh picture of the subject in your mind.

If time is short, or if the weather threatens to curtail your painting trip, make a rapid pencil sketch of the subject; then take one area of colour, and mix the paints until you feel you have the correct colour, and apply just a blob of paint somewhere within FIRST STEPS
When you first start painting, it is sensible to choose a relatively straightforward subject. This basket of fruit is a perfect example of an uncomplicated subject, which can be simplified even further. Here, the artist has simplified the rounded forms of the fruits, and suggested the texture of the basket in general terms, rather than specific detail.

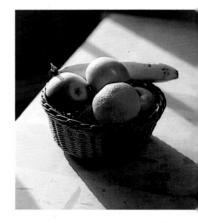

the area. Using the same method, blob in all the remaining colours. The result will be a drawing dotted with blobs of colour representing what you actually saw. From this plan, you will be able to reconstruct the scene at a later date by mixing paint to match the blobs.

Portrait and figure painting

Working from a model is both exciting and rewarding. Whether you are painting a portrait, a single figure or a group, it is important to make the pose as natural as possible. Any stiffness or awkwardness in the sitter's position will be reflected in your painting, and will detract from the finished work. A good general rule is to spend time and thought in the initial stages, trying a variety of poses and making sure your model is as comfortable as possible. When you have found the right pose and the model is confident of being able to stay in the same position, try to forget about the other person and concentrate on the work in hand.

When painting a portrait the pose is especially important because the face is the focal point of the picture; the facial expression, the angle of the head, and the right choice of background are all crucial to the success of the painting. Often a portrait is painted with the subject looking directly at the artist, but you may prefer to paint your sitter "in profile", or take a "three-quarter" view. Whichever pose you choose, the emphasis should be on a natural, unforced appearance, with the subject's face relaxed in a normal expression. Dramatic gestures and over-bright smiles tend to falter and collapse during long sittings.

Backgrounds are especially important in portrait and figure paintings. These can be simple, with the model placed against a completely plain wall; or, alternatively, the figure may be part of a more complex composition, with the shapes, colours and tones of the background playing an essential role in the overall painting. Whichever you choose, make the decision a conscious one by planning your picture carefully from the outset.

COLOUR NOTES

There will be occasions when you do not have the opportunity, or the time to complete a picture on the spot. If this is the case, first make a rapid line drawing of the subject, and then indicate the colours of the various elements with blobs of paint, as the artist has done here. You can then take your sketch home and work on it at leisure.

THE PORTRAIT

When you are painting a portrait, you should keep some basic principles in mind. There are for instance, three standard poses - full front, half-front and profile. Although these are not rigid requirements, initially you will find it easier to restrict yourself to them. In the examples illustrated, the artist has simplified the effects of directional light on the various poses.

COMPOSITION

WHERE SHOULD YOU place the subject on the paper? How much space should you leave around the subject? What is the best way to arrange many different elements within a single picture? Decisions such as these must be made before you embark on your painting and are generally referred to as "composition".

Even the simplest of paintings – perhaps a picture of a single object standing against a plain wall – must be thoughtfully composed. There are endless possibilities, and to start, without considering the alternatives, by opting for the easiest, or the most obvious solution, is to place a sad limitation on your work. Just as no two artists see a subject in the same way, so there is no "right" way of planning a composition. Composition is a matter of personal choice. It can be conventional, or highly idiosyncratic. You can "go by the book", or you can reject the rules, but it is important to be aware of the options.

If you look at the series of sketches on this page, you will see that the artist has experimented with various ways of tackling the subject: the vase of flowers is viewed from different angles; depicted as small or large in relation to the space around it; and tried in various positions within the rectangular picture area. Every sketch records a fresh and interesting approach, taking nothing for granted, and each one of them turns a mundane subject into a visually stimulating image.

ARRANGING THE SUBJECT
If you are painting a still life or a figure, it is important to spend time arranging the subject and considering the composition. Here, the position of the subject in relation to the background, and its scale in relation to the surrounding picture area are crucial factors. In the diagrams (right) the artist explored a variety of compositions, by changing the position of the subject, and by altering the vertical and horizontal background divisions.

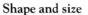

Choose a support to suit the subject. This will usually be rectangular, but not necessarily so. Square, circular, oval and unconventionally shaped compositions have all been used successfully by watercolour painters, so do not just accept the given shape of a sheet of paper as the basis for your composition. Instead, let the subject dictate the proportions of the painting and, if necessary, cut your paper down to suit your specific requirements.

The shape of the paper dictates the proportion of space which can be left around the subject, and this can literally affect how the viewer perceives that subject; for example, a tree painted on a horizontal rectangle (known as "landscape") may look stunted and squat. This is because there is less space at the top and bottom of the picture than at the sides. Conversely, the same tree placed on a vertical rectangle ("portrait") will appear tall and slender. Common sense will often recommend the correct shape for a particular subject.

Size, too, should be a matter of choice. Watercolour is frequently thought to be a "delicate" paint, a refined medium for making small pictures of elegant subjects; however, the work of many contemporary painters proves that this is far from the truth. The size of an area of colour depends on the size of the brush used to paint it, and again this depends on the subject and how you,

the artist, choose to treat it. Size of work is largely a matter of personal preference.

Harmony and rhythm

Traditionally, artists have sought to achieve harmony in their compositions. The aim is to lead the viewer's eye into the composition and to hold it there, drawing attention gently from point to point via the arrangement of forms and shapes within the picture. Discordant elements and distracting shapes and colours are avoided, as is anything which takes the viewer's attention outside the picture area. This approach, found in many Old Masters, is based on an imaginary circular shape within the rectangle or square of the painting. The "action" of the painting is concentrated within the circle; very little takes place in the corner areas of the composition, because of their distracting, outward-pointing nature.

Picture the scene

It is not easy to visualize how a subject will look in a picture, or to decide where the boundaries of that picture should be. This is especially true of landscapes, with their organic, often nebulous shapes, and lack of mechanical horizontals or verticals to provide guidelines. The human eye tends to move hopelessly from one

mass of foliage to another, from a nearby tuft of grass to a distant hilltop, without knowing how best to encapsulate the scene in a pictorial composition.

One useful method is to look at the subject through a series of "viewers" – holes cut to different shapes and proportions, usually from a piece of stiff card. By moving the viewer around you will quickly find possible compositions, and then be able to select the best angle from which to paint. Using two L-shaped brackets instead of a fixed rectangle, will enable you to change the proportions of the rectangular shape, and thus to experiment with a whole range of possible compositions.

The same technique can be used for any subject, and is also helpful when working from a large drawing or sketch. In the latter case, move the viewer across the drawing to find potential "paintings" within the larger picture. It can also be helpful to make a series of "thumbnail" sketches when planning and assessing the possibilities for a larger composition.

CHOOSING A COMPOSITION
Every subject offers an almost infinite
number of possible compositions.
There are no rigid rules about which is
right, or which is wrong: the choice is
a personal one. When painting this
beach scene, the artist selected one
of several possible compositions. The
views illustrated are just a few of the
alternatives.

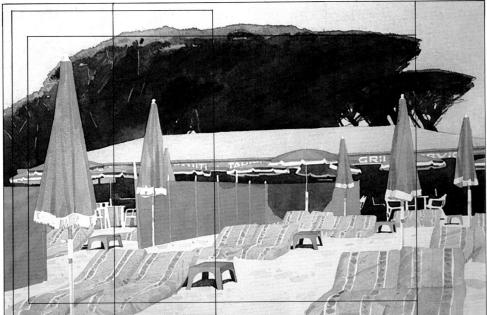

DRAWING FOR WATERCOLOUR

DRAWING FOR PAINTING is a special category of drawing; it is very different from making a drawing which is intended as an end in itself. One of the differences is that you do not have to think about tone when drawing for a watercolour, as this will be indicated later by the paint; an outline, therefore, is usually sufficient at this stage.

There are various ways of making drawings for watercolour, but the most usual is probably to execute a line drawing in ordinary graphite pencil. An HB or B pencil would be best. If the drawing is too soft, the graphite becomes mixed with the colours, producing a dirty looking painting.

Remember that the lines of the drawing should not be too heavy, otherwise they will show through the paint. In some cases, this might be permissible if you are aiming for a certain effect, but generally it is not desirable. Therefore, if your drawing is too dark, or you find that you have a large number of corrections, rub over it with a putty eraser, until you have a faint, light drawing which is just clear enough to act as a guide for painting in the colour.

HOW TO START

Coloured pencils

Some artists, particularly illustrators, use coloured pencils for their initial drawings, often making the outline a darker tone of the local, painted colour. On the whole, this produces a decorative rather than a representational effect, but it is well worth experimenting, in order to broaden your visual repertoire. Remember, however, that this method tends to flatten a picture, turning it into a more illustrative image.

Painting direct

Quite often you can work without drawing an outline. If you are painting wet into wet, with loose washes, you can build up the image by imposing areas of tone and colour without the use of linear contours. This approach can be employed for any subject, but is particularly appropriate for atmospheric landscapes, skies, clouds, reflections in water, or any other subject which consists of a nebulous mass rather than defined shapes. It can also be useful when you wish to produce a personal impression, an interpretation rather than a strictly representational picture. Caroline

a Graphite pencil

There are two basic ways of starting a watercolour: you can draw an outline in pen, or pencil; or you can paint directly onto the paper. These diagrams illustrate the varied results produced by different approaches. a It is best to use a fairly hard pencil, because the graphite will not smudge into the paper, and is light enough not to show through the watercolour. b Draw the outline in the local colour of the subject, so that the line will integrate with the watercolour. c If an outline is done in waterproof ink, the watercolour does not dissolve the lines, but leaves them sharp and intact. d Lines done in water-soluble ink bleed into the wet paint, producing a soft, blended appearance, e When colour is applied directly, without any preliminary drawing, it produces a loose, washy effect.

Bailey (see p 73) uses watercolour in this way. By painting directly onto a damp sheet of paper, she seeks to produce a spontaneous burst of colour unrestricted by predetermined outlines.

Pen and wash

Pen and wash is such an established way of working that it is almost regarded as a medium in its own right. There are basically two ways of approaching this technique: you can make a drawing with ink and then wash in the areas of colour; or you can start with loose washes of colour, and then draw into them with line when the paint is dry. For both methods, the traditional dip pen gives an interesting line, as well as allowing you to control the thickness of the line by pressing harder to make thicker lines, or slanting the nib to make thinner marks. Alternatively, you can use a technical pen (rapidograph) to produce lines of a more regular thickness.

Inks come in various colours, although traditionally black and sepia tones are predominant. The ink can be either waterproof, or water-soluble. If you want the line to remain intact and not bleed into the colour, use waterproof ink, but if you want to soften contours, sometimes water-soluble ink can be employed,

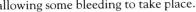

PRACTICAL WATERCOLOUR

It is now time to put principles into action. Here, to help you to do this to best effect, the key watercolour principles and techniques are each explained in detail and are followed by a specially-devised step-by-step project or projects, so that you can put what you have learned into practice and see what specific effects the techniques can be used to create. As a result, you will have a wealth of skills at your fingertips. Your visual vocabulary will have been broadened, allowing you to choose the best possible approach—one that not only suits the subject, but also your own personal way of working.

Remember one crucial point. Although the projects have been specifically devised to demonstrate how the various techniques can be best exploited, you should not struggle to follow the instructions to the absolute letter. Watercolour, by its nature, can be an unpredictable medium, so the effects you achieve will never be precisely the same as the ones illustrated here.

Step by steps by Ian Sidaway

STRETCHING PAPER

THE NEED TO stretch your support arises when you wish to use lightweight paper, or when the picture you have in mind involves a series of very wet washes. In both cases, unstretched paper will tend to buckle (see pp 84-5).

For stretching paper, you will need a suitable board: it has to be smooth, to avoid affecting the surface of the paper, and must be thick enough not to warp when wet, or when the paper contracts. Thin plywood is not suitable—you need a stable drawing board, or a piece of laminated wood.

You can use either gummed paper, or staples to secure the paper to the board.

USING GUMMED TAPE

1. Cut strips of brown gummed tape to fit the edges of your paper.

2. Wet the paper, either by using a sponge, or by immersing it in water.

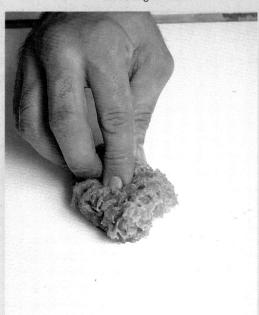

3. Lay the paper flat on the board, sized side up. Remove any air bubbles by rubbing briskly outwards from the centre with a clean cloth, and then stick down the edges with the strips of gummed tape. Allow the paper to dry naturally.

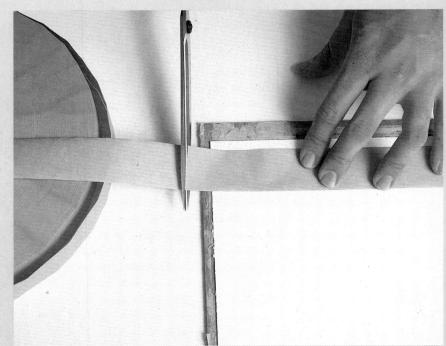

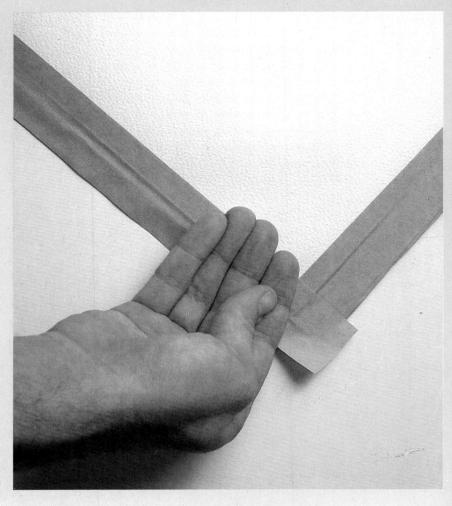

USING STAPLES

- This method is suitable for heavy watercolour papers. Place the paper over the board and fold down the edges. Cut the corners to fit.
- 2. Fold the corners neatly, and press them down. Now, staple the sides of the paper to the board.

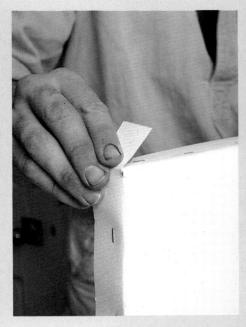

3. Staple the corners down. Finally, wet the surface of the paper with a sponge, and allow it to dry.

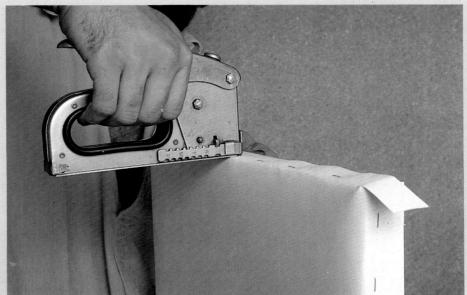

MIXING PAINT

WHEN MIXING WATERCOLOUR paint you have to aim not only at achieving the right colour, but also the correct consistency. The latter is all-important if you want to control the tones and colours, for this transparent medium is built up in several layers.

If you know you will be working in two or three tones of the same colour, it is often a good idea to mix these in advance. Whether you are using pans, cakes or tubes, the mixing is a matter of patient trial and error. You cannot tell by looking at the paint on the palette whether you have achieved the right consistency: the colour must be seen on paper. Therefore, when mixing, you should always have a piece of spare paper to hand for testing the colours.

With cakes or pans, moisten the paint and work the colour with a brush to release the pigment. Cakes are particularly dry and absorbent so this can take quite a long time. Then, transfer some of this colour to your palette, or mixing dish to be mixed with other colours according to your requirements. When using tubes, squeeze a small quantity of the paint directly onto the palette; then pick up a little of the colour on the brush, transfer this to the mixing dish, and gradually add the water, drop by drop. For very pale washes, you need only one or two spots of colour, diluted with a large amount of water.

Once you have achieved a particular colour, the only way you will be able to re-mix it is by trial and error; so, whenever possible, start by mixing the colour you will need.

Gouache

The consistency of gouache does not greatly affect the overall colour, which makes it easier to mix than watercolour. If you use a large amount of water with gouache, you can produce a wash-like effect, but this is never as transparent as pure watercolour.

When mixing gouache to a particular consistency, therefore, you are usually concerned not so much with time, but with how you will use the paint: for example, when masking, the paint should be fairly thick and creamy; while for spattering, it should be comparatively thin.

Gouache dries darker than it appears when it is wet. This means it is important to test the colour first on a piece of paper, allowing it to dry, before applying paint to the actual picture.

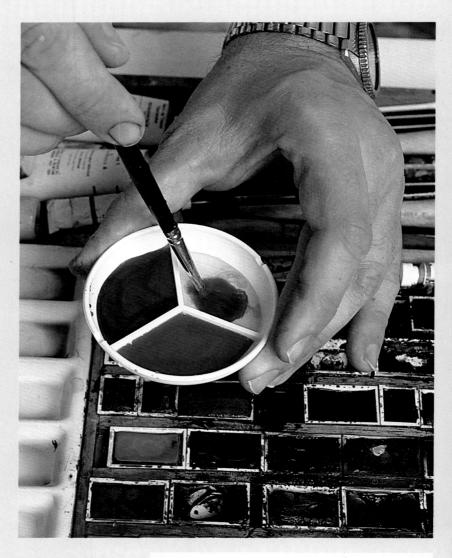

WATERCOLOUR

1. Using porcelain or enamel mixing dishes, mix the water and paint to the required strength. For small quantities of normal, or strong colour, start with the paint and add water drop by drop from the brush. For pale washes, you can add the paint to the water.

2. Mix enough of each colour to complete the task. If you run out of a particular mixed colour, you will find it difficult to re-mix the exact tone

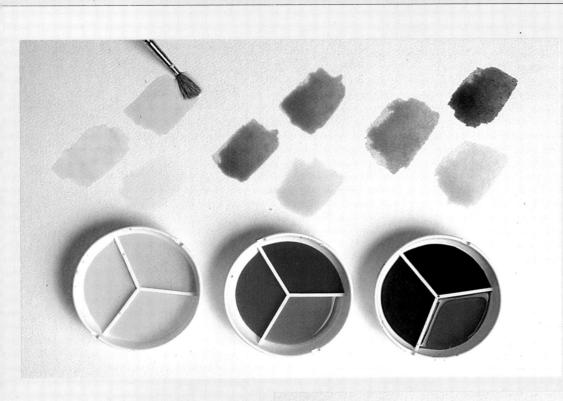

3. Test the colour on white paper to see if you have mixed the correct strength of hue.

GOUACHE

think will achieve a particular hue. Mix together a small quantity of each colour, and adjust the hue by adding more colour. Finally, add water until the paint reaches the required thickness.

2. Gouache, particularly mixed colours, usually dries darker than it appears when wet. It is essential therefore, to test each colour on white paper, and then allow it to dry before using it on the actual picture.

WET ON DRY

WET ON DRY is the expression used to describe the process of painting watercolour onto a dry surface. It is the main, classical method of using watercolours, and includes anything from broad washes applied with a large brush, to adding the tiniest detail. Darker and darker tones are built up by putting one thin layer of colour on top of another; each layer is allowed to dry before the next one is added.

Wet on dry washes can be applied as areas of flat colour, as illustrated; alternatively, they can be graded by diluting, or strengthening the paint to make the colour lighter or darker as you move down the paper. When painting broad washes, it is important to keep the colour moving, and not to let the paint dry between strokes, as this can cause streaks and tidemarks.

The wet on dry method is ideal for precise illustration work: the dry surface "holds" the paint, so that smaller shapes and specific details will not blob or distort. However, this method does not necessarily restrict you to painting shapes with hard, crisp edges: for example, if you are painting a rounded form, you could depict the tones in specific shapes, and then use water to blend them together. Neither does painting wet on dry prevent you from achieving hazy, or atmospheric effects; again, colours can be merged by applying water.

LAYING WET ON DRY

- 1. Slightly tilt the board. Then, load a wash brush with a diluted colour, and begin by painting a band across the top of the support. Work from side to side, spreading the colour evenly, and painting quickly to prevent the edge of the colour from drying.
- 2. When you reach the bottom of the support, set the board flat and allow the colour to dry.

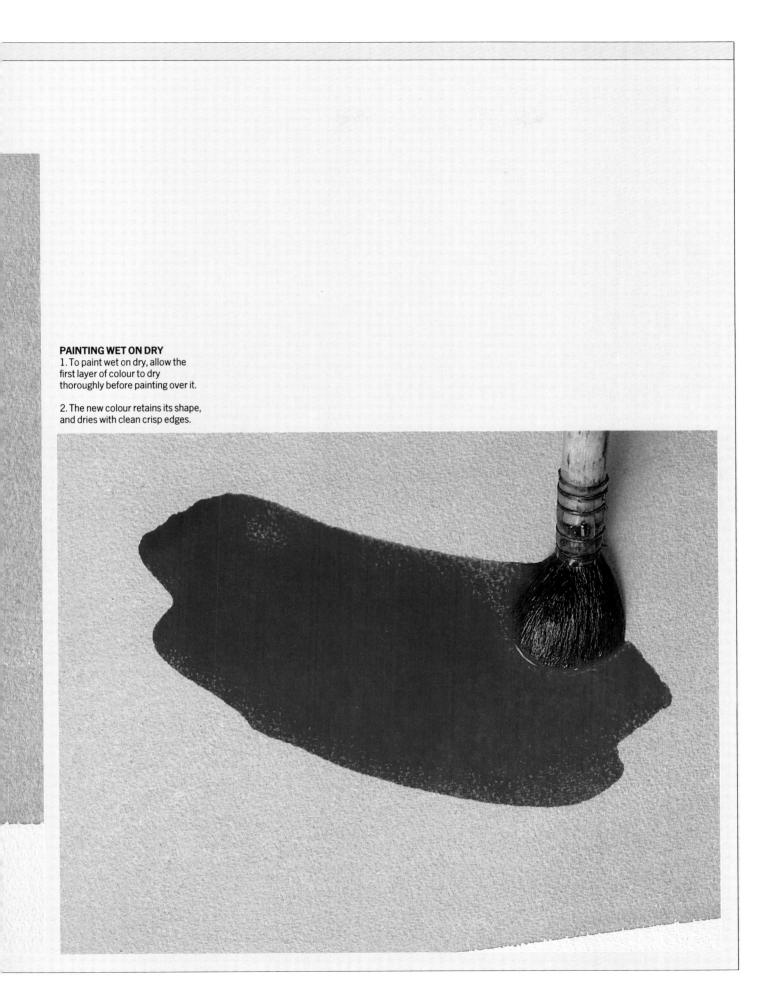

A SEASCAPE

THIS VIEW OF a dramatic outcrop of black and white stratified rocks jutting into the sea was painted with a series of "wet into dry" washes.

By allowing the paint to dry after each wash was applied, in typical "wet into dry" manner, the artist was able to lay the colour in clean, graphic shapes and to use the texture and character of the brushstrokes as a positive feature of the painting. (The strokes are held instantly by the dry surface, instead of blending and running together as they would on wet paper.) For instance, when painting the later stages of the water, he worked with an irregular flicking movement, using the strokes to capture the broken, undulating texture of the sea.

Working in the traditional watercolour method of building up colour, the artist applied layer after layer of consecutive thin washes to create increasingly darker tones, and used the lightness of the paper to represent white areas and highlights. The white base colour of the rocks is simply the white surface of the paper.

Without their seascape context, the rocks themselves would be less interesting. It is the watery void around them which gives the rocks their character, emphasizing the jagged outlines and angular contours. The artist has exploited this contrast in the textures of the rocks and water by deliberately placing the subject in an asymmetrical composition. Divided diagonally by the rocks themselves, the painting is split into two definite halves, the task of the top one being to draw the viewer's attention to the rocks.

WATERCOL	OUR PALETTE
Payne's Grey	Chinese White
Yellow Ochre	Alizarin Crimson
Ivory Black	Cadmium Orange
Raw Umber	
SUP	PPORT
Stretched c	artridge paper

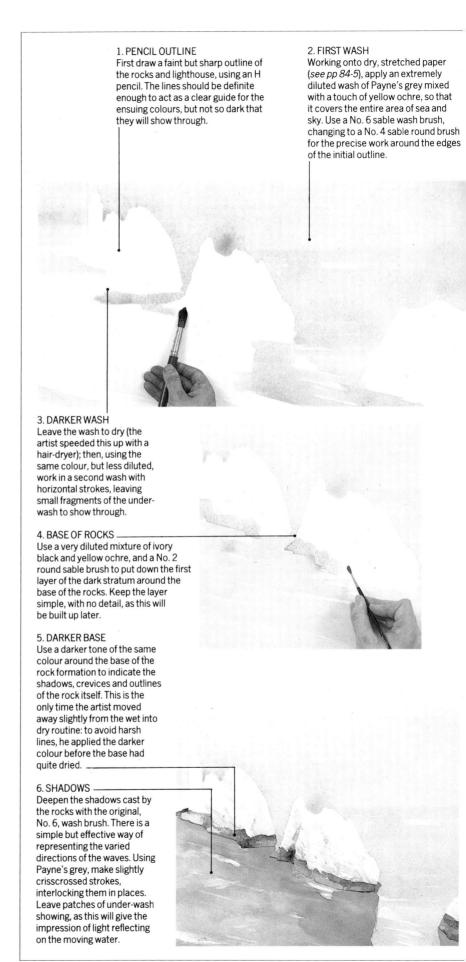

7. ROCK DETAILS
Use a No. 2 round sable brush
for this next stage. Squeeze
the moisture out of the brush
until it is almost dry to pick
up the colour; lightly drag the
Payne's grey and yellow ochre
sea-mixture across the surface
of the rocks, so that the
direction of the lines will
imitate the chipped, flint-like
strata.

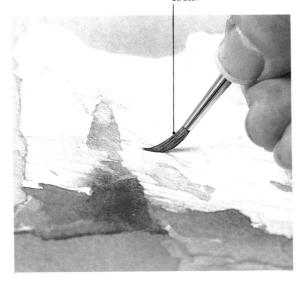

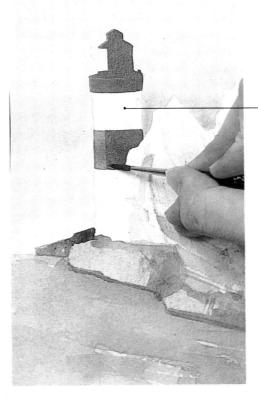

8. LIGHTHOUSE Use a mixture of alizarin crimson and cadmium orange for the red band and top of the lighthouse. First apply a flat, thinnish layer of the colour; then follow it with a deeper version of the same colour. Leave a small section of the first layer showing; the paler colour will indicate reflected light and show the rounded form of the building. Both these steps should be done with the smaller No. 2 brush, ensuring that this part of the picture - the focal point - is tight and precise compared with the wide, loose washes that surround it.

9. FINISHING TOUCHES
With part of the lighthouse now in shade, you can use a light wash to develop the form. Mix the shadow wash for the red areas from cadmium orange and black, and the wash for the white areas from raw umber and ivory black. Next, touch in the windows with ivory black. Tonal adjustments can be made by introducing a little Payne's grey and yellow ochre sea-colour into the dark base areas of the rocks.

You can now add the final touch. To portray the white foam in the water lapping around the rocks, use a No. 2 brush coated in Chinese white and roll the brush on the surface of the water. However, do not become too enthusiastic because, if the effect is overdone, the result will lose credibility.

WET ON WET

PAINTING WET ON WET is used less frequently than the more classical wet on dry approach. You paint onto a damp surface, applying the paint either to paper which has been moistened, or laying one colour on top of another which has not yet dried. It is the way in which some watercolour painters achieve a sense of spontaneity, for the results can never be exactly anticipated. The element of surprise is the reason why, after practice and experience, many painters find this method an exciting and challenging one.

A wet on wet wash involves dampening the paper with a large brush, or a sponge, and then applying colour in broad, horizontal strokes. It takes practice to do this successfully, as it is not always easy to achieve a flat colour.

When you paint a colour onto another wet colour, the two run into each other. This means you cannot work in the traditional light to dark manner because the colours do not remain separate. Caroline Bailey's work is a good example of the effects which can be achieved with this method. Her loosely painted flowers are the result of a very spontaneous, free approach (see b 73).

Working with wet on wet, you will never have complete control over the final effect. However, if you allow the under-layer of colour to dry partially before adding more colours, they will blend without running amok, and you will be able to plan the result to some extent.

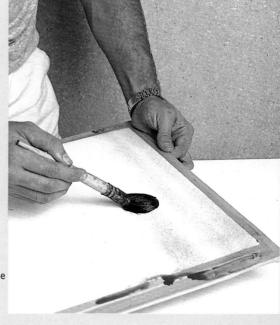

LAYING A WET ON WET WASH

1. Working on stretched paper, and using a natural sponge, wet the surface with clean water. Then, slightly tilt the board, and apply the colour in horizontal stripes from top to bottom.

2. This technique takes practice. There is less risk of tidemarks than when laying a wet on dry wash, but you will occasionally see tonal changes in the horizontal stripes.

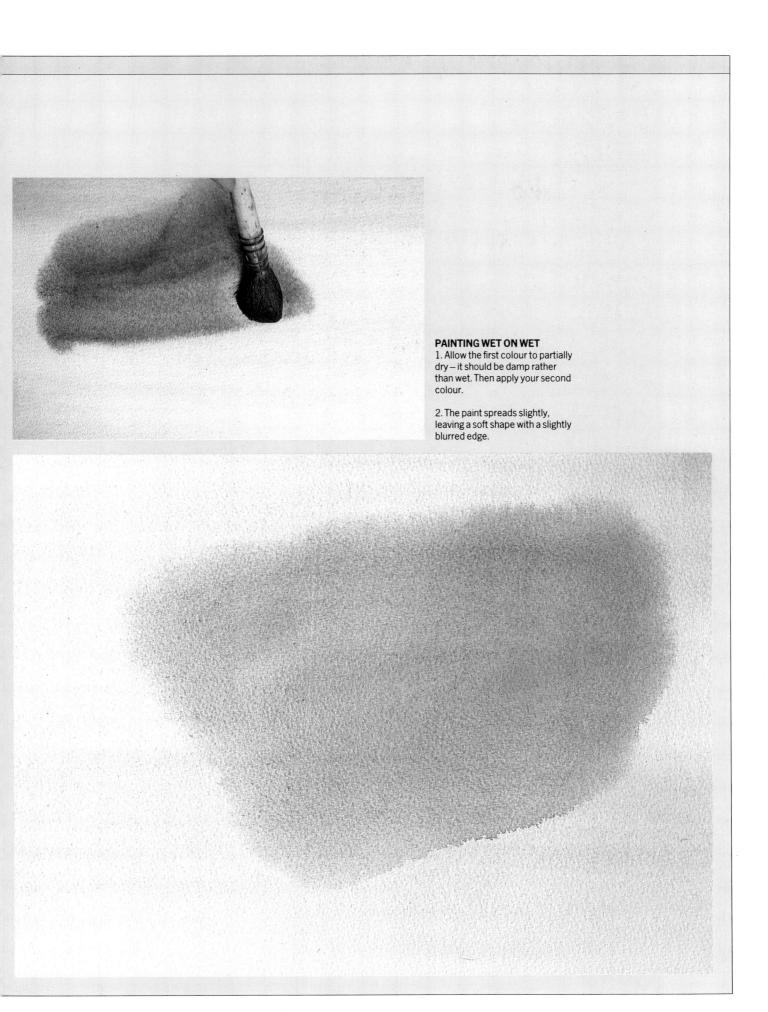

BASKET OF FRUIT

THE TECHNIQUE OF painting wet on wet has been used primarily to establish the main shapes of the image, and to help create colour harmony. The artist laid each colour without waiting for the previous one to dry, which meant that the paint ran, causing the colours to merge in a softly blended edge.

This method can be especially effective for still-life arrangements of fruit because the colours – typically reds, greens, yellows and oranges – are related. Each fruit has elements of all the other colours in it; thus, when they are painted, the red in the peppers can be allowed to blend into the green apples, the green pepper has patches of warm red in it, and so on. This rather loose, splashy beginning therefore acts as a unifying base for further development, as well as being ideal for blending colours on natural forms, and suggesting the rounded characteristics of the fruit. Nowhere are there any harsh divisions of tone or colour.

Wet on wet is not suited to tightly painted detail; however, the artist felt it was important to depict the wicker weave of the basket, as this would bring the whole subject into sharper focus, and help it to hold its own against the dramatic background tone. He therefore abandoned his wet on wet technique, to paint the dark wicker pattern onto dry colour, in crisp calligraphic brushmarks.

Cadmium Orange	Yellow Ochre
Raw Umber	Cadmium Green
Cadmium Red	Cadmium Yellow
Sap Green	Sepia
Lemon Yellow	Indigo
Black	
SUPF	PORT
Bockingford pa 660 × 457mm	aper, stretched n (26 × 18in)

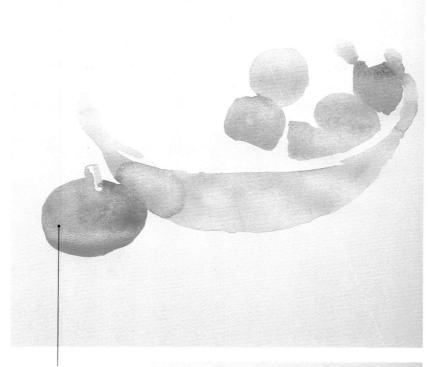

1. FIRST STAGE
Painting directly onto the paper, and without first making a pencil drawing of the subject, start immediately to block in the main areas of colour. Use a wash brush to paint the oranges and pumpkin in cadmium orange; the apple and pepper in cadmium green; and the basket in yellow ochre mixed with raw umber. Keep the colour fairly thin at this stage, so that you can add darker tones later.

2. MORE FRUIT _ Continue to block

Continue to block in the fruit and vegetables in flat shapes of thin wash. Work quickly, without waiting for the paint to dry between colours. Where it is desirable to keep the colours separate, leave an area of white space between the shapes: otherwise, allow the wet colours to run into each other. For example, the artist has allowed the greens, yellows and oranges to merge, and has incorporated these "accidental" effects. Add shadows to the basket and the table in a diluted mixture of sepia and black

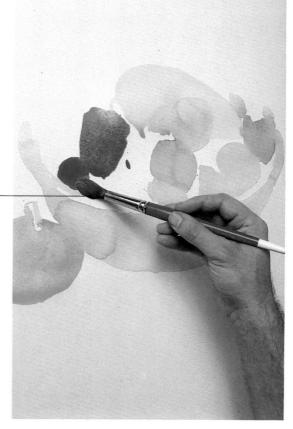

3. TWO-COLOUR SURFACES
Exploit the wet on wet method to
depict fruit and vegetables with two, or
more surface colours: the pepper, for
instance, is red and green; therefore,
the artist has painted cadmium red
onto wet sap green to achieve a
natural-looking effect.

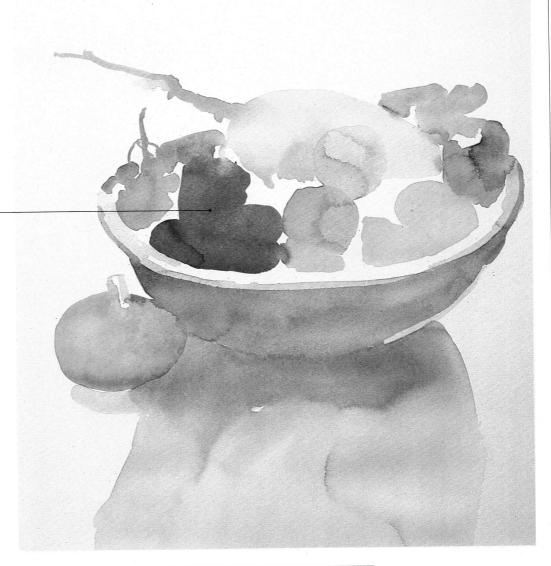

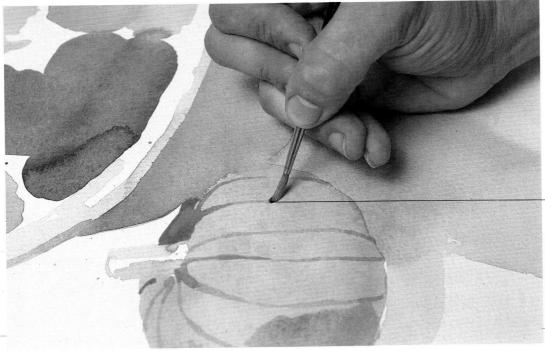

4. DETAILS
Change to a No. 2 brush when developing the details on the fruit and vegetables. You should aim, wherever possible, to describe the forms and surface textures: for example, the dark orange markings on the pumpkin help to depict its rounded form.

5. MORE DETAIL
Work into the grapes with sap
green; and develop the glossy
surface of the pepper with
more red and green, applied
wet on wet. Add darker tones
of cadmium orange to the
pumpkin, without flattening the
effect of the linear markings.

6. DARKER TONES
Work into the darker tones
of the subject and, by
strengthening the colours,
bring out the individual shapes
and characteristics of the
fruits and vegetables. Now,
darken the shadows on the
basket to match these newly
established, stronger colours
and tones. Paint the tabletop
with a pale sepia wash.

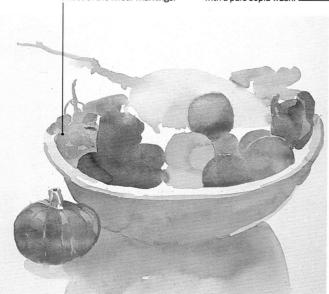

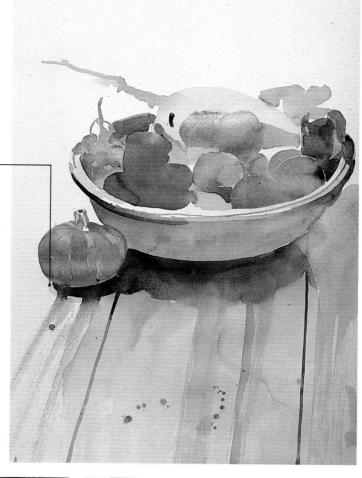

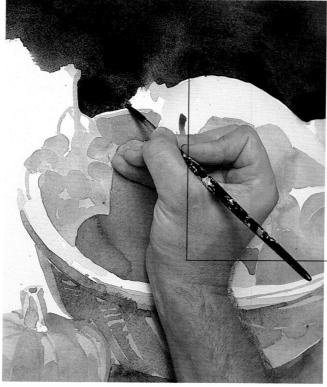

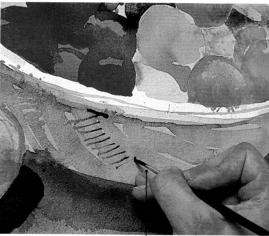

7. BACKGROUND
Block in the background with dark blue. The artist felt that the actual background was too close in tone and colour to the subject, so he chose a mixture of indigo and black, which emphasizes the contrasting colours of the fruit and vegetables. Allow the background to dry before going on to the next stage.

8. BASKET DETAIL
Develop the weave of the basket with black diagonal lines. This dark pattern gives the basket shape and emphasis; and because the black lines are the same strength of tone as the deep blue background, they help the surrounding tone, instead of being overwhelmed by it.

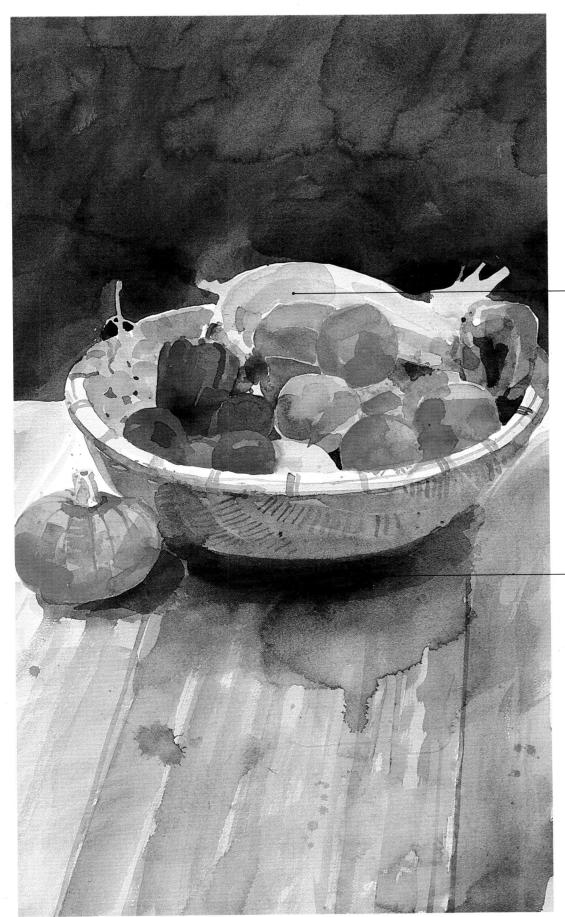

9. ADJUSTMENTS
Working with a wash brush, and using the broad, free approach of the early steps, make any necessary alterations to the colours and tones. Here, the artist took the opportunity to darken and redefine the pepper, apple and bananas.

10. FINISHING TOUCHES
Finally, the artist worked
across the picture, pinpointing
the deepest shadows with black
and indigo. By extending the
background colour into every
part of the image he brought
the separate elements
together, and integrated
the composition.

PEN AND WASH

YOU CAN COMBINE line with watercolour in a very fluid and sympathetic way by using the pen and wash technique – a traditional combination which has been employed for hundreds of years, and was especially popular with the English painters of the 18th century. The method is still a favourite, particularly with illustrators.

Pen and wash allows the artist either to draw the subject first and then add colours, or to block in the image with loose washes of colour, and then to define the image and add details with line. By using an old-fashioned dip pen, the artist can obtain a varied and fluid line, which is particularly in keeping with the watercolour medium. Many artists, including such masters as Thomas Rowlandson (see p 37) and Rubens (see pp 22-3), worked in this way. Black or sepia were the traditional colours for pen and wash, but modern painters and illustrators employ the full range of colours.

Waterproof, or water-soluble inks can be used, depending upon whether you wish to achieve a hard, or a blended line. You can also indicate tone with a pen, by hatching, or cross-hatching the shadows and dark areas with the nib, and using paint for the local colour, as shown here.

LINE ON DRY PAPER

1. Take a dip pen and start to build up the tone in patches of short parallel lines. The darker the tone you wish to achieve, the closer the lines should be, and the more you will need to overlay the shading.

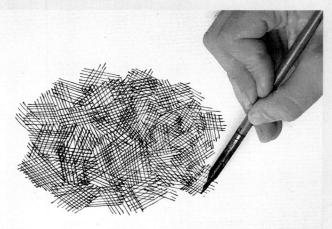

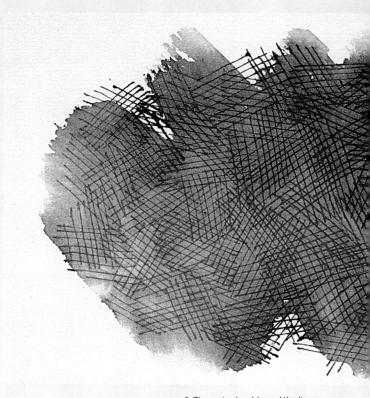

The water has blurred the lines, giving the impression of a watercolour wash.

2. With soluble ink, it is possible to apply clean water to the pen lines to achieve a combination of line and wash.

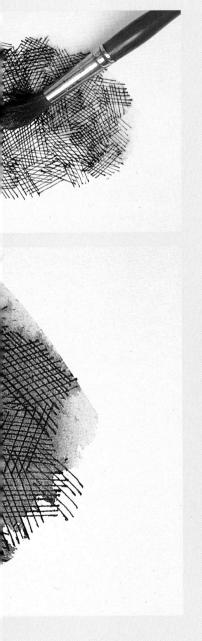

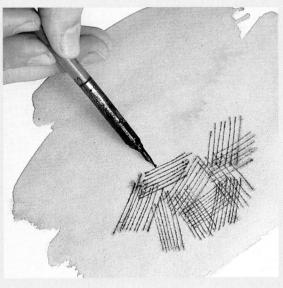

LINE ON WET COLOUR

1. Apply an area of colour and allow this to partially dry. Work onto the colour with dip pen and in!: the ink will bleed slightly into the damp colour.

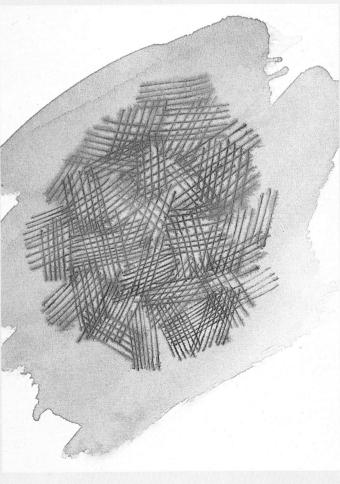

2. The overall effect is of a softened line, which merges slightly with the colour around it

POTTED CACTUS

AN OLD-FASHIONED dip pen has been used for this pen and wash picture in which line and tone play equally important roles. In order to suggest form and growth, the artist chose a dip pen rather than a modern technical pen with a rigid, tubular nib, which would have produced a reliable, but unvaried line; a dip pen draws lines that are broken and irregular, simply because it is necessary to keep stopping to dip the pen in the ink. And for the cactus, with its spiky shapes, this was ideal.

The artist has used both water-soluble and waterproof ink. Where he wanted to create tone with linear cross-hatching, and therefore to retain crisp lines, he used waterproof ink; elsewhere, such as the outlines of the leaves, the drawing was done with soluble ink which merged slightly into the subsequent colour, producing a more natural-looking, organic contour.

WATERCOLO	UR PALETTE
Concentrated w	atercolour inks
Moss Green	True Blue
Sepia	Crimson
SUPP	ORT
Daler Watero	ore ar weard
406×279 mm	$(16 \times 12in)$

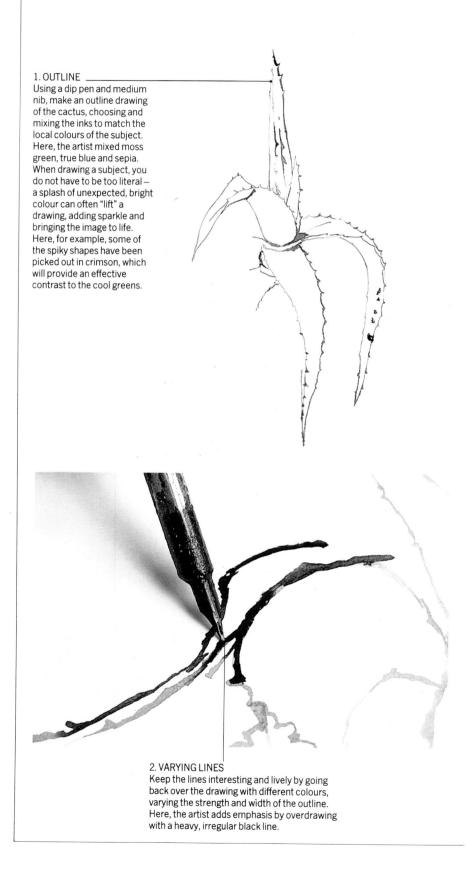

3. COLOUR AND TONE

When you have established the main elements of the composition, introduce general areas of colour and tone. This can be done with the pen, using hatching and cross-hatching or, alternatively, you can use a brush to wash on diluted colour: the lower leaves are hatched in regular lines of sepia and crimson; while shaded areas of the upper leaves are lightly washed in with green and a No. 4 sable brush.

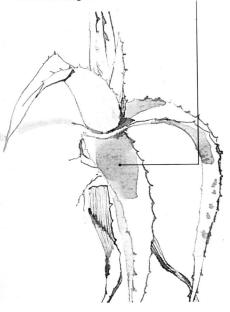

4. INCREASING COLOUR Build up the colour, working from light to dark.
Apply loose green washes to the leaves, using a slightly darker version of the initial colour.

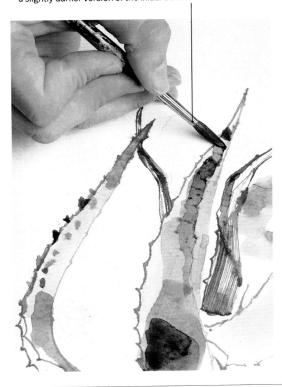

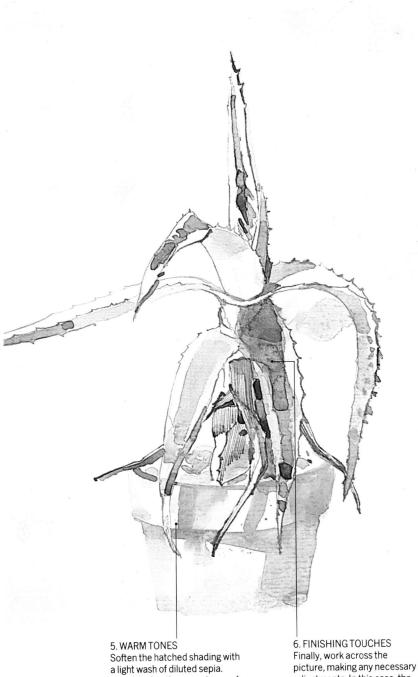

Now, block in the warm tones of

the plant pot. Mix diluted washes of crimson and sepia, applying the colour loosely and allowing the white paper to

represent the lighter tones.

adjustments. In this case, the

artist felt some of the initial cactus tones had lost impact

as the painting developed. These were, therefore, reinforced in stronger colours.

THE VILLAGE CHURCH

PEN AND WASH is a traditional medium, which has been employed by artists for centuries; the subject, too is very conventional. Yet there is no need to be tied to conservative methods and materials when working with pen and wash; instead the artist has made use of a variety of mediums to give a new, fresh touch to this painting of a village church. He has applied gouache, as well as watercolour to produce opaque, solid blocks of colour, which contrast with the translucent brilliance of the watercolour, and the spiky, linear structure of the ink drawing.

This mixture has worked especially well, because the painting has been done on tinted paper: the warm tones of the paper have been allowed to show through, thus bringing together what could otherwise have been unrelated colours and disparate elements, and uniting them in a harmonious composition. Colour has been used spontaneously rather than literally, and lively brushstrokes give a feeling of movement, particularly in the trees.

The colours are intuitive and personal: for instance, the bright red and yellow on the stonework exist in the imagination of the artist, not on the actual church. As your skills develop and your confidence builds up, you will find that experimenting in this way can often be both extremely effective, and rewarding.

OUR PALETTE
Sap Green
Payne's Grey
ACHE
White
K
le black ink
ORT
rtridge paper n (16 × 20in)
֡֜֜֜֜֜֜֜֜֜֜֜֜֜֜֜֜֜֜֜֜֜֜֜֜֜֜֜֜֜֜֜֜֜֜֜֜

1. PEN OUTLINE
Using a dip pen and
watersoluble black ink, start to
draw the church. It should be
placed fairly centrally on the
paper; you may find it helpful
to make a pencil outline first.

2. VARYING LINES
Try to vary the lines, by using the side of the nib to create a fine spidery effect, or by pressing harder to make a broad, bold mark. In this drawing, the artist uses fairly heavy lines for the outlines, and finer ones for the internal contours.

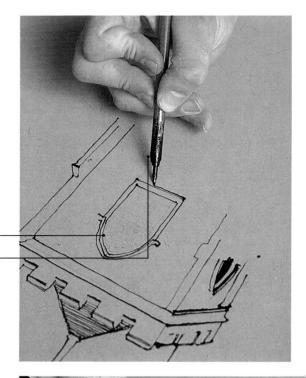

4. COLOUR .

alternatives.

Add bright splashes of colour to the building; later, these will be modified and blended into the painting, but at this stage keep the image lively by exaggerating the colour, and applying it in a spontaneous way. The artist chose lemon yellow and scarlet, but other bright colours could be equally as effective, and you should experiment to find your own

5. STONEWORK WASH
The shapes of the trees stand out in stark
contrast to the linear treatment of the church
behind: the result of a deliberate decision by

the artist to counteract the rather formal, architectural character of the subject. Wash in some of the stonework with diluted black and sepia.

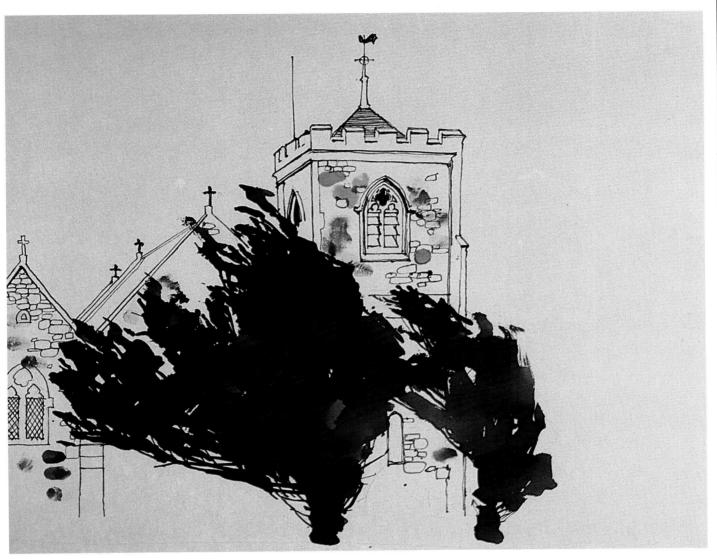

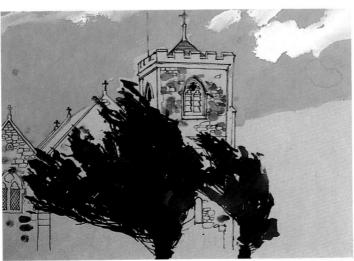

6. SKY
Block in the sky with cobalt blue
and white. The artist chose
gouache for its strength and
opacity, but you can use
watercolour if you prefer – this
will produce a more transparent
effect.

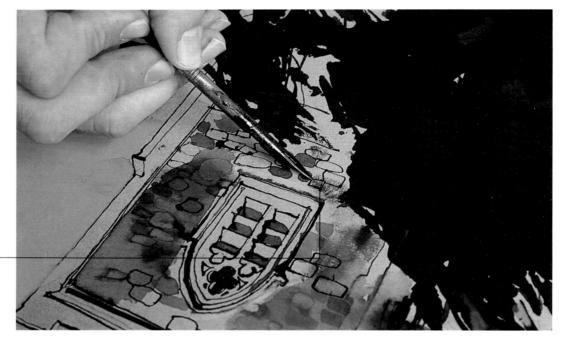

7. BLENDING COLOURS

Quickly wash a little clean water across the stonework on the church, blending the colours slightly, but taking care not to lose them completely. Redefine some of the individual stones, with pen lines.

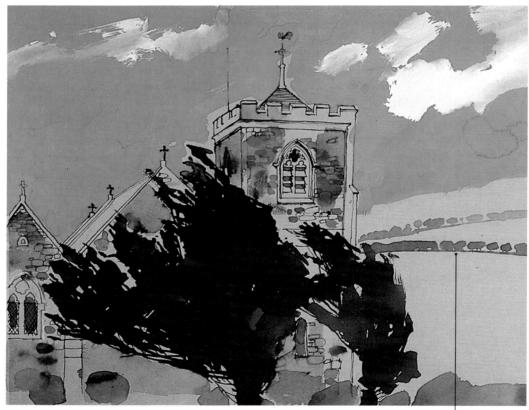

8. TREES

Paint the trees in sap green and
Payne's grey, making the farthest
row paler to indicate distance
(see pp134-5).

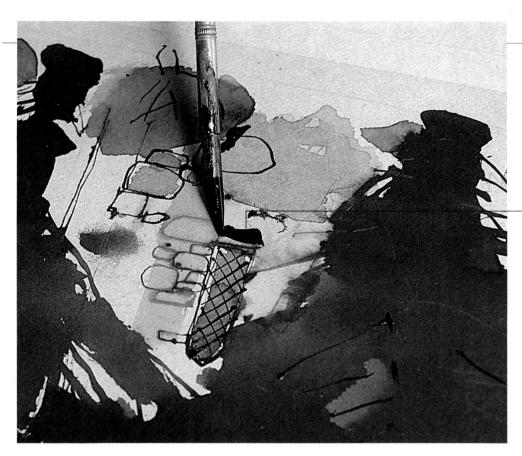

9. STRENGTHENING TONES Work across the painting, strengthening tones, and developing detail. Here, the artist uses bold black to emphasize the window recess.

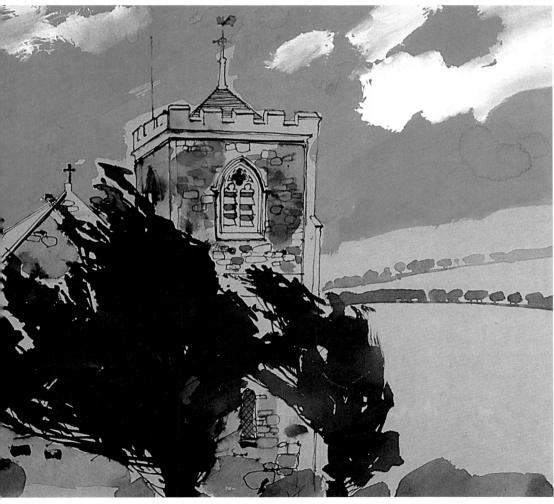

10. FINISHING TOUCHES
A variety of materials and marks bring a lively, graphic quality to the completed picture; while the warmly-toned paper holds the separate elements and unrelated colours together. Thus, despite a free and uninhibited approach, the image retains a strong sense of unity.

PERSPECTIVE

THE SUBJECT RARELY exists which does not contain some sort of perspective, but nevertheless it is not something which should become too obtrusive.

There are two types of perspective - linear and aerial. The former relies on the scientific fact that parallel lines on the same plane always meet at the same vanishing point. In other words, two parallel railway lines will appear to be converging as they recede towards the horizon. They may not actually "meet" before disappearing over the horizon (or out of the edge of the picture), but it seems inevitable that they must meet at some point - this spot is known as the vanishing point. In a drawing or painting, therefore, all parallel lines on the same plane, such as rail tracks or a row of houses, should look as if they will meet in this way. Initially, if you like, you can plot these lines with a ruler, although experienced artists often judge linear perspective by eye. Linear perspective, which is illustrated here, includes "one-point", "two-point" and on rare occasions "three-point" perspective.

If the linear perspective is incorrect, the painting will look odd. Yet it is a mistake to worry too much about this. If you are aware of the basic principles, the results will come in

time and with practice.

Aerial perspective arises when the intensity of colour and tone fades, or becomes diluted, with distance. "Aerial" literally means "air" the painter can represent distance by indicating layers of atmosphere between the eye and the distant objects. Hence ranges of hills become increasingly lighter and bluer as they recede.

LINEAR PERSPECTIVE

The illustrations show how parallel lines on the same plane appear to converge at the same vanishing point. In one-point perspective there is only one visible receding plane and the lines meet at one point. With two-point and three-point perspective, the visible receding planes produce two and three vanishing points respectively.

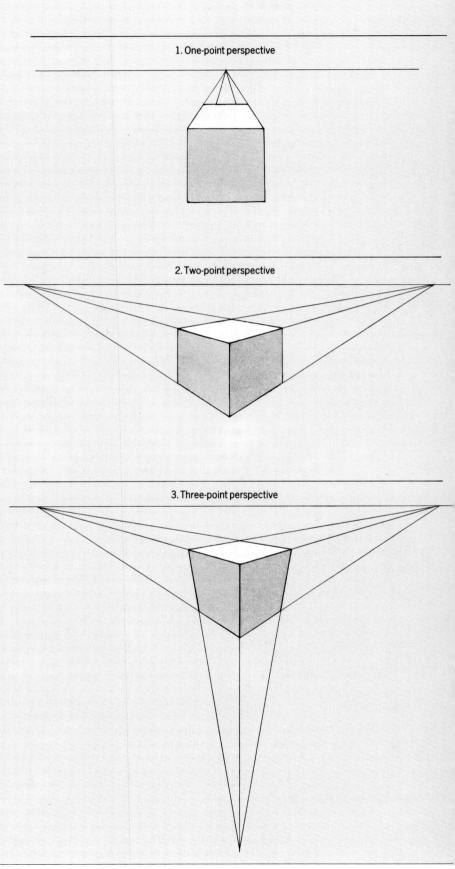

VANISHING POINT

The square bases of the three decorative urns in this picture are evenly positioned and are at right angles to each other; the edge of the lawn to the left hand side of the painting is parallel to the line of the bases. Thus the rule of linear perspective, that parallel lines on the same plane — the plane here is represented by the ground — meet at the same vanishing point, applies in the case of this composition.

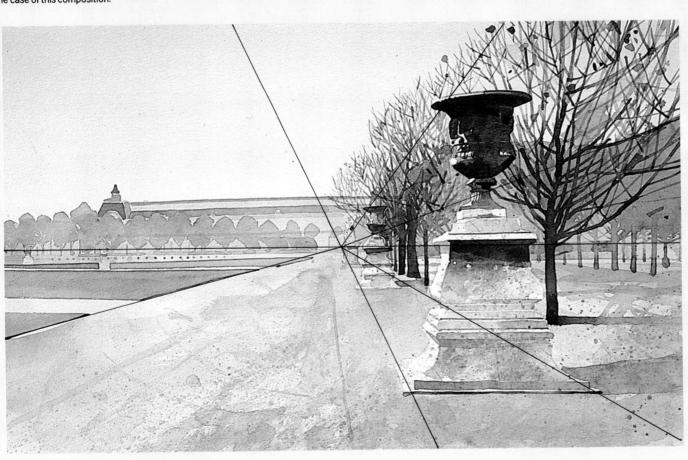

THETUILERIES, PARIS

IN THIS SPACIOUS study, the artist has made use of linear and aerial perspective to create a sense of space and distance. The eye is arrested immediately by the three stone urns standing in a stately row, which take the viewer right to the back of the composition.

The square bases of the urns have the same vanishing point – and here a word of warning is necessary. If you are going to make use of something as obvious and stark as this to give your composition perspective, then you must make absolutely sure you render it correctly. If not, the result shows up as a glaring mistake, so the time spent plotting out the vanishing point and receding lines is well invested. If you cannot do this by eye, it is a good idea to construct it formally with a ruler.

Aerial perspective reinforces the sense of distance. The colours and tones, and therefore the shapes, of the objects in the distance are much fainter and fade into a similarity of tone—all of which creates atmosphere. As well as having its strict vanishing point, the row of urns is also given this aerial perspective. The distant urns become lighter and less defined.

The stone urn in the foreground, however, really jumps out at the viewer, adding to the illusion of distance existing behind it. The artist has deliberately ignored the local colour to concentrate on the contrast between the light and dark of the carved stonework. The urn has a "printed" quality of white and dark grey, with almost no tones in between — although some sense of tone has been suggested in places by using dark colour on a drybrush.

WATERCOLOU	JR PALETTE
Cobalt Blue	Sepia
Brown Madder Alizarin	Ivory Black
Payne's Grey	Sap Green
Yellow Ochre	Lemon Yellow
SUPPC	PRT
Bockingford pap	er, stretched

 356×508 mm (14 × 20in)

1. THE PRELIMINARIES
Make a drawing of the scene,
paying particular attention to
the perspective of the row of
urns – make sure the vanishing
point for all three is in the
same place. When you are
satisfied with the drawing, paint

diluted cobalt blue across the sky area with a wash brush. When this is dry, use a smaller brush to block in the lightest tone on the distant building in sepia and brown madder alizarin. Extend this colour into the foreground. Leave to dry.

2. WORKING ON THE PALACE it helps if you use just two basic tones for the main part of the building—the first light wash, and a second deeper tone of sepia, brown madder and a little black. Use the second colour for the darker architectural details and the row of trees. Then paint the roof with the same mixture, adding some Payne's grey.

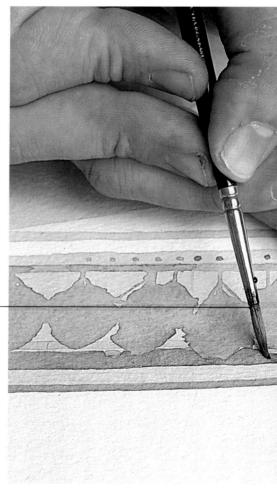

3. DISTANCE AND SPACE So far, the tones are very pale. In line with the principles of aerial perspective, this is to emphasize distance and space. For the same reason, no clear details are depicted on the far-away objects.

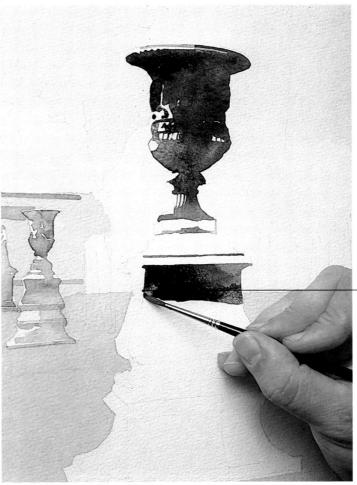

4. URN SHADOWS
Mix some of the warm tones
used so far with more Payne's
grey, and use this to pick out
the shadows on the two distant
urns. Leave the highlights as
crisp white shapes. Then, with
a darker mixture of the same
colour, paint the shadows of
the foreground urn. Again,
allow the paper to represent
the highlights, but now pick
out more of the detail of the
carved stonework.

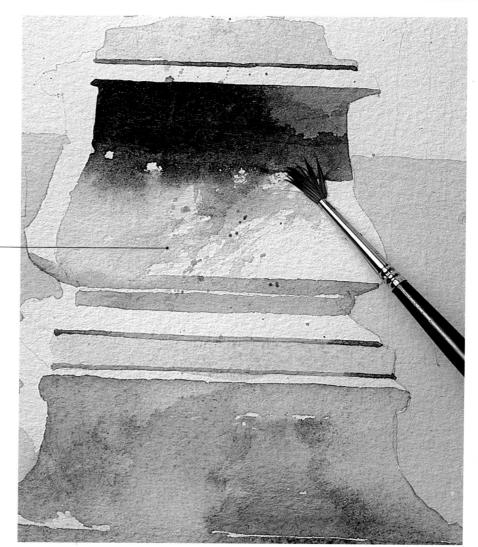

5. DRYBRUSH
Use the drybrush technique to create the pitted, textural surface of the stonework. Do this by squeezing excess moisture from the brush, dipping the ends of the almost-dry bristles in the paint and "scrubbing" the colour onto the paper.

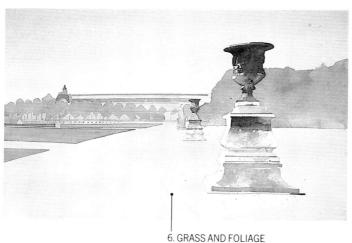

Paint the grass with a mixture of sap green, yellow ochre and lemon yellow. Then, with a very diluted version of the

colour used earlier for the urns, block in the foliage behind them to provide a solid background for the trees. Leave to dry.

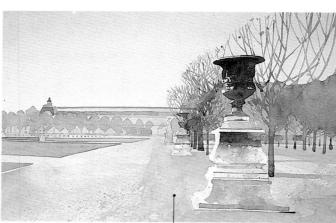

7. GROUND AND TREES
Develop the shadows on the ground, __using loosely applied wash and some drybrush to create the gritty, textural surface. Then, with a diluted mixture of Payne's grey and a little yellow ochre, work with a fine brush to "draw in" the first tone of the bare trees.

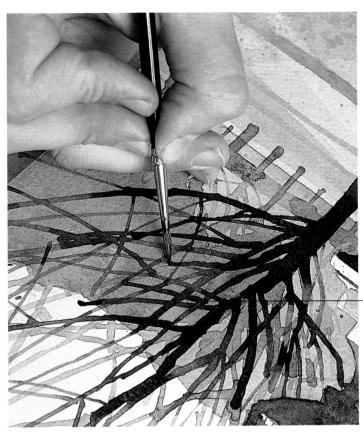

8. PERSPECTIVE
With a deeper version of the
Payne's grey and yellow ochre
mixture, paint over the
foreground tree shapes.
By developing and darkening
the objects in the foreground,
you are again greating aerial
perspective and space in your
painting.

9. FINISHING TOUCHES
Complete the picture by
working across the image,
carefully bringing up the tones
to match the new dark shapes
of the trees. You may want to
darken the tones of the urns,
for instance, as this will
emphasize the contrast
between the light and dark
areas, as well as slightly
darkening the shadows.

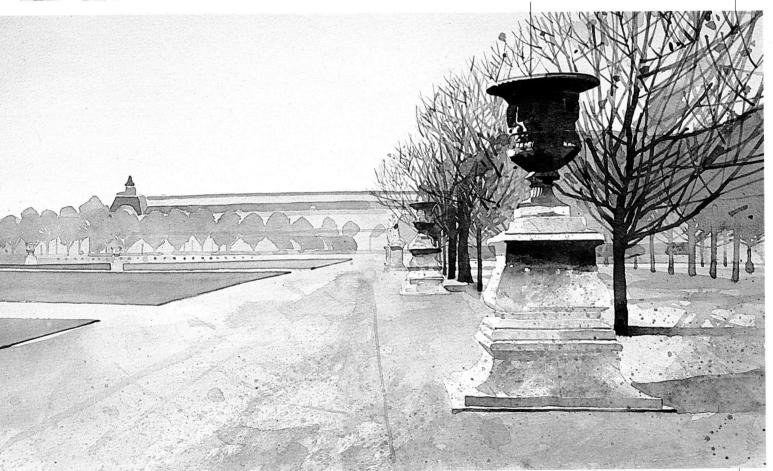

RECEDING HILLS

THIS QUICK WATERCOLOUR sketch of green fields and rolling hills that fade stage by stage into the distance, is a perfect example of aerial, or atmospheric perspective. The artist has used two basic principles.

First, he has created distance by making the hills bluer and lighter as they recede. The shading depicts the varying amount of atmosphere between the viewer and the hills – the hazier and bluer the scenery, the farther away it seems – and this automatically creates a sense of distance. On the other hand, the use of specific local colour can make scenery appear closer. Hence, the bright green fields are obviously in front of the blue background hills.

The second technique used by the artist involves another basic principle of colour theory: cool colours tend to recede, and warm colours tend to come forward. This picture is worked in shades of basic green, which is commonly thought to be a cold colour; but this particular green, mixed from sap green and yellows, is warm compared with the cold blue used for the distant features.

When you are building up ranges of distant hills in this way, it is important to allow each layer to dry completely before painting the next one. If you do not, one range of hills will merge into the next, which tends to pull them onto the same plane, instead of establishing a sense of space between them.

WATERCOLO	OUR PALETTE
Payne's Grey	Cobalt Blue
Sap Green	Lemon Yellow
Yellow Ochre	Sepia
SUPI	PORT
Bockingford p 508 × 356mr	aper, stretched n (20 × 14in)

1. FARTHEST HILLS
Mix a very diluted wash of
Payne's grey and cobalt blue
and, using a large wash brush,
paint the farthest range of hills
as a broad stripe of colour.
This wash is the palest tone in
the composition, so it is
important to get it right; if the
first tone is too deep, the whole
painting will be too dark.

2. SECOND RANGE
Allow the first colour to dry
completely. Now, taking a
deeper version of the Payne's
grey and cobalt blue mix, paint
in the second range of hills:
those immediately in front of
the ones you have just
painted. Allow the paint to dry.

The upper outlines of the hills should be crisp and natural looking. This is easier to achieve if you paint the horizon lines in one stroke, resisting the temptation to go back and re-work them.

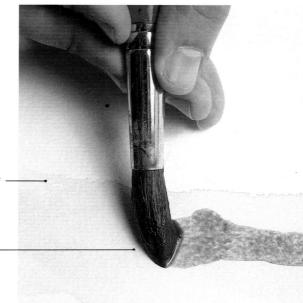

3. THIRD RANGE
For the next range of hills, add
a little sap green to the basic
mixture. Apply this with the
wash brush, following the
contours of the hill. Allow one
or two narrow patches of the
lighter undercolour to show
through to represent sunlight.
Let the paint dry completely.

4. MIDDLE DISTANCE
Introduce more local colour into the fields in the middle distance. Use sap green and lemon yellow for the darker green; yellow ochre and lemon yellow for the lighter one. Do not worry if the tone of the fields appears lighter than that of the distant hills; the brighter, warmer colours create an illusion of nearness.

5. FIELDS

Develop the pattern of the fields, using Payne's grey with sap green to dab in the shapes of the trees and hedges with a No. 7 round sable brush. Avoid painting sharp detail, as this contradicts the illusion of distance and tends to bring the subject into the foreground. Instead, use the shape of the brushmarks to give a general impression of foliage and trees.

6. FOREGROUND With loose brushstrokes, lay in the foreground with a mixture of Payne's grey, sap green and sepia (sepia makes the colour warmer).

7. FINISHING TOUCHES Suggest foliage, twigs and texture by flicking shapes across the damp foreground colours. This slightly

defined detail causes the foreground to "jump" forward, thus establishing a sense of space between the distant hills and the foreground area.

LIGHT TO DARK

PAINTING FROM light to dark is the classical watercolour method: the artist starts with a white sheet of paper and then applies light tones; onto these light washes, progressively darker tones are built up in various areas; the final touches are often very dark areas of shadow and detail. However, in watercolour, the highlights – the touches of light that convey the illusion of body and form – are represented, not by dabs of white paint as in oils, but by patches of the white paper, or the light initial tone, which have been left untouched, so that they show through the colour.

If you wish to build up tones in this structured way, it is essential to allow each layer of paint to dry before applying the next. If you do not, the colours will simply mix, producing a flat pattern instead of an illusion of form.

When faced with what looks like a complicated subject – one with an infinite number of colours and tones – it is a good idea to simplify it. The project "Blue Irises" (see pp 146-9), demonstrates the way in which this can be done. The artist has simplified the main colours, the blue of the flowers and green of the foliage, into light-to-dark layers: three tones of each colour, light, medium and dark.

CREATING FORM

This cylinder has been built up by painting from light to dark. Start with a light wash. Then, paint another wash over it, leaving an area of the light wash untouched to indicate the top of the cylinder. For the curved surface, divide the cylinder into vertical planes, and apply a darker wash, leaving the first plane untouched. Repeat this process, until the entire curve is described by tones.

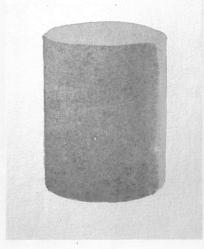

BUILDING UP TONE

With pure watercolour, it is necessary to work from light to dark, in order to build up tone. In each of the crosses, the colour beneath shows through the top colour, although the extent of this effect depends on the strength of the wash, and the pigment used.

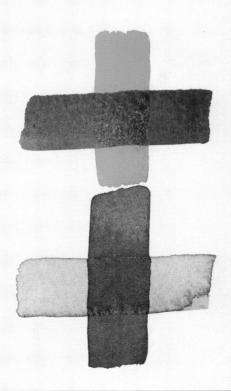

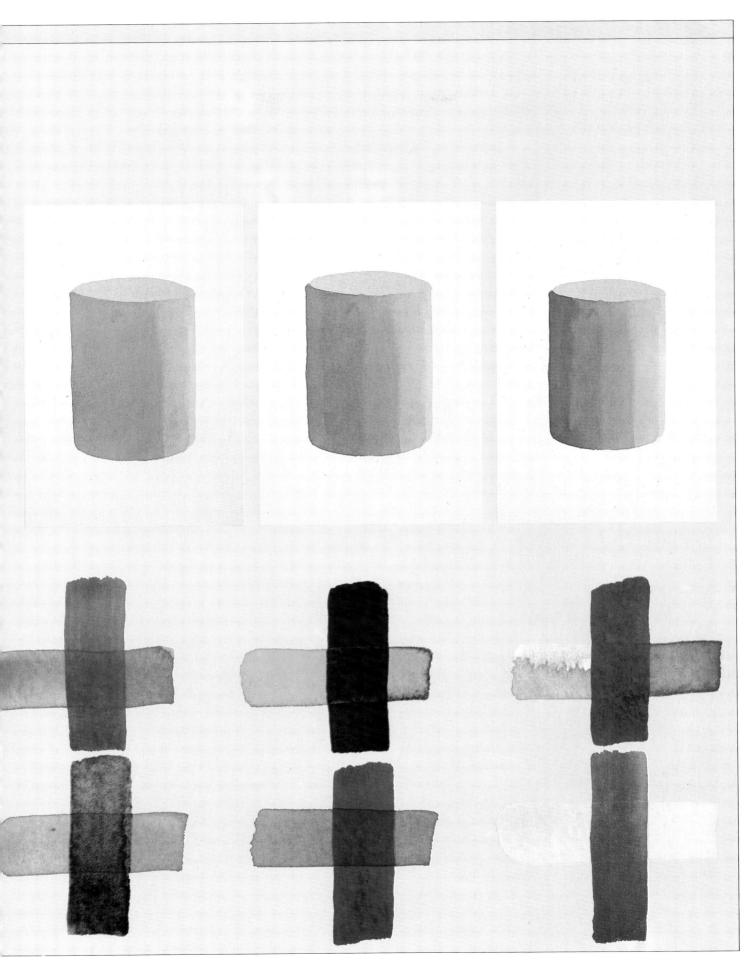

ANEMONES IN A WINDOW

Anemones are naturally bright colour flowers, but, because these stand in front of a window, they are thrown almost into silhouette. As a result, the colours are subdued, and both the flowers and the white jug are darker that they would otherwise appear.

Flowers, because of their detail and subtlety of colour and structure, are notoriously daunting as a subject for beginners. However, in this project the problem has been substantially simplified: the petals are established in two tones of the same colour – a light underpainting and a darker version of the same colour to depict simplified shadows. The basic technique is still the classic one of light to dark, even though the colour range is simple, and the tones are restricted and relatively dark.

The foliage is actually painted in one colour, as flat shapes; but because the lines are fluid and the shapes of the leaves have been faithfully observed, the artist has come close to creating an illusion of real foliage. This effect is enhanced by the fact that where the leaves overlap the colour has flooded, creating barely perceptible areas of light and dark.

The artist decided to leave out the background of treetops, because he thought it would detract from the simple effectiveness of the sharply defined flowers and leaves. A few strokes of blue wash were all that was needed to suggest the sky beyond the window, and establish a sense of a larger world outside the room.

WATERCOLO	UR PALETTE
Alizarin Crimson	Ivory Black
Brown Madder	Violet Alizarin
Ultramarine Blue	Payne's Grey
Sap Green	Yellow Ochre
SUPP	ORT
Saunders pap	er, stretched
737×508 mm	$(29 \times 20in)$

1. FIRST STAGE

Working on stretched paper, make a fairly detailed outline of the subject with an HB pencil. Concentrate on the main shapes and on positioning the subject, rather than on detail. Block in the

shapes of the flower heads, using a diluted mixture of alizarin crimson and brown madder for the pink anemones, and adding a little ultramarine for the blue flowers

2. FOLIAGE

Paint the stems and leaves in a fairly flat mixture of sap green and black, with the tip of a No. 2 sable brush. Work quickly to keep the lines free and fluid. You will find this much easier if you hold the brush in a relaxed manner.

3. FLOWER DETAILS
When the first wash is dry,
paint in the black anemone
centres. Work into the flowers,
painting in the petal shadows —
sap green and violet alizarin on
the blue flowers; sap green and
alizarin crimson on the pink. ___

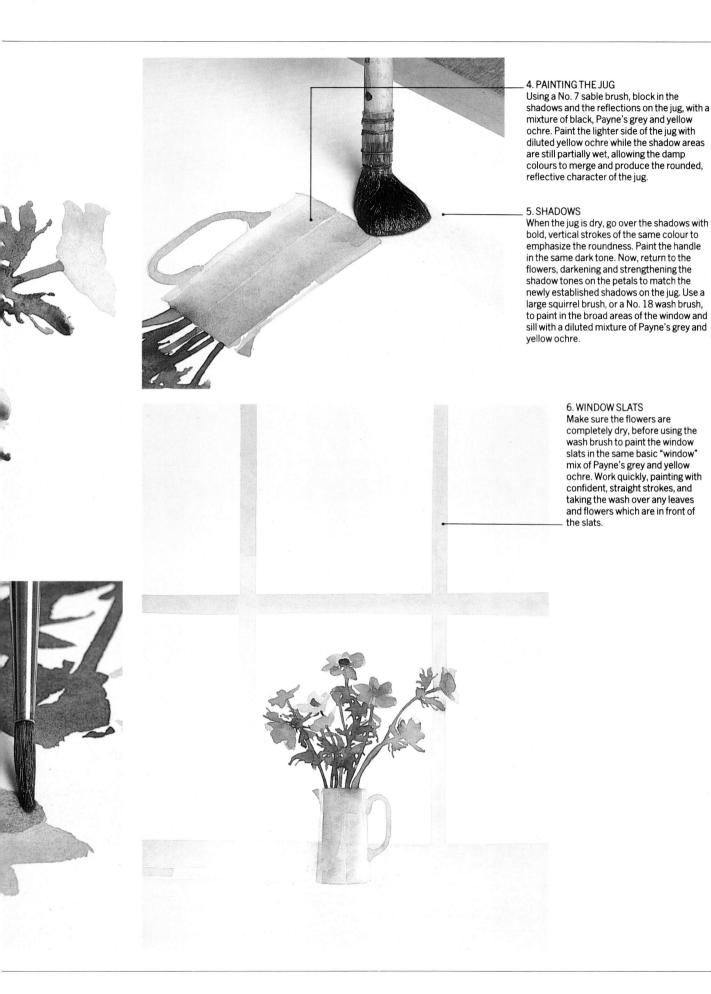

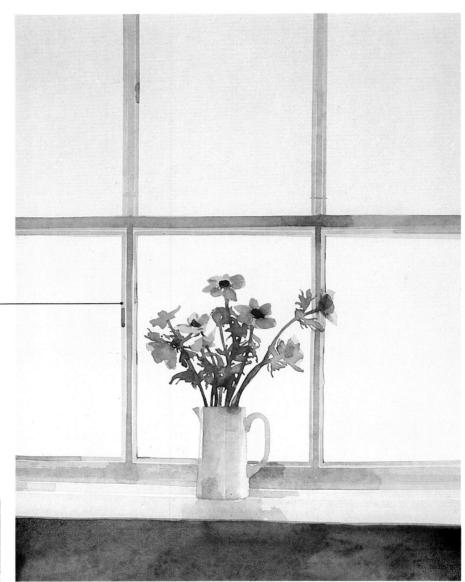

7. THE FRAME.

the same colour.

When the colour on the windows is completely dry, use a ruler to paint the mouldings on the frame in a darker

mixture of Payne's grey and yellow ochre. Block in the bottom ledge in

8. FINISHING THE JUG Darken and develop the tones on the jug. Leaving the white highlights intact, work yellow ochre and Payne's grey into the shadow areas to emphasize the jug's form and shiny surface.

9. DARK TONES -

Darken and strengthen the tones on the surrounding window frames to match those of the subject Use a deep version of the Payne's grey and yellow ochre mixture to emphasize the silhouette effect of the frame.

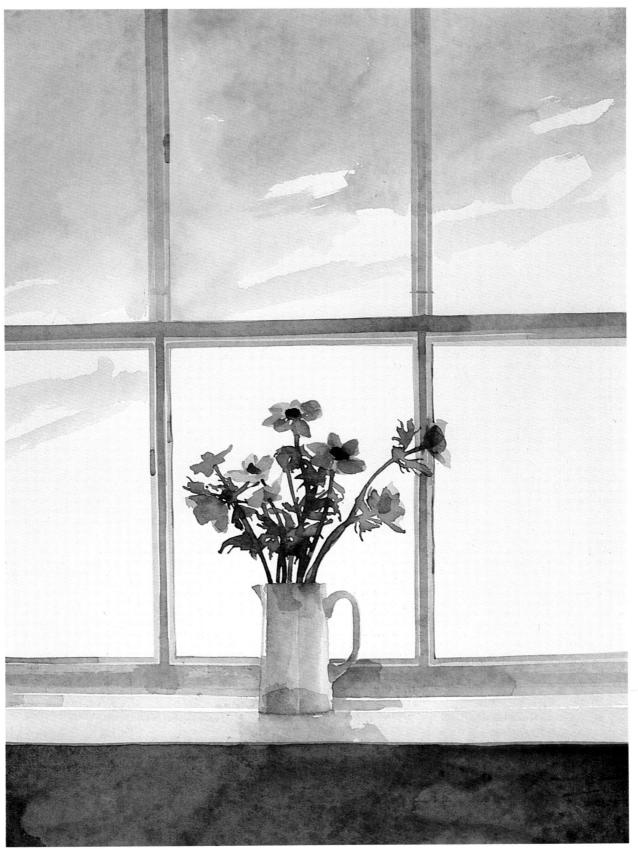

10. THE SKY Finally, wash in the sky with diluted cobalt blue, using a wash brush and plenty of clean water to spread the colour

across the top half of the window area. Take the colour over the window bars, but do this quickly so as not to disturb the underlying colour.

ALEXA

THE LITTLE GIRL'S impish smile, curly hair, and denim clothes are all captured in a portrait which follows the traditional classic water-colour technique: working from light to dark. In this case, the technique is particularly useful because the subject is bathed in golden sunlight and, by giving the whole figure a very pale yellow underpainting, the artist created a base on which to build up local colours and deeper tones. As the painting progressed this pale yellow was allowed to show through in places to represent the warm sunlit areas on the figure.

The portrait looks complicated and filled with lively detail, yet the artist has used a simple device to achieve this effect: each colour is reduced to three or four basic tones. The hair, for example, is painted in light brown, mid-brown and a blackish brown; while the face is depicted in a range of three or four tones of a basic flesh colour; and the denims are simplified in terms of light blue, medium blue and dark blue. This comparatively simple approach is so effective in creating a convincing and realistic image that the artist was able to keep the flat white background and still retain a feeling of solid form and surrounding space.

	OUR PALETTE
Cadmium Yellow	Brown Madder Alizarin
Raw Umber	Alizarin Crimson
Ivory Black	Ultramarine
Sepia	
SUI	PPORT
	paper, stretched

1. FIRST STAGE Make a drawing of the subject using a fairly hard pencil. The lines should be light, acting as an accurate, though minimal, guide for your watercolours. Mix a very light wash of cadmium yellow, and paint this over the whole subject with a No. 12 sable brush. Let the paint dry.

Paint the next lightest tone into the hair with a No. 4 sable brush. Treat the strands of hair as flat shapes, leaving the pale yellow highlight areas untouched. Allow this to dry, then work a slightly deeper version of the same colour into the darker, shaded areas. Again, allow the paint to dry.

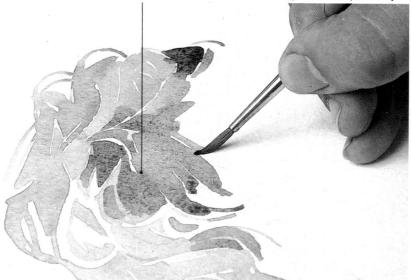

2. DARK TONES Mix black and sepia for the darkest hair tone. Look carefully at the effect of the sunlight falling on one side of the subject, and use this deep tone to pick out the resulting sharp shadows down the darkest side of the head.

3. FLESH TONES

When the hair is completely dry, paint the lightest shadow on the face in a diluted mixture of cadmium yellow, ivory black, sepia and brown madder. Soften the harsh outline of the fringe shadow with a clean brush and a little water, until it blends with the flesh tones.

4. SHADOWS

Paint the dark shadows on the neck and shoulder with a mixture of brown madder, raw umber and ivory black. Add a little gum water to the paint before applying it. The gum water does not affect the colour or texture of the watercolour, but it causes subsequent colours to "bleed" and blend into this initial layer of paint, thus avoiding hard, unnatural edges.

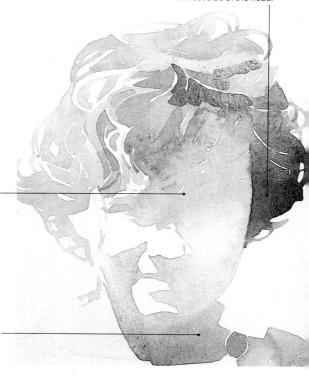

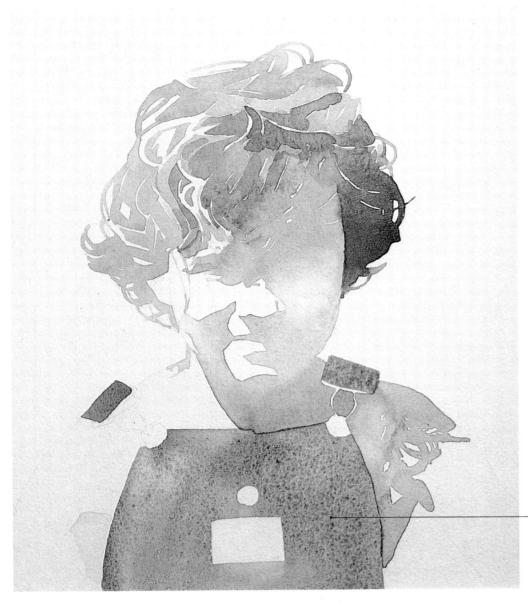

5. CLOTHING Progress to the girl's clothing, and block in the denim overalls with a diluted mixture of black and ultramarine blue. As before, paint the lightest area first, and then build up progressively darker shadows.

6. STRONGER TONES Once some of the basic tones have been established, you can work across the painting, sharpening and strengthening those areas which, in relation to the whole figure, now look too pale. Here, some of the hair shadows are being redefined.

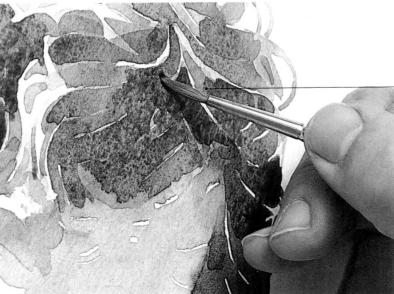

7. FINISHING THE HAIR -

Wait until the hair area is completely dry, then work into this with a darker mixture of black and sepia, carefully painting in the shapes of the shadows. By strengthening these shadow areas — the spaces between the strands of hair — the hair itself is brought into sharper focus.

8. FACIAL FEATURES

Start to add the darker facial features, and develop the deeper shadow tones with brown madder, black and ultramarine. The gum water in the first wash will affect the colours, causing them to run, and then merge into softly defined edges.

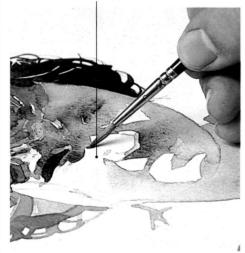

9. FINISHING THE CLOTHING
Work into the denim overalls with a
mixture of ultramarine and black,
using a No.2 brush and picking out the
main shadow areas. Paint the buttons
with diluted raw umber.

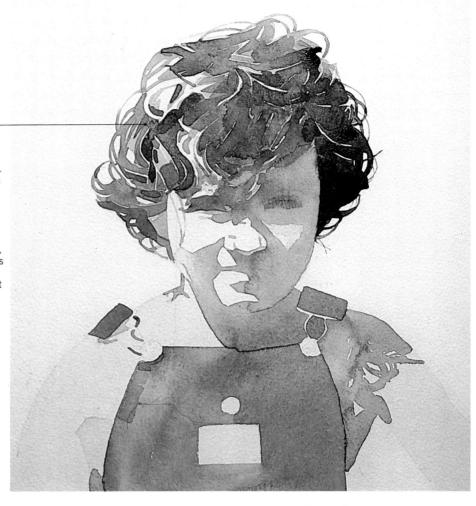

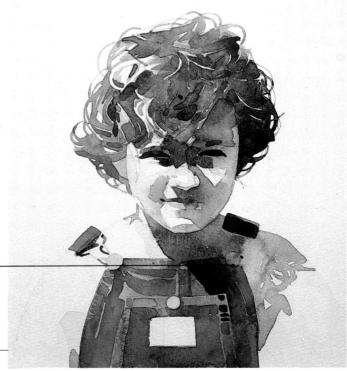

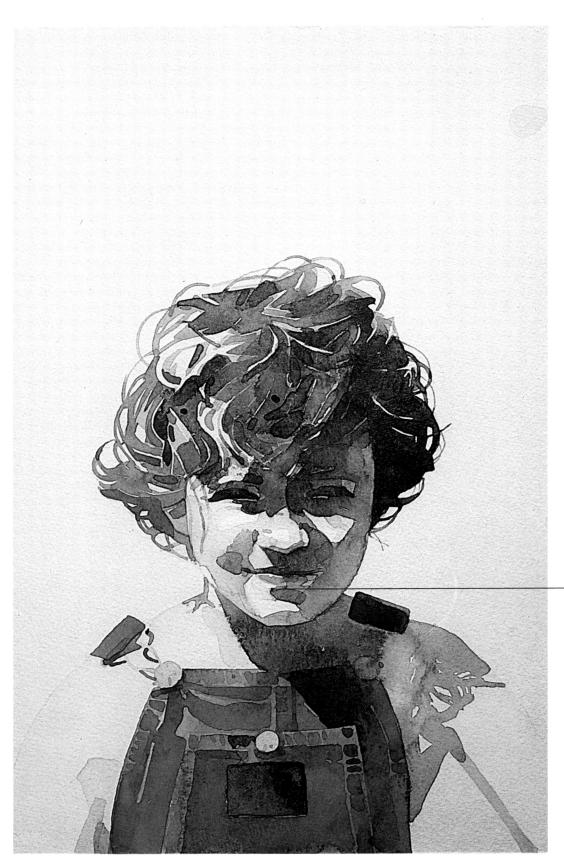

- 10. FINAL TOUCHES Add a few loosely painted shadows to the girl's face, defining and darkening the tones. Finally, paint the lips with a mixture of alizarin crimson and raw umber.

BLUE IRISES

THIS PAINTING IS a study in simplification: the artist has depicted the vase of flowers by picking out certain elements, instead of attempting to imitate every detail of the subject. This is a highly recommended process, both for those who want to paint purely as an exercise, and for those wishing to create a finished picture which concentrates on definite points. In this case, the points emphasized are the fresh, simple colours, and their interplay with light. The painting progresses in simple stages from light to dark. Other elements and detail have been ignored, but one aspect has been deliberately exaggerated - the elongated shadow of the flowers which plays a crucial role in the composition.

The leaves are reduced to three tones – light, medium and dark – as are the petals of the flowers. The simplification continues with the glass jar, where flat white areas have been allowed to show through to depict reflections. The artist has paid close attention to the subject, noting that the lines of the stems are broken visually by the distorting effect water has on light and colour. He has, therefore, carefully distorted the stems of the irises, as they enter the water.

A flat brown wash was all that was necessary to establish the tabletop. The background too is simplified to a thin wash, followed by a second layer of slightly darker, broken colour. Without this top layer of textured paint, the background would have been flat.

WATERCOLO	OUR PALETTE
Sap Green	Lemon Yellow
Yellow Ochre	Ultramarine Blue
Alizarin Crimson	Raw Umber
Payne's Grey	
SUPI	PORT
Stretched Boo	kingford paper

 508×356 mm (20 × 14in)

1 FIRST STAGE The delicate and specific shapes of the irises call for an accurate and careful approach. Start, therefore, by making a fine pencil drawing of the subject to act as a guide for the colour. Using a diluted wash of sap green, lemon yellow and yellow ochre, block in the entire foliage area with what will eventually be the lightest tone of the leaves. Allow this to dry 2. MEDIUM FOLIAGE TONES Look for the medium tones on the leaves - those areas which are neither deep shadow nor pale highlights - and block them in with a slightly darker

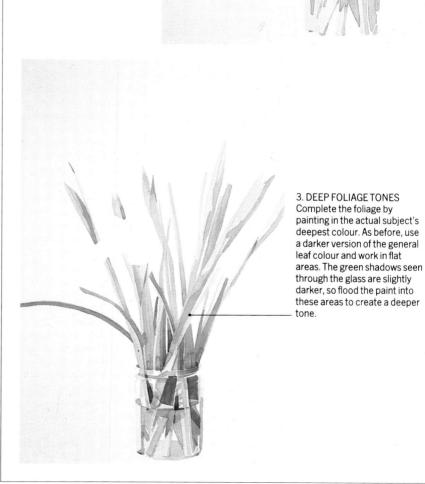

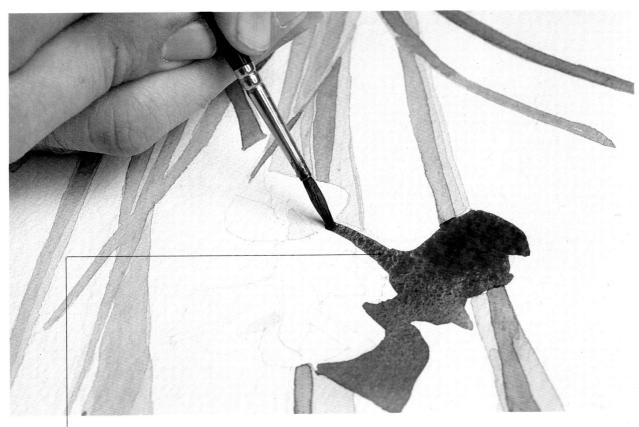

4. FLOWERS Treat the flowers in exactly the same way as the foliage, by separating and simplifying the various colours into three basic tones. For the lightest tone, paint an overall wash of ultramarine blue mixed with alizarin crimson, and allow this to dry.

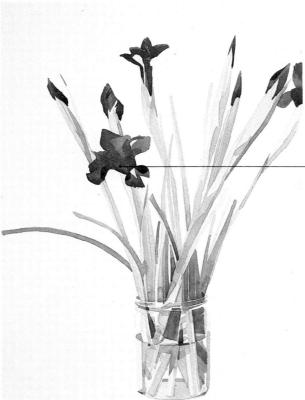

5. MEDIUM TONES
With a darker wash of the same colour, pick out the medium tones of the flowers. Paint the tiny yellow centres in yellow ochre and lemon yellow.

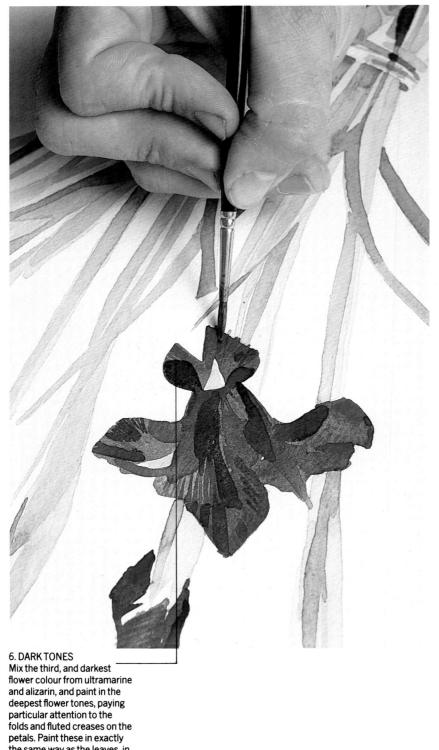

7. TABLETOP
Use a wash of raw umber, yellow ochre and alizarin crimson. Fill in the patches of tabletop visible behind the glass jar.

8. SHADOW
With raw umber and Payne's grey, paint the ____shadow thrown by the jar and flowers. Simplify the direction and shape of the shadow to create a strong, graphic effect.

the same way as the leaves, in delicate shapes of flat colour.

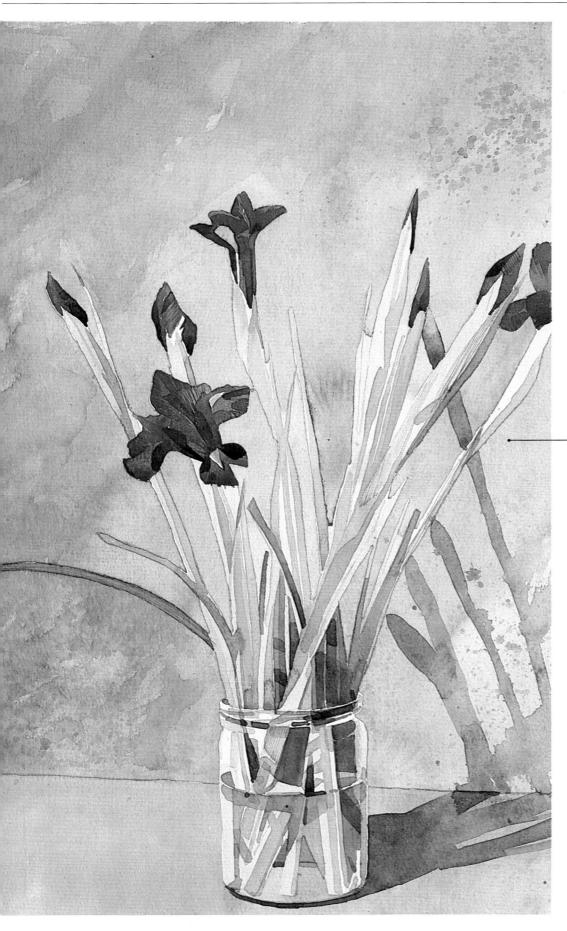

9. FINISHING TOUCHES
Finally, block in the
background wall with diluted
Payne's grey, applied with
loose textural brushstrokes.
Allow this paint to dry, then,
using a deeper version of the
same colour, extend the
shadow shape up the wall with
bold, angular brushstrokes.
The exaggerated shadows add
space and depth, and bring
the composition convincingly
to life.

MASKING

THE TECHNIQUE OF masking involves covering specific areas of the picture, so that they will be protected while the paint is being applied. When the mask is removed, the areas underneath will be untouched. This creative method of making shapes is popular with many artists and illustrators – not only can it be used to produce clear, graphic shapes that give a sense of design to a picture; it can also be employed to facilitate working from light to dark (see pp 136-7).

Certain methods of masking, such as using the edges of pieces of paper, stencilling, or employing masking tape, are better suited to gouache than to pure watercolour; for unless you use paint with a fairly thick consistency, the colours will seep under the masks. These methods are, in fact, more usually associated with oil and acrylic, but gouache, although water based, is often applied more thickly than classic watercolour.

Masking fluid is ideal, however, for both watercolour and gouache. It is a liquid, rubbery solution which can be used to paint out specific areas. When the fluid is dry, you can paint over it, and the rubbery mask will protect the paper underneath. Masking fluid is particularly useful for working in watercolour from light to dark; for instead of having to paint around each tiny, or delicate shape that you wish to highlight in white paper, or light tone, you can cover it with masking fluid. You can practise this technique in the next project "On the Verandah" (see pp 152-5), where tiny highlights will be needed to create the texture of the chairs.

COTTON WOOL MASKING

1. Place the blobs of cotton wool on those areas which are to be protected from the paint. Spatter colour over the surface of the support, (including the cotton wool) by dipping a small decorator's brush in paint and running your thumb over the end of the bristles.

2. Lift up, and remove the enterprotection wool being eartful to

Lift up, and remove the cotton wool, being careful to avoid smudging the edges of the covered areas.

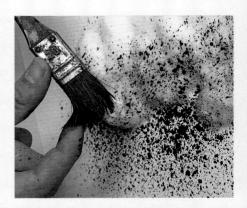

3. The result will be a clear, cutout area of white.

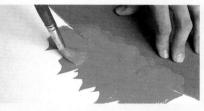

MASKING WITH TORN PAPER

1. This can only be done with fairly thick paint, so is best suited to gouache. Hold the torn paper mask in place, and apply the colour firmly over the edge of the mask.

2. Lift the paper, being careful not to smudge the paint.

3. A torn paper mask produces a characteristic rugged edge, which would be very difficult to achieve with a brush.

MASKING FLUID

1. Paint the masking fluid over the areas which are to be left white. When the fluid is dry, paint over it with watercolour, or gouache. Wait for the paint to dry.

2. Carefully remove the masking fluid by rubbing it with a clean finger, or an eraser.

MASKING TAPE

1. This technique is best suited to thick gouache. Press the tape firmly into position, and then take the colour over its edge.

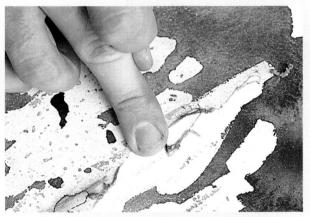

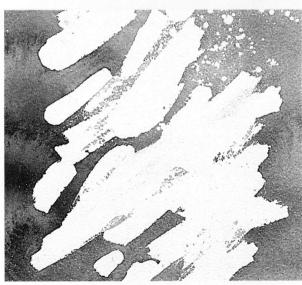

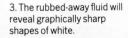

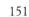

ON THE VERANDAH

MASKING FLUID has helped to transform this seemingly unlikely subject — two chairs on a verandah, in front of a pot of geraniums — into an arresting and unusual image. The fluid has enabled the artist to achieve a graphic painting, with sharply defined shapes and dramatic tonal contrasts. He painted the fluid onto the support before applying any paint, so that when the fluid was rubbed off, it would leave the tiny cutout shapes which so effectively represent the highlights on the woven chair seats.

With a simple subject like this, it is important to exploit to the full its inherent qualities — in this case the stark silhouettes, the texture of the chairs, and the sharply-defined negative shapes (the shapes of the spaces) contained within the chairs themselves. Therefore, instead of forcing the subject into a conventional composition, the artist opted for a symmetrical picture, by dividing the paper into equal halves: the composition is divided horizontally by the edge of the verandah, and vertically by the upright wooden post.

WATERCOLOUR PALETTE			
Cobalt Blue	Alizarin Crimson		
Payne's Grey	Sap Green		
Sepia	Ivory Black		
Cadmium Red	Brown Madder Alizarin		
SU	SUPPORT		
Stretched cartridge paper			
$356 \times 457r$	$356 \times 457 \text{mm} (14 \times 18 \text{in})$		

I. FIRST STAGE

Start by making a light line drawing of the subject. For this painting, the artist used an HB pencil, but you can use a softer one, providing the final lines are light enough not to show through the watercolour. Now, taking an old brush, paint masking fluid over those areas of the chairs which are to be left white.

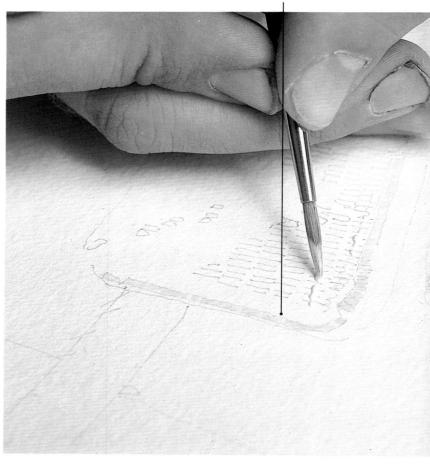

2. CHAIRS

When the masking fluid is dry, paint the chairs in a pale mixture of alizarin crimson, taking the colour over the masking fluid.

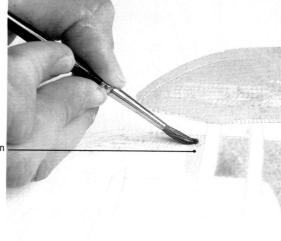

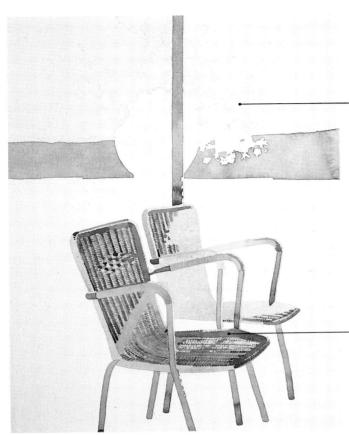

3. SKY AND HILLS
Use a large wash brush to block in the sky with a very diluted wash of cobalt blue, and the distant hills with a mixture of Payne's grey, sap green and cobalt blue. Change to a No. 2 sable brush to paint around the shape of the pot of flowers.

4. DEVELOPING THE DETAILS
Still working over the dried masking
fluid, paint a deeper, middle tone into
the chairs with a mixture of alizarin and
sepia. Paint the legs and arms of the
chairs in Payne's grey, as well as the
wooden post.

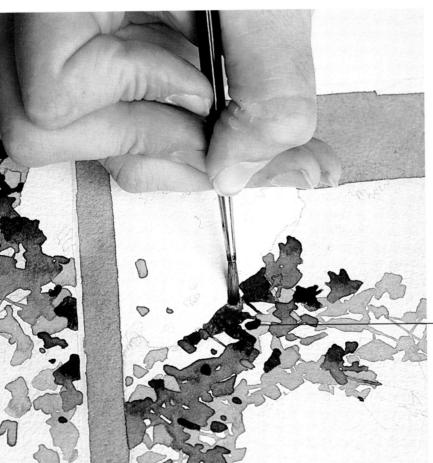

5. GERANIUM FOLIAGE
To paint the geranium leaves, simplify them into two tones of green. Start by establishing the entire foliage area with a very pale wash of sap green and Payne's grey. When this is dry, add more paint to the mixture and work the darker leaves in a stronger version of the same colour.

6. COMPLETING THE GERANIUMS Use two tones of Payne's grey for the plant pot, starting with an overall pale wash and, when this is dry, picking out the geranium shadows in a darker tone. Finally, mix cadmium red and brown madder alizarin, then delicately add flowers with a No. 2 sable brush.

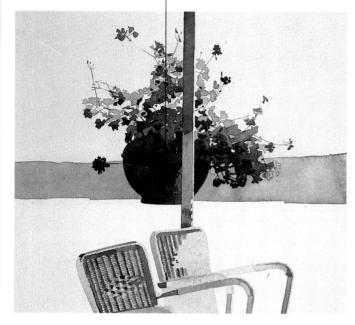

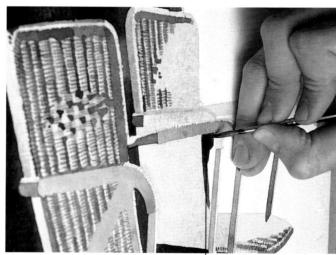

7. THE VERANDAH
Paint the background in ivory black
and sepia, using a No. 7 sable brush
for the large expanses, and a No. 2 for
taking the paint up to the outline of
the chairs. Leave a strip of paper
uncovered between the hills and the
verandah colour, as this will create the
visual effect of a wall. Paint in a second
darker wash on the wall, leaving the
floor area in the lighter wash.

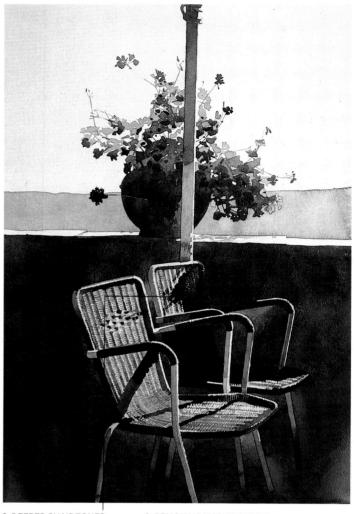

8. DEEPER CHAIR TONES Mix alizarin crimson and Payne's grey, apply as shown, and leave to dry.

9. REMOVING MASKING FLUID When the paint is completely dry, remove the masking fluid by rubbing it off with an eraser, or your finger.

10. FINAL TOUCHES Complete the painting by adding tiny shadows of alizarin crimson and Payne's grey to the wicker texture of the chair.

MONOCHROME

MONOCHROME MEANS restricting your palette to one colour; with watercolour, however, this means you have the benefit of the white paper to lighten the tones.

Working in monochrome is an excellent exercise, because it makes you look for the tones in your subject. It is important that you should do this even when working in full colour, so it is helpful to get into the habit of viewing an object in terms of its contrasting lights and darks. You need to find an interesting tonal composition — a balance of lights and darks—as well as being aware of its colours.

The choice of colour for a monochrome picture is naturally important if it is to be the only one, since the whole range of tones, from light to dark, must derive from it. If you begin with a light colour like yellow, your tonal range is severely limited to the light end of the tonal scale, from pale grey to white. Traditionally, black, sepia and brown are the colours chosen.

Look at your subject, as the artist has done here, and find the tonal equivalent of the colour you see. For instance, any black in the subject will be the equivalent of the darkest tone of your chosen colour, and white will be the white paper.

OBJECTS IN A WINDOW

The artist has picked out the tones of this subject, working in various strengths of Payne's grey. The darkest area, on the shaded sides of the duck and apples, are depicted in full strength colour. The lightest tones are depicted by the white paper. On the right, you can see the results of working in red and green respectively.

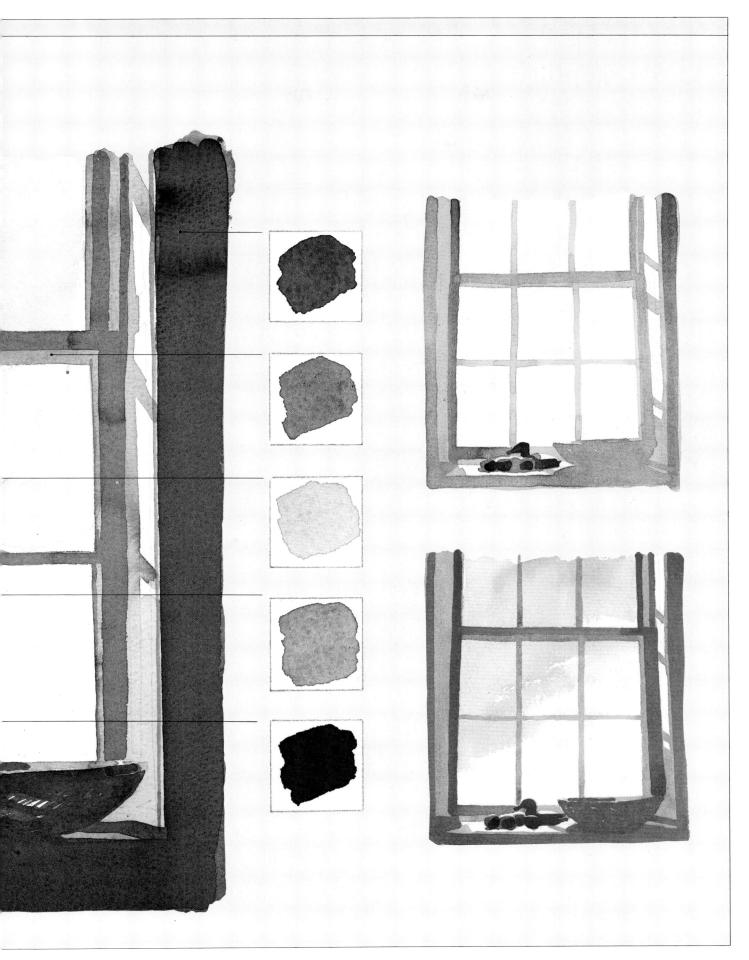

A MISTY SCENE

WITH WATERCOLOUR, it is possible to work literally in monochrome, without introducing white paint to lighten the tone of the selected colour. In this way, by planning carefully, and by using the white of the paper, you can capture your subject in all its tones with just one colour on the palette.

For this picture, the artist chose Payne's grey, a colour which is so dark when undiluted that it is often used instead of black. By diluting it to varying degrees, he was able to explore an extremely broad range of tones, from the white of the paper to the very darkest grey of the paint.

The artist has made use of aerial perspective (see pp 134-5) to help establish a sense of space. He washed in the background with a very diluted tone, and then strengthened the shapes as they come nearer to the foreground.

A special technique was employed to create a misty atmosphere. The artist mixed gumwater with the initial wash; the gum suspended the pigment in the paint, which meant that much of the colour was prevented from sinking into the paper. He then applied a damp sponge to the shapes of the distant trees: the gum dissolved, making the colour easier to remove, and the resulting blurring gives the distant shapes their hazy quality.

The same technique was used on the foreground trees. Even though these were darker and more definite, they needed to be slightly blurred to convey a convincing sense of mist.

The composition relies on a simple juxtaposition of the foreground trees, with their strong shadows. The colour was applied quite freely to these trees, giving a textural effect which rescued the picture from appearing too uniform.

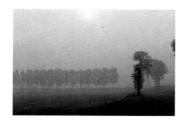

WATERCOLOUR PALETTE

Payne's Grey SUPPORT

Bockingford paper, stretched 432×559 mm (17×22 in)

1. FIRST WASH
Restrict your palette to
Payne's grey (light greys and
whites are obtained by using
the white tone of the paper).
Start by blocking in the distant
trees and fields with a diluted
wash of Payne's grey mixed
with a little gum arabic.

2. DARKER TONES
When the first tone is
completely dry, paint in the
nearer objects — the two trees
and the hillock — with a darker
wash of Payne's grey mixed
with a little gum arabic. Allow
this to dry.

3. SHADOWS
Paint in the tree shadows,
and strengthen the trees
themselves with a darker
version of the same solution.

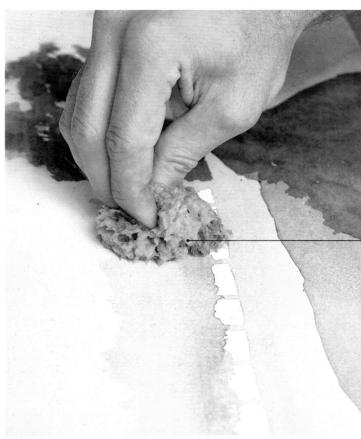

4. MIST
Soften the edges of the trees
with a sponge, to create the
impression of a scene being
viewed through mist. The gum
arabic mixed with the paint
allows the colour to be wiped
off the paper easily without
leaving a strong stain.

5. TEXTURE
Finally, strengthen the trees
and shadows with darker
colour. Use the brushstrokes
to represent the general
texture of the foliage and
the grass.

CREATING WHITE

WHITE PAPER IS A key element in watercolour painting, but you are not restricted simply to leaving areas of the support unpainted. There are other ways of exploiting the whiteness, some of which also add a textural dimension to the painting.

You can scratch the dried paint on the surface of the picture with scalpels, knives, or any other sharp object, to reveal etched streaks, or specks of white. This technique, known as sgraffito, is particularly useful for texturing, lifting dull areas of colour, creating the shimmering highlights on expanses of water, and making tiny, specific, highlighted areas. Sandpaper produces a similar, though more overall effect.

Colour can sometimes be lifted by removing some of the paint while it is still wet. Any absorbent material, such as blotting paper, tissue, cotton wool, or cotton buds can be used for this, as well as for mopping up mistakes and unwanted areas of colour. Domestic bleach, or gumwater, is also useful for lifting pigment to create pale areas.

In addition, some of the textural techniques mentioned on pages 172-5, such as wax resist, can be used for creating white, as can the masking technique described on pages 150 1.

SGRAFFITO

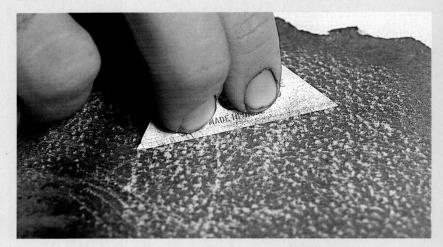

1. If the flat edge of a craft knife is scraped across the top relief of textured paper, it leaves a mottled, even effect.

2. Sandpaper has the same result, but gives a definite directional appearance to the etched white area.

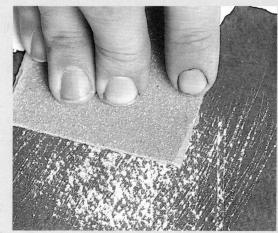

3. Use the pointed end of a craft knife, or scalpel to etch hatched white lines in the colour.

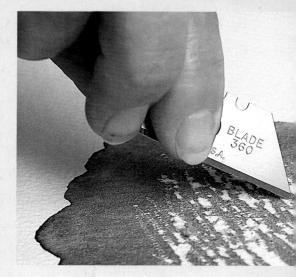

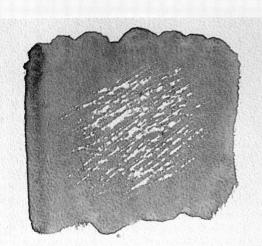

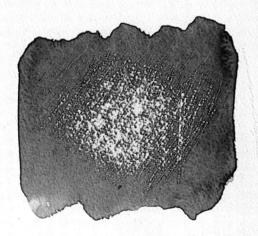

4. The sandpapered whiteness (bottom) produces a more evenly textured effect than the sharply etched scalpel lines (top).

BLEACH1. Use an old paint brush to apply domestic bleach to the areas you wish to lighten.

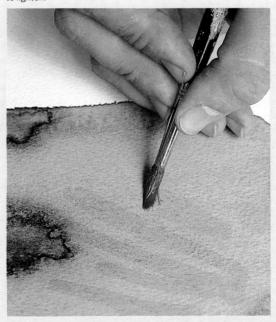

2. Leave the bleach in place: the colour will gradually lighten. With some pigments, it can also change the colour slightly, so experiment first.

FINE LINES

I. To create finer lines with a sharp implement, first mix the colour with gum arabic, and then scratch the surface before the paint is dry.

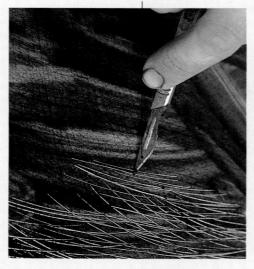

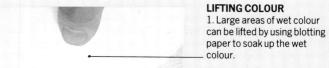

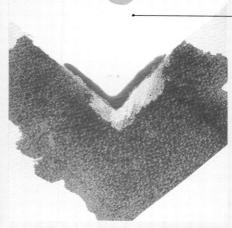

2. Quite small areas of wet colour can be lifted with cotton buds.

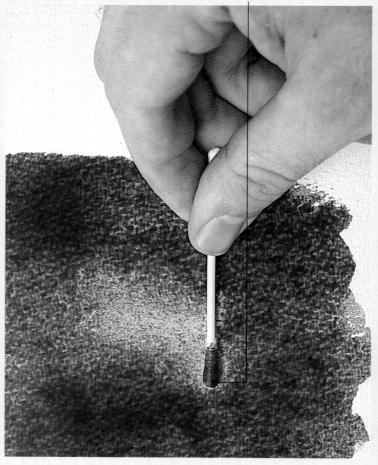

1. Mixing a little gum arabic, or gumwater, with paint makes it easier to lift the colour.

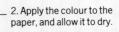

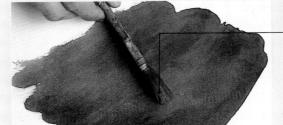

3. Wet the areas which you want to lighten, with clean water.

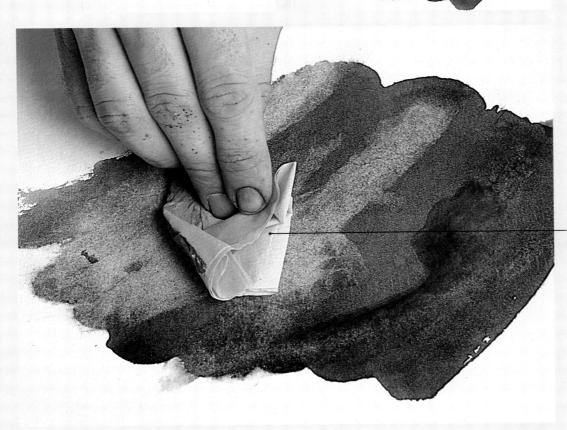

4. Blot off the water. This will remove colour, and reveal lightened areas.

STILL LIFE

IN THIS PAINTING, white has been created by scratching the paint surface, as well as by leaving areas of the white paper unpainted. The subject is ideally suited to this sgrafitto technique, because a considerable amount of wood is involved.

The artist used a scalpel to scratch prominent downward strokes on the pepper pot and wooden spoon, producing a typical pattern that also helped to create something of the warm atmosphere of a comfortable kitchen, with its familiar utensils. In the finished picture, the jug of utensils is placed upon a coarse wooden tabletop. Scratch marks have been scored with a knife, revealing specks of white — the light streaks of the grained wood. The artist also rubbed sandpaper firmly across the surface to lift the colour and roughen the texture.

Notice, too, how the artist has adapted the setting of this still life. The original arrangement was on a white tabletop against a woodchip background, but the artist decided to reverse the colours in the painting, so setting the utensils against a plain white background. The arrangement of a still-life subject can often be adjusted in such a way – many artists depart from the subject altogether, using it merely as a starting-off point.

The choice of objects in this arrangement was deliberate, however, as the artist wanted a variety of shapes and finishes.

WATERCOLOU	JR PALETTE
Brown Madder Alizarin	Yellow Ochre
Burnt Umber	Sepia
Sap Green	Ivory Black
Raw Umber	Cadmium Red
Payne's Grey	
SUPPC	PRT
Stretched Waterfor	d paper (rough)

 432×559 mm (17 × 22in)

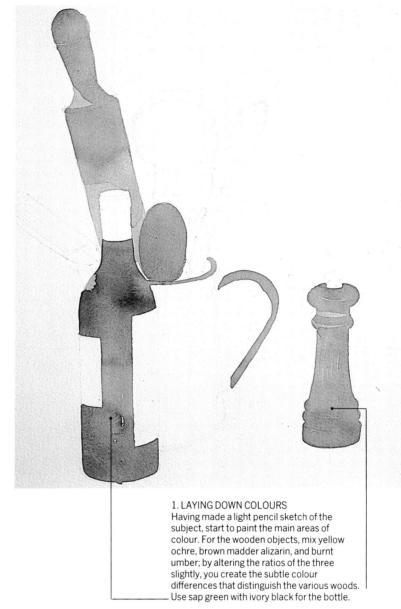

2. BUILDING UP
Continue blocking in the local colour of the objects with thin layers of colour. Use cadmium red with brown madder alizarin for the ladle and bottle top; Payne's grey with a touch of yellow ochre for the metal utensils; and yellow ochre with a little Payne's grey for the jug. Working wet on dry, paint the shadows on the wooden spoon, pepper pot and rolling pin in a deeper version of the first colour.

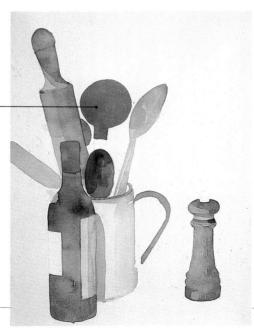

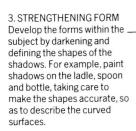

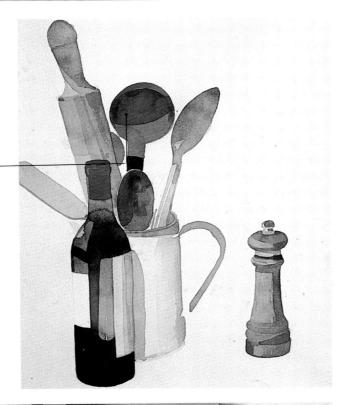

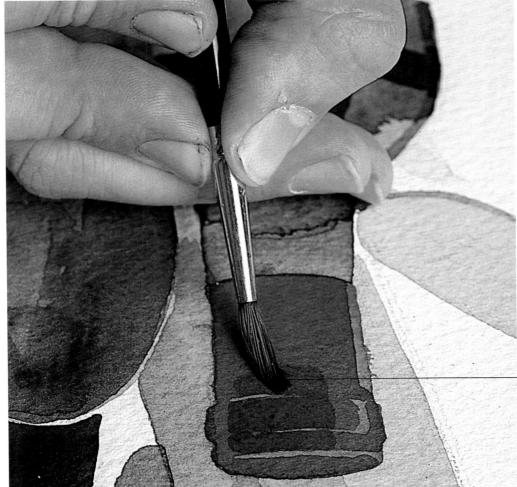

4. THE BOTTLE TOP
Here, the artist is painting the shadow
on the bottle top with a darker mixture
of cadmium red and sepia. Again, the
shape of this shadow is used to
describe the cylindrical form of the
bottle neck.

5. THE TABLE
Paint the tabletop with a diluted
mixture of raw umber, yellow ochre and
Payne's grey. When this is dry,
establish the shadows – Payne's grey
and raw umber across the table, and
Payne's grey with yellow ochre up the
wall

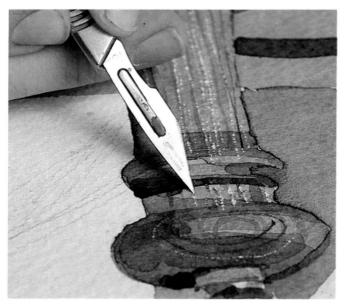

7. IMITATION GRAIN
By combining scratched white lines with the dark painted ones, the artist has created a convincing and effective imitation of wood grain. Notice how the pattern carefully follows the contours and curved form of the pepper pot.
Similar textural marks and scratches are used elsewhere in the composition, such as on the rolling pin and tabletop.

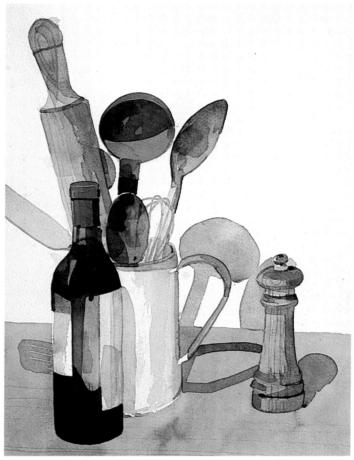

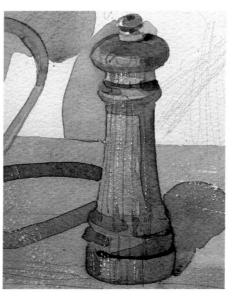

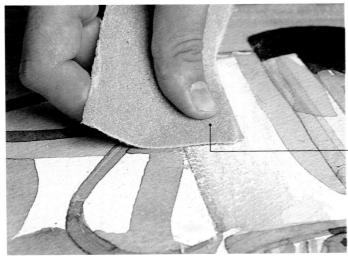

8. SANDPAPER TEXTURING Use coarse sandpaper when a smooth, mottled texture is required. On rough watercolour paper, the sandpaper lifts the colour from the raised parts of the surface to create a light, speckled effect.

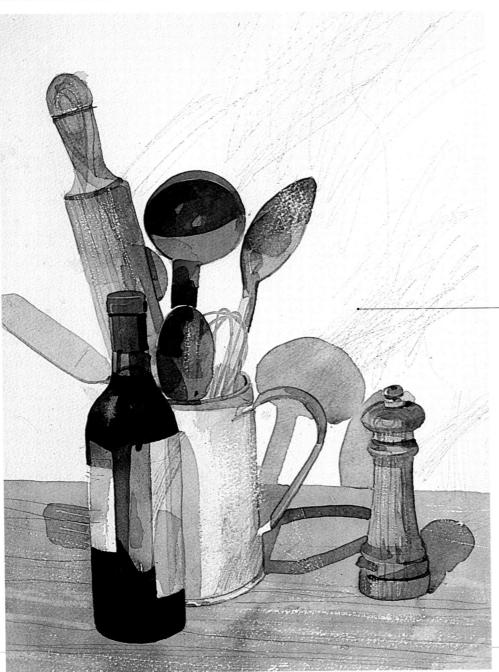

9. THE FINISHED PICTURE
The finished picture shows how the artist has exploited several texture-making techniques, combining scratched marks, also known as "sgraffito", with loose pencil scribbling to break up the flat areas of colour and so enliven the image. It also shows how the original still-life model has been adapted to suit the medium of watercolour.

SEATED NUDE

THE WHITE PAPER plays a dominant role here. Very bold areas are left unpainted, so that they emerge in the finished picture as streaks of brilliant sunlight. A strong directional light, from the daylight coming through the window, illuminates and describes the form of the figure, making the picture a vigorous example of classical watercolour technique.

The elongated areas of white are used to separate different parts of the body. They go all the way down the left arm, the left side of the body and the face, and describe the shoulders and collar bone, giving a sharp basic overall structure to the figure. Their use means that the artist can now work more freely – applying colours in a loose manner without making the figure formless. This washy, less definite approach is ideal for the rest of the body, because, with the light coming from behind, these other areas are quite dark and undefined. White is also used in the same strong manner to depict the window seat, the light planes along the window frame, and the sky.

WATERCOLO	UR PALETTE
Brown Madder Alizarin	Cadmium Orange
Cobalt Blue	Payne's Grey
Black	Sepia
Yellow Ochre	Olive Green
Sap Green	
SUPPO	ORT
Daler Water	colour card
508×381 mm	$(20 \times 15in)$

1. THE FIGURE

Mix a diluted wash of brown madder alizarin and cadmium orange and apply this to the figure area. Add small quantities of cobalt blue to the solution as you move down the body, to suggest the cooler, darker shadows on the arms and legs. Leave patches of white paper to represent highlights — particularly the narrow shapes which separate distinct areas, such as the strips between the knees and

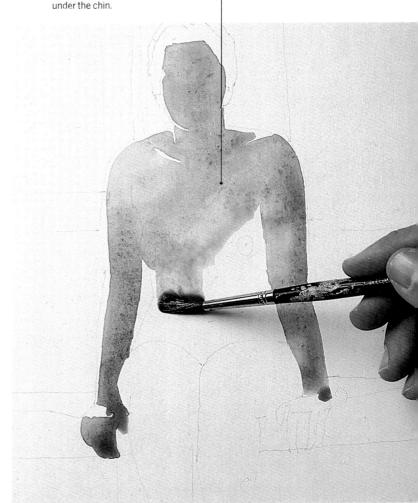

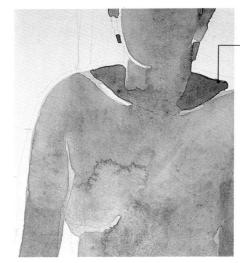

2. BLOCKING IN Make a cool shadow colour by mixing brown madder alizarin and Payne's grey, and begin to block in the shaded areas of the face and shoulders with a No. 2 brush, remembering to keep the white highlights intact. Use a deeper solution of the initial brown madder alizarin wash for the lighter, warmer areas. Apply this before the cool shadows are completely dry, allowing the colours to run into each other. The artist also applied blobs of water to selected areas to create "backruns" - patches of light, watery colour that look mottled when they dry.

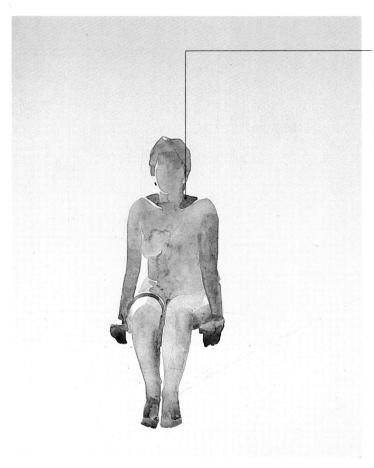

3. DEEPENING SHADOWS
Work into the deeper shadows
with stronger mixtures of both
warm and cool shadow tones.
While these colours are still
wet, touch in the darkest areas
with a mixture of sepia and
black, allowing this to bleed
into the neighbouring colours.

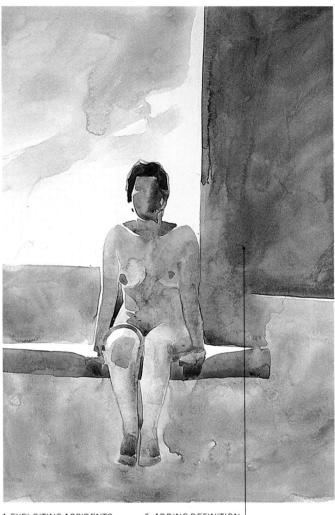

4. EXPLOITING ACCIDENTS
Try to incorporate some of the accidental runs and textures into the overall picture. Here, for example, the dark tone has run into the wet colour of the face, and the artist decided to exploit this unintentional effect by using the "run" to represent the shadow down the side of the woman's head.

5. ADDING DEFINITION |
Block in the right-hand background area and the edge of the window seat in Payne's grey mixed with yellow ochre. Use a wash brush for the large areas, changing to a No. 2 brush to define the contours of the figure. Block in the lower wall area and the back of the window seat with a more diluted solution of Payne's grey. Again, leave narrow strips of white paper to represent the highlights. Indicate the sky with a few loose strokes of watery cobalt blue.

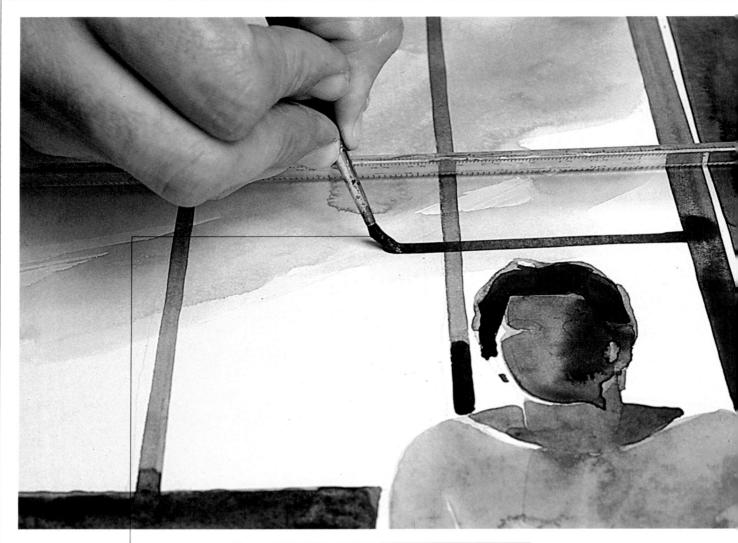

6. PAINTING THE WINDOW When the sky is dry, use a ruler as a guide to help you paint the straight edges of the window frame. Mix some Payne's grey to a fairly thin consistency then, holding the edge of the ruler slightly above the paper, run your painting hand along it. Do not let the paint come into direct contact with the ruler, or allow the ruler to touch the paper, as otherwise the colour will bleed and smudge.

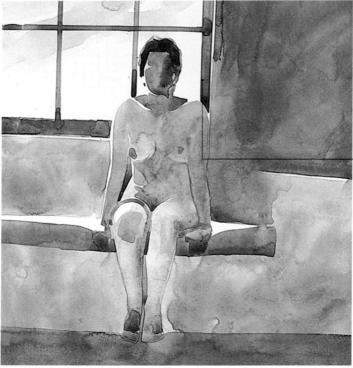

7. FINISHING THE FRAME Finish painting the window frame, using the ruler as a guide throughout. The starkness and graphic simplicity of the mechanically straight lines will help to create emphases and contrasts with the softer, irregular forms of the figure.

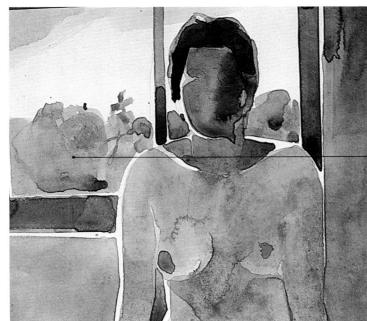

8. THE FOLIAGE When the window frame is completely dry, paint the foliage with loose strokes of olive green and sap green.

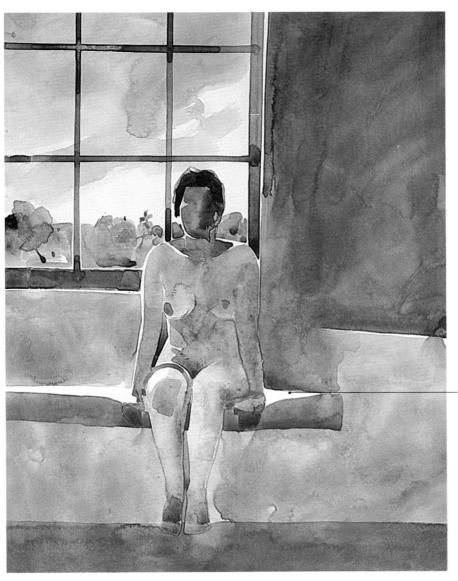

9. THE FINISHED PICTURE
You can see just how
important a role the white
highlights play in the finished
painting. They clearly separate
the various elements, and
divide what would otherwise be
amorphous blobs of colour
into clearly defined forms.
They also help to describe the
forms themselves. Being the
lightest planes in the picture,
they represent the daylight as
it falls upon the figure and seat.

CREATING TEXTURE

EVERYTHING IN REAL life has a texture, whether it is the choppiness of the sea, or the roughness of concrete. These surface characteristics can often be conveyed by brushwork; alternatively, you can sometimes texture the surface of the picture.

Texturing can be employed not only to represent the real-life appearance of the subject, but to enliven the actual paint surface of the picture itself. There are three basic methods of texturing surfaces: a brush can be used to apply broken colour, spatters, speckles or other paint effects; paint can be applied by other means, such as a sponge; the paint can be made to react by applying substances such as wax to the paper, or by mixing the paint with an additive, such as gum arabic.

When gum arabic is mixed with paint, it gives the colour a gloss and texture which retains the shape of the brushmarks when the paint is applied to the paper. The mixture can also be combed, or scratched with a texturing tool, to make a surface pattern. Paint mixed with gum arabic, or the thinner gumwater, can be dissolved easily when dry, because the gum suspends the pigment, prevents it from soaking into the paper, and prepares the way for some of the special effects illustrated.

It is important, however, to realize that texturing techniques can be overdone: a painting may be ruined by arbitrary marks. It is better to be selective, and only to apply a little texture to a particular area.

USING SALT

1. Sprinkling sea salt over wet paint is one way of creating a granular, textured effect.

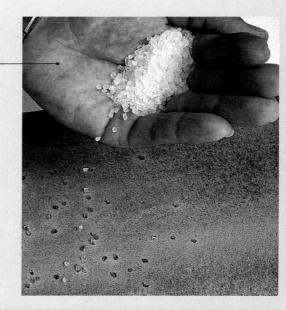

2. Leave the salt for a few minutes, to allow it to absorb the wet colour. When the paint is dry, brush away the grains of salt to reveal a mottled pattern.

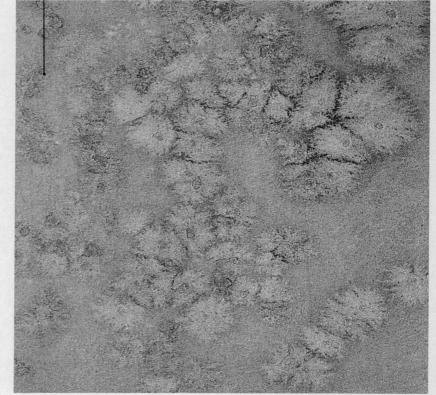

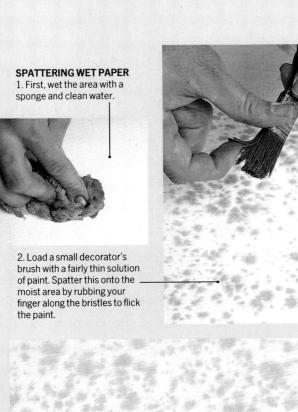

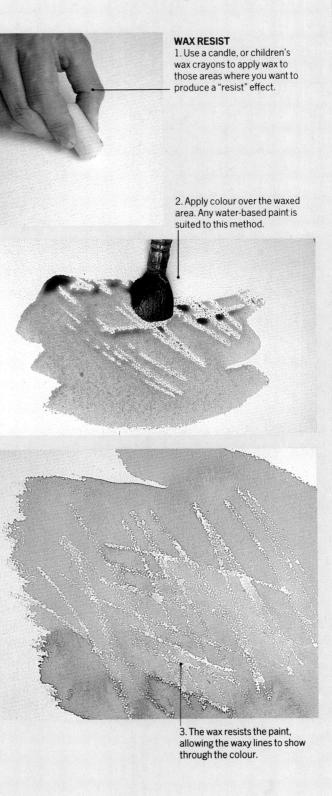

3. The spatters bleed into the water, producing a soft, marbled pattern.

USING A SPONGE
1. Mix a solution of paint, dip a natural sponge into it, and dab colour onto the paper.

2. This technique produces a broken texture, with a smooth quality.

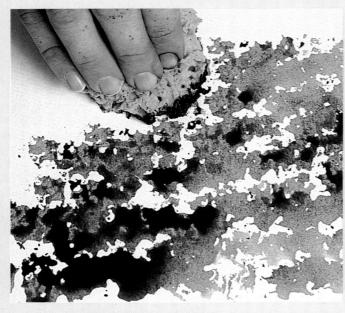

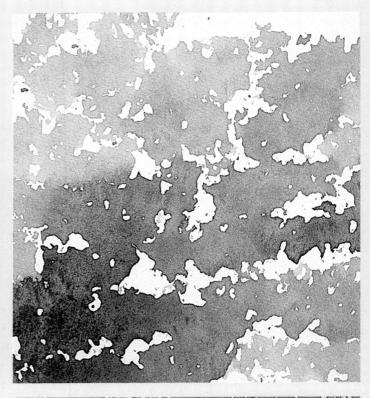

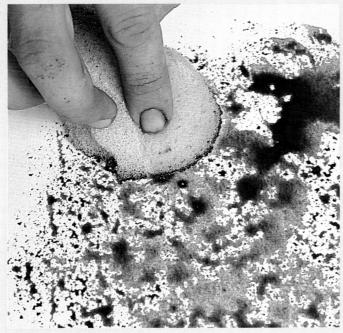

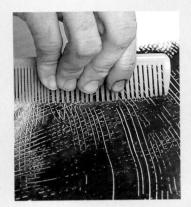

GUM ARABIC

1. Mix gum arabic with your colour to thicken the paint, and give it a resinous quality. Apply the mixture to the paper. Because of its thickness and stickiness, you can create a texture in a variety of ways, including the combing effect shown.

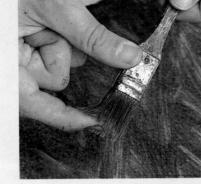

SPATTERING WITH GUM

ARABIC

1. Cover the surface with paint which has been mixed with gum arabic. Allow the paint to dry. Using a decorator's brush, spatter the paint with flecks of water.

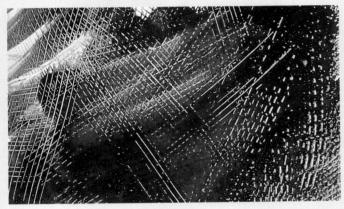

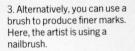

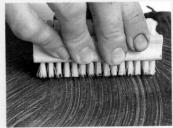

4. The result is a fine, hair-like

3. The water lifts the colour, forming a granular pattern

CRAB

THE CRAB'S SHELL has a rough, pitted surface, which immediately presented the artist with the problem of how best to capture its texture. He chose to paint in gouache because it would enable him to establish the solid form and colour quickly. However, gouache also dries flat and opaque, tending to result in a dull, matt finish, which can be a disadvantage when a textured surface is required. The artist, therefore, had to explore ways of creating interesting finishes.

Gouache allowed him to exploit the possibilities of painting light on dark; its opaque quality also helped him to establish a convincingly realistic and solid form, with definite planes of light and shade. However, to achieve the characteristic texture of the actual shell, the artist splattered light flecks of paint onto this surface with a decorator's brush. (A toothbrush, or nailbrush would have achieved similar results.) The spattered texture immediately lifted the image, bringing it to life.

A texturing technique was also used to enhance the grain of the wooden table. The artist first painted in the dark brown stripes; then, he rubbed the surface horizontally with coarse sandpaper to score the paint, scratching in the characteristic, light lines of the grain.

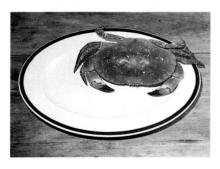

WATERCOLO	UR PALETTE	
Goua	iche	
Cadmium Yellow	Cadmium Red	
Cadmium Orange	Raw Umber	
White	Yellow Ochre	
Cobalt Blue	Ivory Black	
Ultramarine Blue		
SUPPORT		
Daler Waterc	colour Board	
$356 \times 457 \text{mm}$	$(14 \times 18in)$	

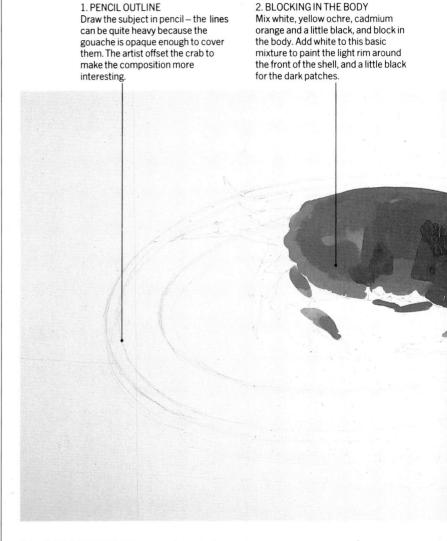

3. SHADOWS AND TEXTURE
Work over the body, developing the
form with dark shadows. Make the
brushstrokes in different directions to
suggest the rough, matt surface of the
shell.

4. LIGHT AND SHADE
Still using white, yellow ochre,
cadmium orange and black, mix a
range of tones from these colours, and
go back over the shell and the front
legs, painting in the planes of light and
shade. Add small quantities of
cadmium red and cadmium yellow for
some of the brighter areas. Block in
the smaller, back legs in one flat
colour.

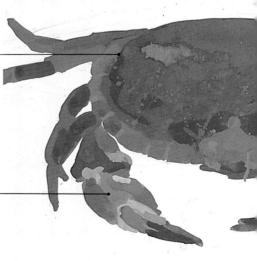

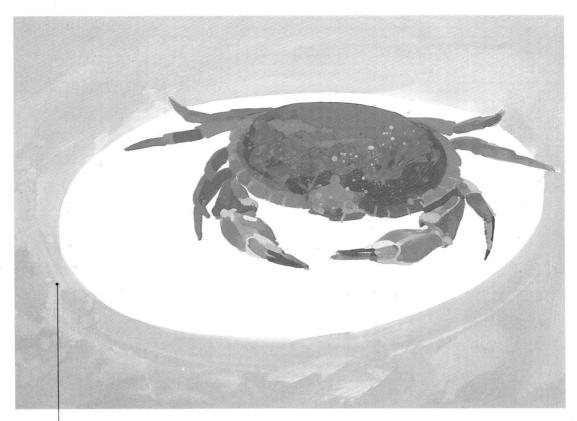

5. TABLETOP
Paint the tabletop in a light tone of the crab colour, using a large wash brush.
Remember, wet gouache looks uneven.

6. UNDER-SHADOW Mix cobalt blue, black and yellow ochre, and paint the shadow under the crab.

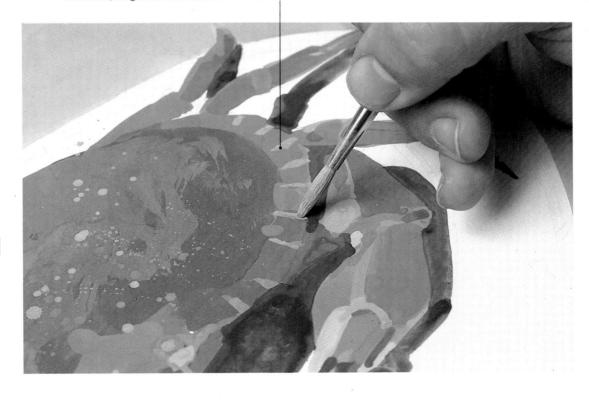

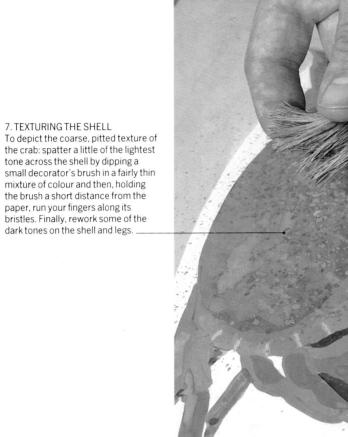

7. TEXTURING THE SHELL

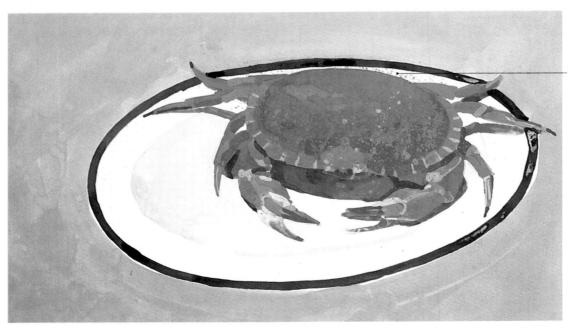

8. THE PLATE
Add the decorative ring
around the plate in ultramarine
blue, darkened with a little black. Mix this colour with white, and use a large wash brush to paint the curved shadow which describes the rounded form of the plate.

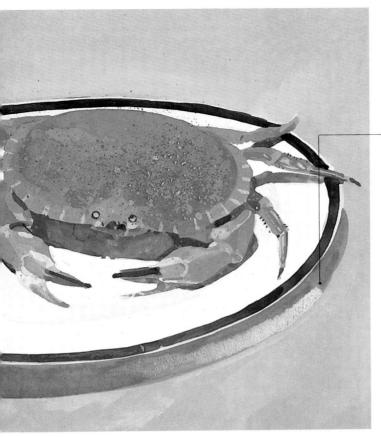

9. UNDER-SHADOW
Mix raw umber, black and a little cadmium orange; then paint the shadow under the plate, using the large brush to achieve a continuous, curved shape.

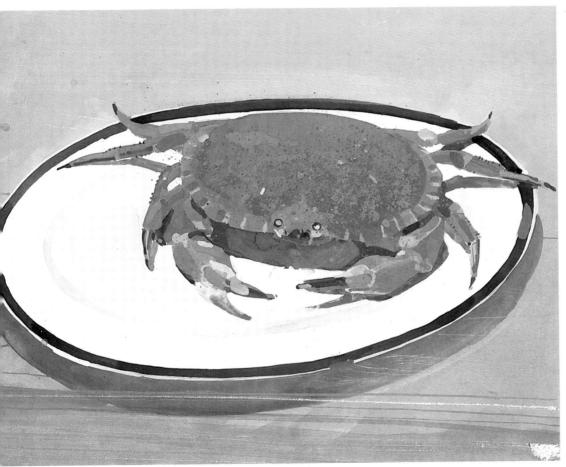

10. WOOD GRAIN
Use this same shadow colour to indicate the wood grain in the tabletop with thin horizontal lines. When the paint is dry, firmly drag a sheet of coarse sandpaper horizontally across the table area to emphasize the granular texture of the wood.

11. FINISHED PICTURE
The completed painting
reveals how the artist has used
a limited range of colours,
building up the forms in tonal
planes with opaque gouache
paint. The dull, matt surface of
the gouache is enlivened by
the texture: spattered colour
on the crab, and the
sandpapered grain of the
wooden table.

CHAPEL WITH CYPRESS TREES

CAREFUL SELECTION of texture gives another dimension to this painting of a chapel, specific techniques being used to achieve all of the desired effects. The objective was to capture the rough stucco nature of the chapel wall and the way it contrasted with the foliage of the cypress, without overdoing it, and so allowing the textures to dominate the picture to excess.

As a first step, a rough paper was selected as the ground. Because watercolour responds to textured paper, the paint on a coarse surface like this would already create a flecked effect, but, to heighten the effect, candlewax was rubbed across the initial pale wash used to depict the chapel wall. The candlewax caught on the upper ridges, or prominent spots, of the relief on the paper surface, which meant that, when the next, darker, wash, was applied, the paint sank into the crevices of the paper, but was resisted by the wax. The result was a pleasant mottled effect.

Gum water (see pp 172-3) was used to create the texture on the tree. The water, when it dries after application, suspends the pigments to a certain extent, so preventing them from sinking too deeply into the surface of the paper. Here, the first colours were mixed with gum water, and the tree was painted as a solid shape. This was allowed to dry. The artist then spattered the tree with ordinary water, which dissolved some of the pigment on the dried layer. When this was blotted, the light mottled shapes you see in the final rendering were left.

WATERCOLOUR PALETTE		
Coeruleum Blue	Ivory Black	
Yellow Ochre	Raw Umber	
Cadmium Yellow	Sepia	
Burnt Sienna	Hooker's Green	
Payne's Grey	Brown Madder Alizarin	
Raw Sienna	Sap Green	
SUI	PPORT	
Waterford paper (rough)		
406×508 mm (16×20 in)		

1. THE SKY
Having made a light outline drawing of
the subject, block in the sky with a
dilute wash of coeruleum, leaving large
flecks of white to represent the clouds.

2. FIRST WASH
Mix a light solution of ivory black and yellow ochre and apply this to the darker areas – the building and foreground – with a large wash brush.

3. SHADOWS AND TOWER
When the pale underpainting is
thoroughly dry, use a darker version
of the black and yellow ochre mix to
suggest irregular shadow shapes on
the face of the building. Paint the brick
bell tower in a light mixture of raw
umber, cadmium yellow and brown
madder alizarin.

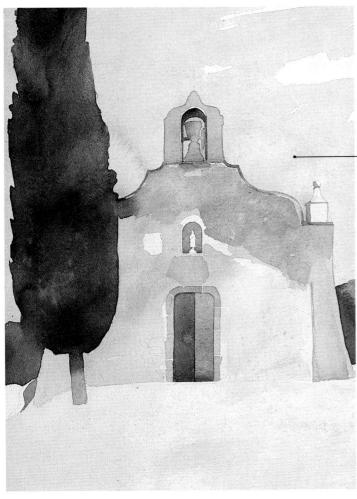

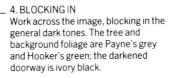

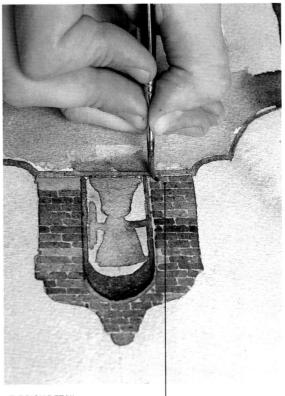

5. BRICK DETAIL
Using the tip of a round sable brush, _
pick out the bricks in varying
combinations of burnt sienna, brown
madder alizarin, raw sienna and
Payne's grey. Leave narrow strips of
the light underwash showing through
between each brick.

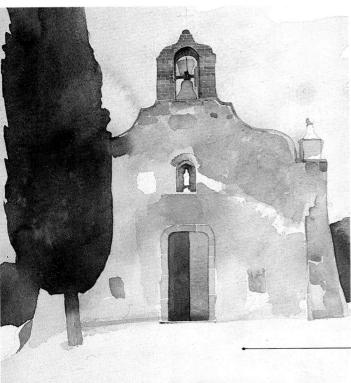

6. THE DRYING STAGE
The main blocking in is now complete.
Allow the colours to dry thoroughly before moving on to the next stage (here, a hairdryer was used to speed up the process).

7. THE RESIST
Using an ordinary domestic
candle, rub wax across the dry,
grey paint of the chapel wall.
This creates the necessary
resist for the next watercolour
wash.

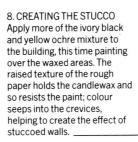

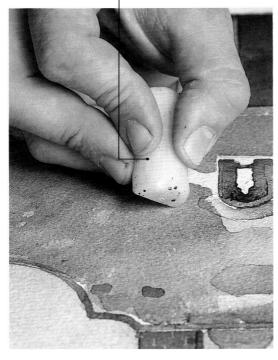

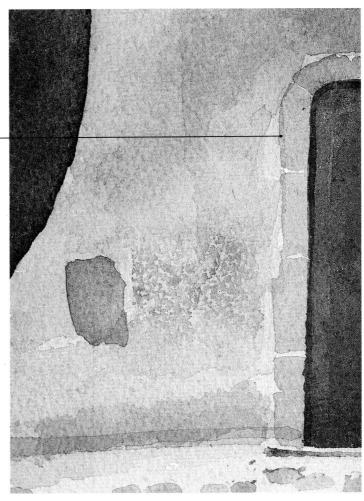

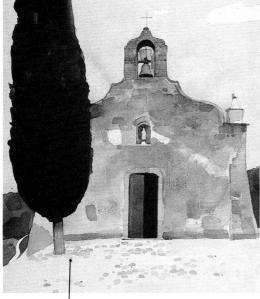

9. COBBLES AND TREE
Develop the foreground, suggesting the cobblestones with various mixtures of Payne's grey, yellow ochre and sepia.
Then mix Hooker's green, sap green and Payne's grey with a little gum water and use this to strengthen the colour of the cypress tree. Allow to dry.

10. TREE TEXTURE
Sprinkle a little water onto the tree, and immediately dab this off with a clean, dry tissue or cloth. The gum water allows the top layer of paint to come off easily with the water, leaving a leafy, mottled texture on the tree.

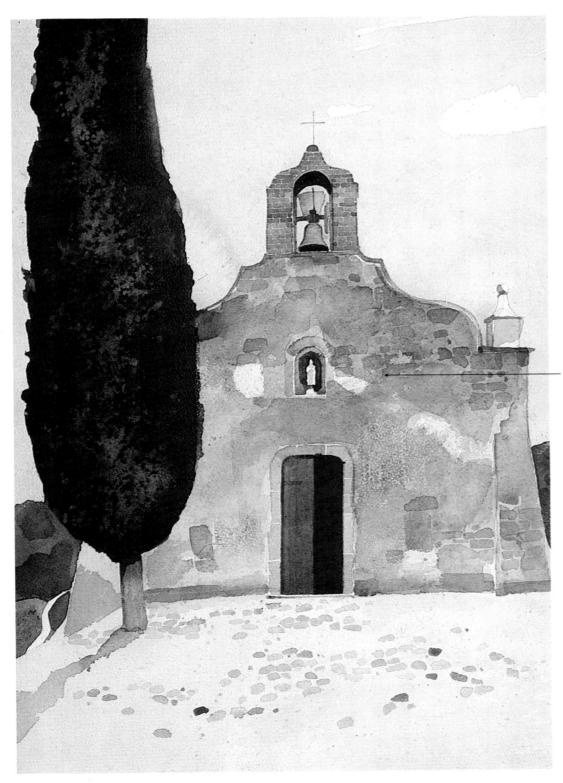

11. THE FINISHED PICTURE In the finished picture, the subtle textures on the tree and building help to bring the scene alive, introducing a rugged, almost tactile quality to the painting.

SNOW SCENE

THIS IS A VERY simple, but effective, scene, created with a minimum of brushstrokes. The strokes themselves play an important part in depicting the crisply marked surface of the snow, and the stark green trees. The artist painted the latter by loading a small brush with colour and rolling it over the surface to create the jagged impression of conifer branches. Similarly, the marks and shadows in the snow are also described by brushstrokes – large, loose strokes for the shadows, and small calligraphic marks to indicate the frozen grass poking up through the snow.

Another important piece of texturing in the picture is the white spattering to indicate falling snow. This is not done evenly, for this would have given the painting an unconvincing "Christmas card" look. Instead, the spattering was irregularly and lightly scattered across the image, which works particularly effectively on the dark, almost silhouetted shapes of the trees.

WATERCOLO	UR PALETTE
Payne's Grey	Indigo
Sepia	Sap Green
Goua	ache
Titanium White	
SUPP	ORT
Bockingford pa	
406×559 mm (16×22 in)	

1. THE FIRST WASH Splash a wash of Payne's grey and indigo loosely across the sky and shadow areas of the ground. Do this quickly with a wash brush.

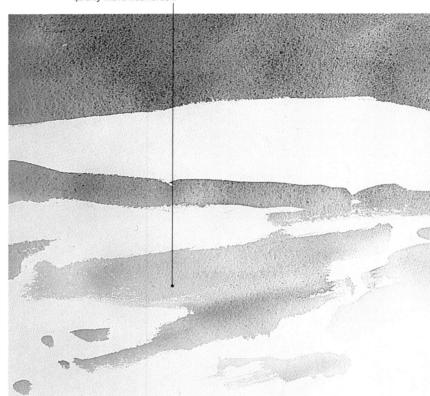

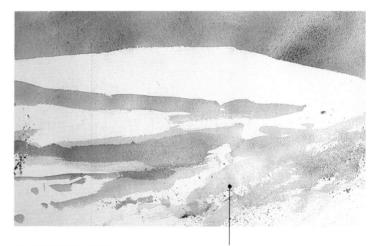

2. SHADOW AND DETAIL
When the first wash is dry, strengthen
some of the shadows with a darker
version of the same colour. Change to
a smaller brush, such as a No. 2 sable,
and use it with a mixture of sepia and

Payne's grey to suggest animal tracks and dead grass in the snow. Try not to work tightly and to retain the dry, feathery nature of the subject, representing the snow by rolling the brush loosely across the paper.

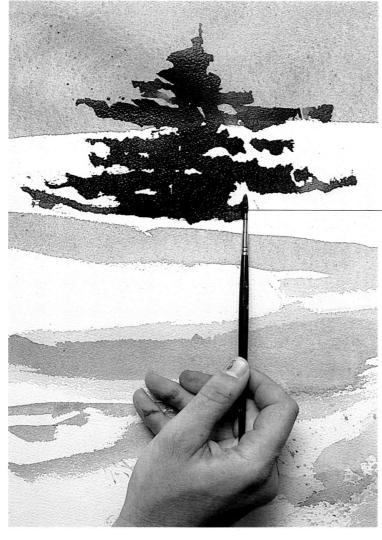

3. THETREES
Mix sepia, Payne's grey and sap green for the trees. Still working with the smaller brush, roll the colour onto the picture, creating dark broken streaks to represent the spiky branches of the firs.

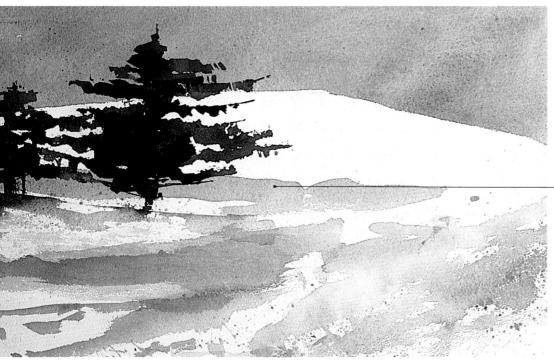

4. PAINTING SHADOWS
Take a little of the tree colour
and paint the shadows,
blending these into the
surrounding areas with clean
water.

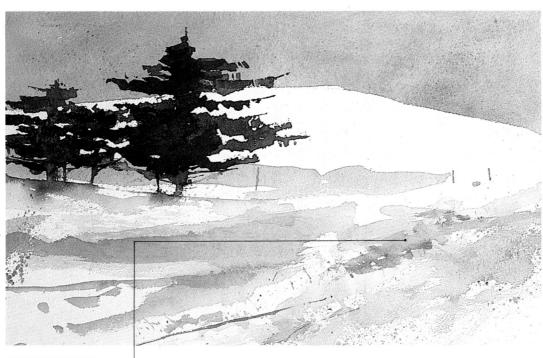

6. SPATTERING SNOWFLAKES Mix white gouache to a fairly runny consistency and, with a small decorator's brush, spatter this across the scene to represent snowflakes.

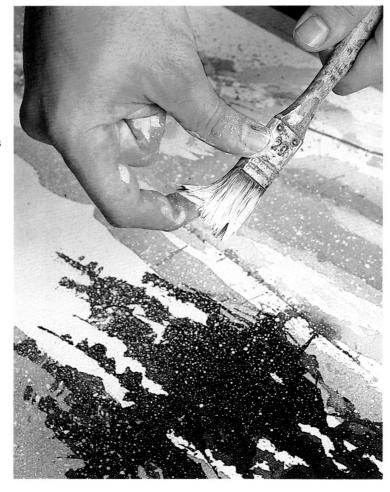

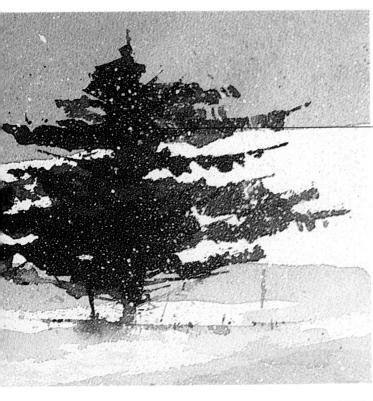

7. MAXIMIZING EFFECT
Take care not to overdo your
spattering. A few spatters on some of
the darker areas, such as the trees, is
more effective and convincing than a
film of regular white dots over the
whole picture. Stop working on the
picture as soon as you have finished
applying the snow.

8. THE FINISHED PICTURE
The freshness and crispness of the
final image comes from working rapidly
and knowing when to stop. The aim is
to create an impression, rather than
emphasizing specific details; you
should rely on the brushstrokes
themselves to describe the subject.

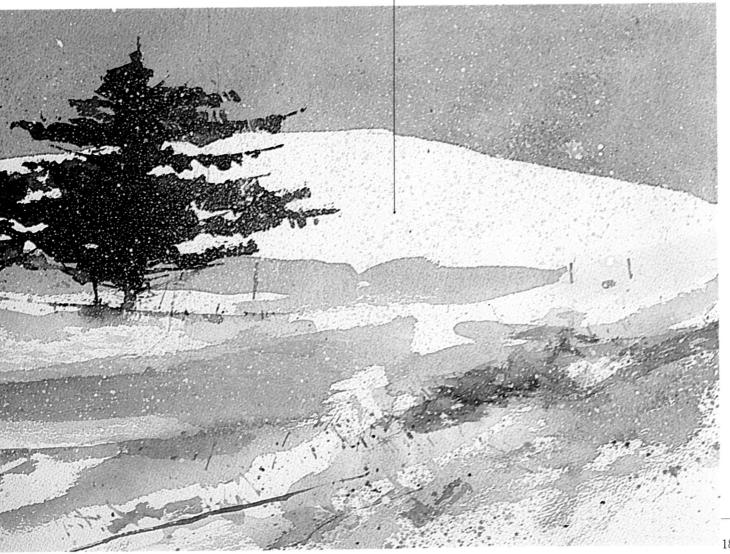

DRYBRUSH

A VERY DISTINCTIVE, subtle texture can be achieved by using what is known as "drybrush" technique. Squeeze, or wipe the moisture from the brush until the bristles are almost dry. When the paint is applied to the paper, the result has a feathery quality. This characteristic can be increased, and controlled, if you press your thumb against the top of the bristles to splay them in a fan shape.

The American painter, Andrew Wyeth is one of the leading exponents of drybrush technique (see p. 65). He uses it tonally – first applying a light wash, and then covering it with a slightly darker tone of the same colour, painted with a drybrush. Wyeth often employs this technique to convey the directional texture of grass, or the coarse surfaces of walls and buildings.

DRYBRUSH MARKS

1. With the brush squeezed almost dry, use short, directional strokes to create a loose, feathery texture.

3. First, apply loose blobs of dark grey colour, and then drybrush a lighter tone over these, to create a loose, textured effect.

2. For a vertical pattern, make upward and downward strokes in a loose, sweeping manner.

4. Dip the dried brush in paint, splay the bristles into a fan shape, and then drag the colour across the paper in regular horizontal strokes.

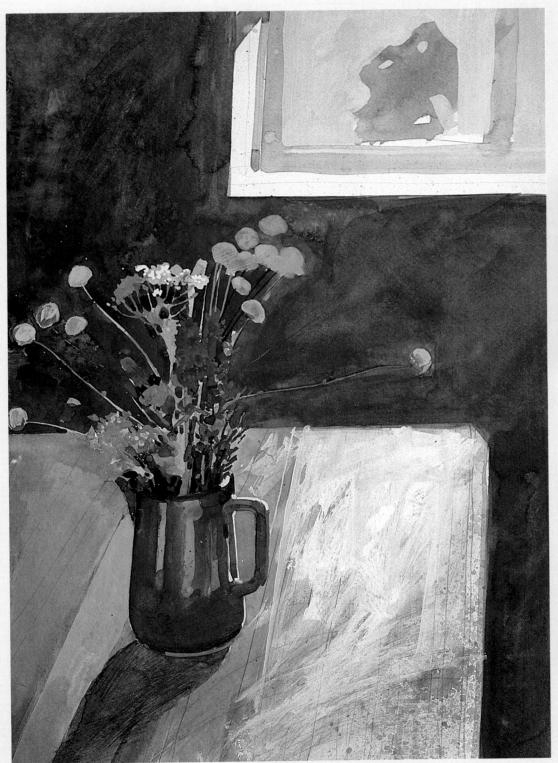

STILL LIFE WITH DRYBRUSH

This still life of a jug of flowers relies on the drybrush technique to bring the picture to life. There is a large amount of space around the subject; therefore, texturing the background and the tabletop has added interest to the composition.

1. The background has been textured by drybrushing Payne's grey onto a lighter tone. This breaks up the flatness of the large expanse of wall behind the flowers.

2. When painting the tabletop, the artist reversed the colour scheme, drybrushing an opaque light tone over a dark grey undercolour.

WINDOWS AND SHUTTERS

THERE IS LITERALLY no space in this unusual picture; foreground, middle and far distance are all equally absent. Everything is flat – in complete opposition to the normal type of composition, which presents the viewer with an illusion of depth. The task of the artist was to find ways of counteracting the flatness, which could easily make this picture very dull.

The method chosen by the artist was to create the illusion of texture and shadows, though in achieving the former, care had to be taken not to overdo the effect, as a flamboyant surface would have looked unrealistic. The answer was to use drybrush to represent the gritty, gravelly nature of the plaster finish on the wall. First a light wash was applied, and then subsequent tones and shadows were built up with drybrush, so allowing the first wash to show through in broken areas.

The area of brickwork was small, but it had a textural quality that needed to be brought out as well. The bricks were painted separately, using different proportions of the same colour mix, some light and some dark.

Apart from this, the painting is extremely simple, with dark window panes, black graphic lines around them, and plain grey shutters. Though simple to create, the shadows of the shutters are important, as they help to offset the flatness of the composition.

Looking at the finished picture demonstrates just how the drybrush technique, plus some careful painting of brickwork and shadow, has brought this strange composition to life. It shows how, if not overdone, textures can make a painting interesting. Here, the sunlight beats down upon an empty wall, while a deep, cool, rather mysterious darkness seems to dwell inside the windows.

WATERCOL	OUR PALETTE
Sepia	Payne's Grey
Ivory Black	Indigo
Ultramarine	Hooker's Green
SUP	PORT
Waterford pa	aper, stretched
508×356 m	$m(20 \times 14in)$

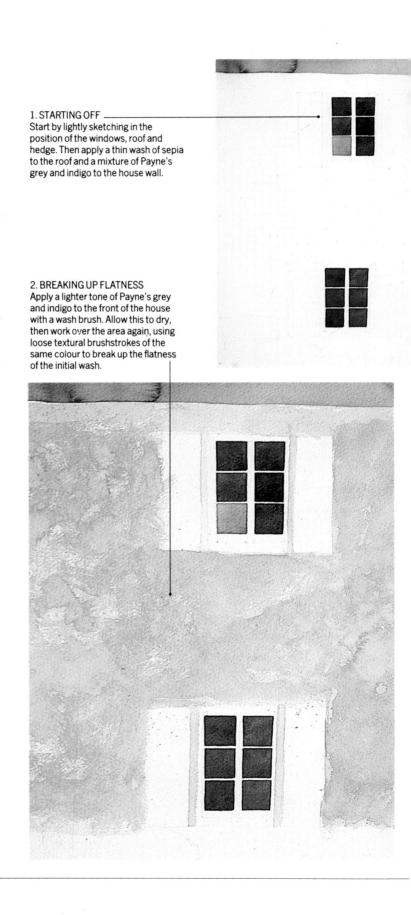

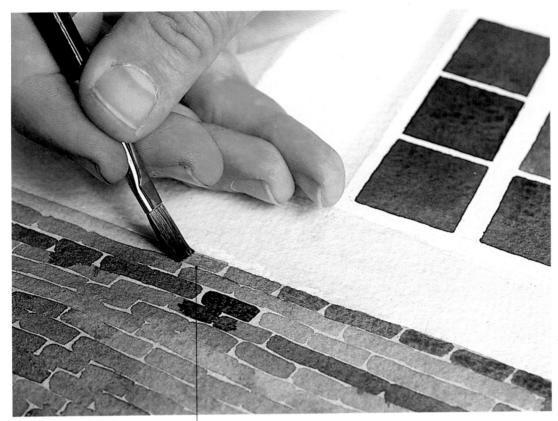

3. PAINTING THE BRICKS
Use a flat-bristled brush to paint in the bricks, using regular, single brushstrokes and allowing these to dictate the shape of each brick. Use sepia and Payne's grey, changing the proportions of the mix as necessary to vary the tone of the bricks.

4. DRYBRUSH Block in the window shutters with black and ultramarine. When these are dry, work over the flat wall again with a mixture of indigo and Payne's grey, using drybrush. To do this, squeeze the excess water from the bristles before dipping the brush in the paint, and then literally scrub colour on to the wall. Use a darker shade of the same colours for the shadows under

the window.

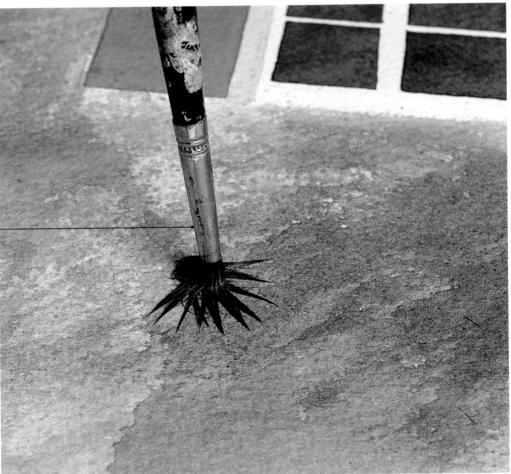

5. THE HEDGE
Paint the hedge in Hooker's green and black, mixed with gum water to give a sheen to the colour.

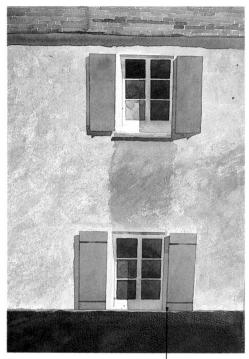

6. FINE DETAIL
Use a fine brush, such as a No. 2 sable, to paint the narrow shadows around the windows, under the eaves, and on the shutters in indigo and black. Darken the hedge area with a deeper version of the same colour.

7. FINISHING TOUCHES
Add the final details. Here the artist is using a ruler to aid the positioning of the dark lines of the window frames.

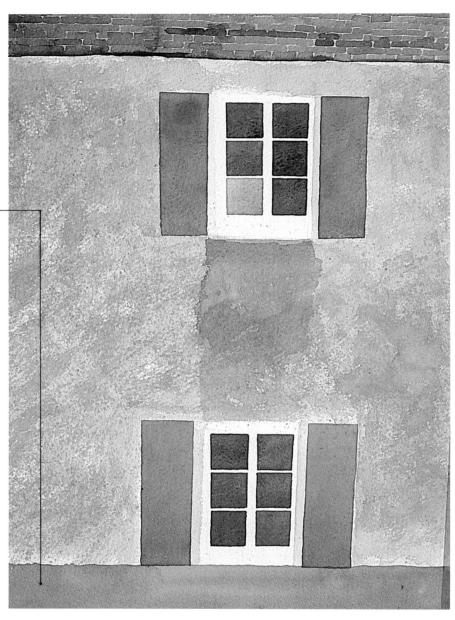

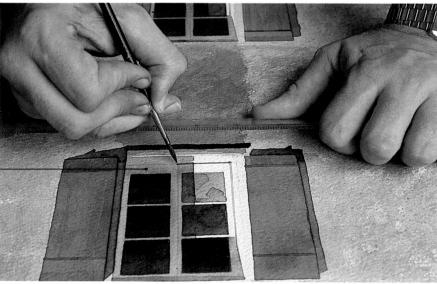

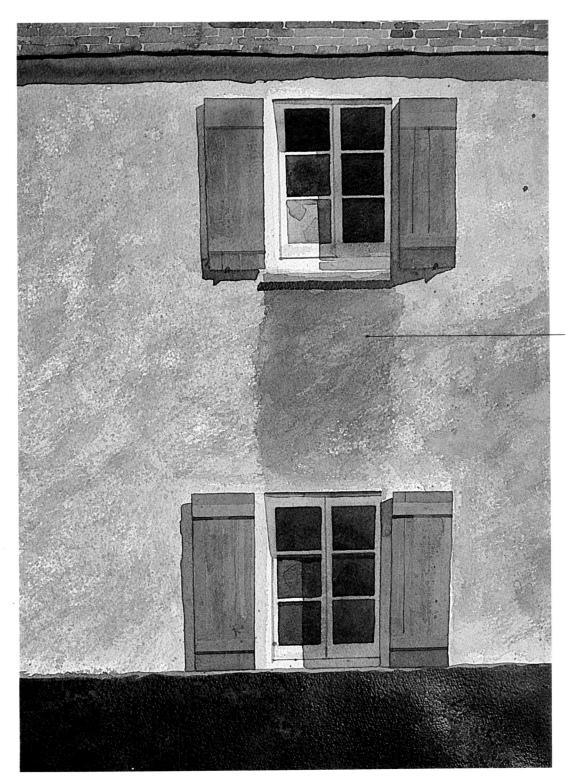

8. THE FINISHED PICTURE
The chosen subject, with its
deliberate flatness and lack of
scale or distance, relies for
interest on its inherent
textures. The most important
of these is the roughened wall
which the artist has used an
overall drybrush technique to
depict.

WARM AND COOL COLOURS

THE COLOUR WHEEL on page 94 reflects the fact that colours can be roughly divided into two main types – warm and cool. Blues, greens and purples are the cool colours, and reds, oranges and yellows are the warm ones. You will rarely see anything in real life which does not contain both warm and cool hues, although one type may predominate. This means that both warm and cool colours are likely to feature in nearly every picture you paint, and that it is important to strike a harmony between the two. Even the snow scene on page 184, which has a very chilly feel, is offset by a faintly warm shadow containing touches of sepia.

It is difficult to identify the colour temperature of any hue in isolation, although the more extreme ones like bright red are obvious. For instance, yellow is generally regarded as a warm colour; but if two yellows are placed next to each other, one an acid-lemon and the other a gold, then the lemon appears quite cold and the gold warm. Neutrals too have a colour temperature. If you see a range of different greys together, it will immediately become apparent that some of them are bluish and some brownish and that, therefore, some are tending towards cool and others towards warm.

For the painter, depicting the counterplay of warm and cool colours on the human skin is probably one of the most important aspects of colour temperature. The shadows are generally darker and cooler, containing greys, blues or greens; while the parts of the face, or figure on which normal light falls are predominantly composed of warm tones. This applies to all skin types. In the portrait on page 200, the artist has constructed the face from planes of cool dark and light warm washes of colour.

STILL LIFE WITH COOL, OR WARM COLOURS

The mood of a painting can be significantly changed, depending on the predominance of warm or cool colours. These two pictures are identical, except for the fact that the artist has shifted the emphasis of colour temperature from cool (left) to warm (right).

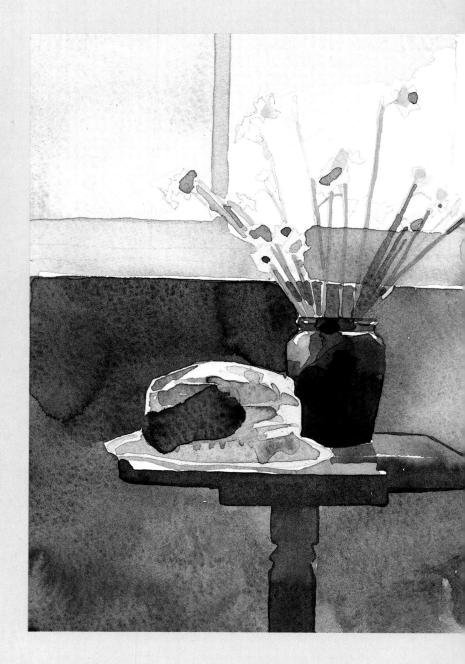

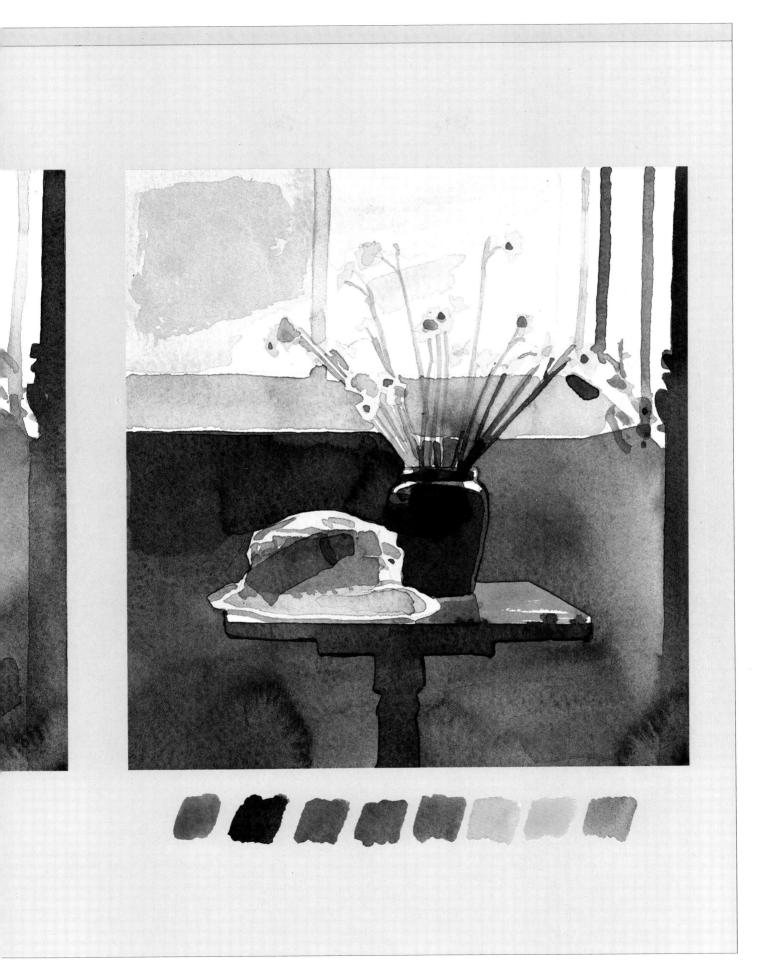

APPLES ON A PLATE

THIS EXERCISE SHOWS you how to make the most of warm and cool colours. The apples, the focal point of the picture, are red and green – in other words, warm and cool – but the artist has exploited the inter-relationships between warm and cool colours elsewhere in his composition as well. The warm brown tones of the wooden tabletop, for instance, contrast with the cold grey of the background, together with the blue grey shadows of the plate and the area around the apples.

The apples are painted wet on wet, so that the red and green colours merge naturally, forming a brownish neutral join. Where the colours meet, they are not overworked. They are allowed simply to fuse slightly and dry; otherwise they could have become muddy and the colours would have lost their freshness as a result.

Symmetry and rigid divisions could have spoiled this composition had the artist not taken conscious steps to avoid them. The plate of apples was therefore slightly offset, and placed low on the paper. The edge of the table divides the picture diagonally; to avoid splitting the image into two separate halves, this edge is subtly interrupted by one of the apples, thus avoiding a stark division.

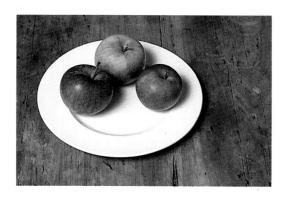

W/A	FERCO	OLIB	DΔI	ETTE
w a			I MI	

Sap Green

Yellow Ochre

Alizarin Crimson

Raw Umber

Payne's Grey

SUPPORT

Stretched cartridge paper 356×508 mm (14×20 in)

BLOCKING IN
 Having made a light outline pencil drawing of the subject, block in the

drawing of the subject, block in the apples with a pale wash of sap green and yellow ochre, leaving white areas

of paper for the highlights. While the paint is still wet, use cotton buds to soak up the colour from those parts of the fruit which are to be painted red.

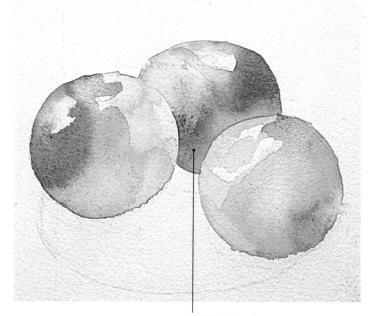

2. THE CHEEKS

Mix alizarin crimson with raw umber and apply this to the white areas on the apples to create the red cheeks. Work quickly, without allowing the paint to dry. If necessary, you can re-wet the area with clean water. The warm red bleeds into the damp green, the result being a natural looking contour and a gradual merging of the two colours.

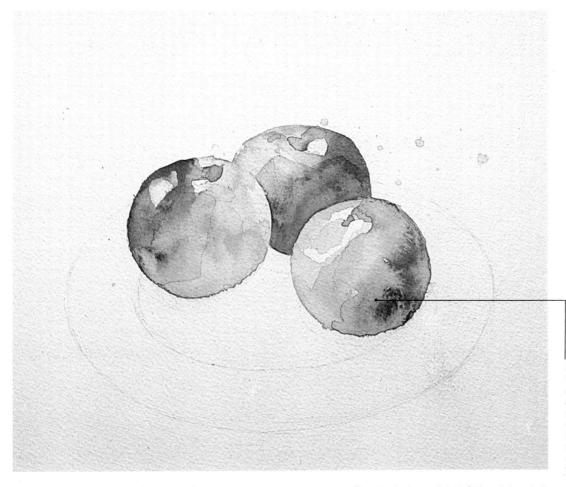

3. APPLE SHADOWS
Paint a little raw umber into the apples while they are still wet, allowing this to merge into the red and green. This slightly darker tone represents the lighter shadows on the fruit; its use means that you are starting to describe the round form of the apples.

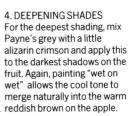

5. THE PLATE
Mix a thin wash of Payne's grey
to depict the edge of the plate
and to suggest the shadows
that lie underneath the apples.

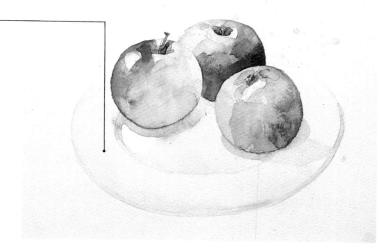

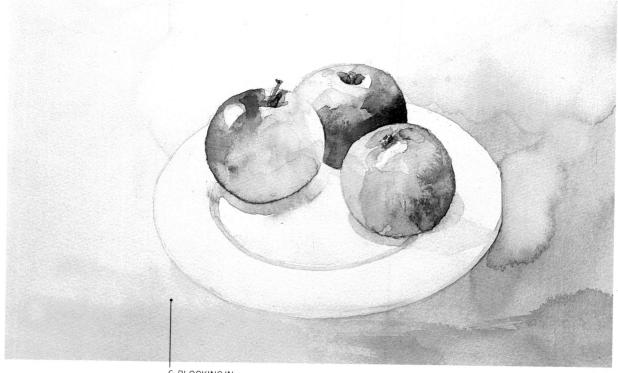

6. BLOCKING IN
Use a thin solution of raw umber to
block in the table, working with a wash
brush and darkening the wash slightly
towards the foreground of the picture.
Suggest the wood grain with darker
streaks of the same colour.

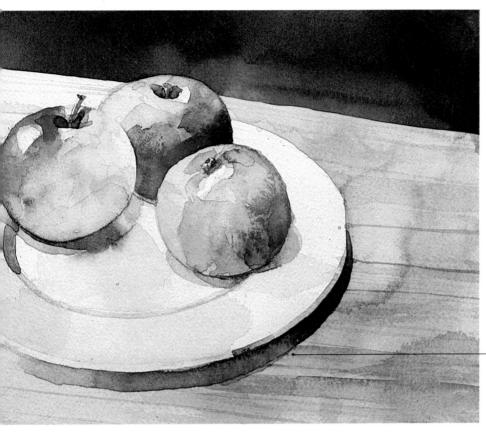

7. THE PLATE AREA Paint the shadow around the plate in Payne's grey, and then develop and strengthen the tones on the plate itself to match this.

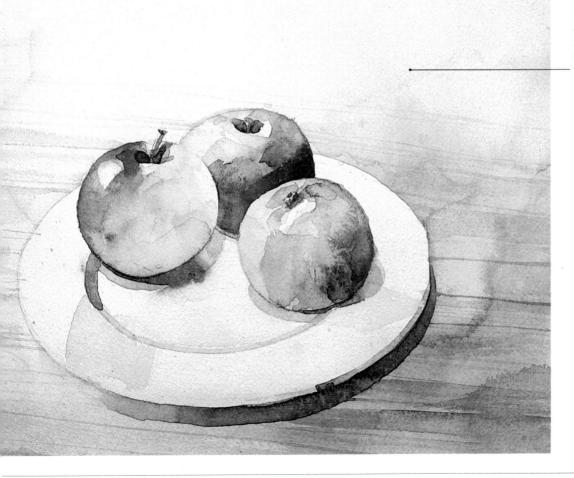

8. THE BACKGROUND Finally, paint the background in Payne's grey, making sure that the tone of this is of approximately the same strength as the darkest shadow areas on the main subject.

THE ARTIST'S FATHER

A CENTRAL FEATURE of this graphic portrait is the use of warm and cool colours in the flesh tones – an area of painting which has tested the skills of artists for centuries. Where human flesh is concerned, the highlights are usually warmer and lighter than they would otherwise be, while the shadows are cooler and darker. These principles have been adopted, refined and adapted by artists through the centuries, all of whom have developed their own individual touches. Here, too, the artist has followed a personal approach, using brown madder alizarin, cadmium orange and sepia for the warm areas, and Payne's grey, indigo and black for the cooler ones. These have been applied as thin overlapping layers of colour, picking out the planes of light and shade on the model's face. The deepest shadows, around the eyes and eye sockets and underneath the chin and neck, are predominantly cool grey, with discernable touches of warmer tone relating them to the rest of the face. The strongest light tones, down the lefthand side of the face, are depicted by the colour of the white paper.

The background is blocked in with sap green and gumwater, giving it a lively textural quality and enriching the colour of the paint. This creates a pleasing contrast with the figure itself, which is actually quite flat — an effect caused mainly by the clothes. The shirt and jacket are painted as light, flat areas.

WATERCOLO	UR PALETTE
Brown Madder Alizarin	Cadmium Orange
Sepia	Payne's Grey
Indigo	Ivory Black
Sap Green	Cadmium Red
Raw Umber	
SUPPO	ORT
Stretched care	tridge paper

 406×558 mm (16×22 in)

1. STARTING POINT Start by blocking in the warm, light

start by blocking in the warm, light tones of the face with an extremely diluted wash of brown madder alizarin and cadmium orange. You may find it helpful to start with the forehead, and then to establish the position of the eye sockets with cooler shadows. Though it is not essential, you may

also find it useful to make a light pencil drawing before you begin to paint. Then develop the shadow tones, working slowly and building up the layers of tone gradually. Generally, you should wait for each area to dry before proceeding, but occasionally lay some paint wet on wet, as this makes the skin tones blend slightly.

2. SPECTACLE FRAMES
Use the tip of the brush – the artist here is using a No. 4 sable – to paint the frames of the spectacles with Payne's – grey and raw umber. The solid colour of the spectacles provides a useful tone against which the strengths of subsequent lights and darks can be assessed.

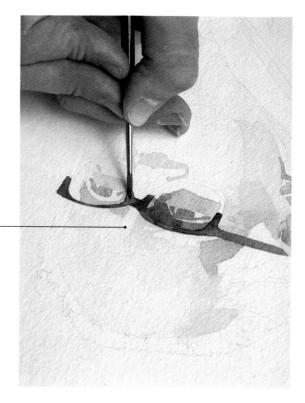

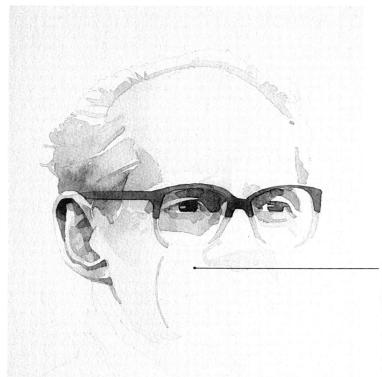

23. FACE AND HAIR Continue to build up the face tones. For the warm areas use brown madder alizarin and cadmium orange, occasionally adding sepia and a little Payne's grey to vary the colour and tone of a particular area. For the cooler, dark shadows, mix indigo, black and more Payne's grey with the warmer colour. Allow the whiteness of the paper to represent bright highlights. Paint the hair in indigo and black.

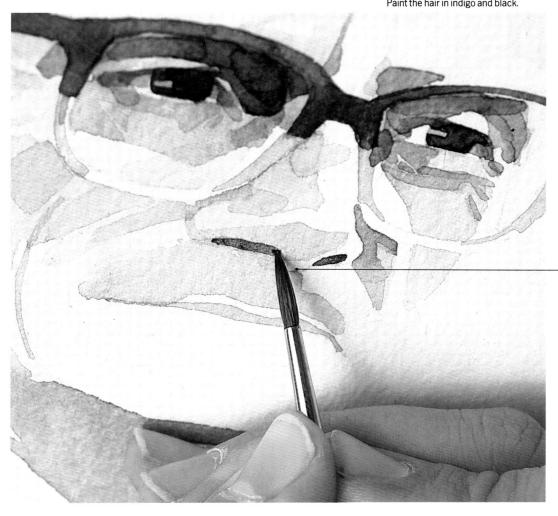

4. CREATING THE FORM Work down the face, building up and overlapping tiny areas of warm and cool planes to create the form. Paint in the dark tones of the eyes and nostrils in Payne's grey mixed with a little of the flesh mix.

6. THE JACKET
Use Payne's grey for the jacket. Paint this as a flat shape, but allow more colour to flood into shaded areas, such as the shadows under the collar and the wrinkles of the sleeves.

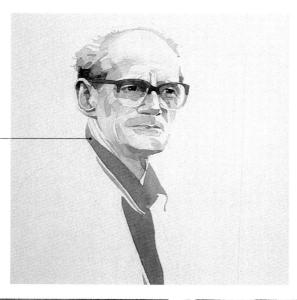

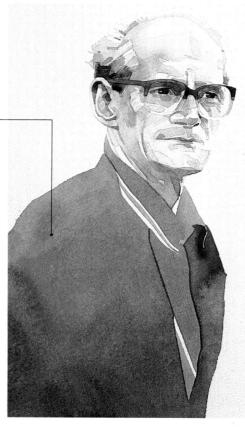

5. DEVELOPING SHADOWS

Develop the main shadows, blocking in the cool area under the chin in Payne's grey and indigo mixed with a little of the warmer skin tone. Look carefully at the shape of this shadow, which helps describe the form of the chin, throat and neck. When the neck area is completely dry, block in the shirt as a flat shape, using cadmium red toned with a little sepia. Allow this to dry.

7. THE BACKGROUND
Paint the background in sap green mixed with gum water, using a wash brush to create bold, broken texture. The gum water enriches the paint, so producing a slightly glossy surface. This creates a nice contrast with the thin, somewhat matt surface of the figure

8. ADJUSTING TONES
The new rich background inevitably affects the tones on the figure, making some of them look faded and drab in comparison. Here, the artist is working into the shadows on the clothing, considerably darkening these to match the background tone.

9. FINISHING TOUCHES
In the finished picture, the
tones have been substantially
developed, both to emphasize
the form of the figure and to
strengthen the subject in
relation to the surrounding
background.

DARK TO LIGHT

WORKING FROM dark to light is only possible with opaque paint; gouache, therefore, is an ideal medium. This technique gives the artist more freedom than the traditional watercolour method of painting from light to dark (see pp 136-7). When painting with gouache, you do not have to decide in advance which areas will remain light; instead you can change the painting as you work, and add light touches at later stages, just as with oils. However, you must still work quickly, remembering that gouache is also a water-soluble paint: for instance, if you have painted a red flower, and you then add a vellow centre to it, you will find that the underlying red will mix into the new wet paint, if you work it around too much.

Gouache is frequently combined with pure watercolour, particularly for adding paler details and highlights. This technique has been employed for centuries; the early watercolourists made use of what they called "body colour", which was in fact a form of gouache.

CREATING FORM

Whereas the cylinder on page 136-37 is built up from light to dark in transparent washes, the approach here is reversed. Using opaque paint, start with an overall dark colour then gradually build up successive layers of light tone. Finally, add the lightest colour to the top of the cylinder.

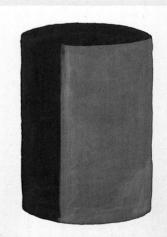

BUILDING UP TONE

When using gouache, light colours can be applied over dark ones. Unless the gouache is very diluted, the top pale colour completely hides the colour beneath

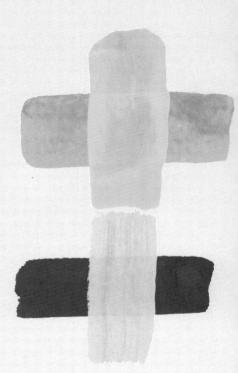

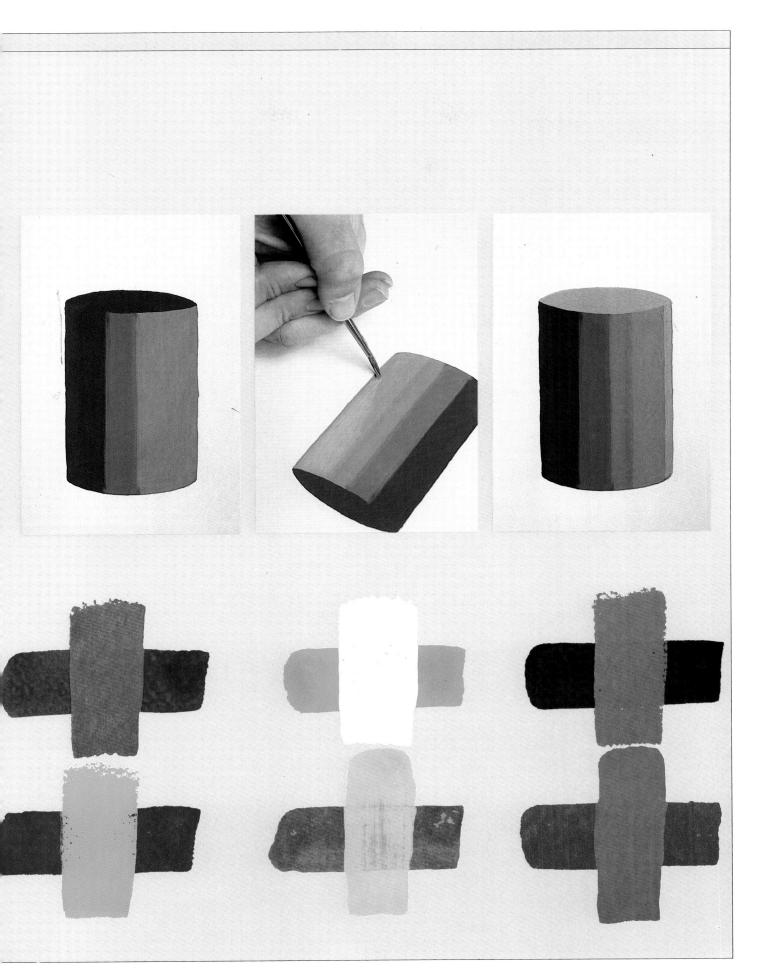

JARS WITH DRIED FLOWERS

THE OPAQUE QUALITY of gouache has been exploited to the full to create this fresh, colourful painting, which is full of earth tones highlighted by touches of reflected daylight. Starting from the warm tone of a piece of tinted card, the artist has used the opaque paint to work lighter tones onto darker ones.

Though the technique is slightly unconventional, there are still parallels with classical watercolour procedure. The gouache has been heavily diluted, producing a thinner mixture. Parts of the support have been allowed to show through as well — just as white paper does in traditional light-to-dark watercolour.

The tinted card plays a positive role, since its warm tone suits the subject's main elements, which are depicted in warm natural beiges and browns. The chairback, for instance, is left untouched, showing through the painting as a beige silhouette.

The flowers form a splash of colour in the middle of the earthy tones. These are created in traditional gouache style, working from dark to light. The artist has blocked in the flower areas with deeper tones — usually the local colour of the flower with black added to darken it. In this way, the main shapes of the heads of the flowers have been established. Then brighter, lighter colours are applied, brushstrokes being used to describe the different types of petals and flower characteristics — as with the short, spiky strokes used to paint the chrysanthemums.

WATERCOLO	OUR PALETTE	
Gou	ache	
Jet Black	Yellow Ochre	
Raw Umber	Burnt Sienna	
Cadmium Yellow	Lemon Yellow	
Titanium White	Ultramarine Blue	
Cadmium Red	Alizarin Crimson	
SUPPORT		

Sepia coloured card 533 × 533mm (21 × 21in) 1. INITIAL BLOCKING
Decide how you want to
position the subject in the
picture, and make a simple
pencil drawing to establish this.
Then, working from an initial

palette of black, white, yellow ochre, raw umber and burnt sienna gouache, start to block in the darkest tones of the subject.

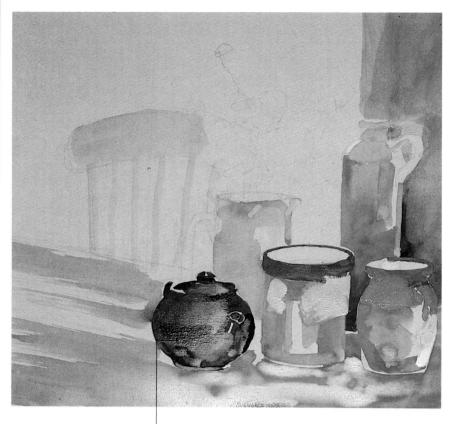

2. DEVELOPING THE TONES Without allowing the dark tones, to dry, develop the subject by adding the lighter tones and some local colour. Use black and raw umber for

the teapot; raw umber, cadmium red and black for the rim of the centre jar; and mix white with a little of the local colour to paint in the lighter tones elsewhere.

3. THE BACKGROUND

Block in the large background areas in white mixed with a little raw umber and yellow ochre, working with a large brush (here a No. 12 Dalon watercolour brush is being used).

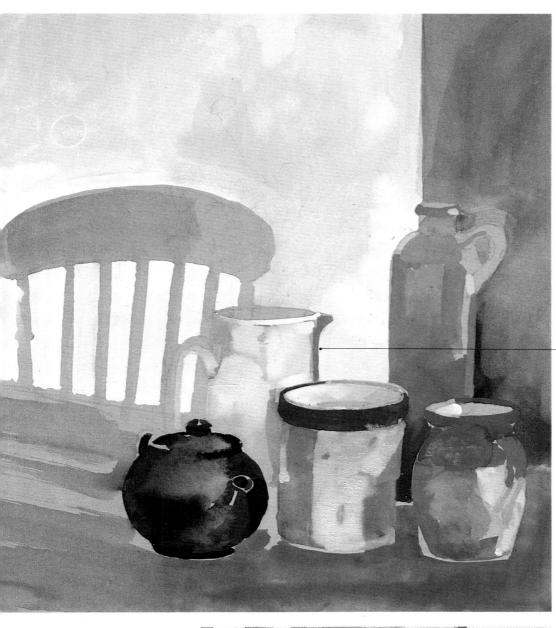

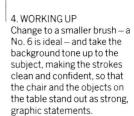

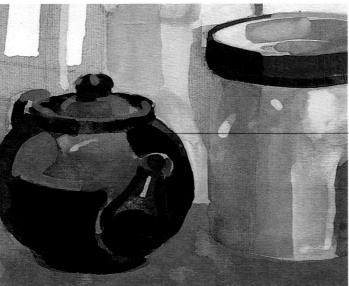

5. DESCRIBING THE TEAPOT Now, turn your attention to the objects themselves. Work into these, applying broad planes of light and shade in order to describe their forms. The white jug, for example can be depicted in just two tones—both mixed from varying proportions of white, yellow ochre and black. Similarly, develop the teapot and the earthenware pot next to it, working in two or three tones of the appropriate colours. Because the objects are glossy, the highlights are almost white, modified with a small quantity of local colour.

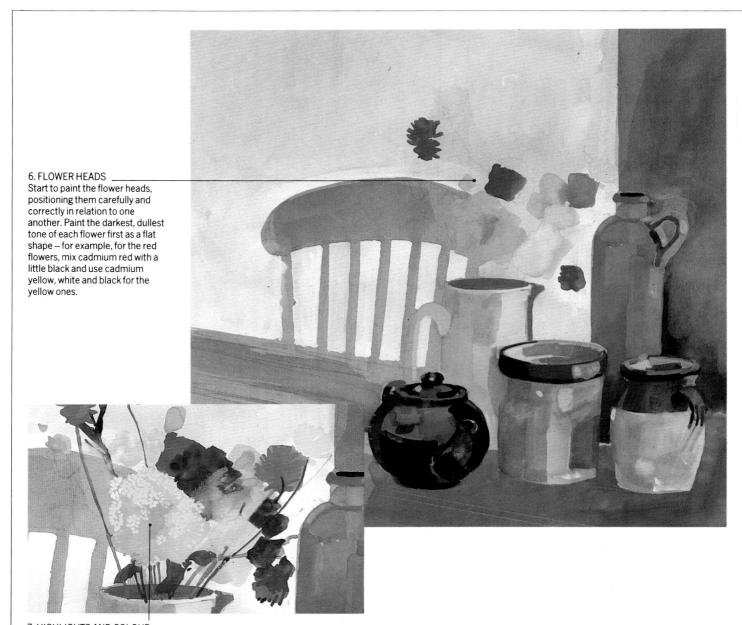

7. HIGHLIGHTS AND COLOUR When you start to develop the flowers, use a No. 4 sable brush to add bright highlights and colour to the petals. The opacity of the paint enables you to paint light tones over darker ones quite easily.

8. TEXTURE AND DETAIL Look carefully at the texture and character of each bloom, choosing and manipulating your brushstrokes to depict the petals on each type of flower accurately.

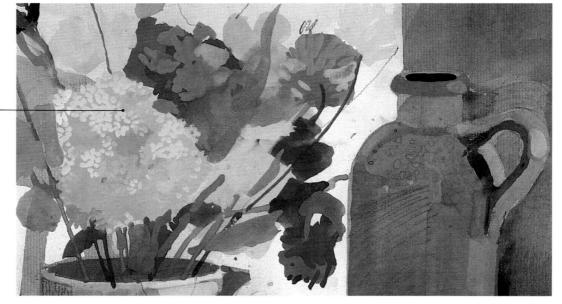

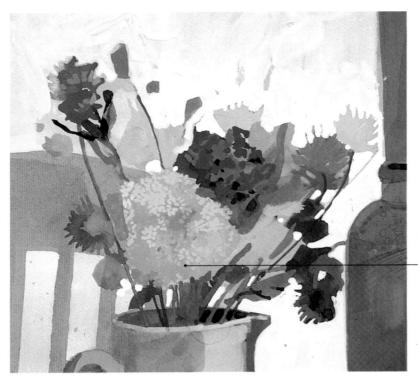

9. FLOWER DETAIL
Use cadmium yellow, lemon
yellow and white to dot in the
bright flecks on the large
yellow flower; ultramarine and
white for the blue flower;
cadmium red, cadmium yellow
and white for the bright red
flower; and alizarin and white
for the bright pink bloom.

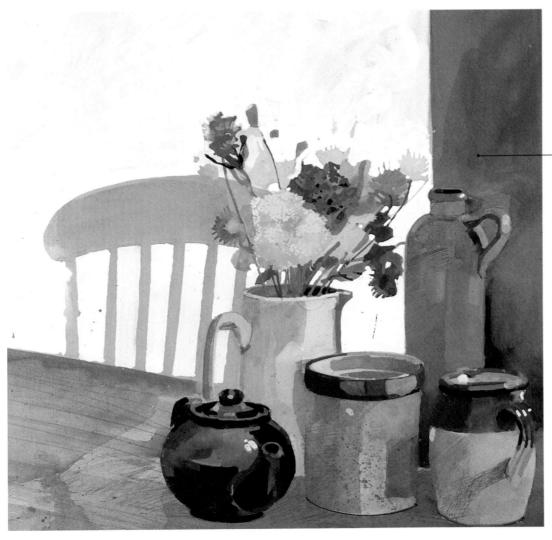

10. THE FINISHED PAINTING
The warm, harmonious tones
of the finished painting are
greatly enhanced by the
choice of sepia coloured
stationer's — not artist's — card
as the support. The earthy
sepia is allowed to show
through deliberately in places,
reflecting the general colour
theme of the subject and
helping to hold together the
separate elements.

SUNLIT FIELD

THE OPAQUE QUALITY of gouache allowed the artist to work light onto dark to produce a vividly graphic picture of countryside flooded with sunlight. The graphic approach is a characteristic of this particular artist, who has worked as an illustrator, and the composition is seen very much in terms of shape, colour and tone. It works as an abstract arrangement as well as a landscape. Linear elements, such as the barbed wire fence, have been introduced, together with a variety of textures which contrast with the slightly stylized way in which the artist has simplified the composition.

The artist wanted to tint the background – a classical painting technique. However, this popular method (usually employed by oil painters) in which the canvas is toned before starting, is impossible with ordinary watercolour because of its transparency; neither can the ground be tinted with gouache, because even when dry the paint is still soluble. For a specific tint you can lay down a coat of insoluble acrylic paint first. In this case, however, the artist found a sheet of medium-tone green paper which was perfectly suited to the colour scheme. With this medium tone already established, lighter and darker tones, related to the tone of the paper, could then be added.

WATERCOLO	OUR PALETTE
Gou	ache
Sap Green	Sepia
Ivory Black	Yellow Ochre
Titanium White	Cadmium Yellow
Coeruleum	
SUPI	PORT
	nted paper
356×508 mr	$m(14 \times 20in)$

1. FIRST STAGE

Working on medium-toned green paper, start by making a light outline drawing. Then, using the colour of the paper as a middle tone, look for the darkest tone present in the subject — in this case, the shadows in the tree foliage. Mix this colour from sap green, sepia and ivory black, and paint in the shadow shapes with a No. 2 sable brush. Use the same colour for the trunk of the tree.

2. GRASS
Loosely wash in the field, using a light wash of yellow ochre and sap green, and a wash brush.
Leave patches of the paler paper showing through to represent the light areas of the grass.

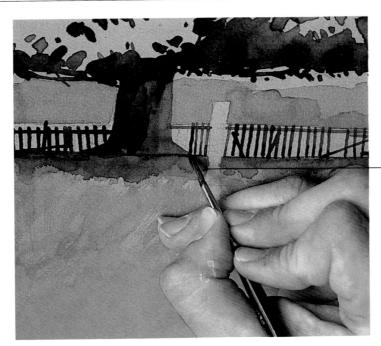

3. FENCE Paint the fence in a mixture of ivory black and sepia, with a No. 2 sable brush.

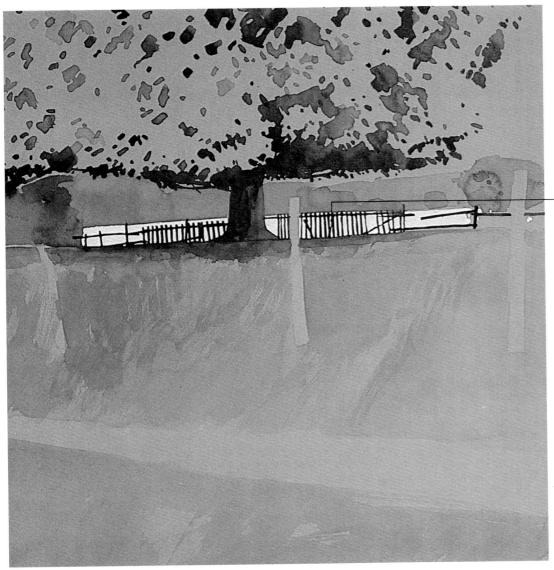

4. NEGATIVE SHAPES
Mix titanium white and
cadmium yellow for the sunlit
field, and pick out the negative
shapes – the shapes of the
spaces – between the fence
posts. Take the light yellow
carefully up to the dark posts,
defining the shapes and
throwing the fence into sharp,
linear silhouette against its
paler background.

5. SKY
For the sky, mix white with a little
coeruleum blue. Use this to dot in the
tiny fragments of sky showing between
the leaves, and to block in the larger
expanse behind the tree.

6. GRASS TEXTURE Scribble in the grass texture with bold, jagged pencil strokes. Here, the artist uses a green pencil, and an ordinary graphite drawing pencil to suggest tall, wavy grass.

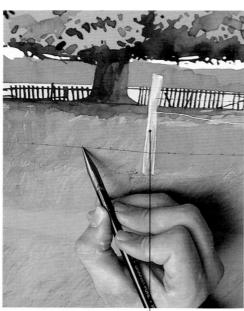

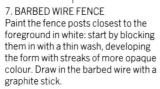

8. BARBED WIRE

Draw the top strand of barbed wire with a fine, light grey pencil line.

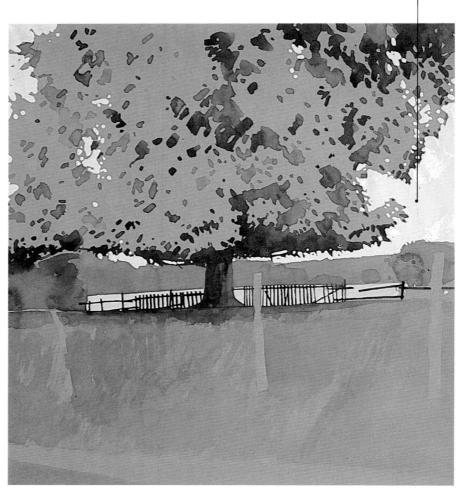

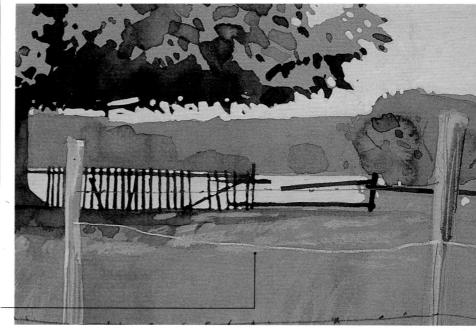

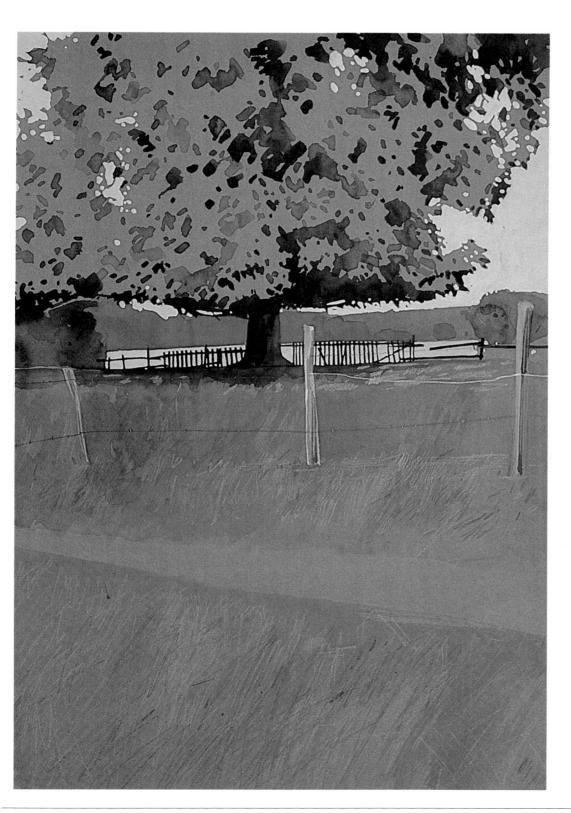

9. FINISHING TOUCHES
By using light and dark tones
on medium-toned paper, the
artist has successfully and
graphically captured the
effect of sunlight and flickering
shadows in this rural scene.
The textures are subtle but
varied, providing just enough
contrast with the matt gouache
paint to transform an
arrangement of flat shapes
into a lively and unusual
pictorial composition.

WATERCOLOUR PENCILS

USE WATERCOLOUR PENCILS as you would ordinary coloured pencils, to work in loose scribbles, or in quite fine, precise detail. When you have completed the picture, or a stage of the picture, with pencils, you can use a wet brush to blend the colours.

You will never have quite the same control over the result as you would with watercolour paint, because when you wet a coloured pencil mark, the colour often becomes darker and brighter. If your pencil strokes are too heavy in the first place, especially with the dark colours, then the water will be unable to dissolve the lines completely, and the pencil marks will show through. Practice is vital, so that you will know what to expect.

Watercolour pencils are probably most effective when water is used only on parts of the painting. This creates a contrast between the "painted", and the textural, pencilled areas.

Not all supports are suitable for this recent medium. Some watercolour papers, particularly the more textured ones, tend to disintegrate. When the artist tried to blend colours for the project, "Woman by a Window" (see pp 216-9), he found that the surface lifted off some papers. Finally, he chose a smooth illustration board.

A wet brush drawn through a spectrum of watercolour pencil marks, shows how the colours react to water. Experiment freely to obtain particular effects.

WORKING ON WET

1. Moisten each area of the paper, just before you start working on it.

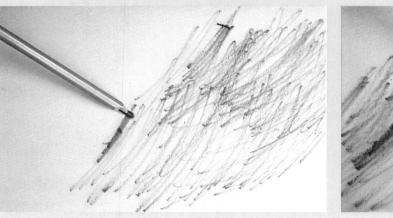

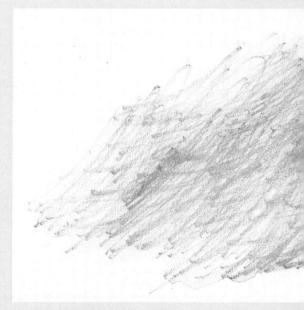

WOMAN BY A WINDOW

IN THIS LOOSELY worked composition of a woman looking out at the view from her window, the artist has fully exploited the versatility of watercolour pencils. These are sometimes used as ordinary coloured pencils, to create a scribbly broken texture in certain areas, and sometimes as traditional watercolour paints to create smoother patches of blended colour. There is an interesting contrast, for instance, between the treatment of the interior - the figure and the room, both of which are rendered in bold textural pencil strokes - and the view through the window. The artist decided to make the exterior scene into a watercolour "painting" by dissolving the colours. Thus, a picture within a picture has been created, while looseness, too, is one of the central themes. Even the figure, the focal point of the composition, is quite freely treated.

Remember, though, that, if you are using water to blend the colours, it is often easier to simplify the image into areas of pure unmixed colour. This is because a clogged, overworked surface will result if coloured pencils are used one on top of the other indefinitely. For this reason, the artist has kept the figure simple and direct, relying on single colours and the dramatic contrast of light and shade on the form, rather than attempting to build up complex layers of colour. Thus, the shaded side of the woman, her back, is mainly blocked in with black. The front of the woman, her front profile, has been left as white paper. Between these two extremes, the colours used are minimal - just a few flesh tones and the bright red of the dress.

WATERCOLOUR PALETTE

A set of 24 watercolour pencils

SUPPORT

Smooth illustration board 356×508 mm (14×20 in)

1. BLOCKING IN THE DRESS
Block in the shadows of the dress
in black, the lighter dress areas in
red, and the flesh tones in light
pink. Use the pencils in exactly the
same way as you would work with
ordinary, coloured ones, building
up the tones in layers of crosshatched strokes.

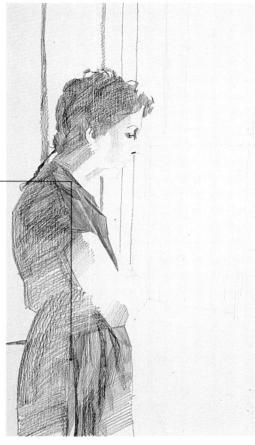

2. THE FACE
Use a mid brown for the facial shadows, blending these into the lighter areas with an eraser to achieve a smooth transition between the light and dark planes.

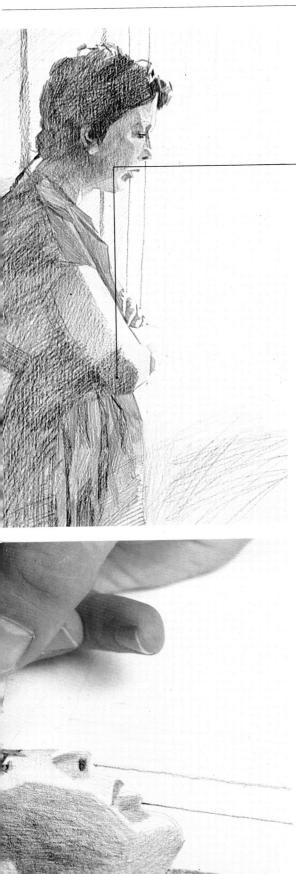

3. BUILDING UP
Continue building up the
planes, using several layers of
light, regular strokes for the
dark tones — this is better than
trying to establish these tones
by pressing heavily on the
pencils. Not only does the
lighter rendering look more
effective, but the colours are
also easier to control when
used in this way.

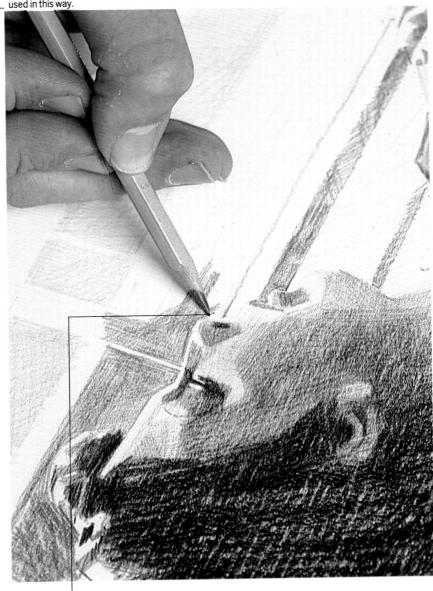

4. HIGHLIGHT
When blocking in the background behind the figure, use the white paper to represent the highlight along your model's profile. Use a sharp pencil to ensure a crisp shape.

5. INTERIOR TONES
Use a ruler for the straight
lines of the window frame,
rendering these with neat,
regular strokes. Working in
loose strokes, block in the
interior tones — the wall
underneath the window and the
shadow behind the figure.

6. THE VIEW
Loosely sketch in the view as seen through the window, blocking in the tones and the approximate shapes of the bridge, trees and river.

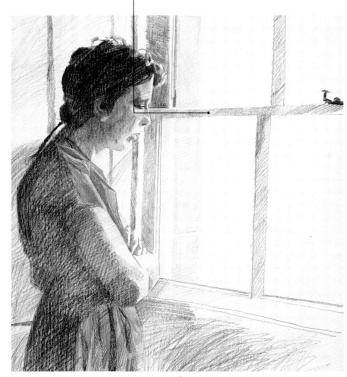

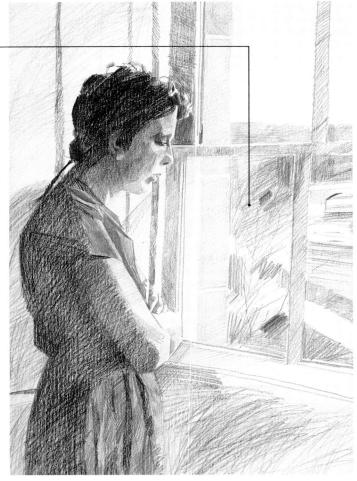

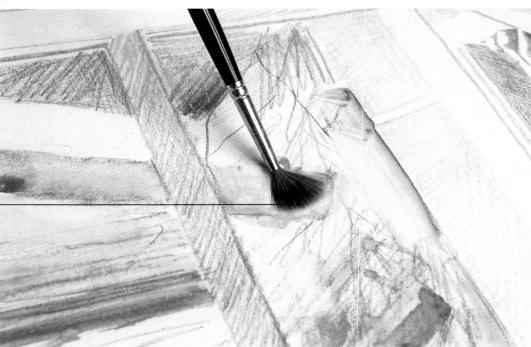

7. BLENDING CONTOURS
Now, using a sable brush and clean water, start to blend the colours of the scene framed by the window.

8. WASHES AND BLOBS
Instead of looking for detail, aim to create loose washes and blobs of colour – an effect similar to that of conventional watercolour painting.

9. THE FINISHED PICTURE

The completed picture shows how two techniques – the loose pencil hatching and the smoother blended tones – can be used in a creative and spontaneous way to enhance the subject. By blending the outdoor colours, the artist has created a picture within a picture, contrasting the interior of the room with the scene outside it.

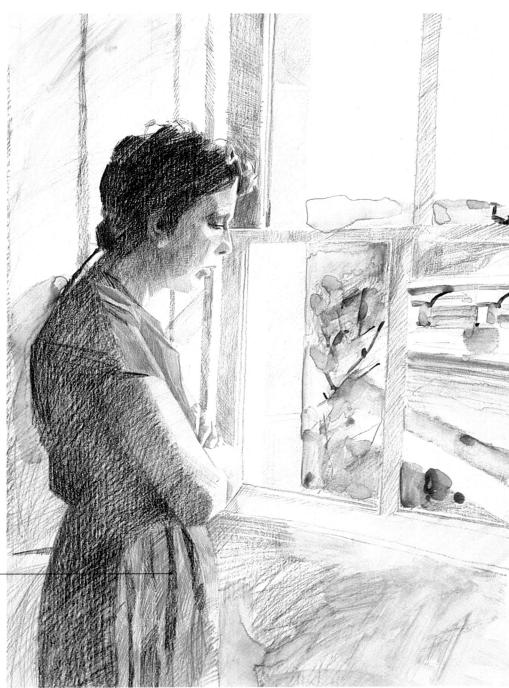

MIXED MEDIA

WATERCOLOUR CAN BE — and has been — combined with almost every other medium, including oil paint. Because watercolour can be applied in thin, flat washes, you can begin by blocking in the subject with pale areas of paint. The colour dries without affecting the texture, or the surface of the paper. This means that you can then work on the dried surface with a great variety of drawing materials — pen and ink, charcoal, pencils, magic marker, pastel, and many others — singly or in combination.

You can also exploit the fact that watercolour does not mix with wax or oil. If you apply wax crayon, oil pastel, turpentine or thin oil paint to an area of the paper, it will resist the watercolour, and the area covered will remain intact – part of the colour and texture of the picture.

Working with mixed media allows the artist scope for creativity and experimentation. As you try out different materials, you will become more familiar with their particular qualities, and with the way they react in combination. As your skill increases, you will be able to experiment with increasing confidence and success; for, more than any other area of water-colour, this is a field where personal taste and originality play an important role.

WATERCOLOUR ON OIL PASTEL 1. Apply the oil pastel.

2. Lightly wash the colour over the pastel. Try not to scrub the pastel with your brush.

3. The oil pastel resists the paint, and its colour shows through the wash.

GOUACHE, CHARCOAL AND

OIL PASTEL

1. Apply an initial layer of colour, using gouache.

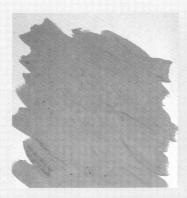

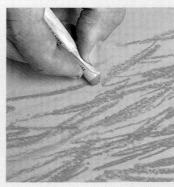

3. You can also draw on the gouache with charcoal.

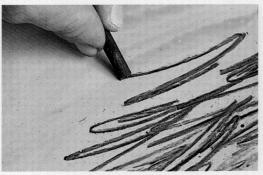

4. Next, add more watercolour, or gouache. The oil pastel resists the paint, but the charcoal mixes, unless it has been protected with fixative.

- 5. Continue to experiment by adding more broken colour. Other materials, such as ink, pencil, and chalk can be introduced to create different effects.
- 6. The varied materials have combined to produce a result where each is still visible; thus contributing to the final effect.

CORN ON THE COB

THIS IS A BOLD experiment with a simple subject and a plain, rather severe style of composition, which could easily have failed, but is enlivened by the use of mixed media.

The picture is basically a watercolour, but the artist used white gouache for the light tones, highlights and some of the linear detail, all of which were added in the later stages. The aim from the start was to achieve a stark, graphic simplicity. The shadows were deliberately painted in a rather flat and dull grey, so that initially they had no more than a compositional role, the straight lines being broken by the organic shape of the stalk of corn. To offset the flatness, the artist worked vigorously into the lines of shadow with a loosely scribbled cross-hatching. This was particularly emphasized in the darker shadows thrown by the corn.

Coloured and graphite pencils were used for the cross-hatching and other parts of the picture, which contributed to the variety of textures. Both types of pencil adhere very well to a matt-painted surface, though the disadvantage is that you cannot easily rub out the marks. Unless you are very experienced, it is best to use pencils in areas where spontaneity will work well, rather than for the more definitive parts of a picture. In any case, it is more effective if you restrict the textured part of a picture to selected areas. Should you overdo this process, the image can look bitty.

WATERCOLO	UR PALETTE
Yellow Ochre	Raw Umber
Cadmium Yellow	Sap Green
Payne's Grey	Ivory Black
Lemon Yellow	
Goua	che
Titanium White	
SUPPORT	
Ivorex Card	
381×508 mm (15×20 in)	

1. THE MAIN SHAPES Working without a preliminary drawing, wash in the main shapes of the corn, positioning the subject fairly centrally and leaving plenty of space around it. Use sap green for the leaves and cadmium yellow

2. BUILDING UP Using deeper versions of the initial washes, work into the corn, building up and strengthening the basic colours. Refer constantly to the subject, using dark tones to suggest the form and shape of the cob.

3. THE TABLETOP
Mix a weak wash of yellow ochre
plus a little raw umber to block
in the first warm tones of the
tabletop. When this has dried, use
Payne's grey to depict the strong
criss-cross shadows and to pick
out the shadows under the leaves.

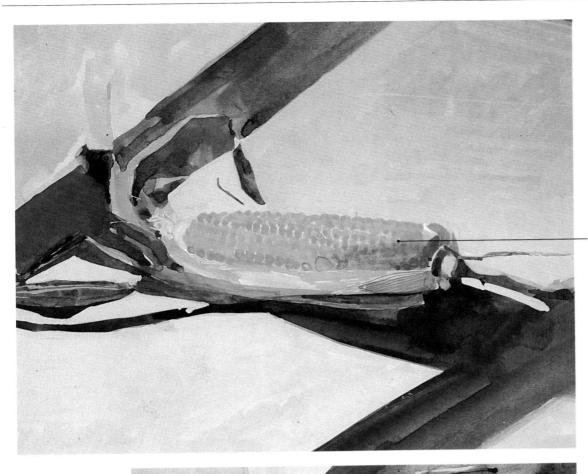

4. DEVELOPING TEXTURE
Working with the tip of a No. 3
brush, start to develop the
texture and detail on the corn.
Paint the striped leaves with
sap green mixed with a touch
of ivory black; add the dark
patches on the corn with raw
umber, and suggest the
surface texture with regular
brushstrokes of cadmium
yellow and raw umber.

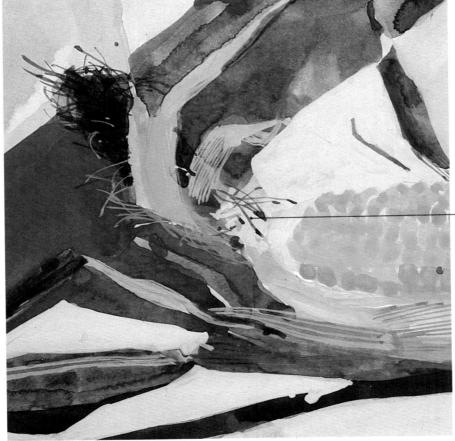

5. THE FOLIAGE
Using the same brush, paint the feathery parts of the foliage in fine lines of diluted black and white. Look closely at the subject and simplify what you see, taking care to make the painted version as subtle as it is in real life.
Clumsily painted lines will dominate and spoil the work.

6. THE SEED SHAPES Use lemon mixed with white gouache ose leftfor mixed with white gouache to clarify the tiny seed shapes on the corn, and then dot in small dark shadow tones of raw umber. When these are dry, add a sharp white highlight to each one, defining the surface texture of the cob.

7. LEAF LINES
Use thin white gouache to paint light lines on the leaves – this brings out the brittle-looking ridges of the foliage.

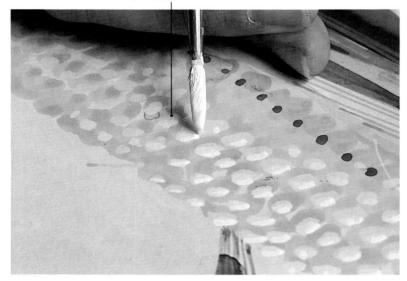

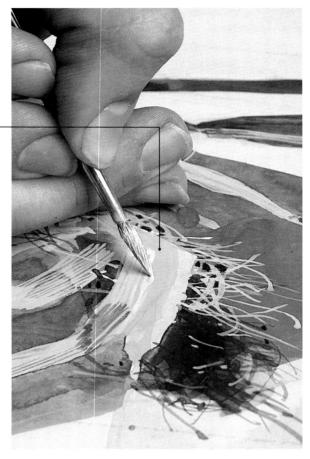

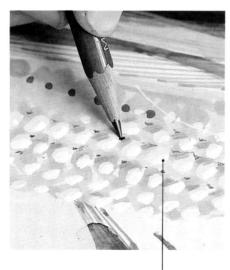

8. SHADOW SPOTS Scribble more deep shadow spots into the corn with a graphite drawing pencil.
The matt paint surface takes the pencil well, with the lightest scribbled marks showing up as quite dark shapes.

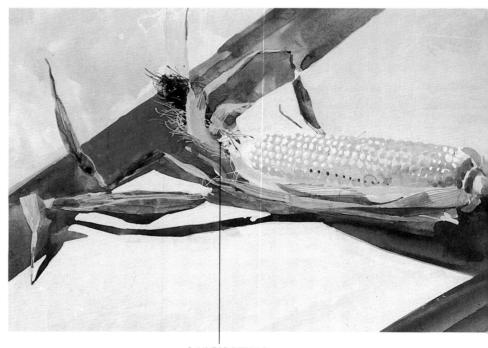

9. LINEAR DETAILS Use coloured pencils to draw in linear details elsewhere. Here, dark green and dark grey are used to develop the leaf patterns, with some light grey on the highlights.

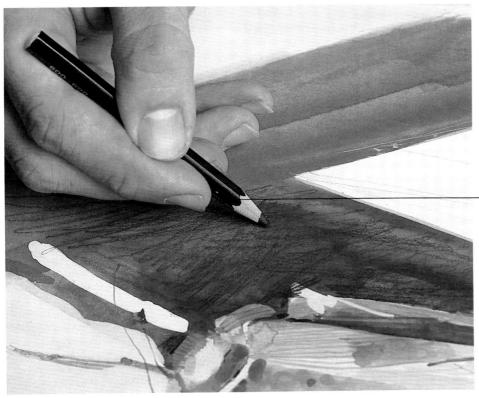

10. DARKENING THE SHADOWS
Work into the shadows with a black pencil,
breaking up the flat grey shapes into areas of
rich, dark texture. Enliven the painted surface
with bold scribbled cross-hatching strokes,
also using them to darken the shadows around
the corn.

11. THE FINISHED PAINTING
The characteristics of the corn have been captured exactly in watercolour and white gouache, with some textural pencil work in the final stages. The use of white gouache enabled the artist to build up the pale tones and highlights and to sculpt the seeded surface by dabbing bright white over pitted pencil shadows.

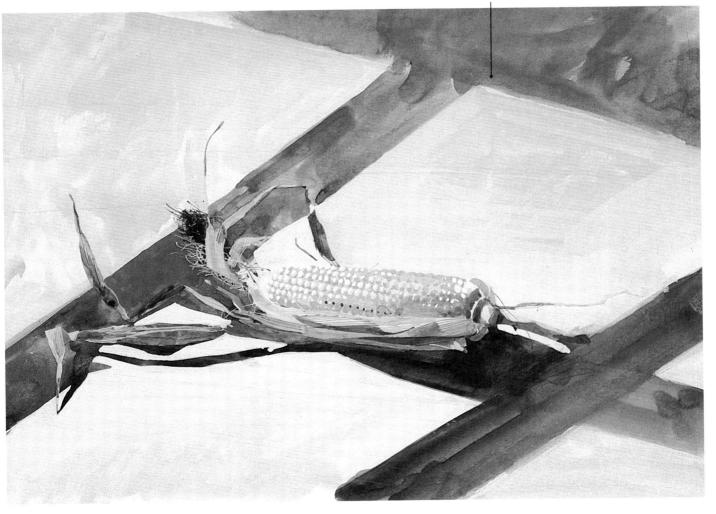

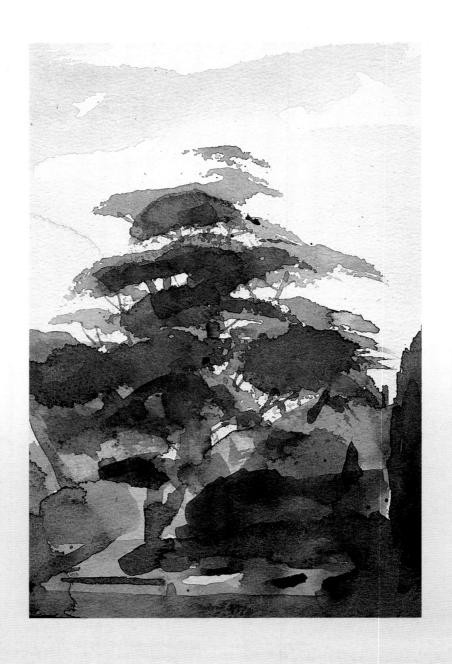

SIMPLE TECHNIQUES

IF YOU FIND A particular subject complicated or difficult, remember that sometimes there is a simple way of tackling it. One point to bear in mind is that, although most artists paint what they see, parts of their pictures are often rendered according to a standard formula, which they may well have worked

out over the years.

There is nothing wrong with reverting to a well-tried technique - indeed, such techniques can often be adapted to help you depict a specific problem subject. Beginners, for instance, often find water, skies and trees daunting; if, however, you study the work of professional artists - and that of great masters of the past - you will frequently find that they, too, have been confronted with the same problems and have developed their own, often simplified, ways of coping with them.

WINTER TREES

IT IS IMPORTANT to look at trees in the same way that the figure painter looks at the human form. When painting the figure, an artist must bear in mind the bones and muscles which dictate the visible shapes and forms. Trees, too, have skeletons — underlying structures which dictate the shape and form of the whole — even though these may be hidden by thick foliage. To paint trees successfully, you must always be aware of this structure and the forms within it.

Look at trees during the winter months, when you can see clearly the growth pattern of the trunk, branches and twigs. When drawing and painting trees, start with the main trunk and the larger branches, working outwards towards the smaller twigs, as the artist has done in this project. Pay particular attention to the shape of the spaces between the branches and twigs: these will help you to establish the positive shapes – the branches themselves.

1. BASIC SHAPE Start with the trunk and main branches, looking carefully at the way in which the branches radiate from the main trunk, and at the shapes of the spaces created between these branches. Use a light wash - here, the artist worked in black and raw umber with a darker tone of the same colour to suggest the shadows on the rounded forms. 2. SMALLER BRANCHES Draw the smaller branches with the tip of the brush, working outwards from the main forms.

WATERCOLOUR PALETTE

Black

Raw Umber

SUPPORT

Stretched cartridge paper 254×356 mm (10×14 in)

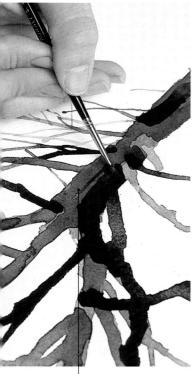

3. SHADOWS Introduce bold, black shadows to the trunk and main branches – this helps to create a sense of volume and solidity.

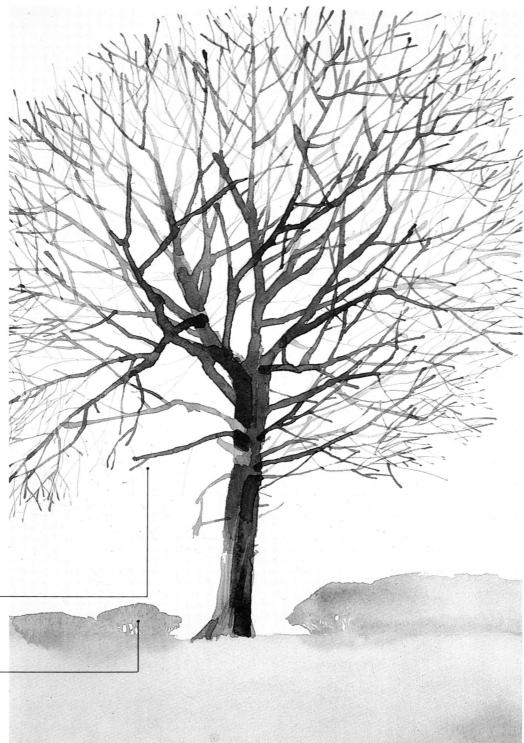

4. FOREGROUND BRANCHES You can also give a feeling of space to the tree by darkening some of the foreground branches, so causing them to stand out from the main tree shape.

5. FINISHED TREE _____ There is no secret formula for painting trees; however, because every tree, whatever the type, has a similar structure, you can always start with this basic approach. At the same time, every tree is different, and must be carefully studied and analyzed if it is to be painted successfully.

SUMMER TREES

ONE OF THE tricks to remember when painting trees in the distance is to avoid the temptation to paint details that you know to be there, even if you cannot actually see them. What you must try to do is to capture the specific shape and structure of the trees, which is evident even from a distance.

Remember, too, that there is no "correct" way to paint trees; various techniques can be used, as this picture demonstrates. You can paint them with a brush, working from light to dark and either building up the leaves as small dabs of colour, or treating the foliage more broadly as a single mass. Alternatively, you can use a sponge – the rounded end of a synthetic sponge is perfect for the umbrella-shaped branches of certain trees

WATERCOLOUR PALETTE

Cobalt Blue Sap Green

Lemon Yellow Sepia

Payne's Grey

SUPPORT

Stretched Bockingford paper
356 × 533mm (14 × 21in)

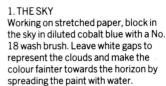

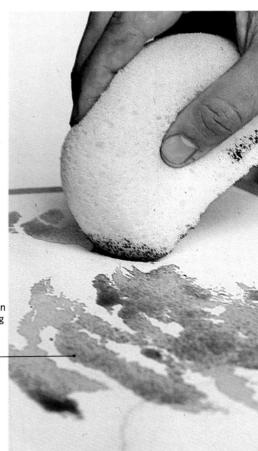

2. BRANCHES AND FOLIAGE
Mix a thin wash of sap green, lemon
yellow and a little sepia for the trees in
a shallow mixing dish or saucer. Using
the rounded end of a synthetic
sponge, dab in the shapes of the
branches and foliage.

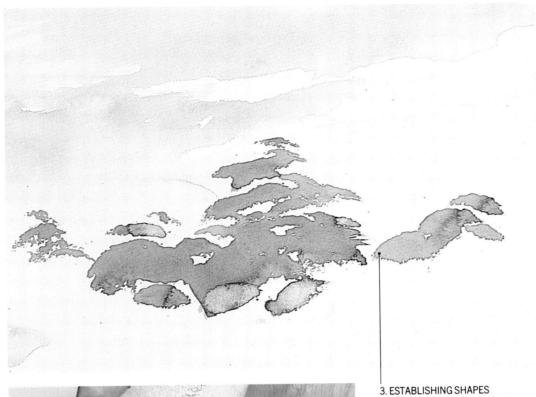

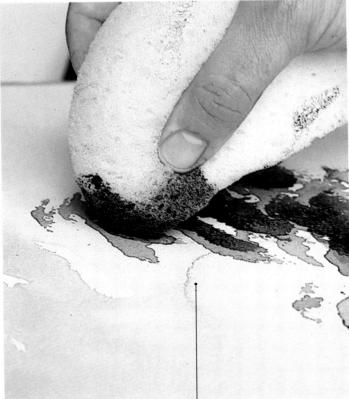

3. ESTABLISHING SHAPES
Continue applying this initial light
tone with the sponge until all the
main tree shapes are well
established.

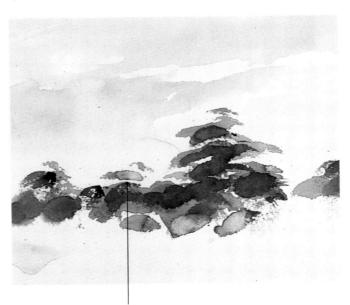

4. DARKERTONE
For the darker foliage tone, mix
Payne's grey, sap green and sepia
together. Still using the rounded end
of the sponge, dab shadows onto the
previous shapes in a slightly lower
position.

5. SPONGING PRECAUTION
Do not overdo the sponging – too
much will flatten the texture and spoil
the effect. As here, a few lively marks
are sufficient to indicate the form of
the leafy branches.

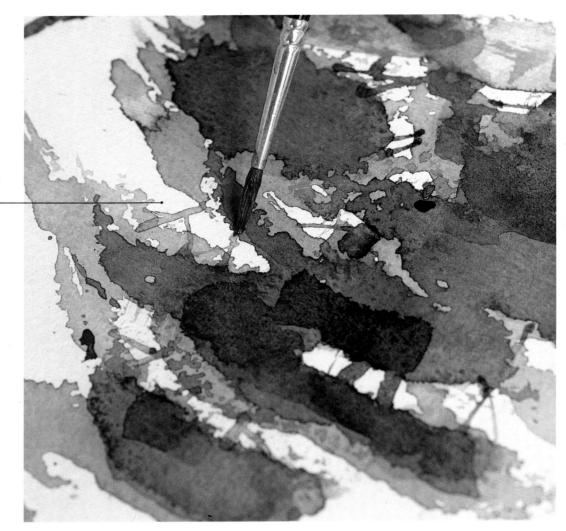

6. TWIGS AND BRANCHES Paint in the twigs and branches with the tip of a round sable brush, using a thin solution of Payne's grey.

7. THE CONIFERS
Mix a thin wash of Payne's grey and sap green for the conifers, painting these initially as flat shapes.

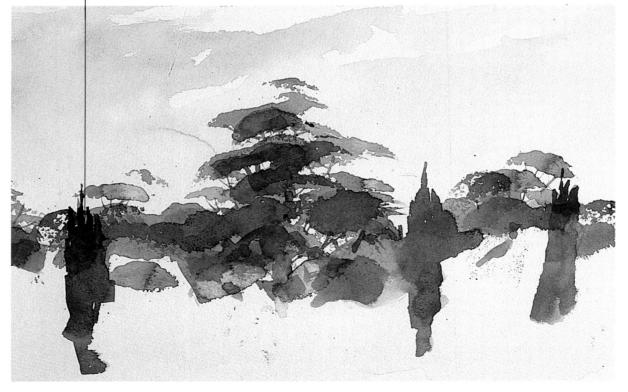

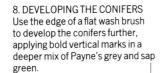

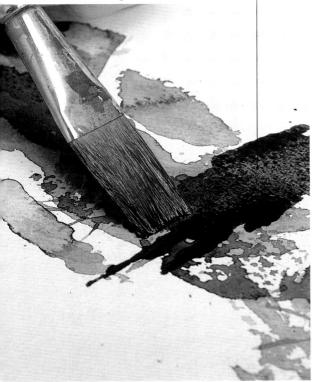

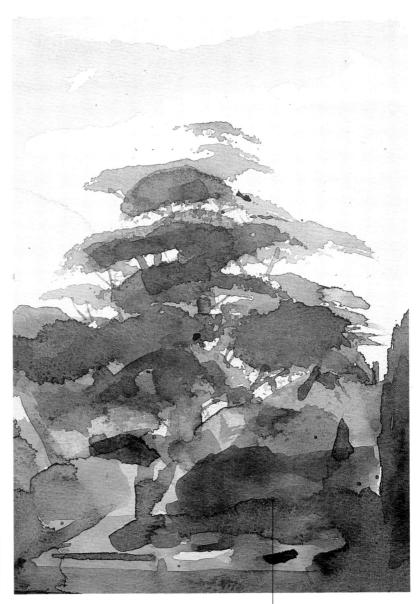

9. DARKENING THE WHOLE Take this dark tone into the rest of the composition. Work quickly, allowing the loose blobs of colour and the brushmarks to describe the foliage.

10. FINISHING TOUCHES Finally, block in the foreground in Payne's grey and sap green, adding touches of lemon to this to indicate the sunlit areas between the trees.

STUDY

CONTRARY TO THE nebulous impression you may have of them, skies often contain quite clear shapes and have distinct markings. Here the artist has recognized this, using masking fluid to block in the clouds, and depicting each one as a sharply defined shape. Although these eventually needed softening and modifying, the masking fluid enabled the artist to treat each cloud independently, and to add shadows and reflected sunlight to the basic forms. Remember most clouds have a distinctive threedimensional form, which can be described by the light and shadows falling upon them.

1. PAINTING THE SHAPES Using an old brush, paint the cloud shapes with masking fluid. Allow the fluid to dry before proceeding.

through the wash. Leave the

wash to dry. Using the same

brush, paint dark horizontal

stripes across the sky with a

and indigo. Again, fade the

of the painting. Allow to dry.

diluted mixture of Payne's grey

colour towards the lower edge

2. INITIAL WASH

Apply a pale wash of

coeruleum blue, fading this

picture by adding more water

to the paint. Use a large wash

flecks of the support showing

towards the bottom of the

brush, leaving small white

WATERCOLOUR PALETTE Coeruleum Payne's Grey Indigo Ivory Black Yellow Ochre SUPPORT

Stretched Cartridge Paper $275 \times 350 \text{mm} (11 \times 14 \text{in})$

234

3. REMOVING THE FLUID
Rub off the masking fluid
carefully. If you use your
finger to do this, wash your
hands first; if you use an
eraser, make sure it is clean.
Any dirt will make grubby
smudges.

4. SOFTENING CLOUDS

To modify the hard shapes of
the newly-revealed clouds,
use a smaller brush, such as
a No. 7 sable, and paint the
underside of the clouds with
a light wash of ivory black
mixed with yellow ochre.

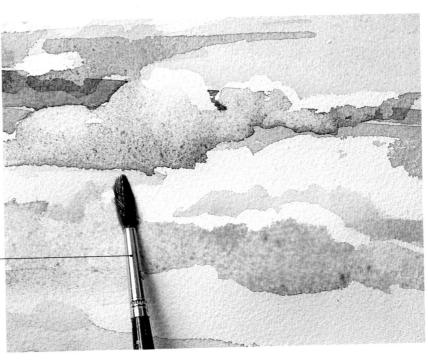

5. FINISHING TOUCHES
Use the same mixture of
black and yellow ochre to
add small dark fluffy clouds
and to break up any large
flat areas of the first wash.

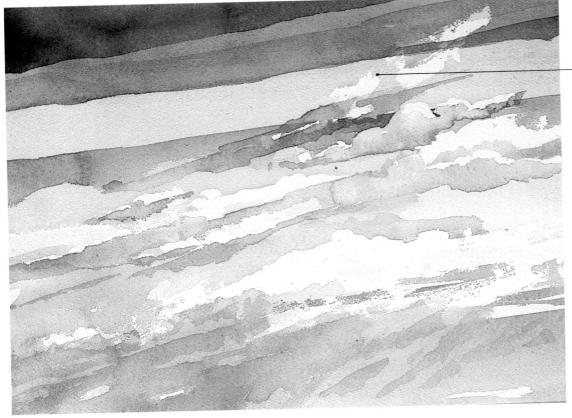

SUNSETS

SKIES VARY enormously, from lowering thundery ranks of cloudbank to bright red and yellow sunsets like the one depicted here. Each sky should be viewed in the same way as any other part of a picture, being examined for its own characteristics and colour and for the way light falls upon it. In this painting the colours are predominantly red and yellow, with streaks of warm Davy's grey introduced for the darker areas. These streaks of broken grey are a crucial part of the composition, giving scale and depth to the expanse of red and yellows.

graded wash, running from lemon yellow to cadmium red, over it. Work quickly, using a large wash brush to help you blend the colour.

1. GRADED WASH Wet the paper and lay a

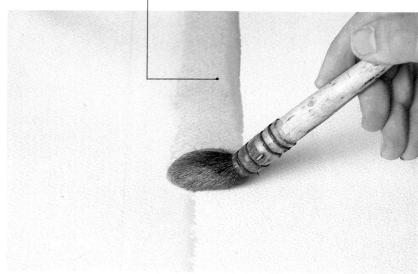

2. DRYING STAGE Allow the wash to dry thoroughly before applying further colour.

WATERCOLOUR PALETTE

Lemon Yellow

Cadmium Red

Davy's Grey

SUPPORT

Stretched Cartridge Paper 275 × 356mm (11 × 14in)

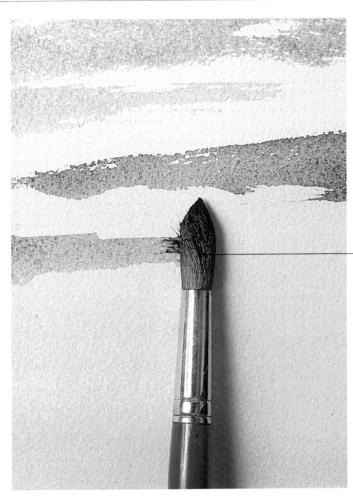

3. USING THE GREY
Mix a weak solution of Davy's grey
(this is a particularly warm tone)
and block in the top of the
painting, blending the edge into
the red and yellow wash with clean
water. Use a No. 10 sable brush to
roll the grey across the painting,
so creating irregular broken
streaks of dark cloud. Allow to dry.

4. DARKENING THE TONE Work over the upper part of the sky with a deeper solution of Davy's grey, allowing the lighter colour to show along the lower edge.

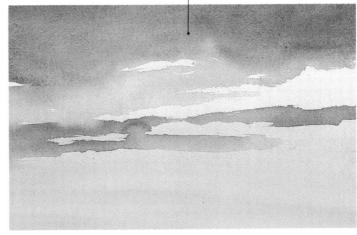

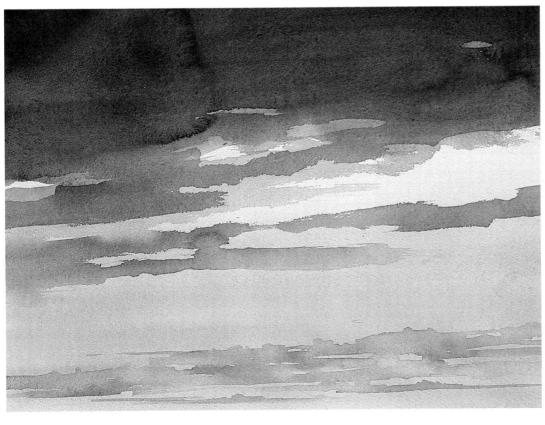

5. THE FINISHED PICTURE
Just three colours were all that
was needed to create this
effective impression of the sky
at sunset. The technique is
simple and quick, requiring
just a little patience in allowing
the paint to dry between
stages.

GOUACHE SKIES

USUALLY, A FLAT blue sky is something to avoid, as it will make the resulting picture look uninteresting. If you neglect the sky, with all its indication of weather and light, you will find that the final composition has been fatally flattened. Even when depicted by a minimum of brushstrokes or colour, the sky is still a focal part of the overall composition, and conveys a great deal about the scene. Here the artist has created a living, moving sky by simply applying a few loose strokes of gouache.

1. FIRST STEP
Apply a mixture of coeruleum blue and titanium white gouache loosely across the top part of the painting with a wash brush. Try to vary the consistency of the paint – this will cause the colour to dry in uneven patches, so creating the effect of the irregularities, clouds and reflections that are

3. SPREADING THE WHITE.

Spread the white quickly with

your wash brush, dragging the paint into the wet blue. Use a

little water to make the thick

white paint more workable.

WATERCOLOUR PALETTE Gouache

Coeruleum

Titanium White

Ivory Black

Yellow Ochre

SUPPORT

Ivorex.board 356×508 mm (14 × 20in)

4. CREATING CLOUDS
Roll the brush, flicking the white
gouache across the flat blue to create
an impression of fluffy clouds. Keep
the brushstrokes as fresh and lively as

possible and allow them to represent the clouds on their own. Do not be tempted to work into the marks, trying to neaten or "improve" the shapes as this will spoil the effect.

5. FINAL TOUCHES
Finally, define the forms of the clouds
by applying a little diluted ivory black
and yellow ochre to their undersides.

USING A SPONGE

ALTHOUGH SKIES differ in an almost infinite number of ways you can begin by laying down a thin wash and then soaking up areas of this with a sponge to represent clouds and light patches.

From this base, you can then work in any detail you wish. This basic format can be used to depict varying conditions, from a bright summer day to an overcast, threatening sky. Here the artist has worked with dark tones – hence the thundery appearance of the low clouds.

1. THE INITIAL WASH
Apply a diluted wash of cobalt
blue and indigo across the
whole paper. Add more water
to the mixture as you move
towards the horizon at the
bottom of the picture.

2. CREATING THE CLOUDS
Allow the wash to partially dry,
and then work into the damp
paint with a small sponge to
create the cloud shapes,
dabbing and rubbing to soak

up the colour. Continue sponging until most of the colour has been absorbed, leaving small irregular patches of pale blue between the white clouds.

WATERCOLOUR PALETTE

Cobalt Blue

Indigo

Alizarin Crimson

Ivory Black

SUPPORT

Bockingford paper, stretched 254×330 mm (10×13 in)

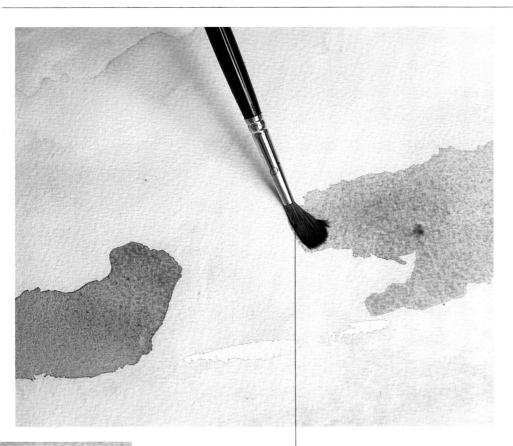

3. DARKENING THE SKY
When the paint is dry, work into the sky with streaks of a darker tone — alizarin, indigo and black. Roll the brush to obtain elongated stretches of this colour, painting around the clouds to define the shapes.

4. THE FINISHED PAINTING
The deep colours used here give the impression of a heavy, thundery sky.
By changing the colours and tones or adapting them slightly, you can create an entirely different atmosphere and weather conditions.

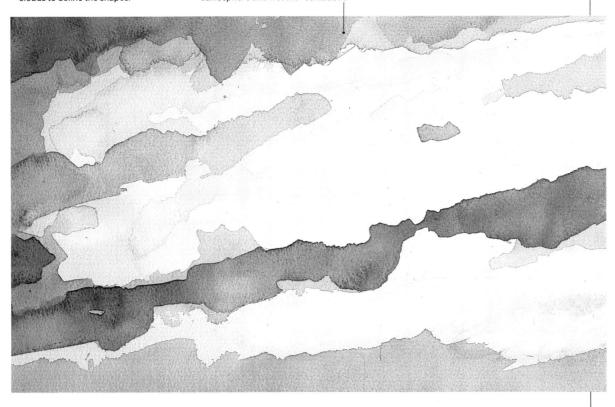

CHOPPY WAVES

THIS SUBJECT, the frothy, rough effect of choppy waves, is a favourite of the artist, who has developed his own particular approach to the problem of capturing the movement of the water. He starts by using horizontal brush-strokes to indicate reflective areas of the water, developing on this slightly with added darker colour.

The key element here is the white gouache, which is first rolled thickly on with the brush to suggest the texture of the froth or foam. Thinner white gouache is then spattered along the top of the foreground waves to create a convincing imitation of spray.

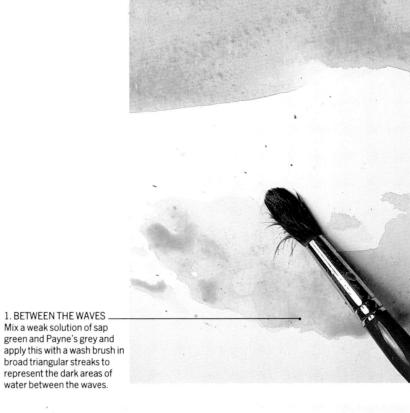

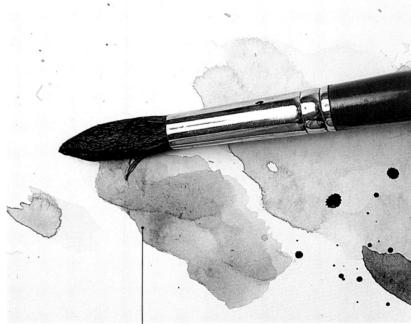

2. SURFACE RIPPLES
After the first wash has dried,
work into the same areas with
a deeper version of the same
colour, plus a little coeruleum.
Apply the new colour in
horizontal strokes to indicate
the shadows of the surface
ripples. The ripples in the
foreground should be choppier
and more pronounced than
those in the distance.

WATERCOLOUR PALETTE Sap Green Payne's Grey

Coeruleum Payne's Gre

Gouache

Titanium White

SUPPORT

Daler watercolour board 356 × 406mm (14 × 16in)

3. USE OF GOUACHE Roll thick white gouache across the white areas of paper to create the frothy texture of the waves.

4. SPATTERING
Mix some white gouache to a runny consistency and spatter th crests of the waves with a sma decorator's brush, to achieve th impression of foam.

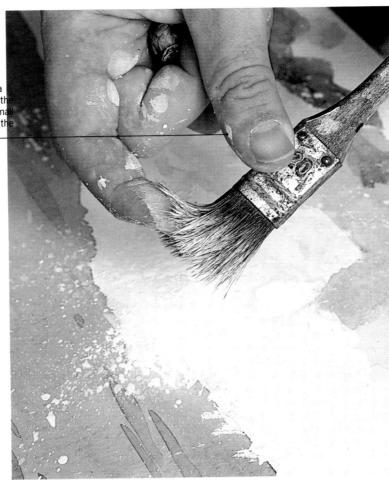

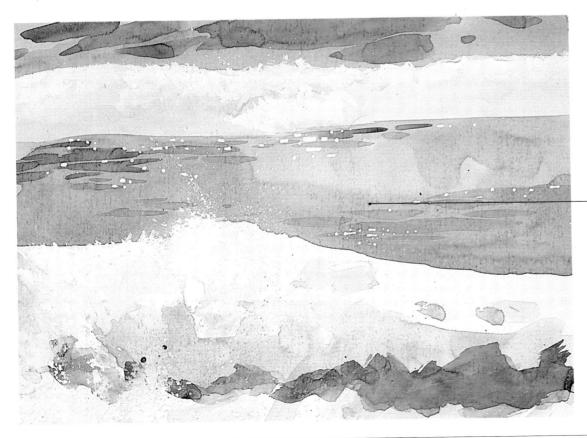

5. FINISHING TOUCHES Finally, change to a smaller brush and spot in tiny white flecks to represent patches of froth on the water.

WATERFALL

A SHALLOW WATERFALL tumbles into a pool surrounded by rocks and grass – the artist has captured the movement through the ripples on the surface of the water, which radiate outwards from where the waterfall flows into the pool. The ripples are simply described in terms of light and shade, while the addition of a little spattering as an extra touch brings the waterfall to life.

1. POOL AND GRASS Loosely splash a pale mixture of sap green and indigo across the pool area with a wash brush. Paint the grass with a fairly deep sap green and then leave the paint to dry.

2. FOLIAGE AND ROCKS
Mix a slightly darker solution of cobalt blue and ivory black, and wash in the swirling surface of the pool, leaving the light ripple shapes unpainted. Block in the dark foliage across the top of the composition in sap green mixed with ivory black, and paint the rocks in a very pale wash of ivory black and yellow ochre.

3. CREATING THE RIPPLES When the water area is dry, work into it with a deeper wash of sap green, cobalt blue and a little black. Again, leave most of the ripple shapes untouched, and create new ones by leaving more swirling shapes unpainted. Use ivory black for the shaded undersides of the rocks, dragging the colour into the water to represent reflections.

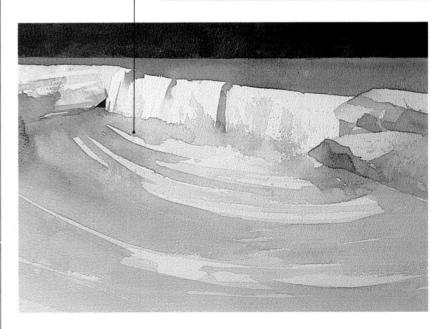

WATERCOLOUR PALETTE

Sap Green

Indigo

Cobalt Blue

Ivory Black

Yellow Ochre

SUPPORT

Stretched cartridge paper 305×381 mm (12×15 in)

4. RIPPLE SHADOWS
Using a smaller brush, such as a No. 4 sable, paint in the shadows of the ripples. Use black, sap green and cobalt blue for this, picking out the underside of the ripple shapes, and adding new smaller ripples around those already depicted around the waterfall.

5. FINISHING TOUCHES
Still using the shadow colour,
paint in the dark shaded ridge
along the bottom of the
waterfall in jagged, vertical
brushstrokes. Complete the
painting by shaking a few flecks
of colour from the brush
across the lighter, top edge of
the waterfall to break up the
large area of reflection and to
give the impression of spray.

SWIMMING POOL

THE PROBLEM WITH painting this swimming pool was to capture the quickly-changing shapes on the surface of the water. The artist could have worked from a photograph or, as here, by carefully studying the characteristic shapes of the water in life and then aiming deliberately to give an artistic, rather than a totally realistic, impression in the actual painting.

The moving surface was also suggested by the distortions of the figure under water and the broken lines of reflection in the pool itself.

1. THE FIRST TONES. Start by making a light outline sketch of the figure with an H pencil. Then, with a small sable brush, such as a No. 2, block in the lighter figure tones with a pale wash of alizarin crimson and cadmium yellow. Allow to dry before painting in the second lightest tone in a mixture of sepia and brown madder alizarin. Carefully observing the shape of the figure through the distorting ripples of the water, mix a little ultramarine with the flesh tone and paint in the shadow tones of the parts of the figure that are underwater.

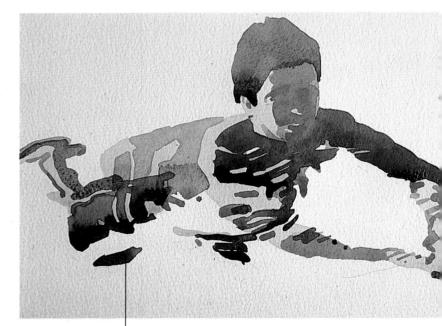

2. SHADOWS AND HAIR
Mix a deeper version of the
cool shadow tone, using these
to develop the dark
underwater shadows and to
block in the hair.

WATERCOLOUR PALETTE	
Alizarin Crimson	Cadmium Yellow
Brown Madder Alizarin	Sepia
Ultramarine Blue	Black
Scarlet Lake	Manganese Blue
SUPPO	ORT
Bockingford paper, stretched	
381×508 mm (15×20 in)	

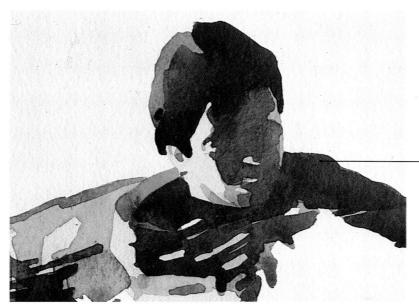

3. DARKS AND WARMS
Look for the deepest shadow tones on the subject, and block these in with a mixture of black and ultramarine. Add flecks of contrasting warm tone to the figure in brown madder alizarin mixed with scarlet lake. Allow to dry.

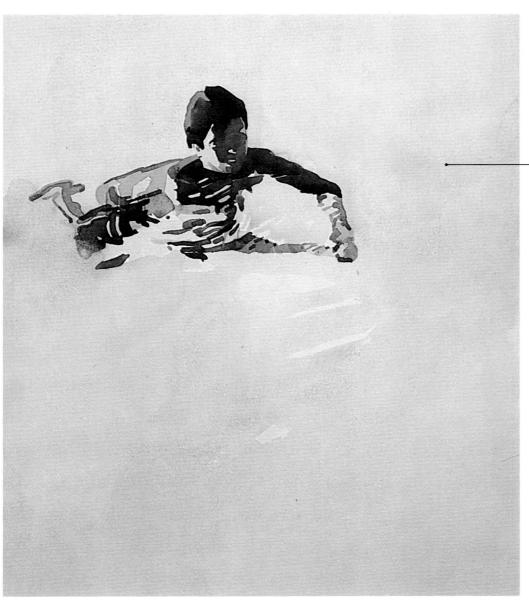

4. LIGHT WATER TONES
Paint in the lightest water tone
with a very diluted solution of
manganese blue and using a
wash brush. Leave flecks of
white paper showing to
represent the highlights.
Change to a smaller brush to
take the colour up to the edge
of the figure. Allow the water
colour to dry.

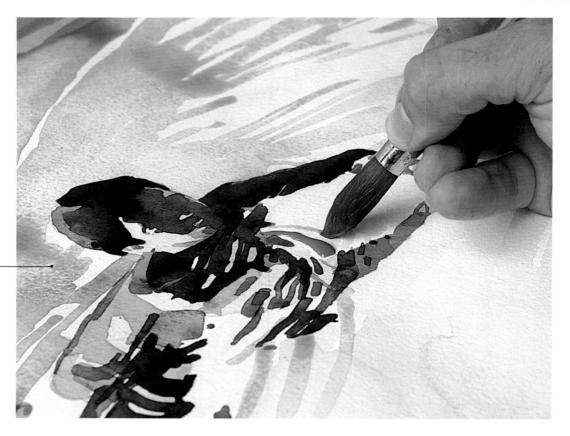

5. MEDIUM TONE Pick out the medium-toned shapes of the water with a deeper wash of manganese blue and using a No. 4 brush.

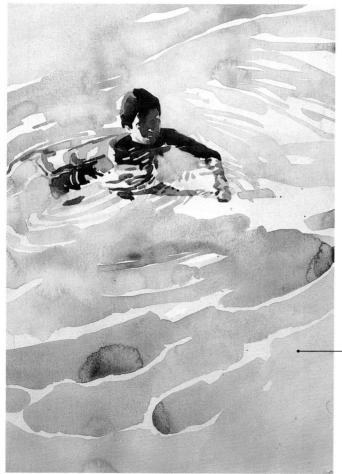

- 6. REFLECTIONS
Work across the water surface, applying the blue in loose, swirling strokes, trying to capture the character of the shapes and reflections. Add a little cadmium yellow to the blue as you move towards the bottom of the picture – this will give the water a greenish glow.

7. BLOCKING IN
Once the paint has dried, work over the water area with a mixture of ultramarine and manganese blue, blocking in the darkest reflections with this deep water tone.

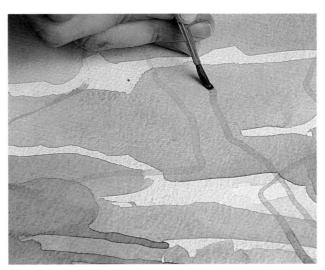

8. LINEAR REFLECTIONS Use a wash brush for the large areas, and a No. 2 sable for the linear reflections that zigzag vertically across the water.

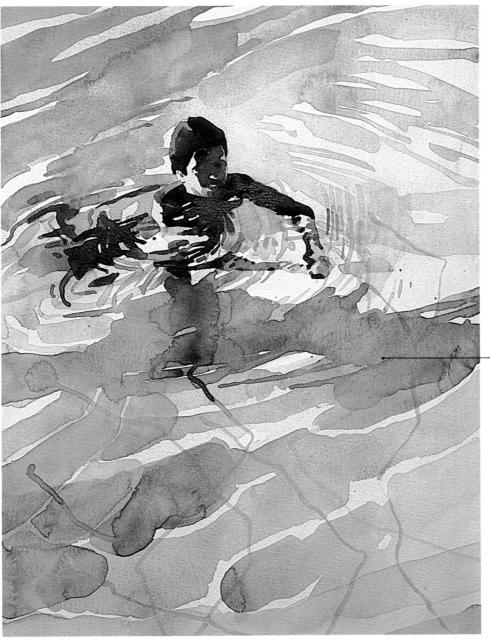

9. MULTIPLE TONES
A close-up of the water shows how simple the technique actually is to follow. The artist has used three tones of blue, allowing the paint to dry in between the various layers.
Colour was built up from light to dark, so creating the impression of moving light and reflections on the surface of the water.

GLOSSARY

ABSTRACT ART Art which does not depend upon a realistic approach to the subject matter to express form, colour and shape.

ACRYLIC PAINT Paint in which the pigment is bound with a synthetic resin. Developed in the 1920s and 1930s, acrylics do not fade and are resistant to atmospheric and weather conditions. Acrylics are diluted with water, but, once dry, they become insoluble. The paint can be used thickly like oils, or thinly to obtain an effect similar to that of watercolour painting.

ADDITIVE MIXING When the wavelengths of the light primaries – red, green and blue – are combined, the result is white. This is known as "additive mixing".

AERIAL PERSPECTIVE Distance and space are represented in painting by the way the artist depicts the air, or atmosphere. As objects recede into the distance they look fainter because they are seen through a haze of atmospheric particles.

ALCOHOL Spirit used to speed up the drying process of paint.

ASPECTIVE An unnaturalistic style of representation practised in ancient Egypt and found in many naive paintings today. Figures and objects are usually depicted in profile or with a full frontal view; scenes and landscapes contain no indication of perspective or scale.

BINDER A medium which is mixed with pigment to make paint. The traditional binder used in watercolour paints is gum arabic.

BISTRE A brownish pigment, traditionally made from soot or charred wood. In the 18th century bistre was used mainly as a wash – Rembrandt's pen and wash drawings are a good example of this.

BODY COLOUR Opaque paint, such as gouache, which has the "hiding" or "covering" capacity to obliterate underlying colour. White body colour is sometimes mixed with pure watercolour to make the paint less transparent.

BLOCKING IN Roughly filling in the main shapes and forms of the overall composition before developing specific areas or adding detail.

BRIGHT A short-bristled brush with a squared end.

CALLIGRAPHIC A term used to describe the artist's technique. "Calligraphic" brushwork generally means free, loose strokes which are used to produce a visual rhythm, similar to that of handwriting.

CARTOON A full-scale drawing, or design, on paper, usually done for a painting, mural or other finished work. The design is transferred onto the final support either by pricking the outline with pins, or by chalking the back of the cartoon and retracing the lines to reproduce a faint, chalky impression of the subject.

CLASSICAL Conforming to the tastes and models of ancient Greece and Rome. In the 18th century there was enormous interest in learning from the antiquities, hence the term "Neoclassical".

COMPLEMENTARY COLOUR Each of the primaries – red, blue and yellow – has an opposite, or complementary, colour created by mixing the remaining two primaries: for example, the complementary colour of red is green, which is a mixture of blue and yellow.

COMPOSITION Arranging or putting together the different elements of a subject to create a satisfying whole. The word is also sometimes used to describe a work of art, usually of a scene, or a group of objects or people.

COOL COLOUR Colour which is predominantly blue, green or violet.

CROSS-HATCHING Shading created by layers of overlapping parallel lines. The term usually applies to drawing, but cross-hatching is occasionally done in painting, especially tempera.

CUBISM A modern art movement started in Paris in the early 20th century by Picasso and Braque. The Cubists sought to analyze the structure, space and colour of the subject and to interpret these instead of making a purely representational painting. Cubism is generally regarded as being the forerunner of all abstract art.

DARK OVER LIGHT Because pure watercolour is transparent, the colours must be applied using the lightest tones first – hence "dark over light". The expression "light to dark" means the same thing.

DRYBRUSH A technique in which the moisture is squeezed from the brush before being loaded with fairly thick or undiluted paint. This is then dragged across the surface of the paper to create areas of broken colour and texture.

EARTH COLOURS Colours made from those pigments which come from the metal oxides. These include the siennas, umbers and ochres.

ENGRAVING Print taken from a metal plate on which a design or drawing has been gouged out with acid. The rest of the surface of the plate is protected from the acid by a coat of ground – a substance made from asphalt, beeswax, gum-mastic and pitch.

FERRULE The metal part of a paintbrush which holds the bristles in place.

FIGURATIVE A term used to describe works of art in which the subject is usually depicted as a recognizable form.

FILBERT A paintbrush which has flattened bristles and a tapered end.

FLAT A paintbrush which has short, flattened bristles.

FRESCO Wall-painting done on plaster in a medium similar to watercolour.

FRESCO BUONO "True" fresco, in which colour is applied while the plaster is wet. The technique, practised in Italy since the 13th century, is one of the most permanent forms of painting known.

FRESCO SECCO Less enduring than fresco buono, fresco secco is colour painted onto dry plaster.

FUGITIVE COLOUR A pigment which fades quickly, or is otherwise impermanent.

FUTURISM A modern Italian art movement dating from 1909 which rejected the stagnant, predictable art of the time, turning instead to the contemporary themes of speed, machines and violence for its inspiration.

GLYCERINE A liquid obtained from the fat and oil of vegetables or animals and used in the manufacture of watercolours.

GOUACHE An opaque type of watercolour, sometimes referred to as "body colour".

GRAIN The texture of paper or card. This may be fine or coarse, and is an important factor in creating paint effects.

GRAPHITE A type of carbon also known as "black lead" used in the manufacture of pencils. The carbon is compressed with clay for pencil making,

and is also available in sticks and powder form.

GUM ARABIC Water soluble gum from the acacia tree which is used as a binder in watercolour and gouache paints. Gum arabic can also be used to enhance the texture and colour of paints.

GYPSUM The mineral from which plaster of Paris is made. One of the earliest white pigments used in painting

HATCHING Shading by means of regular parallel lines. Mainly a drawing technique, hatching is occasionally used by painters, especially those working in tempera.

HERBAL A book containing the names, and usually the illustrations, of herbs and plants.

HIGH RENAISSANCE The later period of the Italian Renaissance, dating from about 1500 to 1527, which includes the works of Leonardo da Vinci and the earlier works of Michelangelo.

IMPRESSIONISM One of the most important movements in contemporary art. Impressionism was born in Paris in 1874 and its exponents – including Monet, Sisley, Renoir and Pissarro – were concerned chiefly with the effects of light and colour rather than line and structure. They often used bright, broken colour to achieve the shimmering effects of nature.

KELMSCOTT PRESS A printing press started by William Morris in 1890, for which he designed the type faces and the decorations.

LINEAR PERSPECTIVE Based on the rule that receding parallel lines on the same plane converge at a point on the horizon – the vanishing point. The system is used by artists to create accurate spatial distance in a picture.

LOCAL COLOUR The colour of an object when it has not been modified by light, shadow or atmosphere.

MANNERISM A style of painting in Italy, dating from about 1520-1600, which was based to a large extent on the influence of Michelangelo. It is characterized by elongated, sinuous figures and theatrical gestures.

MASKING The process of protecting the support, or an area of colour, when another colour is applied.

MASKING FLUID A liquid rubber solution which is painted onto the support to mask certain areas from

subsequent paint. Colour can be applied over the areas masked by the fluid. The dried mask is eventually rubbed off with an eraser or finger.

MEZZOTINT A finely grained printing method popular in the 18th century which enabled the engraver to obtain precise tones. It has largely been replaced by photographic reproduction methods.

MEDIUM The material in which a painting or drawing is executed—watercolour, oils, coloured pencil, etc. The term is also used to describe the various additives which can be mixed with the paint by the artist in order to change the effect or the property of the material

MIXED MEDIA A work of art created from a variety of media. The combination can be traditional, such as watercolour and ink, or the mixture can be more experimental. Contemporary works often contain a variety of materials

MONOCHROME A drawing or painting done in one colour.

MOP A watercolour brush with a full, round head of bristles useful for large areas of colour and washes.

NEOCLASSICAL An 18th century movement whose aims were to recreate the standards and styles of Greece and

"NOT" A term used to describe paper manufactured by being cold-pressed rather than hot-pressed (the paper is not hot-pressed, hence the origin of the expression "not" paper.

OLD STONE AGE The palaeolithic period, or first part of the Stone Age, when tools and implements were stones and flints chipped into various shapes.

OPACITY When referring to paint, this term means the "covering" or "hiding" ability of a paint, or colour, to obliterate the underlying colour.

PALETTE A tray, board, or mixing dish used for mixing and thinning paints. The term is also used to describe a selection of colours as used by a particular artist, or in a specific picture.

PARCHMENT Support for writing or painting on, made from animal skin, usually sheep or goat.

PIGMENT Colouring substances obtained from mineral, animal or vegetable sources. The same pigments are used to make all types of paint.

POINTILLISM A painting technique based on the optical mixing of colours – allowing the colours to mix in the viewer's eye rather than pre-mixing them on the palette: for example, an area of green might be largely built up with tiny dots of yellows and blues, and modified with a few other colours.

POSTER COLOUR An opaque type of watercolour. Poster colour is similar to gouache, but is a cruder product and is generally available in a fairly limited range of colours.

PRE-RAPHAELITE BROTHERHOOD A 19th century English movement which looked to the art of 14th and 15th century Italy for its inspiration. The artists used bright colours, sharp detail, and featured mythology and symbolism in much of their work.

PRIMARY COLOUR Artists' primary colours are red, yellow and blue.
Theoretically, all other colours can be made from the three primaries, although in practice this is not the case.

PURE COLOUR The primary colours – red, yellow and blue – and any mix of two of them, are referred to as "pure".

RENAISSANCE Artistic and cultural revival of classical ideals which took place in Europe, particularly Italy, from the 14th to the 16th centuries.

RESIST Technique involving two materials which do not mix: for example wax crayon or oil paint used under watercolour will repel, or resist, the paint to produce a particular effect.

RIGGER A soft brush with long, tapering bristles, used mainly by calligraphers and sign-writers, but also employed by painters to produce flowing, undulating lines.

ROMANTIC MOVEMENT An 18th century art movement which was concerned primarily with the expression and emphasis of idealized human emption

ROUND Standard brush type with bristles which are held in a circular ferrule.

SABLE Kolinsky, or Siberian weasel. The hairs from the tail of this small rodent are used for making superior paintbushes.

SATURATION Term used to describe the strength or intensity of a colour.

SCALPEL Cutting tool with a removable blade. The scalpel was

originally used for surgical purposes, but is widely employed by artists, designers and craftspeople.

SECONDARY COLOUR Colour mixed from two of the primary colours. Orange, green and violet are the secondary-colours in painting.

SEPIA Brownish pigment, traditionally obtained from the ink of the cuttlefish.

SGRAFFITO Scratching or scoring technique, usually done with a sharp instrument, o lift the colour in order to reveal the white paper underneath.

SIZE Glue obtained from animal skin and used for sealing canvas and paper.

SKETCH A rapid drawing aimed at capturing the essential elements of a subject. A sketch is often made to work out a particular aspect of the subject prior to painting it, or to be used as reference for a painting to be done at a later date.

SPATTERING Texturing technique done by shaking a loaded brush onto the picture, or by flicking colour from the brush with the thumb or finger.

STENCIL Card, or other stiff material, with a pattern or motif cut out of it. The stencil is laid on the support and the paint dabbed over the cut out areas to reproduce the design.

STIPPLE Texture created by dabbing colour with a special brush. A stippling brush has a short stiff head of bristles cut squarely to form a flat end when the brush is used in an upright position.

SUBTRACTIVE MIXING Mixing of the artists' primaries—red, yellow and blue—to create secondary and tertiary colours. When these three are mixed in equal quantities the result is dark grey.

SUPPORT Paper, canvas, board, or other surface on which to paint or draw.

TEMPERA Paint made from pigment, an emulsion of oil, and water. Tempera popularly means egg tempera in which the emulsion used is egg yolk.

TERTIARY COLOURS Colours which are the result of a primary colour mixed with an equal amount of a secondary colour.

THUMBNAIL SKETCH Tiny line or colour sketches done to help the artist make decisions about composition, colour, etc, before embarking on a full-scale work.

TONE Light and dark values are referred to as tones. Every local colour has a tone—an equivalent grey. Gradations of tone are also created by the effect of light and shade on a three-dimensional object.

TOPOGRAPHY Detailed, descriptive drawing aimed at showing the specific features of a scene. The object of a topographical drawing is to convey information about the subject rather than to express a personal interpretation of it.

VANISHING POINT The theoretical point at which converging parallel lines meet when constructing linear perspective.

VARNISH Transparent, resinous coat applied to the finished painting to protect the surface.

VORTICISM English art movement similar to Cubism, formed by the painter and writer, Wyndham Lewis.

WARM COLOUR Reds, oranges and vellows are the warm colours.

WASH Diluted colour applied thinly to the support. A wash can be graded from light to dark, or can be laid in two or more colours. The object of a wash is usually to obtain an area of transparent colour in the early stages of a painting.

WATERCOLOUR Waterbased paint made from pigment suspended in gum arabic. Unlike most other paints, watercolour is transparent and must be worked by laying the lightest tones first.

WAX RESIST Resist technique based on the fact that wax repels water; candles, wax crayons, or any other waxy substance can be used.

WET ON DRY Applying paint to a colour which has been allowed to dry thoroughly, or to a dry support, in order to achieve crisp shapes and controlled brushstrokes.

WET ON WET Applying paint to a colour while it is still wet, or to a dampened support, in order to achieve soft forms and bleeding colours.

INDEX

Page numbers in *italic* refer to illustrations and captions

A

About, Edmond, 40 acrylic paint, 72 additives, 88 aerial perspective, 128, 130 alcohol, 88 Alexa, 142, 142-5 American Water Color Society, 60 Anemones in a Window, 138, 138-41 Apples on a Plate, 196, 196-9 The Artist's Father, 200, 200-3 artist's paints, 80 Audubon, John, 60

B

backgrounds, portrait and figure painting, 99 Bailey, Caroline, 73, 114 Oriental Poppies and Lupins, 73 Banks, Sir Joseph, 48 Basket of Fruit, 116, 116-9 Bauhaus, 58 Blake, William, 38, 38, 44 Satan Arousing the Rebel Angels, 38-9 bleach, 160, 161 Blue Irises, 146, 146-9 body colour, 204 Book of the Dead, 13 botanical art, 48, 48-51, 73 box easels, 86, 86 Braque, Georges, 71 Brighton, Catherine, 59 Blind Girl Wearing Fox Fur, 59 brights, 82, 82

brown wash, 26 Browne, H.K. (Phiz), 56 brushes, 82-3, 82-3 care of, 83 shapes, 82 sizes, 83 specialist, 82-3 Buchan, Alexander, 48 Burne-Jones, Edward, 46

Calvert, Edward, 44 caricatures, 36 cartoons, 22, 24 Cassatt, Mary, 60 cave paintings, 10, 10-11 Cézanne, Paul, 63, 66, 66 Still Life with Chair, Bottle and Apples, 66 Chapel with Cypress Trees, 180, 180-3 charcoal, 221 Chinese art, 16, 16-17, 18 Choppy Waves, 242, 242-3 Chou Fang, 16 Claude Lorraine, 26 Cloud Study, 234, 234-5 cold-pressed papers, 84 Colman, Samuel, 60 colour: colour theory, 92-4, 92-5 colour wheels, 94, 94 complementary, 94, 95 cool, 194, 194-203 monochrome, 156, 156-9 optical mixing, 93, 93 pigments, 90-1, 90-1 primary colours, 92-3 secondary colours, 93, 94, 95 tertiary colours, 94, 95 tone and, 96, 96-7 warm, 194, 194-203 complementary colours, 94, 95 composition, 100-1, 100-1

choosing, 101

harmony and rhythm, 101 shape and size, 100-1 Constable, John, 42, 52 View over a Wide Landscape with Trees in the Foreground, 52 Cook, James, 48 cool colours, 194, 194-203 Corn on the Cob, 222, 222-5 Cotman, John Sell, 40, 42 Greta Bridge, Yorkshire, 44 Cox, David, 40, 40 Rhyl Sands, 40 Cozens, John Robert, 30 Lake Nemi, 30-1 Crab, 176, 176-9 Cristall, Joshua, 36 Crome, John, 42 Cubism, 71

D

dark to light, 204, 204-13 Daumier, Honoré, 56 Les (Deux) Confrères, 56 De Wint, Peter, 40, 42, 42 Bridge over a Tributary of the Witham River in Lincolnshire, 42 Delacroix, Eugène, 52 Di Stefano, Arturo, 75 Cloud Mocks Ixion, 74-5 drawing, 102-3, 102-3 cartoons, 22, 24 drawing boards, 88 drybrush, 188, 188-93 drying time, 88 Dürer, Albrecht, 20, 20-1, 22, 48 The Great Piece of Turf, 20-1 Dyck, Anthony van, 22

E

Eakins, Thomas, 60, 60 Negro Boy Dancing, 60 easels, 86, 86-7 Egyptian painting, 12, 13 Everdingen, Allart van, 22

I

figure painting, 36, 98, 98, 168, 168-71, 216, 216-9
ancient Egyptian, 12
caricatures, 36
Chinese, 16
filberts, 82
Finch, Francis Oliver, 44
flat brushes, 82
flowers, 138, 138-41, 146, 146-9, 206, 206-9
form, creating, 136, 204
fresco buono, 14
fresco secco, 14
frescoes, 14, 14-15
Fuseli, Henry, 38, 38

G

Gillray, James, 36 Giotto, 14 Girtin, Thomas, 32, 34, 42 The Garden Terrace, 34 Gleyer, Charles, 62 glycerine, 88 gouache, 66 illustrators' use of, 56 mixing, 108, 109 painting skies, 238, 238-9 paints, 81 sketching in, 52, 54, 55 working dark to light, 204 grand tours, 30 gum arabic, 88, 163, 172, 175 gumwater, 88, 163, 172, 175, 180

hand-made papers, 84 harmony, 101 herbals, 48 Hogarth, William, 36 Homer, Winslow, 60, 65 Palm Tree, Nassau, 65 hot-pressed papers, 84 Howard, Luke, 52 Hui Tsang, 16 Hunt, William Holman, 46 Huysum, Jan van, Cabbage Rose, 51

illustration work, 56 Impressionists, 62, 63, 65, 66, 93 Indian art, 19 ink, pen and wash, 103, 103, 120, 120-7 Iris with Butterflies and Insects, 16-17

Jars with Dried Flowers, 206, 206-9 John, Gwen, 52, 54 Girl Carrying a Palm Frond, 55 A Stout Lady, and Others, 54 Jordaens, Jacob, 22 Josephine, Empress, 50

K

Kaempfer, Engelbert, 48
Kandkinsky, Wassily, 66, 69
Study for Improvisation 25, 69
Kelmscott Press, 46
Klee, Paul, 66
Ku K'ai-chih, The Admonitions of the
Court, 18

landscapes, Chinese, 16
Larsson, Carl, 58
The Flower Window, 58
Le Moyne de Morgues, Jacques, 48
Lewis, Wyndham, 71
At the Seaside, 71
light, paint and, 92-3, 92-3
light to dark, 136, 136-49
lighting, studio, 78
Lindisfarne Gospels, 13
linear perspective, 128, 128
lines, fine, 162
Linnell, John, 44
liquid watercolour, 81

INDEX

Los Pocho, 62 Lowe, Adam, 75 Drawings from the Emblems and Icons Series, 75

M

Malton, Thomas, 32 masking, 150, 150-5 masking fluid, 88, 150, 151 mediums, 88 Merian, Maria Sibylla, 48, 48, Hog Plum, 48 Michelangelo Buonarroti, 38 Sistine Chapel, 15 Millais, John Everett, 46 A Misty Scene, 158, 158-9 mixed media, 220, 220-5 mixing paint, 108, 108-9 monochrome, 156, 156-9 Monro, Henry, A Portrait of Dr. Thomas Monro, 34-5 Monro, Thomas, 30, 32, 34, 34, 42 Morris, William, 46, 46 Avon Chintz, 46-7 Mortimer, John Hamilton, 36 Mu-ch'i 16 murals, frescoes, 14

N

Nakhte and his Wife, 13
Nash, John, 68
Two Submarines by a Jetty, 68
Nash, Paul, 68
Neo-Impressionists, 65
neutrals, 96, 97, 194
New Society of Painters in Miniature
and Watercolour, 40
Norwich School, 42

0

oil pastels, 220
Old Watercolour Society, 40, 40, 41, 42
On the Verandah, 152, 152-5
optical mixing, 93, 93
Ostade, Adriaen van, 22
Ostade, Isaak van, 22
outdoor painting, 98-9
outlines, 102-3
oxgall, 88

P

paints, 80-1 80-1 adhesiveness, 88 drying time, 88 mixing, 108, 108-9 Palmer, Samuel, 38, 42 In a Shoreham Garden, 44-5 papers, 84-5, 84-5 invention, 16 stretching, 85, 106, 106-7 papyrus, 12, 13 parchment, 12 Parkinson, Sydney, 48 pen and wash drawing, 103, 103 techniques, 120, 120-7 pencils: coloured, 102, 102 graphite, 88, 102, 102 watercolour, 81, 214, 214-19 perspective, 128, 128-35 aerial, 128, 130 linear, 128, 128 photographs, as reference, 59 Picasso, Pablo, 70, 71 Young Acrobat and Child, 70 pigments, 90-1, 90-1

ancient Egyptian, 12
plaster, frescoes, 14, 15
pointillism, 66, 93
Portrait and Symbol of St Matthew, 13
portraits, 142, 142-5
pose, 98, 98
poster colours, 80
Potted Cactus, 122, 122-3
Poussin, Nicolas, 26
Pre-Raphaelite Brotherhood, 46
prehistoric art, 10, 10-11
Prendergast, Maurice, 60, 63
Low Tide, Beachmont, 63
primary colours, 92-3
tonal value, 96

R

Rajasthani school, 19 Raphael, 22, 24, 24 Tapestry of the Miraculous Draught of Fishes, 24-5 Receding Hills, 134, 134-5 Redouté, Pierre-Joseph, Ellebore Oillet, 50 Rembrandt, 26 retouching brushes, 83 Rhadha and Krishna in a Grove, 19 rhythm, 101 Richmond, George, 44 riggers, 82, 83 Rooker, Michael 'Angelo', 30 Rossetti, Dante Gabriel, 46 round brushes, 82, 83 Rowlandson, Thomas, 36, 36, 120 The French Hunt, 36-7 Royal Academy, 28, 34, 40, 60 Rubens, Sir Peter Paul, 21-2, 22, 120 Nereid and Triton, 22-3

stretching, 85, 106, 106-7 Swimming Pool, 246, 246-9 The Village Church, 124, 124-7 Vorticists, 71

S

salt, texturing with, 172 Sandby, Paul, 28, 28 A Milkmaid in Windsor Great Park, Sandby, Thomas, 28 Sargent, John Singer, 60 A Seascape, 112, 112-3 Seated Nude, 168, 168-71 secondary colours, 93, 94, 95 Seurat, Georges, 66, 95 sgraffito, 160, 160 shadows, 94 shape, composition, 100 Shoreham Ancients, 38, 42, 44 Sidaway, Ian, Portrait of a Young Girl, 72 Signac, Paul, 93 silk, painting on, 16 Sistine Chapel, 15, 22, 24, 24-5 size, composition, 100 sketchbooks, 52 sketches, 101 skies, painting, 234-41 Smith, J.R., 42 Snow Scene, 184, 184-7 Society of Artists, 34 spattering, 173, 175, 184 Spencer, Stanley, 44 sponges: painting skies, 240, 240-1 texturing with, 174 spontaneity, 52 Still Life, 164, 164-7 stretching paper, 85, 106, 106-7 student's paints, 80 studio space, 78, 78-9 subjects: arranging, 100 simple, 98-9 Summer Trees, 230, 230-3 Sunlit Field, 210, 210-13 Sunsets, 236, 236-7 supports, 84-5, 84-5

tabletop easels, 86, 86 tapestries, 24, 24-5 tertiary colours, 94, 95 texture, 172, 172-87 drybrush techniques, 188, 188-93 The Good Samaritan Arriving at the Inn, 26-7 thumbnail sketches, 101 tonal washes, 26, 26-7 tones, 96, 96-7 building up, 136, 204 topographical watercolours, 30 trees, painting, 228, 228-33 Tsai-Lun, 16 The Tuileries, Paris, 130, 130-3 Turner, J.M.W., 32, 34 Tintern Abbey, 32-3

U

United States, 60, 60-5

V

vanishing point, 128, 129 Varley, Cornelius, 41 Varley, John, 40, 40, 41, 42, 44 *Waltham Abbey*, 41 varnish, 88 viewers, 101

Ward, James, 36 warm colours, 194, 194-203 washes, tonal, 26, 26-7 water, painting, 242-9 watercolour: liquid paint, 81 mixing, 108, 109 modern versatility, 72 paints, 80 sets and boxes, 81, 81 watercolour pencils, 81, 214, 214-9 Waterfall, 244, 244-5 wax resist, 173 West, Benjamin, 60 wet on dry, 110, 110-3 wet on wet, 62, 114, 114-9 Whistler, James Abbott McNeill, 60, Grey and Green: a Shop in Brittany, white, creating, 160, 160-71 White, John, 48 Windows and Shutters, 190, 190-3 Winter Trees, 228, 228-9 Woman by a Window, 216, 216-9 workplace, 78, 78-9 Wyeth, Andrew, 64, 188 End of Winter, 64 Wyeth, N.C., 64

ACKNOWLEDGMENTS

The Paul Press Ltd would like to thank all those who have helped with this book. We would especially like to thank George Short for his patience and journalistic expertise, Ian Sidaway and Ian Howes for all their hard work and long hours, and Daler-Rowney for their help and generosity in providing materials for the demonstrations and studio photography.

The Paul Press Ltd would also like to thank the following organizations to whom copyright in the photographs noted belongs:

11 The Bridgeman Art Library; 12 Michael Holford; 13 The British Library; 14-15 The Bridgeman Art Library; 17,18 reproduced by courtesy of the Trustees of the British Museum; 19 Michael Holford; 21 Graphische Sammlung Albertina, Vienna; 23 The Bridgeman Art Library; 25 Photo Vatican Museums; 27,29 reproduced by courtesy of the Trustees of the British Museum; 31,33 by courtesy of the Board of Trustees of the Victoria and Albert Museum; 34 National Portrait Gallery, London; 35 by courtesy of the Board of Trustees of the Victoria and Albert Museum; 37 reproduced by courtesy of the Trustees of the British Museum; 39 The Bridgeman Art Library; 43 Tate Gallery, London; 44 reproduced by courtesy of the Trustees of the British Museum; 45 Bridgeman Art Library; 47 Bridgeman Art Library; 49 reproduced by courtesy of the Trustees of the British Museum; 50 The Bridgeman Art Library; 51 reproduced by courtesy of the Trustees of the British Museum; 53 The Bridgeman Art Library; 54, 55 National Museum of Wales; 57 Sterling and Francine Clark Institute, Williamstown, Mass; 58 Nationalmuseum, Stockholm; 61 The Metropolitan Museum of Art, Fletcher Fund, 1925 (25.97.1); 62 Hunterian Art Gallery, University of Glasgow, Birnie Philip Gift; 63 Worcester Art Museum, Worcester, MA; 64 Gift of Eleanor Conway Sawyer, Dickinson College, Carlisle, PA; 65 The Bridgeman Art Library; 67 Courtauld Institute Galleries, London (Courtauld Collection); 68 The Imperial War Museum; 69 Solomon R. Guggenheim Museum, New York; Photo: David Heald (c ADAGP 1986); 70 The Justin K. Thannhauser Collection, Solomon R. Guggenheim Museum, New York; Photo: David Heald (c DACS 1986); 71 by courtesy of the Board of Trustees of the Victoria and Albert Museum; 85, 86 (top) Daler-Rowney